Landscape and Power

LANDSCAPE AND POWER

SECOND EDITION

Edited by

W. J. T. Mitchell

THE UNIVERSITY OF CHICAGO PRESS • *Chicago and London*

The University of Chicago Press, Chicago 60637
The University of Chicago Press, Ltd., London
© 1994, 2002 by The University of Chicago
All rights reserved. Published 2002
Printed in the United States of America

11 10 09 08 07 06 05 04 03 02 1 2 3 4 5
ISBN: 0-226-53205-4

CIP data is available.

∞ The paper used in this publication meets the minimum
requirements of the American National Standard for Information
Sciences—Permanence of Paper for Printed Library Materials, ANSI
Z39.48-1992.

Contents

Preface to the Second Edition of *Landscape and Power*

Space, Place, and Landscape

W. J. T. MITCHELL

If I were given the chance to retitle *Landscape and Power* today, some years after its first appearance, I would call it *Space, Place, and Landscape,* for two reasons. The first is that the point about power has been made abundantly, and is thoroughly contested in these pages. If one wanted to continue to insist on power as the key to the significance of landscape, one would have to acknowledge that it is a relatively weak power compared to that of armies, police forces, governments, and corporations. Landscape exerts a subtle power over people, eliciting a broad range of emotions and meanings that may be difficult to specify. This indeterminacy of affect seems, in fact, to be a crucial feature of whatever force landscape can have. As the background within which a figure, form, or narrative act emerges, landsape exerts the passive force of setting, scene, and sight. It is generally the "overlooked," not the "looked at," and it can be quite difficult to specify what exactly it means to say that one is "looking at the landscape."

This peculiar indeterminacy reveals itself as a kind of redundancy when one rephrases the landscape imperative as we do in everyday parlance: "look at the view." Not "look at the mountain" (or the ocean, the sky, the plains, the forest, the city, the river), but "look at the view." The vernacular expression suggests that the invitation to look at landscape is an invitation not to look at any specific *thing*, but to ignore all particulars in favor of an appreciation of a total gestalt, a vista or scene that may be dominated by some specific feature, but is not simply reducible to that feature. (A similar problem could be traced when the mandate is to *paint* or *depict* a

landscape.) The landscape imperative is a kind of mandate to withdraw, to draw out by drawing back from a site. If a landscape, as we say, "draws us in" with its seductive beauty, this movement is inseparable from a retreat to a broader, safer perspective, an aestheticizing distance, a kind of resistance to whatever practical or moral claim the scene might make on us. Raymond Williams's remark still holds true: "a working country is hardly ever a landscape."[1] The invitation to look at a view is thus a suggestion to look at nothing—or more precisely, to look at looking itself—to engage in a kind of conscious apperception of space as it unfolds itself in a particular place.

This leads me to the positive change I would make in the title of this book. What happens to landscape when its effects are gauged in relation to space and place? How do these three terms resonate together? In many contexts, of course, we use them interchangeably. A landscape just is a space, or the view of a place. In both the phenomenological and historical materialist traditions of this subject, space and place are the crucial terms, and landscape is taken for granted as an aesthetic framing of the real properties of space and places. David Harvey's work may be taken as exemplary here.[2] Harvey attempts to synthesize the phenomenological and experiential tradition exemplified by Gaston Bachelard and Martin Heidegger with the Marxist tradition represented by Henri Lefebvre, Michel de Certeau, and Michel Foucault. Despite the many differences between these traditions, they agree on the primacy of "space" and "place" as the fundamental categories of analysis. Landscape remains relatively underanalyzed. It has been left primarily to art historians interested in painting or landscape architecture, or to cultural geographers such as J. B. Jackson. To my knowledge, no one has really attempted to think the three terms together as a conceptual totality.

Perhaps the most straightforward beginning would be provided by Michel de Certeau, who divides the "field" between space *(espace)* and place *(lieu)* in terms of a whole series of binary oppositions. Place is associated with "stability," "the law of the proper," and the specific, definite location. Space, by contrast,

exists when one takes into consideration vectors of direction, velocities, and time variables. This space is composed of intersections of mobile elements. . . . In contradistinction to the place, it has thus none of the univocity or stability of a "proper."

In short, *space is a practiced place.* Thus the street geometrically defined by urban planning is transformed into a space by walkers. In the same way, an act of reading is the space produced by the practice of a particular place: a written text, i.e., a place constituted by a system of signs.[3]

David Harvey echoes this sort of distinction when he exemplifies a place as a gated community that has to be "secured against the uncontrolled vectors of spatiality" (292) in the form of invading pressures from poor black neighborhoods. Indeed, he sees the central dynamic of capital as a "tension between place-bound fixity and spatial mobility" (296). One can glimpse here a whole set of familiar oppositions extrapolated from the distinction between space and place. De Certeau aligns the terms with the differences between operations and objects, itineraries and maps, parole and langue, transgression and law, action and immobility.

Space and place make an attractive dialectical opposition in ordinary language as well. Space has connotations of abstraction and geometry, while place resonates with particularity and qualitative density. There is outer space, but "outer place" sounds odd. For something to "take place" is radically different grammatically from "taking space" (or should it be "taking *up* space"?) Place is an intransitive verb that takes an object: "I placed a jar in Tennessee." "Space" only becomes a predicate as a metaphor for displacement and disorientation (one can be "spaced out" or "space" objects by widening the distance between them, so that the verb "to space" seems directly counter to the action of placing). To some extent these vernacular connotations reverse de Certeau's oppositions, insofar as they link space with number, negation, measurement, surveillance, and control, while place retains a concrete, complex, and sensuous existence beneath the spatial codes of mapping and depiction. An empty space is not the same thing as an empty place. An empty place is filled with space, as if space were the negative void that rushes in when a place is vacated. It is the spectral absence that "fills" a hollow shell or a clearing in the forest. A place, however, is basically the same thing as "a" definite, bounded space, while space as such, without the definite article, becomes abstract and absolute. There is no absolute place, however, except in Borges's "The Aleph," where the mystical Hebrew letter is the place that contains all other places.[4]

In contrast to this dyadic approach to the field, Henri Lefebvre's classic *Production of Space* insists on a relentlessly triadic conceptual organization, based in the differences between what he calls perceived, conceived, and lived space.[5] Perceived space corresponds roughly to what de Certeau calls "spatial practices," the daily activities and performances that "secrete" a society's space, like the pathways that spontaneously appear on a greensward as a result of habitual walking patterns. Conceived space is the planned, administered, and consiously constructed terrain of engineers, city planners, and architects, as expressed (Lefebvre notes) in "numbers" and "intellectually worked out" verbal signs. Lived space (what Lefebvre also calls "representational space"), finally, is mediated through "images

and symbols" addressed to the imagination. It is the province of "inhabit-
ants" and "users, but also of some artists and . . . a few writers and philoso-
phers who *describe* and aspire to do no more than describe. This is the
dominated—and hence passively experienced—space which the imagina-
tion seeks to change and appropriate" (39).

As will probably be evident, Lefebvre's three categories roughly corre-
spond to what I have been calling "space, place, and landscape." I'm less
interested, however, in forcing a correspondence of this sort, than in taking
Lefebvre's more general advice to triangulate the whole topic, and to resist
the temptation to binarism.[6] More concretely, the language of space, place,
and landscape offers a vernacular entry into our field that perhaps none of
these terms can provide in isolation or in tandem. What I propose in this
second edition of *Landscape and Power,* then, is not just some important
new material—the essays by Edward Said, Jonathan Bordo, Michael Taus-
sig, Robert Pogue Harrison, and myself—but a new reading of all the
essays provoked by an attention to this more capacious and differentiated
theoretical field.

One might think, then, of space, place, and landscape as a dialectical
triad, a conceptual structure that may be activated from several different
angles. If a place is a specific location, a space is a "practiced place," a site
activated by movements, actions, narratives, and signs, and a landscape is
that site encountered as image or "sight." Central Park in New York City
is thus located in a specific place on the earth; it is the site of innumerable
activities and practices; and it is consumed (and was designed to be con-
sumed) as a series of picturesque tableaus or "landscapes" derived from
European landscape painting. No one of these terms is logically or chrono-
logically prior to the others: one could speak of spatial activities as produc-
ing or modifying a place, or of the properties of a place making possible
some spatial activities and preventing others (thus, place may be seen as
having a kind of agency, despite de Certeau's notion that space is the active
and dynamic term). Landscape could be seen as the first cognitive encoun-
ter with a place, and an apprehension of its spatial vectors (thus, an appreci-
ation of landscape may well include a reading—or an inability to read—
its narrative tracks or symbolic features).

Perhaps the most important of Lefebvre's and de Certeau's insights is
the expression of power in the landscape as a manifestation of law, prohibi-
tion, regulation, and control—the whole sphere of what Lacan calls "the
Symbolic." This is Lefebvre's "conceptualized space," the administered or
shaped space produced by the landscape architect or engineer, the taboo or
sacred space declared off-limits by the shaman, or the conquered territory
named, claimed, and controlled by the colonial administrator. To this no-
tion of space as the dimension of the Symbolic (as law or negation) I would

then add the notion of place as the location of the Lacanian Real, the site of trauma or the historical event. We say, "this is the place where this happened," while it would seem slightly odd to say "this is the space (or landscape) where this occurred." The memorial or monument is erected to mark a place. Spatial practices (rituals, pilgrimages, tourism) may then activate the place, and it may become the object of imaginary renderings (postcards, descriptions, *son et lumière* spectacles, fantasies, memories).

My point, however, is not to rigidly identify space, place, and landscape with Lacan's symbolic, real, and imaginary, but to activate the dialectical resources of this conceptual triad. The aim is to release the vernacular resources of theory embedded in these terms, to "listen to our metalanguage," as Heidegger might have put it. We need to do this because we do not know, quite literally, how to name the "field" or "topic" (much less the discipline) subtended by these terms. Are we talking about cultural or humanistic geography? About landscape architecture, environmental studies, or deep ecology? About the history of art, literature, or media? About the sociology, anthropology, or phenomenology of locations, regions, and territories? Any attempt to stabilize the inquiry around one of these terms, to establish "space," for instance, as the foundational concept and to treat the other two as derivative modifications, tends to reify and impoverish the discussion. Better, in my view, to begin (as Lefebvre insists) with a triangulation of the topic. This gesture may actually be a reflex of some fundamental process in cognitive mapping as such, a way of orienting ourselves in any perceptual or conceptual field whatsoever. Our "topic" (understood literally as place) then dictates a process of thinking space/place/landscape as a unified problem and a dialectical process.

The new contributions to this edition all evoke this triad in various ways. Edward Said's "Invention, Memory, and Place," written as the keynote address to a memorable 1998 conference on "Landscape Perspectives in Palestine." shows the way a host of mediations (writing, memory, imagination) produce a "human space," that is, a space/place/landscape complex, specific in its location and history, scarred and traced by spatial vectors and movements across its face. My own contribution (written for the same conference) on "Holy Landscape" in Israel/Palestine and the American West is, similarly, focused on the way an imaginary landscape is woven into the fabric of real places (e.g., the desert of the western United States, the desert areas of the West Bank) and symbolic spaces (territories as subject to legal and military authority). The specific site at which these papers were first delivered, Bir Zeit University in the West Bank, is moreover a crucial aspect of their meaning, as is their sense of double locatedness in an American setting so deeply tied by symbolic, imaginary, and real bonds with Israel and Palestine.

Jonathan Bordo's essay on the wilderness is, similarly, a site-specific intervention into a North American and Candian imaginary of "untouched" or "virgin" landscape, coupled with a real history of destructive spatial practices and regimes of symbolic control. Michael Taussig's meditation on "The Beach (A Fantasy)" is, as the title suggests, an exploration of those imaginary shores where "the beginning of man" from the "salt sea" is traced, but also of the very real destruction of the "port" as public space in our century, and the symbolic resonances of a specific place such as the surfing beach of Bondi in Sydney, Australia. Robert Pogue Harrison's "Hic Jacet," finally, reopens the Heideggerean question of place as simultaneously determined by and determining our "being in the world," Dasein. Do we make places, or do they make us? The shifting valences of this question, attributing agency to living human subjects, or to the places of their burial, seems to bring the whole question of space, place, and landscape back to "the ground," as it were. Whatever the power of landscape might be, and of its unfoldings into space and place, it is surely the medium in which we live, and move, and have our being, and where we are destined, ultimately, to return.

Notes

1. Raymond Williams, *The Country and the City* (New York: Oxford University Press, 1973), 120.
2. See especially David Harvey, *Justice, Nature, and the Geography of Difference* (Cambridge, Mass.: Blackwell, 1996).
3. Michel de Certeau, *The Practice of Everyday Life* (Berkeley: University of California Press, 1984), 117.
4. In Jorge Luis Borges, *The Aleph and Other Stories: 1933–1969* (New York: E. P. Dutton, 1970).
5. Henri Lefebvre, *The Production of Space* (1971), translated by Donald Nicholson-Smith (Oxford: Blackwell, 1991).
6. See Edward Soja, *Thirdspace* (Blackwell, 1996), especially his discussion of "the trialectics of spatiality."

Acknowledgments

This volume first began to crystallize at a Midwest Faculty Seminar entitled "The Power of Landscape," developed by Elizabeth O'Connor Chandler of the University of Chicago's Office of Continuing Education in the spring of 1990. Ann Adams, Ann Bermingham, David Bunn, Elizabeth Helsinger, W. J. T. Mitchell, and Joel Snyder presented papers. We all owe thanks to the lively and critical discussion provided by the college teachers of art, anthropology, psychology, and literature who gathered for this seminar, and to Elizabeth O'Connor Chandler and her colleagues Susan Kastendiek and Pearl Gonzalez, and to the sponsorship of the Lilly Foundation for making this a feast of learning. I thank Ann Adams for agreeing to team-teach a graduate seminar "Verbal and Visual Landscape" with me in the spring of 1990, and the guest lecturers—Anne Burkus on Chinese landscape, Martha Ward on European modernism, and Larry Silver on German landscape—who helped to make its international explorations possible.

W. J. T. Mitchell

Introduction

W. J. T. MITCHELL

The aim of this book is to change "landscape" from a noun to a verb. It asks that we think of landscape, not as an object to be seen or a text to be read, but as a process by which social and subjective identities are formed. The study of landscape has gone through two major shifts in this century: the first (associated with modernism) attempted to read the history of landscape primarily on the basis of a history of landscape painting, and to narrativize that history as a progressive movement toward purification of the visual field;[1] the second (associated with postmodernism) tended to decenter the role of painting and pure formal visuality in favor of a semiotic and hermeneutic approach that treated landscape as an allegory of psychological or ideological themes.[2] I call the first approach "contemplative" because its aim is the evacuation of verbal, narrative, or historical elements and the presentation of an image designed for transcendental consciousness—whether a "transparent eyeball," an experience of "presence," or an "innocent eye." The second strategy is interpretative and is exemplified in attempts to decode landscape as a body of determinate signs. It is clear that landscapes can be deciphered as textual systems. Natural features such as trees, stones, water, animals, and dwellings can be read as symbols in religious, psychological, or political allegories; characteristic structures and forms (elevated or closed prospects, times of day, positioning of the spectator, types of human figures) can be linked with generic and narrative typologies such as the pastoral, the georgic, the exotic, the sublime, and the picturesque.

Landscape and Power aims to absorb these approaches into a more comprehensive model that would ask not just what landscape "is" or "means" but what it *does*, how it works as a cultural practice. Landscape, we suggest, doesn't merely signify or symbolize power relations; it is an instru-

1

ment of cultural power, perhaps even an agent of power that is (or frequently represents itself as) independent of human intentions. Landscape as a cultural medium thus has a double role with respect to something like ideology: it naturalizes a cultural and social construction, representing an artificial world as if it were simply given and inevitable, and it also makes that representation operational by interpellating its beholder in some more or less determinate relation to its givenness as sight and site. Thus, landscape (whether urban or rural, artificial or natural) always greets us as space, as environment, as that within which "we" (figured as "the figures" in the landscape) find—or lose—ourselves. An account of landscape understood in this way therefore cannot be content simply to displace the illegible visuality of the modernist paradigm in favor of a readable allegory; it has to trace the process by which landscape effaces its own readability and naturalizes itself and must understand that process in relation to what might be called "the natural histories" of its own beholders. What we have done and are doing to our environment, what the environment in turn does to us, how we naturalize what we do to each other, and how these "doings" are enacted in the media of representation we call "landscape" are the real subjects of *Landscape and Power*.

Although this collection does not contain any essays on cinematic landscape, it should be clear why moving pictures of landscape are, in a very real sense, the subtext of these revisionist accounts of traditional motionless landscape images in photography, painting, and other media. The basic argument of these essays is that landscape is a dynamic medium, in which we "live and move and have our being," but also a medium that is itself in motion from one place or time to another. In contrast to the usual treatment of landscape aesthetics in terms of fixed genres (sublime, beautiful, picturesque, pastoral), fixed media (literature, painting, photography), or fixed places treated as objects for visual contemplation or interpretation, the essays in this collection examine the way landscape *circulates* as a medium of exchange, a site of visual appropriation, a focus for the formation of identity. Thus, even the most traditional subject of landscape aesthetics, Dutch painting of the seventeenth century, is treated by Ann Adams in this collection as a dynamic, transitional formation that participates in an ecological revolution (the literal creation of Nether-*lands* from the sea) and the formation of a complex network of political, social, and cultural identities. In Adams's account, Dutch landscape is not merely a body of paintings to be interpreted "in historical context" but a body of cultural and economic practices that *makes* history in both the real and represented environment, playing a central role in the formation of social subjects as unreadably "private" identities and determinately public selves figured by regional and national identities.

In a similar way, Ann Bermingham's account of the "politics of English landscape drawing" in the 1790s treats the representation of landscape both as a "discourse" in which various political positions may be articulated and as a cultural practice that silences discourse and disarticulates the readability of landscape in order to carry out a process of institutional and political legitimation. Elizabeth Helsinger shows how, for Turner, landscape doesn't merely represent natural sites but creates a system of "circulating sites" associated with the dissonant class interests of burgeoning British tourism, nationalism, and imperialism, a system that reflects back, in turn, on the very conditions of political representativity in the public sphere. Joel Snyder examines the processes by which the American frontier is first appropriated and domesticated by landscape photography in the nineteenth century and then (in the work of Timothy O'Sullivan) is, as it were, alienated from modes of popular consumption to be re-presented as an object of dangerous power that can be grasped only by professional expertise. David Bunn examines the transference of European landscape conventions (especially British) from the metropolian center to the imperial periphery, focusing on the ways "transitional" and "prosthetic" features in both verbal and visual representations of South African landscape work to naturalize the position of the colonial settler and to manage the experiential contradictions of exile and domestication, exoticism and familiarity.

This collection is framed at the beginning and end by a pair of essays that take antithetical approaches to the question of landscape. My essay, "Imperial Landscape," sets out to displace the genre of landscape painting from its centrality in art-historical accounts of landscape, to offer an account of landscape as a medium of representation that is re-presented in a wide variety of other media, and to explore the fit between the concept of landscape in modernist discourse and its employment as a technique of colonial representation. Charles Harrison's concluding essay, "The Effects of Landscape," reopens the question of landscape as a genre of painting, traces its fortunes in the pictorial practices of modernism, and analyzes its effects, especially its moments of resistance to ideological constructions of the spectator. Harrison keeps us mindful of a point to which all the contributors of this volume would subscribe. An account of the "power" of landscape or of the medium in which it is represented is not to be had simply by reading it as a representation of power relations or as a trace of the power relations that influenced its production. One must pay attention to the specificity of effects and to the kinds of spectatorial work solicited by a medium at a particular historical juncture. Landscape in the form of the picturesque European tradition may well be an "exhausted" medium, at least for the purposes of serious art or self-critical

representation; that very exhaustion, however, may signal an enhanced power at other levels (in mass culture and kitsch, for instance) and a potential for renewal in other forms, other places.

Notes

1. This approach to landscape aesthetics is most fully developed in the influential work of Ernst Gombrich, particularly his essay "The Renaissance Theory of Art and the Rise of Landscape," in *Norm and Form: Studies in the Art of the Renaissance* (Chicago, 1966). See also Kenneth Clark, *Landscape into Art* (Boston, 1963), which popularizes and universalizes Gombrich's claim.

2. See, for instance, *Reading Landscape: Country—City—Capital,* ed. Simon Pugh (Manchester, 1990): "This collection of essays proposes that landscape and its representations are a 'text' and are, as such, 'readable' like any other cultural form" (2–3).

O N E

W. J. T. MITCHELL

Imperial Landscape

Theses on Landscape

1. Landscape is not a genre of art but a medium.

2. Landscape is a medium of exchange between the human and the natural, the self and the other. As such, it is like money: good for nothing in itself, but expressive of a potentially limitless reserve of value.

3. Like money, landscape is a social hieroglyph that conceals the actual basis of its value. It does so by naturalizing its conventions and conventionalizing its nature.

4. Landscape is a natural scene mediated by culture. It is both a represented and presented space, both a signifier and a signified, both a frame and what a frame contains, both a real place and its simulacrum, both a package and the commodity inside the package.

5. Landscape is a medium found in all cultures.

6. Landscape is a particular historical formation associated with European imperialism.

7. Theses 5 and 6 do not contradict one another.

8. Landscape is an exhausted medium, no longer viable as a mode of artistic expression. Like life, landscape is boring; we must not say so.

9. The landscape referred to in Thesis 8 is the same as that of Thesis 6.

We are surrounded with things which we have not made and which have a life and structure different from our own: trees, flowers, grasses, rivers, hills, clouds. For centuries they have inspired us with curiosity and awe. They have been objects of delight. We have recreated them in our imaginations to reflect our moods. And we have come to think of them as contributing to an idea which we have called nature. Landscape painting marks the stages in our conception of nature. Its rise and development since the middle ages is part of a cycle in which the human spirit attempted once more to create a harmony with its environment.

—Kenneth Clark, *Landscape into Art* (1949)

We have come a long way from the innocence of Kenneth Clark's opening sentences to *Landscape into Art*. Most notably, perhaps, the "we" for whom Clark speaks with such assurance can no longer express itself outside of quotation marks. Who is this "we" that defines itself by its difference from "trees, flowers, grasses, rivers, hills, clouds" and then erases this difference by re-creating it as a reflection of its own moods and ideas? Whose history and whose nature is "marked" into "stages" by landscape painting? What disruption required an art that would restore the "human spirit" to "harmony with its environment"?

Recent criticism of landscape aesthetics—a field that goes well beyond the history of painting to include poetry, fiction, travel literature, and landscape gardening—can largely be understood as an articulation of a loss of innocence that transforms all of Clark's assertions into haunting questions and even more disquieting answers. "We" now know that there is no simple, unproblematic "we," corresponding to a universal human spirit seeking harmony, or even a European "rising" and "developing" since the Middle Ages. What we know now is what critics like John Barrell have shown us, that there is a "dark side of the landscape" and that this dark side is not merely mythic, not merely a feature of the regressive, instinctual drives associated with nonhuman "nature" but a moral, ideological, and political darkness that covers itself with precisely the sort of innocent idealism Clark expresses.[1] Contemporary discussions of landscape are likely to be contentious and polemical, as the recent controversy over the Tate Gallery's exhibition and the monograph on the works of Richard Wilson suggest.[2] They are likely to place the aesthetic idealization of landscape alongside "vulgar" economic and material considerations, as John Barrell and Ann Bermingham do when they put the English landscape movement in the context of the enclosure of common fields and the dispossession of the English peasantry.[3]

I might as well say at the outset that I am mainly in sympathy with this darker, skeptical reading of landscape aesthetics and that this essay is

an attempt to contribute further to this reading. Our understanding of "high" art can, in general, benefit considerably from a critical perspective that works through what Philip Fisher has called the "hard facts" embedded in idealized settings.[4] My aim in this essay, however, is not primarily to add to the stock of hard facts about landscape but to take a harder look at the framework in which facts about landscape are constituted—the way, in particular, that the nature, history, and semiotic or aesthetic character of landscape is constructed in both its idealist and skeptical interpretations.

As it happens, there is a good deal of common ground in these constructions, an underlying agreement on at least three major "facts" about landscape: (1) that it is, in its "pure" form, a western European and modern phenomenon; (2) that it emerges in the seventeenth century and reaches its peak in the nineteenth century; (3) that it is originally and centrally constituted as a genre of painting associated with a new way of seeing. These assumptions are generally accepted by all the parties in contemporary discussions of English landscape, and to the extent that they provide a common grammar and narrative shape for criticism, they foster a kind of mirror symmetry between the skeptical critique and the idealist aesthetic it opposes. Clark's opening paragraph, for instance, may be read as *still true* if only its key terms are understood in an ironic sense: the "different structure" of nature is read as a symptom of alienation from the land; the "reflective" and imaginary projection of moods into landscape is read as the dreamwork of ideology; the "rise and development" of landscape is read as a symptom of the rise and development of capitalism; the "harmony" sought in landscape is read as a compensation for and screening off of the actual violence perpetrated there.

The agreement on these three basic "facts"—let us call them the "Western-ness" of landscape, its modernity, and its visual/pictorial essence—may well be a sign of just how well founded they are. If critics of radically different persuasions take these things for granted, differing mainly in their explanations of them, then there is a strong presumption that they are true. The modernity of European landscape painting, for instance, is one of the first lessons landscape historians pass on to their students. Ernst Gombrich's classic essay "The Renaissance Theory of Art and the Rise of Landscape" (1953), with its story of the "revolutionary" emergence of a new genre called landscape in sixteenth-century European painting, is still the basic reference point for art-historical treatments of this topic.[5]

Kenneth Clark expresses the lesson in its most general form: "People who have given the matter no thought are apt to assume that the appreciation of natural beauty and the painting of landscape is a normal and enduring part of our spiritual activity. But the truth is that in times when

the human spirit seems to have burned most brightly the painting of landscape for its own sake did not exist and was unthinkable."[6] Marxist art historians replicate this "truth" in the narrower field of English landscape aesthetics, substituting the notion of ideology for Clark's "spiritual activity." Thus Ann Bermingham proposes "that there is an ideology of landscape and that in the eighteenth and nineteenth centuries a class view of landscape embodied a set of socially and, finally, economically determined values to which the painted image gave cultural expression."[7] Neither Bermingham nor Barrell makes the explicit claim for world-historical uniqueness that Clark does; they confine their attention quite narrowly to the English landscape tradition, and to even more specific movements within it. But in the absence of any larger perspective, or any challenge to Clark's larger claims, the basic assumption of historical uniqueness remains in place, subject only to differences of interpretation.

A similar point might be made about the visual/pictorial constitution of landscape as an aesthetic object. Bermingham regards landscape as an ideological "class view" to which "the painted image" gives "cultural expression." Clark says that "the appreciation of natural beauty and the painting of landscape *is*" (emphasis mine) a historically unique phenomenon. Both writers elide the distinction between viewing and painting, perception and representation—Bermingham by treating painting as the "expression" of a "view," Clark by means of the singular verb "is" that collapses the appreciation of nature into its representation by painting. Clark goes on to reinforce the equation of painting with seeing by citing with approval Ruskin's claim in *Modern Painters* that "mankind acquired a new sense" along with the invention of landscape painting. Not only landscape painting, but landscape *perception* is "invented" at some moment of history; the only question is whether this invention has a spiritual or a material basis.[8]

There are two problems with these fundamental assumptions about the aesthetics of landscape: first, they are highly questionable; second, they are almost never brought into question, and the very ambiguity of the word "landscape" as denoting a place or a painting encourages this failure to ask questions. But the blurring of the distinction between the viewing and the representation of landscape seems, on the face of it, deeply problematic. Are we really to believe, as Clark puts it, that "the appreciation of natural beauty" begins only with the invention of landscape painting? Certainly the testimony of poets from Hesiod to Homer to Dante suggests that human beings did not, as Ruskin thought, acquire a "new sense" sometime after the Middle Ages that made them "utterly different from all the great races that have existed before."[9] Even the more restricted claim that landscape *painting* (as distinct from perception) has a uniquely

Western and modern identity seems fraught with problems. The historical claim that landscape is a "postmedieval" development runs counter to the evidence (presented, but explained away as merely "decorative" and "digressive" in Clark's text) that Hellenistic and Roman painters "evolved a school of landscape painting."[10] And the geographic claim that landscape is a uniquely western European art falls to pieces in the face of the overwhelming richness, complexity, and antiquity of Chinese landscape painting.[11] The Chinese tradition has a double importance in this context. Not only does it subvert any claims for the uniquely modern or Western lineage of landscape, the fact is that Chinese landscape played a crucial role in the elaboration of English landscape aesthetics in the eighteenth century, so much so that *le jardin anglo-chinois* became a common European label for the English garden.[12]

The intrusion of Chinese traditions into the landscape discourse I have been describing is worth pondering further, for it raises fundamental questions about the Eurocentric bias of that discourse and its myths of origin. Two facts about Chinese landscape bear special emphasis: one is that it flourished most notably at the height of Chinese imperial power and began to decline in the eighteenth century as China became itself the object of English fascination and appropriation at the moment when England was beginning to experience itself as an imperial power.[13] Is it possible that landscape, understood as the historical "invention" of a new visual/pictorial medium, is integrally connected with imperialism? Certainly the roll call of major "originating" movements in landscape painting—China, Japan, Rome, seventeenth-century Holland and France, eighteenth- and nineteenth-century Britain—makes the question hard to avoid. At a minimum we need to explore the possibility that the representation of landscape is not only a matter of internal politics and national or class ideology but also an international, global phenomenon, intimately bound up with the discourses of imperialism.

This hypothesis needs to be accompanied by a whole set of stipulations and qualifications. Imperialism is clearly not a simple, single, or homogeneous phenomenon but the name of a complex system of cultural, political, and economic expansion and domination that varies with the specificity of places, peoples, and historical moments.[14] It is not a "one-way" phenomenon but a complicated process of exchange, mutual transformation, and ambivalence.[15] It is a process conducted simultaneously at concrete levels of violence, expropriation, collaboration, and coercion, and at a variety of symbolic or representational levels whose relation to the concrete is rarely mimetic or transparent. Landscape, understood as concept or representational practice, does not usually declare its relation to imperialism in any direct way; it is not to be understood, in my view, as a mere

tool of nefarious imperial designs, nor as uniquely caused by imperialism. Dutch landscape, for instance, which is often credited with being the European origin of both the discourse and the pictorial practice of landscape, must be seen at least in part as an anti-imperial and nationalistic cultural gesture; the transformation of the Netherlands from a rebellious colony into a maritime empire in the second half of the seventeenth century indicates at the very least how quickly and drastically the political environment of a cultural practice can change, and it suggests the possibility of hybrid landscape formations that might be characterized simultaneously as imperial and anticolonial.[16]

Landscape might be seen more profitably as something like the "dreamwork" of imperialism, unfolding its own movement in time and space from a central point of origin and folding back on itself to disclose both utopian fantasies of the perfected imperial prospect and fractured images of unresolved ambivalence and unsuppressed resistance. In short, the posing of a relation between imperialism and landscape is not offered here as a deductive model that can settle the meaning of either term, but as a provocation to an inquiry. If Kenneth Clark is right to say that "landscape painting was the chief artistic creation of the nineteenth century,"[17] we need at least to explore the relation of this cultural fact to the other "chief creation" of the nineteenth century—the system of global domination known as European imperialism.

The "Rise" of Landscape

Man had not only reconquered his rights, but he had reentered upon his possession of nature. Several of these writings testify to the emotion which those poor people felt on beholding their country for the first time. Strange to relate! those rivers, mountains, and noble landscapes, where they were constantly passing, were discovered by them on that day: they had never seen them before.

—Michelet, *History of the French Revolution* (1846)

Thence up he flew, and on the Tree of Life,
The middle tree and highest there that grew,
Sat like a cormorant; . . .

.
. . . nor on the virtue thought
Of that life-giving plant, but only used
For prospect, what, well used, had been the pledge
Of immortality. . . .

—Milton, *Paradise Lost*
IV: 194–96; 198–201

When does landscape first begin to be perceived? Everything depends, of course, on how one defines the "proper" or "pure" experience of landscape. Thus, Kenneth Clark dismisses the landscape paintings that adorned Roman villas as "backgrounds" and "digressions," not representations of natural scenery in and for itself. Landscape perception "proper" is possible only to "modern consciousness," a phenomenon that can be dated with some precision. "Petrarch," Clark tells us, "appears in all the history books as the first modern man," and so it is no surprise that he is "probably the first man to express the emotion on which the existence of landscape painting so largely depends; the desire to escape from the turmoil of cities into the peace of the countryside." Clark might admit that some version of this emotion appears rather frequently in the ancient genre of the pastoral, but he would probably insist that the enjoyment of the view "for its own sake" is not quite achieved prior to "modern consciousness." Petrarch doesn't just flee the city in good pastoral fashion for the comforts of the country; he seeks out the discomforts of nature. "He was, as everyone knows, the first man to climb a mountain for its own sake, and to enjoy the view from the top."[18]

A fact that "everyone knows" hardly requires an argument, but Clark goes on to give one anyway. The unique historical placement of Petrarch's perception of landscape at the originary, transitional moment from ancient to modern is "proved" by showing that Petrarch himself lives in both worlds, is both a modern humanist and a medieval Christian. Thus, Clark notes that at the very moment Petrarch is enjoying the view, "it occurred to him to open at random his copy of St. Augustine's *Confessions* to a passage that denounces the contemplation of nature: "And men go about to wonder at the heights of the mountains, and the mighty waves of the sea, and the wide sweep of rivers, and the circuit of the ocean, and the revolution of the stars, but themselves they consider not."[19] Properly abashed by this pious reminder, Petrarch concludes that he has "seen enough of the mountain" and turns his "inward eye" upon himself. What Clark's "historical" narrative of the development of landscape ignores is that St. Augustine's admonition is itself testimony to the antiquity of the contemplation of nature. Long before Petrarch and long before St. Augustine, people had succumbed to the temptation of looking at natural wonders "for their own sake."

Numerous other "originary moments" in the viewing of landscape might be adduced, from Jehovah's looking upon his creation and finding it good, to Michelet's French peasants running out of doors to perceive the beauties of their natural environment for the first time. The account of landscape contemplation that probably had the strongest influence on English painting, gardening, and poetry in the eighteenth century was

Milton's description of Paradise, a viewing, we should recall, that is framed by the consciousness of Satan, who "only used for prospect" his vantage point on the Tree of Life. The "dark side" of landscape that Marxist historians have uncovered is anticipated in the myths of landscape by a recurrent sense of ambivalence. Petrarch fears the landscape as a secular, sensuous temptation; Michelet treats it as a momentary revelation of beauty and freedom bracketed by blindness and slavery; Milton presents it as the voyeuristic object for a gaze that wavers between aesthetic delight and malicious intent, melting "pity" and "Honor and empire with revenge enlarged" (iv. 374; 390).

This ambivalence, moreover, is temporalized and narrativized. It is almost as if there is something built into the grammar and logic of the landscape concept that requires the elaboration of a pseudohistory, complete with a prehistory, an originating moment that issues in progressive historical development, and (often) a final decline and fall. The analogy with typical narratives of the "rise and fall" of empires bcomes even more striking when we notice that the rise and fall of landscape painting is typically represented as a threefold process of emancipation, naturalization, and unification. The article "Landscape Painting" in *The Oxford Companion to Art* provides a handy compendium of these narratives, complete with "origins" in Rome and the Holy Roman Empire of the sixteenth century and "endings" in twentieth-century Sunday painting. Landscape painting is routinely described as emancipating itself from subordinate roles like literary illustration, religious edification, and decoration to achieve an independent status in which nature is seen "for its own sake." Chinese landscape is prehistoric, prior to the emergence of nature "enjoyed for its own sake." "In China, *on the other hand,* the development of landscape painting is bound up with . . . mystical reverence for the powers of nature."[20]

The "other hand" of landscape, whether it is the Orient, the Middle Ages, Egypt, or Byzantium, is preemancipatory, prior to the perception of nature as such. Thus, the emancipation of landscape as a genre of painting is also a *naturalization,* a freeing of nature from the bonds of convention. Formerly, nature was represented in "highly conventionalized" or "symbolic" forms; latterly, it appears in "naturalistic transcripts of nature," the product of a "long evolution in which the vocabulary of rendering natural scenery gained shape side by side with the power to see nature as scenery." This "evolution" from subordination to emancipation, convention to nature has as its ultimate goal the *unification* of nature in the perception and representation of landscape: "It seems that until fairly recent times men looked at nature as an assemblage of isolated objects,

without connecting trees, rivers, mountains, roads, rocks, and forest into a unified scene."[21]

Each of these transitions or developments in the articulation of landscape presents itself as a historical shift, whether abrupt or gradual, from ancient to modern, from classical to Romantic, from Christian to secular. Thus, the history of landscape painting is often described as a quest, not just for pure, transparent representation of nature, but as a quest for pure *painting*, freed of literary concerns and representation. As Clark puts it, "The painting of landscape cannot be considered independently of the trend away from imitation as the *raison d'être* of art."[22] One end to the story of landscape is thus abstract painting. At the other extreme, the history of landscape painting may be described as a movement from "conventional formulas" to "naturalistic transcripts of nature."[23] Both stories are grail-quests for purity. On the one hand, the goal is nonrepresentational painting, freed of reference, language, and subject matter; on the other hand, pure hyperrepresentational painting, a superlikeness that produces "natural representations of nature."

As a pseudohistorical myth, then, the discourse of landscape is a crucial means for enlisting "Nature" in the legitimation of modernity, the claim that "we moderns" are somehow different from and essentially superior to everything that preceded us, free of superstition and convention, masters of a unified, natural language epitomized by landscape painting. Benedict Anderson notes that empires have traditionally relied on "sacred silent languages" like the "ideograms of Chinese, Latin, or Arabic" to imagine the unity of a "global community."[24] He suggests that the effectiveness of these languages is based in the supposed nonarbitrariness of their signs, their status as "emanations of reality," not "fabricated representations of it." Anderson thinks of the nonarbitrary sign as "an idea largely foreign to the contemporary Western mind," but it is, as we have seen, certainly not foreign to Western ideas of landscape painting. Is landscape painting the "sacred silent language" of Western imperialism, the medium in which it "emancipates," "naturalizes," and "unifies" the world for its own purposes?[25] Before we can even pose this question, much less answer it, we need to take a closer look at what it means to think of landscape as a medium, a vast network of cultural codes, rather than as a specialized genre of painting.

The Sacred Silent Language

The charming landscape which I saw this morning, is indubitably made up of some twenty or thirty farms. Miller owns this field, Locke that, and Manning

the woodland beyond. But none of them owns the landscape. There is a prop-
erty in the horizon which no man has but he whose eye can integrate all the
parts, that is, the poet. This is the best part of all these men's farms, yet to
this their land-deeds give them no title.

—Emerson, *Nature* (1836)

I have been assuming throughout these pages that landscape is best under-
stood as a medium of cultural expression, not a genre of painting or fine
art. It is now time to explain exactly what this means. There certainly is
a genre of painting known as landscape, defined very loosely by a certain
emphasis on natural objects as subject matter. What we tend to forget,
however, is that this "subject matter" is not simply raw material to be
represented in paint but is always already a symbolic form in its own
right. The familiar categories that divide the genre of landscape painting
into subgenres—notions such as the Ideal, the Heroic, the Pastoral, the
Beautiful, the Sublime, and the Picturesque—are all distinctions based,
not in ways of putting paint on canvas, but in the kinds of objects and
visual spaces that may be represented by paint.[26]

Landscape *painting* is best understood, then, not as the uniquely central
medium that gives us access to ways of seeing landscape, but as a represen-
tation of something that is already a representation in its own right.[27]
Landscape may be represented by painting, drawing, or engraving; by
photography, film, and theatrical scenery; by writing, speech, and presum-
ably even music and other "sound images." Before all these secondary
representations, however, landscape is itself a physical and multisensory
medium (earth, stone, vegetation, water, sky, sound and silence, light and
darkness, etc.) in which cultural meanings and values are encoded,
whether they are *put* there by the physical transformation of a place in
landscape gardening and architecture, or *found* in a place formed, as we
say, "by nature." The simplest way to summarize this point is to note
that it makes Kenneth Clark's title, *Landscape into Art,* quite redundant:
landscape is already artifice in the moment of its beholding, long before
it becomes the subject of pictorial representation.

Landscape is a medium in the fullest sense of the word. It is a material
"means" (to borrow Aristotle's terminology) like language or paint, em-
bedded in a tradition of cultural signification and communication, a body
of symbolic forms capable of being invoked and reshaped to express mean-
ings and values. As a medium for expressing value, it has a semiotic
structure rather like that of money, functioning as a special sort of com-
modity that plays a unique symbolic role in the system of exchange-value.
Like money, landscape is good for nothing as a use-value, while serving
as a theoretically limitless symbol of value at some other level. At the most

basic, vulgar level, the value of landscape expresses itself in a specific price: the added cost of a beautiful view in real estate value; the price of a plane ticket to the Rockies, Hawaii, the Alps, or New Zealand. Landscape is a marketable commodity to be presented and re-presented in "packaged tours," an object to be purchased, consumed, and even brought home in the form of souvenirs such as postcards and photo albums. In its double role as commodity and potent cultural symbol, landscape is the object of fetishistic practices involving the limitless repetition of identical photographs taken on identical spots by tourists with interchangeable emotions.

As a fetishized commodity, landscape is what Marx called a "social hieroglyph," an emblem of the social relations it conceals. At the same time that it commands a specific price, landscape represents itself as "beyond price," a source of pure, inexhaustible spiritual value. "Landscape," says Emerson, "has no owner," and the pure viewing of landscape for itself is spoiled by economic considerations: "you cannot *freely* admire a noble landscape, if laborers are digging in the field hard by."[28] Raymond Williams notes that "a working country is hardly ever a landscape," and John Barrell has shown the way laborers are kept in the "dark side" of English landscape to keep their work from spoiling the philosophical contemplation of natural beauty.[29] "Landscape" must represent itself, then, as the antithesis of "land," as an "ideal estate" quite independent of "real estate," as a "poetic" property, in Emerson's phrase, rather than a material one. The land, real property, contains a limited quantity of wealth in minerals, vegetation, water, and dwelling space. Dig out all the gold in a mountainside, and its wealth is exhausted. But how many photographs, postcards, paintings, and awestruck "sightings" of the Grand Canyon will it take to exhaust its value as landscape? Could we fill up Grand Canyon with its representations? How do we exhaust the value of a medium like landscape?

Landscape is a medium not only for expressing value but also for expressing meaning, for communication between persons—most radically, for communication between the Human and the non-Human. Landscape mediates the cultural and the natural, or "Man" and "Nature," as eighteenth-century theorists would say. It is not only a natural scene, and not just a representation of a natural scene, but a *natural* representation of a natural scene, a trace or icon of nature *in* nature itself, as if nature were imprinting and encoding its essential structures on our perceptual apparatus. Perhaps this is why we place a special value on landscapes with lakes or reflecting pools. The reflection exhibits Nature representing itself to itself, displaying an identity of the Real and the Imaginary that certifies the reality of our own images.[30]

The desire for this certificate of the Real is clearest in the rhetoric of

scientific, topographical illustration, with its craving for pure objectivity and transparency and the suppression of aesthetic signs of "style" or "genre." But even the most highly formulaic, conventional, and stylized landscapes tend to represent themselves as "true" to some sort of nature, to universal structures of "Ideal" nature, or to codes that are "wired in" to the visual cortex and to deeply instinctual roots of visual pleasure associated with scopophilia, voyeurism, and the desire to see without being seen.

In *The Experience of Landscape,* Jay Appleton connects landscape formulas to animal behavior and "habitat theory," specifically to the eye of a predator who scans the landscape as a strategic field, a network of prospects, refuges, and hazards.[31] The standard picturesque landscape is especially pleasing to this eye because it typically places the observer in a protected, shaded spot (a "refuge"), with screens on either side to dart behind or to entice curiosity, and an opening to provide deep access at the center. Appleton's observer is Hobbes's Natural Man, hiding in the thicket to pounce on his prey or to avoid a predator. The picturesque structure of this observer's visual field is simply a foregrounding of the scene of "natural representation" itself, "framing" or putting it on a stage. It hardly matters whether the scene is picturesque in the narrow sense; even if the features are sublime, dangerous, and so forth, the frame is always there as the guarantee that it is only a picture, only picturesque, and the observer is safe in another place—outside the frame, behind the binoculars, the camera, or the eyeball, in the dark refuge of the skull.

Appleton's ideal spectator of landscape, grounded in the visual field of violence (hunting, war, surveillance), certainly is a crucial figure in the aesthetics of the picturesque. The only problem is that Appleton believes this spectator is universal and "natural." But there are clearly other possibilities: the observer as woman, gatherer, scientist, poet, interpreter, or tourist. One could argue that they are never completely free from the subjectivity of (or subjection to) Appleton's observer, in the sense that the threat of violence (like the aesthetics of the sublime) tends to preempt all other forms of presentation and representation. Appleton's landscape aesthetic applies not just to the predator but to the unwilling prey as well.

We might think of Appleton's "predatory" view of landscape, then, as one of the strategies by which certain conventions of landscape are *forcibly* naturalized. Nature and convention, as we have seen, are both differentiated and identified in the medium of landscape. We say "landscape is nature, not convention" in the same way we say "landscape is ideal, not real estate," and for the same reason—to erase the signs of our own constructive activity in the formation of landscape as meaning or value, to produce an art that conceals its own artifice, to imagine a representation

that "breaks through" representation into the realm of the nonhuman. That is how we manage to call landscape the "natural medium" in the same breath that we admit that it is nothing but a bag of tricks, a bunch of conventions and stereotypes. Histories of landscape, as we have seen, continually present it as breaking with convention, with language and textuality, for a natural view of nature, just as they present landscape as transcending property and labor. One influential account of the European origins of landscape locates it in the "free spaces" of medieval manuscript illumination, an "informal space left vacant by the script" in "the margins and *bas-de-pages* of manuscripts" where the painter could improvise and escape from the demands of doctrinal, graphic, and illustrative subordination to "the severe lines of the Latin text" for a romp with nature and pure painting.[32] This double semiotic structure of landscape—its simultaneous articulation and disarticulation of the difference between nature and convention—is thus the key element in the elaboration of its "history" as a Whiggish progress from ancient to modern, from Christian to secular, from the mixed, subordinate, and "impure" landscape to the "pure" landscape "seen for itself," from "convention" and "artifice" to the "real" and the "natural."

These semiotic features of landscape, and the historical narratives they generate, are tailor-made for the discourse of imperialism, which conceives itself precisely (and simultaneously) as an expansion of landscape understood as an inevitable, progressive development in history, an expansion of "culture" and "civilization" into a "natural" space in a progress that is itself narrated as "natural." Empires move outward in space as a way of moving forward in time; the "prospect" that opens up is not just a spatial scene but a projected future of "development" and exploitation.[33] And this movement is not confined to the external, foreign fields toward which empire directs itself; it is typically accompanied by a renewed interest in the re-presentation of the home landscape, the "nature" of the imperial center.[34] The development of English landscape conventions in the eighteenth century illustrates this double movement perfectly. At the same time as English art and taste are moving outward to import new landscape conventions from Europe and China, it moves inward toward a reshaping and re-presentation of the native land. The Enclosure movement and the accompanying dispossession of the English peasantry are an internal colonization of the home country, its transformation from what Blake called "a green & pleasant land" into a landscape, an emblem of national and imperial identity. Pope's "Windsor Forest" is one such emblem, epitomizing British political and cultural sovereignty ("At once the Monarch's and the Muse's seats"), and its imperial destiny, figured in the "Oaks" that provide the material basis for British commercial and naval power: "While

by our Oaks the precious loads are born, / And realms commanded which those Trees adorn" (lines 31–32).

Decline and Fall

If, indeed, the reader has never suspected that landscape-painting was anything but good, right, and healthy work, I should be sorry to put any doubt of its being so into his mind. . . . I should rather be glad, than otherwise, that he *had* formed some suspicion on this matter. . . . We have no right to assume, without a very accurate examination of it, that this change has been an ennobling one. The simple fact that we are, in some strange way, different from all the great races that existed before us, cannot at once be received as the proof of our own greatness.

—Ruskin, "On the Novelty of Landscape"

The "realms" that proved most dramatically vulnerable to the "Oaks" of British sea power at the height of the eighteenth- and early nineteenth-century landscape movement were the islands of the South Pacific and the larger continental prize of Australia. Between the first voyage of Captain Cook in 1768 and the voyage of Darwin's *Beagle* in 1831, the British established unrivaled naval supremacy in the South Pacific and planted colonies that would develop into independent English-speaking nations. The ease of this conquest makes it of special interest for the understanding of landscape. Unlike the colonial landscapes of India, China, or the Middle East, the South Pacific had no ancient, urbanized, imperial civilizations or military establishments to resist colonization. Unlike Africa, it presented few land masses inaccessible to British "Oaks."[35] Unlike North America, it did not quickly develop its own independent pretensions to be an imperial, metropolitan center.[36] The scattered cultures of Polynesia were seen, in Marshall Sahlin's phrase, as "islands of history," the last refuges of prehistoric, precivilized people in a "state of nature."[37] The South Pacific provided, therefore, a kind of tabula rasa for the fantasies of European imperialism, a place where European landscape conventions could work themselves out virtually unimpeded by "native" resistance, where the "naturalness" of those conventions could find itself confirmed by a real place understood to be in a state of nature.

Bernard Smith's *European Vision in the South Pacific* documents this process in encyclopedic detail, noting the way that specific places were quickly assimilated to the conventions of European landscape, with Tahiti represented as an arcadian paradise in the style of Claude Lorrain and New Zealand as a romantic wilderness modeled on Salvator Rosa, complete with Maori "banditti."[38] Australia was a bit more difficult to codify,

not because of any native resistance (the aborigines were probably subjugated and erased from the landscape more quickly than any other people in the South Pacific), but because of the ambivalence in England's own sense of what it wanted to see there—a fearsome, desolate prison for transported convicts, or an attractive pastoral prospect for colonial settlers.[39] But Smith's account of the development of the South Pacific landscape suggests that ambivalence about the proper forms of representation, and about the "independence" or "otherness" of the colonized landscape, is constitutive of its perceived nature. Here is Smith's overview of the story his book will tell:

> The opening of the Pacific is . . . to be numbered among those factors contributing to the triumph of romanticism and science in the nineteenth century world of values. Whilst it will be shown how the discovery of the Pacific contributed to the challenge to neoclassicism in several fields, more particular attention will be given to the impact of Pacific exploration upon the theory and practice of landscape painting and upon biological thought. For these two fields provide convenient and yet distinct grounds in which to observe how the world of the Pacific stimulated European thought concerning the world of nature as a whole; in the case of the former as the object of imitation and expression, in the case of the latter as an object of philosophical speculation.[40]

The ambivalence of European vision ("Romantic" versus "scientific," "neoclassicism" versus "biological thought," "imitation and expression" versus "philosophical speculation") is mediated by its absorption into a progressive Whig narrative that overcomes all contradictions in the conquering of the Pacific by science, reason, and naturalistic representation. The crucial moments in Smith's accounts of landscape painting are typically found in "fearless attempts to break with neo-classical formulas and to paint with a natural vision."[41] Smith treats the Pacific as a spatial region that was there to be "opened," "discovered," and constructed as an object of scientific and artistic representation, one that reserves all "challenges" and historical, temporal movements for the internal unfolding of European thought, its overcoming of its own attachment to artifice and convention. The real subject is not the South Pacific but European imperial "vision," understood as a dialectical movement toward landscape understood as the naturalistic representation of nature.

Empires have a way of coming to an end, leaving behind their landscapes as relics and ruins. Ruskin seems to have sensed this even as he celebrated the "novelty" of landscape, questioning whether "we have a legitimate subject of complacency" in producing a kind of painting (and its associated feelings) that reveals us as "different from all the great races that have existed before us."[42] Kenneth Clark says that "landscape paint-

ing, like all forms of art, was an act of faith" in a nineteenth-century religion of nature that seems impossible today;[43] for Clark, abstract painting is the successor to landscape, a logical outgrowth of its antimimetic tendencies. Perhaps abstraction, the international and imperial style of the twentieth century, is best understood as carrying out the task of landscape by other means.[44] More likely, the "end" of landscape is just as mythical a notion as the "origins" and developmental logic we have been tracing. But there is no doubt that the classical and romantic genres of landscape painting evolved during the great age of European imperialism now seem exhausted, at least for the purposes of serious painting.[45] Traditional eighteenth- and nineteenth-century landscape conventions are now part of the repertory of kitsch, endlessly reproduced in amateur painting, postcards, packaged tours, and prefabricated emotions. That doesn't mean that beautiful scenery has lost its capacity to move great numbers of people; on the contrary, more people now probably have an appreciation of scenic beauty, precisely because they are so estranged from it. Landscape is now more precious than ever—an endangered species that has to be protected from and by civilization, kept safe in museums, parks, and shrinking "wilderness areas." Like imperialism itself, landscape is an object of nostalgia in a postcolonial and postmodern era, reflecting a time when metropolitan cultures could imagine their destiny in an unbounded "prospect" of endless appropriation and conquest.

As a conclusion to this essay, I would like to examine two imperial landscapes that exhibit in quite contrary ways this "precious" and "endangered" condition in the rearview mirror of a postcolonial understanding. The first is New Zealand, a land that is virtually synonymous with pristine natural beauty, a nation whose principal commodity is the presentation and representation of landscape; the second is the "Holy Land," the contested territories of Israel and Palestine. It is hard to imagine two landscapes more remote from one another, both in geographic location and in cultural/political significance. New Zealand is at the periphery of European imperialism, the last and remotest outpost of the British Empire, an unspoiled paradise where the nineteenth-century fantasies of ideal, picturesque, and romantic landscape would seem to be perfectly preserved. The Holy Land has been at the center of imperial struggle throughout its long history; its landscape is a palimpsest of scar tissue, a paradise that has been "despoiled" by conquering empires more often than any other region on earth. The juxtaposition of these two landscapes may help to suggest something about the range of possibilities in colonial landscape—the poles or antipodes between which the global features of imperial landscape might be mapped in (say) Africa, India, China, the Americas, and the South Pacific. More important than any global mapping, however, is the

possibility that a close reading of specific colonial landscapes may help us to see, not just the successful domination of a place by imperial representations, but the signs of resistance to empire from both within and without. Like all scenes framed in a rearview mirror, these landscapes may be closer to us than they appear.

Circumference and Center

Columbus's voyage on the round rim of the world would lead, he thought, back to the rocks at its sacred center.
—Stephen Greenblatt, *Marvelous Possessions*

New Zealand would seem at first glance to be the site of least possible resistance to the conventions of European landscape representation. Its sublime "Southern Alps," its picturesque seacoasts, lakes, and river valleys, and its sheep-herding economy make it seem tailor-made for imposition of European versions of the pastoral. The fact that New Zealand was originally colonized by missionaries who rapidly converted the Maori inhabitants to Christianity redoubles its identity as a "pastoral" paradise.[46] If Australia was imagined as a prison-scape for the incarceration of the British criminal class, New Zealand was thought of as a garden and a pasture in which the best elements of British society might grow into an ideal nation, bringing the savage inhabitants into a state of blessed harmony with this ideal nature. It's hardly surprising, then, that landscape painting has always been the dominant mode in New Zealand art, and that this painting has consistently been bound up with questions of national identity. New Zealand represents itself as a nation of backpackers, mountain climbers, shepherds, and Sunday painters (a glance at any travel brochure will confirm this), a refuge from the problems of modern civilization, a nuclear-free English socialist utopia in the South Pacific.

The hegemony of New Zealand landscape had, however, a contradiction built into it from the very first. How could New Zealand present itself as a unique place with its own national identity, while at the same time representing itself with conventions borrowed from European landscape representations? How could it reconcile its desire for difference with its equally powerful desire to be the same? An answer was suggested in the early eighties by Francis Pound, a New Zealand art critic who caused a storm of controversy by questioning the uniqueness and originality of New Zealand landscape painting. Pound shows that the history of this painting, like that of its European predecessors, has largely been told as the familiar story of the movement from convention to nature, from the Ideal to the Real, and that this story underwrites a progression from

cultural colonialism and dependency to national independence. Pound exposes what he calls the "fallacy . . . that there is a 'real' New Zealand landscape with its 'real' qualities of light and atmosphere" and suggests that this naturalism is nothing but a "critical myth," a "fantasy of the truth" that was devised for the purpose of "inventing a country."[47] Pound insults the desire for difference by continually discovering the same in New Zealand painting, showing that no new conventions of landscape were invented in New Zealand; on the contrary, New Zealand painters simply imported European conventions and absorbed the alien land into them. Landscape painting in New Zealand is thus a derivative, attenuated simulacrum of styles, techniques, and conventions invented elsewhere.

A good example of this pictorial colonization is John Alexander Gilfillan's *Native Council of War* (1855), which inserts the "native" Maoris into the familiar landscape conventions of the Claudean picturesque (see fig. 1.1). However much we may admire the beauty and the technical skill of this painting, there can be no doubt that it is a throwback to an earlier style of landscape painting, not the discovery of a new style or a new reality. The clearest evidence of this fact is the placement of the cultural "others," the Maori war council, into the serpentine "line of beauty" that had been understood, at least since Hogarth, as the iconic form of visual curiosity, of access to the varieties of visual experience.

Pound attacks the nationalist/naturalist claims of traditional New Zealand art history with an internationalist discourse of cultural relativism and conventionalism. The result is a considerable refinement in the understanding of that history and the visual conventions that constitute it. But his replacement of naturalist fantasies with historical conventions raises a new problem that he is quick to acknowledge:

All the aforesaid may arouse the objection that it is merely a sevenfold classification of eighteenth and nineteenth century landscape into pigeonholes—the holes labelled the God in Nature, the Ideal, the Sublime, the topographical, the picturesque, the sketch, and the Impressionist. It can be answered with the assertion that previously in the critical literature all New Zealand landscapes were stuffed into two pigeonholes: the true and the untrue to New Zealand. The present text's classifications have the advantage of offering concepts used at the time of the paintings, rather than those that merely answer the nationalistic concerns of critics a century later.[48]

Pound replaces the binary oppositions of a retrospective nationalist myth with the historical categories appropriate to the self-understanding and self-representation of New Zealand landscape. The question is whether this move doesn't simply reinstate the categories of imperial landscape conventions without questioning their specific historical function.

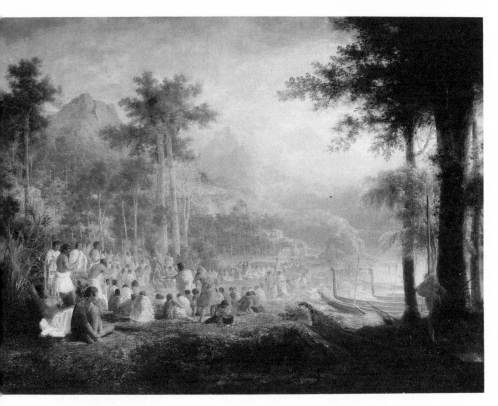

1.1 J. A. Gilfillan, *A Native Council of War* (1853). Courtesy of the Hocken Library, Dunedin, New Zealand.

Pound's analysis of the Gilfillan landscape, for instance, like most of his commentaries, tends to reduce the painting to an itemized list of its conventional elements with their appropriate emotional epithets—the picturesque, the sublime, the beautiful—and the sentiments appropriate to these conventions are simply recirculated. The discourse of imperial landscape is reinstated in the name of history, but at the expense of its historical function in the formation of a colonial and national identity.

A historical, as distinct from a historicist, understanding of this sort of painting would, in my view, not simply retrieve their conventionality but explore the ideological use of their conventions in a specific place and time. Gilfillan, Pound tells us, "made precise pencil sketches from life" of all the figures in this design except two—the "Titianesque" woman and the seated man beside her, who serve as "lead in figures." These figures are inserted on the threshold of the painting, the transition space between

observer and observed. They "sit in" for the European observer, reassuring us that the Maori see things as we do, while maintaining their difference. The key figure in mediating this difference is the bare-breasted woman, the Renaissance Venus who plays the role of eye-catcher, a titillating bit of soft-core colonial pornography, an emblem of native "nature" opening herself for easy access to the imperial gaze while her husband's back is turned (the husband, by contrast, covers his nakedness, holding himself in).[49] These figures of access are the only "invented" elements in the painting, the only features that were not "drawn from life"; they are also its most conspicuously conventional and derivative feature, the element that declares most explicitly the fantastic sameness of colonial representations of difference. This idyllic absorption of the strange into the familiar comes to seem all the more fantastic when we come to it with the information that the painter's wife and three children had been killed by a Maori raiding party just eight years before this painting was finished in the relative safety of Australia.

Gilfillan's painting allows (understandably perhaps) for no resistance to conventions of European landscape, except perhaps for the slight indication of compositional dissonance in the way the oval, canoe-shaped circle of the Maori war council cuts off the serpentine access route. By contrast, Augustus Earle's *Distant View of the Bay of Islands,* in spite of a title that seems to announce nothing more than another picturesque scene, offers quite pointed, if subtle resistance to European conventions (see fig. 1.2). Francis Pound's commentary enumerates the specific conventions evoked by the painting: "Earle uses the traditional system of planes of shadow alternating with planes of light; and though the landscape itself has not allowed him the assistance of any convenient tree, he has managed to place an appropriate *repoussoir* [a picturesque side-screen] at the right," in the form of the carved figure.[50] The problem with this reading is not just that it immediately reduces the painting to a familiar code and a conventional response ("the effect is of solemn splendor"). The real problem is that it doesn't push conventionalism far enough and draws back to an appeal to what nature—"the landscape itself"—allowed the painter to do. But one of the key principles of the picturesque tradition was that it allowed the painter to introduce a convenient tree (or to cut it down), in accordance with the demands of the convention. As William Gilpin puts it: "Though the painter has no right to add a magnificent castle, he may shovel the earth about him as he pleases . . . he may pull up a paling or throw down a cottage."[51] Gilfillan's introduction of the Titianesque Venus illustrates precisely this inventive license.

If Earle were simply following picturesque conventions, the "landscape itself" would have had nothing to say about the matter. And if the "un-

1.2 Augustus Earle, *Distant View of the Bay of Islands, New Zealand* (ca. 1827).
Watercolor, 26 × 44.1 cm. Courtesy the Rex Nan Kivell Collection, National Library
of Australia.

couthly carved figure" at the right (to use Earle's words) is really to be
seen as a stand-in for the picturesque side-screen or "lead-in" figure, it is
a singularly awkward, ineffectual, and ironic one. It does not, like the
traditional *repoussoir,* provide a dark refuge for the viewer to hide behind,
nor does it provide a convenient stand-in for the beholder's gaze within
the composition. On the contrary, it is a hazard, an emblem of an alien
vision that stares back into the space of the beholder. The function of the
figure in Maori culture is to stand guard over tabooed territory, to separate
the sacred, forbidden landscape from the territory surveyed and traversed
by the European traveler and his Maori companions.[52] The carved figure
may, like the lopped tree trunks that so often appear in the foregrounds
of early New Zealand landscapes, allude to the traces and vestiges of the
picturesque side-screen; the figure may "stand in the place of" the *repous-
soir,* but it does so only to show that convention displaced by something
else.

What is this "something else"? It is certainly not "the landscape itself"
or nature but *another convention* for organizing and perceiving the land-
scape, one that contends with and reshapes the convention that Earle
carries as a picturesque traveler. That convention is the Maori experience

and representation of landscape symbolized by the carved figure, who stands as rigidly erect and still as the halted European traveler, gazing on a holy land. So far as I know, Pound is correct to say that "the Maori did not paint landscape," but he is seriously mistaken in claiming that "landscape, the pictorial attitude to the land, stopping still just to look at it, is purely an imported convention."[53] Earle's picture suggests a more complicated situation. The Maori statue indicates at a minimum that "stopping still just to look" at the land is so important to the Maoris that they erect a statue to keep surveillance over a place. Nor is this surveillance confined only to the carved figure. The Maori bearer on the left seems to be hesitating as he walks, turning to the side to scan the tabooed territory, while raising his war club slightly to ward off a potential threat. The Maori warrior just ahead of the European traveler, moreover, seems to be joining in the western gaze, looking out toward the opening clouds and horizon. His musket, upright posture, and European garments suggest that he is the Maori chief in this party and that he is able to make the transition from Maori sense of taboo landscape to a sharing in the European appreciation of "prospect" about as easily (and perhaps at as great a cost) as he is able to replace a war club with a musket.[54]

This intermingling of landscape conventions runs deepest, however, not in the explicit iconographical signs but in the odd, somber composition and coloring. Most notable is the way the picturesque convention of the serpentine line from foreground to background is cut off in this picture and turned back on itself. A tiny reminder of the serpentine appears in the middle distance, just to the left of the Maori chief, but it is only a vestige or trace of the convention, not a fulfillment of it—in much the same way the carved figure reminds us of the picturesque side-screen while eliminating its function as refuge. In the place of the serpentine access route, the composition deploys a crescent, canoe-shaped hollow, enveloping a procession of equally scaled figures across the shallow surface of the painting. This effect, which is reminiscent of the treatment of figures in a bas-relief, is heightened by the flattening of the perspective by alternating bands of light and dark monochrome wash across the painting. The effect is of an oval or circular procession, advancing up toward us on the left, retreating away from us on the right, eternally suspended on the canoe-shaped threshold between two landscapes, the picturesque prospect of the *pakeha,* or European, and the taboo space of the Maori.[55]

Both scenes are "arresting" sights that fixate the depicted observers in complexes of emotion—fear, awe, and wonder. Earle does not—he cannot—represent the visual field of the Maori: that is beyond the frame, out here in the dark with us. But he can represent the Maori gaze as a presence in the landscape, as something figured forth in the sculptural quality (as well as the sculpted figures) of his composition. That quality

is underscored by the color scheme. The green and reddish ochre-brown of earth and wood and the white of bone dominate the palette, as if the carved figure at the right were emanating its color to the entire landscape, tinting the *pakeha* vision and decentering its imperial gaze.

There is no appeal to "nature" in this reading, unless one insists on the blatantly ideological move of placing the Maori in a "state of nature." (Earle himself regarded the Maoris as a complex, advanced culture; he admired and copied their art, both the wood carvings and their elaborate tattoo designs.)[56] The reading is of the encounter between two conventions, an encounter that leaves us in an odd, disturbing, liminal space, the threshold between two cultures. Yet nature is not left out, whether it is the demands of a particular place or persons, or a historical moment, or deeply engrained habits of perception, or recognizable canons of truth, pleasure, and morality. At least one moral of the picture is quite transparent. *Pakeha* and Maori see eye-to-eye on one thing: the naturalness of a hierarchical social order in which some do the work while others do the gazing. Earle had become close enough to Maori culture to recognize that it was not simply a passive field for colonization but a vital, expansive form of life that had its own imperial ambitions, its own sense of place and landscape.

The marks of imperial conquest in Israel/Palestine, in contrast with New Zealand, would seem to be absolutely unavoidable. The face of the Holy Landscape is so scarred by war, excavation, and displacement that no illusion of innocent, original nature can be sustained for a moment. That doesn't prevent both the picturesque tourist and the resolute settler from trying to put on some sort of blinders to idealize the landscape and erase all signs of violence. Postcards from Israel frequently depict a kind of "desert pastoral," complete with a palm tree (suggesting the oasis refuge) in the foreground, and a Bedouin on a camel in the distance, recalling a time when the Israelites were merely another group of nomads among the Semitic tribes of Abraham. Other versions of the pastoral are more tendentious. The first time I delivered this essay publicly, at a conference on landscape at Bar-Ilan University in Tel Aviv, I was assured (1) that the ancient terraces cut into the hillsides around Jerusalem were excavated by the ancient Israelites to catch the rain and "make the desert bloom," and (2) that the presence of these terraces constitutes a prima facie basis for the legitimacy of Israel's claim to the land, on the twin grounds of prior occupation and agricultural improvement.[57]

A more apocalyptic "reading" of the landscape was offered at Masada, whose sublime prospect from the ancient Roman fortress overlooking the Dead Sea was called "an emblem of modern Israel" by our guide. Landscape in Israel, as in New Zealand, is central to the national imaginary, a part of daily life that imprints public, collective fantasies on places and

1.3 Jean Mohr, "Israel 1979." Reproduced from *After the Last Sky*. Courtesy Jean Mohr.

scenes. Masada, the terraced hillsides, and the Arabian pastoral are all, in their ways, attempts to unify the landscape in the frame of both pictorial conventions and ideological convictions: the pastoral expresses nostalgia for a Self that is now the colonized Other;[58] the georgic hillsides offer the prospect of permanent legitimate settlement; the sublime vista from the Roman ruin invites meditation on collective self-annihilation as an alternative to surrender.

The truth of the unified Holy Landscape is clearly division and conflict. Jean Mohr's photograph of an Israeli condominium in the West Bank simply makes this fact formally explicit and unavoidable (see fig. 1.3).[59] Like Augustus Earle, Mohr depicts the collision of two media of spatial organization in the landscape; this time architecture, not sculpture, mocks the role of picturesque *repoussoir*, or side-screen. The picturesque valley in the distance is framed and dominated by the modern condominium, its windows sighting down on the Arab village. Like the eyes of the Maori carving, they keep the taboo territory under perpetual surveillance. Unlike Earle's composition, Mohr's landscape offers no threshold for the encounter of conventions, the interchange of gazes, only a stark confrontation between traditional organic topographical forms and a crystalline, "cubist" architecture; only the contrast between a passive, observed scene and the gaze that is fixed upon it. The landscape is conspicuous for its lack of figures. The Arab village is too far away, and the foreground refuge too

uninviting to delay anyone but the photographer. No one is about to mistake Israel for New Zealand. Native and *pakeha* are at war in the former, partly over the question of who is the native, who the alien, and it would take a massive effort of picturesque "screening" and selection of prospects to keep the signs of this war out of the landscape. Wordsworth might have called this "an ordinary sight"; certainly it is a daily and unavoidable prospect for the settlers who live in the condominium. Yet it is also, in Mohr's stark composition, a scene of what Wordsworth would have called "visionary dreariness."

Emerson says that "landscape has no owner" except "the poet," who can integrate its parts. But Mohr's photograph shows the sort of sight— and site—that demands a poet capable of asking, "Who owns this landscape?" The colonizing settlers who watch from their fortified dwellings? The inhabitants of the traditional dwellings in the valley, a space that must look just as deadly and threatening to the colonial gaze, as its watchtowers look to them? The photographer, who has chosen this image from all those available and presented it to us as a representative landscape of a contested territory? The only adequate answers seem at first glance radically contradictory: no one "owns" this landscape in the sense of having clear, unquestionable title to it—contestation and struggle are inscribed indelibly on it. But everyone "owns" (or ought to own) this landscape in the sense that everyone must *acknowledge* or "own up" to some responsibility for it, some complicity in it. This is not just a matter of geopolitics and the question of Israel as the site of big-power imperialist maneuvering; it is also a matter of a global poetics in which the Holy Land plays a historical and mythic role as the imaginary landscape where Eastern and Western cultures encounter one another in a struggle that refuses to confine itself to the Imaginary.

I realize that this analysis will sound hopelessly evasive, generalized, and equivocal to those who insist on "owning" this landscape in the first sense, while refusing to "own" any responsibility for its fractured, agonized appearance. But only an equivocal poetry of this sort will, I suspect, prove adequate to Emerson's project of "integrating the parts of the landscape" into a unity fit for habitation, much less contemplation. Equivocation may also be the key to practical diplomacy and to the prospect of a critical/poetic answer to the question of Palestine. We have known since Ruskin that the appreciation of landscape as an aesthetic object cannot be an occasion for complacency or untroubled contemplation; rather, it must be the focus of a historical, political, and (yes) aesthetic alertness to the violence and evil written on the land, projected there by the gazing eye. We have known at least since Turner—perhaps since Milton—that the violence of this evil eye is inextricably connected with imperialism and

nationalism. What we know now is that landscape itself is the medium by which this evil is veiled and naturalized. Whether this knowledge gives us any power is another question altogether.[60]

Notes

1. John Barrell, *The Dark Side of the Landscape* (Cambridge, 1980). See also *Reading Landscape: Country—City—Capital,* ed. Simon Pugh (Manchester, 1990). The psychoanalytic reading of landscape as "regressive" symbol has been best developed by Ronald Paulson in *Literary Landscape: Turner and Constable* (New Haven, 1982).

2. *Richard Wilson: The Landscape of Reaction* (London, Tate Gallery, 1982). See John Barrell, *The Political Theory of Painting from Reynolds to Hazlitt* (New Haven, 1986), 340, for a discussion of this controversy.

3. Ann Bermingham, *Landscape an Ideology: The English Rustic Tradition, 1740–1860* (Berkeley, Calif., 1986).

4. Fisher discusses "privileged settings" in American history such as the wilderness, the farm, and the city in conjunction with Indians, slavery, and the marketplace. See his *Hard Facts: Setting and Form in the American Novel* (New York, 1985).

5. Gombrich's essay is reprinted in *Norm and Form: Studies in the Art of the Renaissance* (Chicago, 1966), 107–21. For a critique of Gombrich's argument, see my essay "Nature for Sale: Gombrich and the Rise of Landscape," in *The Consumption of Culture in the Early Modern Period,* ed. Ann Bermingham and John Brewer (London, forthcoming).

6. Kenneth Clark, *Landscape into Art* (1st published 1949; repr., Boston, MA: Beacon Press, 1963), viii. Cf. the article "Landscape Painting" in *The Oxford Companion to Art:* "Until fairly recent times men looked at nature as an assemblage of isolated objects, without connecting [them] into a unified scene. . . . It was in this European atmosphere of the early 16th century that the first 'pure' landscape was painted."

7. Bermingham, *Landscape and Ideology,* 3.

8. Bermingham acknowledges the role of Clark's work in "illuminating the formal and perceptual dimensions of landscape representation," providing her with "important ideas to consider if not always to accept" (ibid., 5).

9. Quoted in Clark, *Landscape into Art,* viii.

10. Ibid., 1.

11. One might ask how the notion of landscape as a modern or Western phenomenon can be sustained in the face of the massive Chinese counterexample. An instructive answer is suggested by the article "Landscape Painting" in the *Oxford Companion to Art,* which suggests that Chinese landscape painting "is closely bound up with an almost mystic reverence for the powers of nature," in contrast to Western (Roman) painting, in which "nature is depicted as unified scene and enjoyed for its own sake." I will discuss the implications of this contrast between religious (or "symbolic" or "conventional") landscape and "naturalistic" landscape further in what follows.

12. See the discussion of Orientalism in the English garden in *The Genius of the Place: The English Landscape Garden, 1620–1820,* ed. John Dixon Hunt and Peter Willis (New York, 1975), 32.

13. For overall accounts of Chinese landscape painting, see Michael Sullivan, *The Birth of Landscape Painting in China* (Berkeley, Calif., 1962); and James Cahill, *Chinese Painting* (New York, 1977). I don't mean to suggest here that the word "empire" denotes some uniform phenomenon that appears in the same form in tenth-century China and eighteenth-century England. For a good account of the varieties of imperial and nationalistic discourses, and their relation to "universal" or "nonarbitrary" languages, see Benedict Anderson, *Imagined Communities: Reflections on the Origin and Spread of Nationalism* (London, 1983), 21.

14. The literature on imperialism is almost as vast as the phenomenon itself. My starting point for this inquiry is the recent shift in the critique of imperialism from a primary concern with economic and political domination to a concern with culture—that is, with imperialism as a complex set of representational and discursive operations. Edward Said's *Orientalism* (New York, 1978) and his subsequent essays on culture and imperialism are fundamental to this whole shift, which is now generating new scholarly work throughout the humanities and social sciences. David Bunn's essay in this volume provides an excellent introduction to this critical turn, illustrates its application to a specific historical site (nineteenth-century South Africa), and shows that the turn to culture and representation need not involve any neglect of the hard facts of colonialism.

15. On imperialism and ambivalence, see Homi K. Bhabha, "Signs Taken for Wonders: Questions of Ambivalence and Authority under a Tree outside Delhi, May 1817," *Critical Inquiry* 12, no. 1 (Autumn 1985): 155–65.

16. For a discussion of Dutch landscape and nationalism, see Ann Adams's essay in this volume and my essay "Nature for Sale" on the relation between northern European landscape and the resistance to imperialism.

17. Clark, *Landscape into Art,* viii.

18. Ibid., 1, 10.

19. Ibid., 10.

20. The assessment of Chinese landscape as premodern and "unscientific" is sometimes buttressed by the claim that the Chinese did not understand natural (i.e., artificial) perspective. See William Chambers, *Dissertation on Oriental Gardening* (1772), collected in *Genius of the Place,* ed. Hunt and Willis.

21. "Landscape Painting" (*Oxford Companion*).

22. Clark, *Landscape into Art,* 231.

23. "Landscape Painting" (*Oxford Companion*).

24. Anderson, *Imagined Communities,* 21.

25. Ibid.

26. Distinctions of styles and techniques in painting (linear, painterly, expressionistic, impressionistic, geometric, etc.) are, in principle, independent of subject matter. Correlations between kinds of painting and kinds of landscape can be made by arguments for certain principles of decorum (e.g., it might be argued that a sublime landscape is best rendered in an expressionistic, painterly style). But these correlations are a secondary matter, a refinement on a generic division that is already firmly installed in a prior medium, that of the landscape itself.

27. William Chambers's discussion of Chinese landscape gardening, for example, routinely refers to the garden as itself a representation; see his *Designs of Chinese Buildings, Furniture, Dresses, Machines, and Utensils* (1757), in *Genius of the Place*, ed. Hunt and Willis 284–85.

28. Ralph Waldo Emerson, *Nature* (1836), in *Nature, Addresses, and Lectures*, ed. Robert E. Spiller and Alfred R. Ferguson (Cambridge, Mass., 1971), 39.

29. Raymond Williams, *The Country and the City* (London, 1973). 120; Barrell, *Dark Side*.

30. For a good discussion of the specific role played by reflections in Romantic landscape representations, see James Heffernan, *The Re-Creation of Landscape* (Hanover, N.H., 1984).

31. Jay Appleton, *The Experience of Landscape* (London, 1975).

32. Derek Pearsall and Elizabeth Salter, *Landscape and the Seasons of the Medieval World* (London, 1973), 139. Cf. p. 163: "Whatever movement toward realism there is takes place in the borders, where the artist has greater freedom to experiment and is less dominated by the stylized ritual of miniature and initial." Pearsall and Salter construct a kind of inverted version of the landscape history I have been describing. The Middle Ages is presented as a period in which the properly natural landscape of the classical tradition is replaced by "conventional" representations of nature, only to be slowly regained as the Renaissance approaches.

33. See Mary Louise Pratt, "Scratches on the Face of the Country; or, What Mr. Barrow Saw in the Land of the Bushmen," in *Race, Writing, and Difference*, ed. Henry Louis Gates (Chicago, 1986), 138–62. Pratt notes the tendency of travel narratives in the eighteenth and nineteenth centuries to downplay "confrontations with the natives" and to concentrate on "the considerably less exciting presentation of landscape" (141), interspersed with "portraits" of the natives. "This discursive configuration, which centers landscape, separated people from place, and effaces the speaking self" (143) of the traveling observer, presenting the author "as a kind of collective moving eye which registers" the "sight/sites" (142) that it encounters in a curious combination of mastery and passive receptivity. "The eye 'commands' what falls within its gaze; the mountains 'show themselves' or 'present themselves'; the country 'opens up' before the European newcomer, as does the unclothed indigenous bodyscape" (143) of the natives.

34. Beth Helsinger's analysis of Constable's evolution into a representative "national" painter who presents scenes of an endangered "deep England" ("Constable: The Making of a National Painter," *Critical Inquiry* 15, no. 2 [Winter 1989]: 253–79) is instructive in this regard as an illustration of the drive to reinforce native domesticity in the face of international pressures—to keep England English. The Chinese imperial park (and places like Kew Gardens in London), in contrast, were designed to be microcosms of landscape features from all regions of the empire and to display or even to exert a kind of homeopathic power. The first emperor in the Ch'in Dynasty, for instance, filled his park with replicas of the palaces of feudal lords he had defeated, and Emperor Wu excavated a scale model of a major lake in the southern kingdom of Tien as a symbolic

anticipation of its conquest. See Lothar Ledderose, "The Earthly Paradise: Religious Elements in Chinese Landscape Art," in *Theories of the Arts in China,* ed. Susan Bush and Christian Murck (Princeton, N.J., 1981), 165–83.

35. See David Bunn's essay on South African landscape in this volume, which argues that nineteenth-century representations of the landscape are best understood in terms of "settler capitalism," not in the framework of the picturesque tour.

36. A fuller account of North American adaptations of British imperial landscape traditions would also have to reckon with the sense of its overwhelming and unmapped land mass (see Joel Snyder's essay in this volume for an account of the way photographers confronted this issue). The resistance of Native Americans, moreover, was not brushed aside quite so easily as that of the Australian aborigines and the Polynesians, and the "Indian Wars" became central to the melodrama of westward expansion and landscape representation in the American national imaginary. The heavy component of landscape representation in the American Western movie would repay attention in terms of this imperial scenario.

37. Sahlins, *Islands of History* (Chicago, 1985).

38. Smith, *European Vision in the South Pacific,* 2d ed. (New Haven, 1984). See p. 69 for discussion of "how Tahiti became identified with classical landscape [and] how New Zealand became identified . . . with romantic landscape."

39. See Robert Hughes's extensive discussion of the double face of Australian landscape in *The Fatal Shore* (New York, 1987). Hughes notes the difficulty early landscape artists like Thomas Watling had in finding the picturesque: " 'The landscape painter,' wrote . . . Watling, 'may in vain seek here for that beauty which arises from happy-opposed offscapes' (meaning the beauty of romantic contrast, *à la* Salvator Rosa)" (93). And yet, at the same time, Hughes suggests that the first British painters of Australian landscape had difficulty in seeing anything *but* the picturesque, arcadian stereotype (2–3) and that they were encouraged to *transform* the "harsh antipodes" into "an Arcadian image of Australia hardly distinguishable from the Cotswolds or a picturesque park" (339). See also Tim Bonyhady, *Images in Opposition: Australian Landscape Painting, 1801–1890* (Melbourne, 1985); and Bernard Smith's chapter "Colonial Interpretations of the Australian Landscape, 1821–35," in *European Vision.*

40. Smith, *European Vision,* 1.

41. Ibid., 80.

42. John Ruskin, "The Novelty of Landscape," in *The Works of John Ruskin,* ed. E. T. Cook and Alexander Wedderburn (London, 1904), 196. See Helsinger, *Ruskin and the Art of the Beholder* (Cambridge, Mass., 1982), 244–45, on Ruskin and Turner's pessimism about the way the "English death" figures in European and biblical landscape.

43. Clark, *Landscape into Art,* 230.

44. For the beginnings of an argument along these lines, see my essay *"Ut Pictura Theoria*: Abstract Painting and the Repression of Language," *Critical Inquiry* 15, no. 2 (Winter 1989): 348–71.

45. For a discussion of the ambivalent relation between modernism and landscape painting, see Charles Harrison's essay in the present volume.

46. See Harrison M. Wright, *New Zealand, 1769–1840: Early Years of Western Contact* (Cambridge, Mass., 1959).

47. Francis Pound, *Frames on the Land: Early Landscape Painting in New Zealand* (Auckland, 1983), 11, 33, 16, 76.

48. Ibid., 28.

49. See Malek Alloula, *The Colonial Harem* (Minneapolis, 1986), for an analysis of the way European fantasies of the Other are mediated through images of women.

50. Pound, *Frames on the Land*, 40.

51. Quoted in ibid., 22.

52. I am grateful to Margaret Orbel of Canterbury University for information on the traditional significance of Maori artifacts.

53. Pound, *Frames on the Land*, 12. There is some evidence, however, that the Maori may have *sculpted* landscape; the conical shapes on the heads of human figures may indicate that they personify mountains.

54. See Wright, *New Zealand, 1769–1840,* for an account of the devastation that guns produced among the warlike Maori tribes.

55. Earle was quite aware that the Maoris were skilled sculptors, and he made numerous sketches of their elaborately ornamented canoes. See his *Narrative of a Nine Months' Residence in New Zealand in 1827* (Christchurch, 1909). Earle remarked on the "great taste and ingenuity" (23) of Maori carving and ornament, and he particularly admired the way painting and sculpture were integrated into the simplest implements of daily life.

56. See ibid., 23.

57. This view, not surprisingly, was hotly contested by many of the Israeli scholars at the conference.

58. Cf. Renato Rosaldo, "Imperialist Nostalgia," *Representations* 26 (1989): 107–22.

59. This photograph is reproduced in *After the Last Sky: Palestinian Lives,* a collaborative photographic essay by Edward Said and Jean Mohr (New York, 1986). For a fuller discussion, see my essay "The Ethics of Form in the Photographic Essay," *AfterImage* 16, no. 6 (January 1989): 8–13.

60. The first drafts of this chapter were written during a research residency as Canterbury Visiting Fellow at Canterbury University in Christchurch, New Zealand. I am grateful to many colleagues at Canterbury, but especially Denis Walker and Margaret Orbel, for their help and advice. The first presentation of the ideas occurred at the University of Auckland, Auckland, New Zealand; I am indebted to Francis Pound and Jonathan Lamb for their critical responses. The paper was written for a memorable conference entitled "Landscape/Artifact/Text" convened at Bar-Ilan University in Israel in November of 1987 by Sharon Baris and Ellen Spolsky. Landscape was not an easy topic to discuss rationally in Israel in 1987 (the *intifada* was in its opening days), but the combination of civility, passionate engagement with ideas, and intellectual openness displayed at this conference still gives me some hope that the optimistic ending of this chapter may be justified.

T W O

ANN JENSEN ADAMS

Competing Communities
in the "Great Bog of Europe"

Identity and Seventeenth-Century

Dutch Landscape Painting

It is a commonplace of art history that the so-called naturalistic landscape first emerged in Holland in the seventeenth century.[1] Histories of western European landscape painting frequently illustrate this point by juxtaposing a Flemish sixteenth-century imaginary world landscape, such as Joachim Patinir's *St. Jerome in a Landscape* (1515–24; see fig. 2.1), with an early seventeenth-century Dutch naturalistic vision, such as Pieter Molijn's *Dunescape with Trees and Wagon* (1626; see fig. 2.2).[2] Something dramatic happened around 1620 in Haarlem, so the narrative goes, as if scales had suddenly and collectively fallen from seventeenth-century Dutch artists' eyes, and they could suddenly see, and faithfully transcribe, the land in which they found themselves. While students of Dutch landscape painting have repeatedly demonstrated that Dutch artists rarely created paintings that were uncritically and uninterpretively transcriptions of the land in which they lived, current studies are still struggling to construct a new perspective upon the subject.[3] A dramatic change has indeed taken place in the function of landscape imagery within western European culture.[4]

For some time students of seventeenth-century Dutch landscape painting have made two observations and an assumption about its representation. First, while Dutch artists portrayed recognizable architectural monuments, they freely moved them about their homeland and sometimes even transformed these monuments or combined several in one imaginary building. Salomon van Ruysdael, for example, startlingly juxtaposed the cathedral and Huis Groenewoude in Utrecht with the two-towered St. Walburgis in Arnheim, more than thirty miles away.[5] Jacob van Ruisdael located the Portuguese-Jewish Cemetery at Oudekerk before the ruins of

35

the castle of Egmond near Alkmaar in a painting now in Dresden (ca. 1660; see fig. 2.3), and in front of the Romanesque Abbey Church of Egmond combined with elements of the Gothic Buurkerk at Egmond-Binnen, about three kilometers west of Alkmaar, in a painting in Detroit.[6] Second, Dutch artists often dramatized the location of a monument, as for example Jacob van Ruisdael's *Bentheim Castle* of 1653 (see fig. 2.4), one of at least a dozen such views the artist made of the site.[7] Bentheim Castle was located in German Westphalia on the eastern border of the United Provinces; as indicated by a photograph, there is no height near Bentheim comparable to the one Jacob shows in the painting (see fig. 2.5).[8] Seymour Slive has colorfully pointed out that to the young Dutchman coming from a country in which the highest point was only 320 meters above sea level, a small hillock on the landscape must have

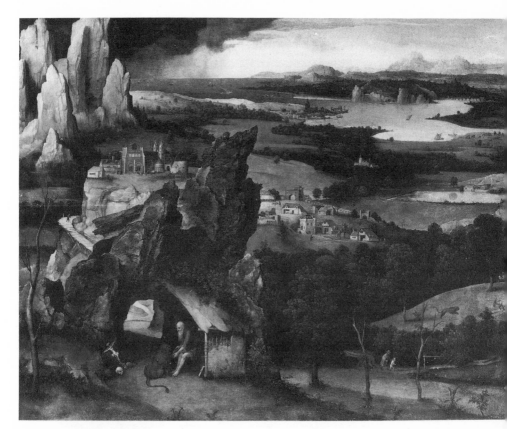

2.1 Joachim Patinir, *St. Jerome in a Landscape* (1515–24). Panel, 74 × 91 cm.
© Prado Museum, Madrid. All rights reserved. Partial or total reproduction prohibited.

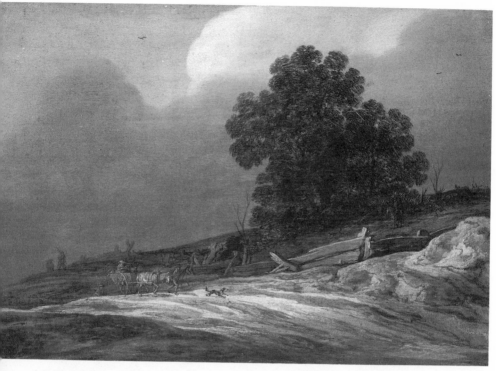

2.2 Pieter Molijn, *Dunescape with Trees and Wagon* (1626). Panel, 26 × 36 cm.
Courtesy the Herzog Anton Ulrich-Museums, Braunschweig. Photo: B. P. Keiser.

looked like an alp. Third, while it is recognized that landscape paintings
are frequently not topographically accurate, nonetheless it is usually as-
sumed that Dutch artists also represented recognizable land formations
that can be identified with particular regions of the country. The latter
assumption has remained unexplored in the literature.

Valuable studies of Dutch landscape painting have outlined stylistic
characteristics, identified sites, and articulated the iconographic content
of particular works or themes. Those landscapes that appear to represent
Dutch landscape formations accurately and that have no apparent literary
or textual referents, however, are frequently celebrated solely for the visual
pleasure in the landscape that they demonstrate on the part of the painter
and that they must have given to their viewers. There is no doubt that
seventeenth-century viewers relished landscape paintings for, in the words
of art theorist Gerard de Lairesse, "diverting and pleasing the eye."[9] There
remains, however, a large gap in our understanding of these works be-
tween the recognition that Dutch landscape painters realistically portrayed

actual monuments and land formations while combining them in unrealistic ways, and the conclusion that many such paintings were created primarily for the pleasure of the viewer.

This essay is a contribution toward filling that gap. I argue here that the selection of identifiably Dutch land formations and sites, their dramatization and physical manipulation, and above all their "naturalization" appealed to the unique conjunction in seventeenth-century Holland of three historical elements. Specifically, the political, economic, and religious shifts that together convulsed seventeenth-century Holland gave new meaning to the local, the prosaic, and recognizable features of land,[10] for

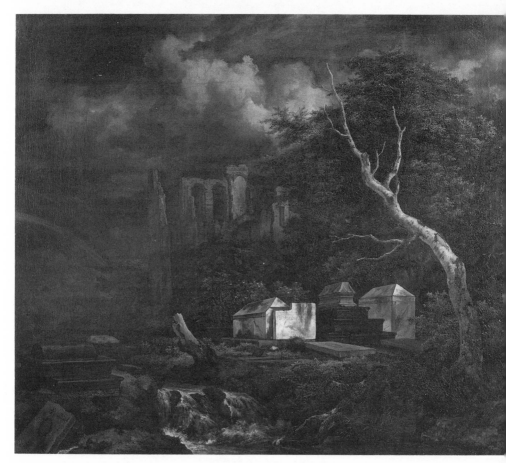

2.3 Jacob van Ruisdael, *Jewish Cemetery* (ca. 1660). Canvas, 84 × 95 cm. Courtesy the Staatliche Kunstsammlungen, Dresden.

2.4 Jacob van Ruisdael, *Bentheim Castle* (1653). Canvas, 110.5 × 144 cm. The Beit Collection, Blessington. Courtesy the National Museum of Ireland.

dramatic changes took place in these three spheres simultaneously. First, on a political level, the Seven United Provinces together declared their independence from Spain in 1579 and almost immediately were inundated by waves of immigrants; second, on the economic front, they exploited to an unprecedented degree many of the practices of the open market economy of today's world, including amassing the capital to undertake the largest land reclamation project in the world; and third, in the religious sphere, Protestantism replaced Catholicism as the professed religion of the land. Dutch landscape imagery responds to and "naturalizes" these three controversial subjects, three hot topics that still today can cause heated debate and personal discomfort in social situations—politics, money, and religion. The so-called naturalization of the land is also integral to the creation of new—and competing—communal identities within an evolving nation composed of a very high percentage of immigrants.

Landscapes were avidly collected by all classes of society in seventeenth-

2.5 Photograph of Bentheim Castle (ca. 1928). Photograph: Jakob Rosenberg, *Jacob van Ruisdael* (Berlin, 1928), fig. 46.

century Holland. Indeed, the Dutch seem to have collected landscapes in larger numbers than any other category of painting. Archival records confirm the impression conveyed by the frequency with which landscape paintings appear in the background of portraits and genre paintings, where they are pictured in interiors ranging from the modest tailor's home shop by Quiringh van Brekelankam (1661, Amsterdam, Rijksmuseum) to the elegantly appointed townhouse by Frans van Mieris (1658, Schwerin, Staatliches Museum).[11] In his systematic study of the subjects of paintings in Delft inventories drawn up between 1610 and 1679, the economist Michael Montias found that throughout the century, and by a wide margin, landscape was the most popular genre. It rose from 25.6 percent of all painting subjects in the period 1610–19 to nearly 41 percent by the decade 1670–79, ahead of the next most popular genres in these two decades by 9 and 23 percentage points respectively.[12] What in the world did the Dutch see in these pictures of their country?

Historically, the Dutch have maintained a unique and tangible relationship with their land. According to a popular Dutch saying, "God created the world, but the Dutch created Holland." From the late sixteenth century the United Provinces undertook the most extensive land reclamation project ever attempted in the history of the world. Between 1590 and 1664 more than 110,000 hectares, or 425 square miles, of land were reclaimed from the sea and inland lakes by means of a complex system of dikes and drainage.[13] The land area of the province of North Holland alone increased by 52.7 percent during this period.[14] These projects left

a large percentage of Holland's land mass below sea level, however, and vulnerable to massive flooding; indeed, today Schiphol Airport and much of Amsterdam lie below the level of the adjacent North Sea. Land was and remains a precious commodity that must be vigilantly protected against the threat of inundation, for dike breaks had created sensational disasters. The break of the dike at Broek during a storm on St. Elizabeth's Day in 1421 was celebrated for centuries in histories and paintings.[15] The chronicles no doubt exaggerated when they reported that the sea flooded 500 square kilometers, killed at least 100,000 inhabitants, and destroyed seventy-two villages, but modern estimates that put the figures at twenty villages destroyed and 10,000 dead remain staggering.[16] The seventeenth century witnessed its own disaster in the break in the St. Antonisdyk at Houtewael during a storm in 1651 pictured by artists including Willem Schellinks, Roelant Roghman, Pieter Nolpe, I. Colin, Jacob Esselens, and Jan van Goyen.[17]

Physical land was not only a tool but also a weapon for Dutch self-defense and self-creation. In 1664 an anonymous pamphleteer sarcastically noted this important asset of defense:

Questioner: I pray, Sir, what is their strength by land?
Answer: The sea, rivers, islands make it invincible . . . it is the great Bog of Europe, not such another Marsh in the World, a National Quagmire that they can overflow at pleasure.[18]

The Dutch turned back advancing Spanish troops at Alkmaar in 1573, for example, by defensively cutting through surrounding dikes. In 1574 they breached the main dikes of southern Holland in order to enable Dutch flat-bottom boats to sail to the rescue of Leiden.[19] Shortly before their declaration of independence from Spain, the Dutch filled in the entrance to the river Scheldt, isolating the Hapsburg capital of the Lowlands from the sea and the valuable trade it provided. This brought to an end Antwerp's economic supremacy and marked at the same time the beginning of Amsterdam's ascendancy as Europe's most prosperous city. The country as a whole followed suit. By 1688 English national income accountant Gregory King compared the per-capita incomes of the major northern European states; the Dutch Republic outranked them all.[20] The growing affluence attracted an unprecedented number of immigrants. In the twenty-two years between 1577 and 1589, the population of Antwerp was reduced by over half, from 100,000 to 49,000 inhabitants; many of these men and women fled to the northern Netherlands, a country that was more prosperous, more religiously tolerant, and less politically restrictive. Between 1500 and 1650, the population of Holland grew threefold; half of that increase occurred between 1580 and 1622.[21]

This physical creation of the country meant not only that land was a constant preoccupation but also that the political structure of the country was radically different from that of the rest of Europe. Because desolate dunes and marshy peat bogs constituted much of the land that composed Holland before the seventeenth century, the region had little appeal to prospective feudal lords who ruled elsewhere in Europe. While nominally under the rule of the dukes of Burgundy from 1428, and united with sixteen other provinces under Charles V, they were governed from a distance through appointed stadholders. A large percentage of the lands were actually owned by the inhabitants who lived on and worked them. Peasant landownership ranged up to 100 percent in some areas, with an average of 42 percent of the peasants in the province of Holland in 1514 possessing the land they worked. As a class, this was more than either the nobility, the church, or the urban bourgeoisie.[22] The elders of Nieuwveen noted that the inhabitants all owned their own land because, they explained, "no one from outside would want any."[23] The lack of appeal the region had for its overlord is suggested by the actual fear Charles V's ministers had for the emperor's health on a visit to Amsterdam in 1540, because of the city's infamously bad drinking water.[24] Holland thus did not have the kind of extensive feudal system of peasants attached to the land serving noble families experienced by the rest of Europe, a relationship vividly pictured in a page representing the month of March from the Book of Hours of the duke of Berry (1413–16; see fig. 2.6), in which the peasants who work the duke's lands are visually circumscribed by the boundaries of the fields to which they are attached.[25] Having never been subservient to a lord, the inhabitants had never been subservient to their land.[26] From the beginning they owned and worked the land as their own; land was a commodity to communally create and to personally own.

According to a long-standing tradition in western Europe, a land was identified with the person of its monarch or feudal lord. The association of the lord with his land and the rights he held from it and over it was an important part of both his and its identity. In the page representing August from the Book of Hours mentioned above, the duke of Berry, whose land is inscribed in his very name as his title, pictures himself in a hunting scene as the proud owner of his properties.[27] When monarchs such as Elizabeth I began to consolidate political power, their person was transformed into a symbol of national identity. Marcus Gheeraerts's portrait of Queen Elizabeth dating from about 1592 shows Elizabeth standing on a globe of the world, with her feet appropriately on Oxfordshire, the home of her adviser Sir Henry Lee, who commissioned the painting (see fig. 2.7). More literally, in 1537 Johannes Bucius created a remarkable map of the Holy Roman Empire that is physically made up of its monarch, with crown, orb, and scepter. Spain constitutes his head,

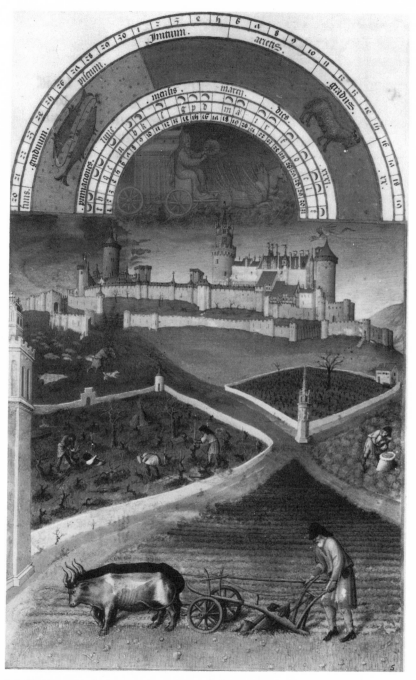

2.6 Limbourg Brothers, "March," from the *Hours of the Duke of Berry* (1413–16), Chantilly.

Italy his right arm, and northern Germany his left; a similar cartographic portrait of Queen Elizabeth dates from about 1600.[28] Similar investment was made by language. Henry the Fifth *is* England; Louis the Fourteenth, France.[29]

But what could be the relationship to provincial or state identity when there was no monarch or lord, and thus no ready body in which to invest the symbols of communal identity? While the northern Netherlands actually made successive overtures to Queen Elizabeth of England, the duke of Anjou (brother to King Henry III of France), and the earl of Leicester, the Dutch insisted upon maintaining a control over their leaders that ultimately brought dissatisfaction and rejections from all prospective princes and monarchs.[30] They thus had no individual in whom they could invest national power, symbolic or otherwise. This is not to say that the Dutch had no national heroes—the leader of the rebellion, Willem I of the House of Orange, could and did catalyze national sentiment. But he could hardly stand as a symbol for the state in all its economic, political, and religious decentralized and rivalrous complexity. With no individual in whom to invest the symbols of national identity and when faced with the problem of the creation of a communal identity, the Dutch turned to their land.

The Dutch identification of their political institutions with their land is inherent in their language itself. Given its physical origins, it is no accident that the country the Dutch inhabit is called Neder-lands, descriptive not of a people, a location, another region, or a political entity but of a physical quality of land, the Low-lands. Similarly, it is not surprising that the names of four of the seven provinces that originally made up the union also refer to land: Hol-land, Gelder-land, Zee-land, Fries-land.[31] Moreover, the word "Vaterland," or "Fatherland," was originally a Dutch word. As English observer William Temple observed in 1672, "The Dutch, by Expressions of Dearness, instead of our Country, say our Fatherland."[32] It initially designated heaven, the home of Our Father, and was first applied to the country of one's birth by the Dutch.[33]

Besides national place-names, historical events were also visually inscribed in landscape imagery. In contrast with representations of historical events elsewhere in Europe such as Rubens's *Peace and War* of 1629–30, Dutch painter Adriaen van de Venne locates his *Allegory of the Twelve Years' Truce of 1609*—a twelve-year cession of hostilities between the United Provinces and Spain—in a landscape site (1616; see fig. 2.8).[34] Rubens seems to have created his painting as a lavish complement to Charles I for making peace with Spain. The painting is, in the words of Charles's curator Abraham van der Doort, "an Emblim wherin the dif-

2.7 Marcus Gheeraerts the Younger, *Queen Elizabeth I (1533–1603)* (ca. 1592).
Canvas, 241.3 × 152.4 cm. Courtesy the National Portrait Gallery, London.

2.8 Adriaen van de Venne, *Allegory of the Twelve Years' Truce* (1616). Panel, 62 × 112.5 cm. Courtesy the Louvre, Paris.

ferrencs and ensuencees betweene peace and warrs is Shewed."[35] Rubens's painting is overwhelmingly composed of allegorical and mythological figures both nude and clothed. Minerva, the helmeted goddess of wisdom in the center, drives off Mars, god of war. In doing so, the goddess protects a woman and child who have been identified as Pax about to suckle the infant Plutus, god of wealth. A young Huymen, god of marriage, crowns a girl who with two others are presented with fruits from a cornucopia, symbols of peace and plenty. Clouds and curtains swirl in the background, through which a landscape is only distantly visible at the right.

While likewise inhabited by allegorical figures, Van de Venne's painting, in contrast, consists primarily of portraits set in an expansive landscape that completely overwhelms them. He represents the Seven Prov-

inces as a bride being led by a Spanish nobleman as bridegroom, proudly pointed out by an overgrown Cupid. In the left foreground a pile of the armor and war implements lay waiting to be removed by a wagon; Discord and Envy cowering between two tree trunks are likewise about to be carried off. On the right the benefits of peace are represented by Dutch bread and wine on Dutch ceramics and silver. Stadholder Maurits and his half-brother Frederik Hendrik of the Protestant northern Netherlands, and Archdukes Albert and Isabella, regents of the Roman Catholic southern Netherlands, witness the marriage along with rows of identifiable advisers and a self-portrait of the artist gesturing toward the viewer.

Keeping in mind this unusual and tangible relationship of the Dutch with their land, I turn now to an examination of how specific issues in the economic, political, and religious spheres may be inscribed in four

of the most familiar themes of Dutch landscape painting. These are the monochromatic dunescape that began to be produced in the vicinity of Haarlem in the mid-1620s, images of a ferryboat on a river popular from the mid-1630s, and later in the century two architectural monuments that are frequently relocated and often transformed, views of the Grote Kerk of Dordrecht and the Pellekussenpoort, Utrecht. I argue that the first two themes naturalize contemporary commercial developments, the latter controversial political and religious issues. I conclude with a few observations about how these paintings may participate in creating communal identities that cut across Dutch society in differing directions.

Students of Dutch landscape painting usually begin their discussion of Dutch naturalism with Pieter van Santvoort's *Landscape with Farmhouse and Country Road* dated 1625 (see fig. 2.9).[36] (As an aside, it is notable that Santvoort has inscribed the landscape in his own name. Born with the surname Bontepaert, the artist seems to have adopted the name Santvoort, meaning "sand extending out," after a small fishing village near Haarlem.)[37] Followed shortly thereafter in works by Jan van Goyen, Pieter Molijn (fig. 2.2 above), and others, these paintings are characterized by an increase in atmospheric effects, a dramatic reduction in bright local color in favor of earthy yellow-browns with gray-green shadows, low viewpoints, and prosaic subjects that may include grasses, a few scrubby bushes and trees, aging farmhouses and barns, rutted sandy roads, and weather-worn hillocks.[38]

Such sandy dunescapes are typical of the land formation running south to north along the coastline to the west of Leiden, Haarlem, Santpoort, and Alkmaar. These dunes protected from the sea the marshes and bogs that were being drained in the regions surrounding Haarlem and Amsterdam, Santvoort's home.[39] Highest in the vicinity of Haarlem, rows of these dunes are pictured to the west of Haarlem in a map by Filips Galle of 1573.[40] Santvoort's dunescape contrasts dramatically with other familiar Dutch land formations, such as the forested areas of Holland's eastern border, as pictured for example by Jacob van Ruisdael in his *Grain Field at the Edge of a Forest* (Oxford, Worcester College).[41]

Santvoort's remarkable pictorial essay in a local and prosaic subject—the turn to a recognizably Dutch land formation—followed in landscapes by others in the same vein were painted at precisely the time that the merchants of Amsterdam and Haarlem undertook an intensive land reclamation project of the inland lakes and marshy bogs in their northern suburbs.[42] Between 1612 and 1635 these citizens gambled at least ten million guilders (more than they had invested in the founding of the Dutch East India Company) to drain 26,000 hectares (100 square miles) of land, increasing in just twenty-three years the size of the region by

one-third.[43] This dramatic accomplishment is illustrated in a diagram that compares the areas of water in 1560 with those in 1650 (see fig. 2.10). It demonstrates how in almost Genesis-like fashion, the Dutch had reclaimed their land almost entirely from the waters.

While authorization had to be obtained from the provincial government, this creation of land was a commercial investment made by private citizens. The draining of the 17,500 acres (7,100 hectares) of the inland lake of Beemster, for example, was undertaken in 1607 by five merchants led by Amsterdam's powerful administrator of the East India Company, Dirck van Oss, with one goldsmith, three burgomasters, and six government officials in The Hague, including grand pensionary of Holland Jo-

2.9 Pieter van Santvoort, *Landscape with Farmhouse and Country Road* (1625). Panel, 30 × 37 cm. Courtesy Staatliche Museen zu Berlin Preussischer Kulturbesitz, Gemäldegalerie.

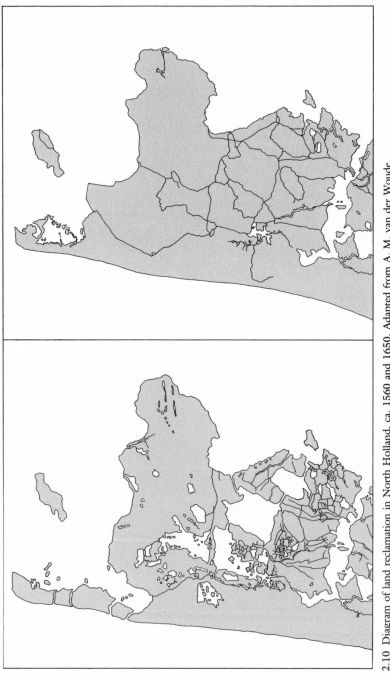

2.10 Diagram of land reclamation in North Holland, ca. 1560 and 1650. Adapted from A. M. van der Woude, *Het Noorderkwartier*, 3 vols., *A. A. G. Bijdragen*, no. 16 (1972): 755, 756.

han van Oldenbarneveld. The project was large and highly visible. By 1612 over one hundred citizens had invested in the scheme; its completion in March of that year was celebrated with a banquet held under a tent erected in the mud.[44] Projects such as these dramatically altered the appearance of the region. These speculators constructed behind the older sea dunes a system of canals and forty-two windmill pumps across the land.[45] The resulting landscape was an extremely flat and highly regular polder, punctuated by a gridlike system of canals and waterways across the drained areas, as vividly pictured in another project by an anonymous artist around 1600 (see fig. 2.11).[46]

In light of the commercial enterprises surrounding Haarlem and Amsterdam taking place precisely at the time of the emergence of the monochromatic dunescape, two qualities of Santvoort's landscape are particularly notable. First, while it represents a site in a local region where real estate is being rapidly created, Santvoort makes no reference whatsoever in the form of a windmill, canal, or flat polder to that commercial enterprise.[47] On the contrary, the farmhouse nestled under the protecting trees appears to have been there for a very long time. Second, while depicting the sandy landscape formation typical of the dunes to the west of Haarlem and Amsterdam, the artist has dramatized his subject by the low viewpoint, a sweeping curve in the road, a rise in the hill, a knot of wind-swept trees, and a darkening sky. This dramatization is evident from a comparison with a drawing of a similar site by Claes Jansz. Visscher that is inscribed "The road to Leiden outside Haarlem/1607" (see fig. 2.12).[48] Santvoort ignores his contemporaries' investment in and creation of the surrounding land; rather, the region in which new land was being created on an unprecedented scale is invested with a history. Thus, while the visual preoccupation with local landscape formations coincides with the first large-scale creation of land in the same region, the "naturalistic" imagery at the same time ignores the commercial enterprise that seems to have catalyzed it. In the cradle of capitalistic creation of real estate, the subject is noncommercial and pseudohistorical.

A similar process of commercial disavowal is apparently operating in another landscape theme popularized from the 1630s by the Haarlem artists Salomon van Ruysdael and Jan van Goyen, the so-called ferryboat on a river.[49] Adapting a theme that had been represented earlier in the century in more imaginary renditions, such paintings as van Ruysdael's *River Landscape with Ferry,* dating from 1649, usually show a flat-bottomed ferryboat laden with passengers and sometimes livestock, being poled along a tranquil river overhung with a few large trees, and frequently showing a glimpse of a church tower or farm buildings in the background (see fig. 2.13).[50] Like the dunescapes of the 1620s that they

replace in popularity, these images of ferryboats on a river were also created in Haarlem in large numbers. Originally showing the subdued coloring and atmospheric effects of the monochromatic dunescapes, by mid-century these broadly worked paintings are rendered with brighter local color and greater atmospheric clarity.

Inland water transportation was another of seventeenth-century Holland's great achievements. The creation of land brought with it the creation of canals; between 1632 and 1665 the Dutch established a remarkable system of inland travel on these canals. In a system of thirty separate ventures, the Dutch invested nearly five million guilders to create 658 kilometers of *trekvaarten,* or "towing canals," an arrangement of exceedingly straight canals along which horse-drawn barges transported passen-

2.11 Anonymous, *Polder "Het Grootslag" near Enkhuizen* (ca. 1600). Panel, 60 × 138 cm. Waagmuseum, Gemeente Enkhuizen.

gers. Like the draining of the landscape, the creation of the *trekvaart* was a communal enterprise, although one more directly involving municipal governments. After gaining permission from the provincial governments, two cities had to reach an agreement to build a linking canal system, develop an administrative system, and finally sell shares in the venture to individual stockholders.[51]

The cover of a timetable for one of these routes illustrates the canal, barge, horse, and towing arrangement of the new system (see fig. 2.14).[52] Inland water carriage had long been an important means of transportation in the northern Netherlands. Until the creation of the *trekvaart,* however, only a few ferry routes provided regular service; many waited for a full load to depart. In 1632 the first *trekschuit* (towing barge), between Am-

2.12 Claes Jansz. Visscher, "The Road to Leiden outside Haarlem" (1607). Pen and brown ink, 125 × 189 mm. Courtesy the Rijksmuseum-Stichting, Amsterdam.

sterdam and Gouda, was opened.[53] By mid-century the system linked all of the major cities of the United Provinces, following schedules of remarkable regularity and dependability. From Amsterdam, for example, the traveler could depart for Haarlem every hour, south to Gouda twice and to Utrecht three times per day, north to Hoorn twelve times daily, and east to Naarden or Weesp six times each day.[54] Bells were rung to announce the departure time, and many barges were equipped with hourglasses. A skipper faced heavy fines for failure to keep to the schedule. In his detailed analysis of the system, de Vries observes that by the time they were fully operating, the *trekschuiten* provided 78 percent of public transportation in the Friesland and Groningen regions, and 81 percent in Holland and Utrecht, in contrast with coaches, which provided for only 6 percent of intercity travel. In the 1660s and 1670s the volume of paid passenger travel on *trekschuiten* was equivalent to every man, woman, and child in the four provinces served by the network spending some six hours on a barge per year.[55] Perhaps the most telling indication of their importance was the observation made in the eighteenth century by Benjamin Silliman that "on account of the equal motion of the Schuits, the Dutch reckon their distances by time."[56]

It is notable that the period of the greatest production of images of ferryboats on rivers closely coincided with the years 1632 to 1665, during

which time this system of barges on canals was under construction.[57] Equally remarkable, these paintings rarely if ever show the new mode of transportation. Like Ruysdael's painting, almost all depict ferryboats polled by a ferryman and along a river rather than a canal—the older sixteenth-century mode of water transportation. Thus, like the dunescape by Santvoort, Ruysdael's *River Landscape with Ferry* seems in its subject to be responding to the intense and remarkable economic achievement that was taking place at the time of its creation—here water transportation. But it too historicizes its subject and recollects an earlier era. Like the monochromatic dunescapes, it also pictures the landscape from a dramatic point of view, for the newer narrow and straight canals were much more prevalent in the Dutch countryside than the ancient broad and winding rivers.

Another level of commerce is embedded in these paintings, for many

2.13 Salomon van Ruysdael, *River Landscape with Ferry* (1649). Canvas, 99.5 × 133.5 cm. Courtesy the Rijksmuseum-Stichting, Amsterdam.

2.14 Cover of "Reys Boek" (eighteenth century).

if not most of these works were for the first time created not for individual patrons to well-defined specifications but for a commercial open market.[58] This raises the question, then, With what kind of viewer did these paintings resonate, and what imaginative function might they have served? The few surviving comments about landscape painting are not specific enough to help us here. We may draw a few conclusions, however, by addressing this question through the contemporary circumstances that I have just outlined. I suggest that this historicizing of the land and the diversion of attention from contemporary commercial enterprises to "natural" historical land formations and activities may be related to the complex contemporary issue of identity formation.

As discussed above, the draining of the land was an enterprise requiring the joint efforts of a group of citizens, and the creation of the *trekschuit* required the involvement of municipal governments. It is thus notable that the few existing paintings showing *trekschuiten* are panoramic city views that were apparently commissioned for or donated to the town halls of the cities they portray. Hendrik Cornelisz Vroom, for example, originally created his *View of the Haarlemmerpoort, Amsterdam* (Amsterdam Historical Museum) without a canal in 1615 before the *trekvaart* was even planned. Vroom apparently added the canal and four barges parked at a dock some seventeen years after he signed and dated the painting—after, that is, the *trekvaart* was completed in 1632.[59] While the seventeenth-century provenance of the painting is unknown, it certainly celebrates and associates the *trekschuit* with the city. Jan van Goyen's view of The Hague includes the *Delftse Vaart* (The Hague, Gemeentemuseum); this work was commissioned by the city magistrates for the considerable sum of 650 gulden in 1651.[60] This association of the *trekschuiten* with the cities that financially and administratively made them possible is consistent with the apparent motivation behind their construction. De Vries notes that *trekschuiten* were in themselves neither economically efficient nor even very profitable; they were, however, important to the larger stimulation of a city's commerce and above all a municipal status symbol as a model public utility.[61]

This lack of reference to commercial enterprise in the two landscape themes discussed above is not unique in Dutch culture. It has been frequently observed that farming, a common subject in fifteenth-century illuminated manuscripts and in sixteenth- and seventeenth-century Flemish painting, is rarely if at all depicted in Dutch landscape painting.[62] While whalers and individual commercial ships are occasionally represented in Dutch seascapes, there are apparently no depictions of the commercial ships of the East India Company.[63] In contrast to landscapes of the Dutch homeland, in the second half of the century industry is a preva-

lent theme of images of colonial communities abroad. Allart van Ever-
dingen, for example, depicted Hendrick Trip's *Cannon Factory at Julita-
broeck in Södermanland, Sweden,* and Hendrik van Schuylenburgh painted
the *Factory of the East India Company in Houghly, Bengal* in 1665 (both
Amsterdam, Rijksmuseum).[64] A rare exception to the general lack of im-
ages of commerce is Jacob van Ruisdael's paintings of the individually
owned bleaching fields of Haarlem, of which he produced at least nine
views.[65] These may have been available to Ruisdael and his public, how-
ever, because traditionally the subject of bleaching was readily invested
with such traditional and noncommercial associations as moral purity.[66]
We cannot conclude, then, that commerce was something the Dutch uni-
versally felt the need to hide. Most of the above-mentioned paintings may
be said to represent individually owned property rather than labor.[67]

Early in the century commercial enterprises may not have yet had a
place among the personal ideals deemed appropriate to express publicly.
Although the amassing of property in this world was considered a sign
of salvation in the next, at the same time the professed ideal was the
favoring of spiritual matters over involvement in the material world. Other
factors, however, may also have been at work here. On one level these
images provide a visual escape to and appreciation of the countryside for
the urban dweller. On another their nostalgic themes could serve to as-
suage guilt for a past landscape that was rapidly being changed if not
destroyed by contemporary commercial enterprise. Finally, they are a vi-
sual appropriation and dominance of that countryside, a visual variation
of an economic relation that by the seventeenth century was firmly estab-
lished.[68] This is a dominance that conveniently overlooks the contempo-
rary economic transformation being wrought on that land by groups of
wealthy individuals, making it symbolically available to a much broader
spectrum of the population. The few surviving documents indicate that
dunescapes were plentiful and cheap, and thus also commercially available
to a wide range of citizens.[69] At the level of local economic interest,
Haarlem dunescapes could have helped to create for their viewers a shared
sense of local regional history (this is not to say that the relation with
the imagined community was the same for all viewers). Ferry scenes,
representing transportation that both tied country to city and cities to
each other, may well have imaginatively functioned for a provincial or
even transprovincial public.

While this is a rich subject for further investigation, the distinguishing
factor between those commercial enterprises that are represented and
those that are not seems to be related to the organization of capital behind
them, the relationship of individuals to each other and their investment.
Commercial enterprise that was undertaken by a group of individuals at

home in the private marketplace, particularly early in the century, may perhaps have been viewed as potentially disruptive to the fabric of society—if citizens had even a concept for thinking about it.[70] In any event, most enterprises appear not yet to have been part of the public discourse of identity. Such an exception as the *trekvaarten*, owned by private investors for public service rather than private gain, may have provided subjects for communal satisfaction within the framework of new entrepreneurial processes.

I turn now to two paintings with subjects that are more openly economic and apparently political. The first is Albert Cuyp's *View of Dordrecht with Cattle*, popularly known as the *Large Dort*, and usually dated on the basis of style to the late 1640s (see fig. 2.15).[71] As with the two paintings just examined, Cuyp shows a monument that is readily identifiable as

2.15 Albert Cuyp, *View of Dordrecht with Cattle (The "Large Dort")* (late 1640s). Canvas, 157 × 197 cm. Reproduced by courtesy of the Trustees, the National Gallery, London.

unmistakably Dutch. Rather than including a land formation or a Dutch barge and river, the artist depicts a view from the southeast of the Grote Kerk, or "Our Lady Church," in Dordrecht; to its left a city gate, the Vuilpoort, is visible. Like the subjects of the two previously discussed paintings, this one is redolent with history, both religious and commercial. Founded before 1200 on a tributary of the Rhine, Dordrecht was the oldest city in Holland and at one time its most important trading center, a role it relinquished in the seventeenth century to Amsterdam and Rotterdam.[72] Begun in 1339, the unfinished brick tower of the Grote Kerk made it among the most visually impressive churches in Holland. The church dominates the city even today.[73] The city had been the site of the first national Reformed synod in 1578 (after the organizational synod at Emden of 1571) and the critical Synod of Dort of 1618–19, held in the Kloveniersdoelen of the city, during which the Calvinist church in Holland consolidated itself and issued an important doctrinal statement, the "Articles of the Synod of Dort."[74] It was at this synod too that plans were made for the translation into Dutch and publication of the official States Bible which finally appeared in 1637.

The painting juxtaposes the prominent church with a small herd of dairy cows, shepherds, and a milkmaid in the foreground. More directly than the two paintings discussed above, these make reference to an important industry. Dutch cattle were renowned throughout Europe for their size, prodigious milk production, and the cheese made from their milk. Weighing an average of 1,600 pounds and producing as much as 1,300 liters of milk a year, Frisian cows were markedly superior to those of the rest of Europe, which weighed only 1,000 pounds on average and produced a mere 700 liters of milk annually.[75] Contemporary literature boasted of Dutch herds.[76] As a cornerstone of agricultural productivity and Dutch prosperity, the commercial cow had been, since the sixteenth century, associated with patriotic sentiment and a symbol of Holland itself. Allegories produced at the time of Holland's independence from Spain represent the northern Netherlands as a healthy cow or bull.[77] As has been frequently pointed out, the association reappears particularly during the 1640s during the time the Dutch were concluding negotiations with Spain that culminated in the Treaty of Munster and the legal recognition of the independence declared by the United Provinces in 1579.[78] A print by Hendrick Hondius II dating from 1644 is typical (see fig. 2.16). The caption on the print cautions the Dutch not to give too much away to Spain in order to conclude the truce: "Watchman, do your best to see that the Dutch cow is not stolen from us."[79]

Thus, the close visual juxtaposition of the historically important church with the economically important cows must have had strong resonances

Voby heeren waebters wel neerftelyck toefiet, Dat Ons gerooft werd de Hollandse Roomie

2.16 Hendrick Hondius II, *Cows in a River* (1644). Etching.

with national patriotic fervor in the Dutch viewer.[80] Did the painting associate Dutch prosperity with the Dutch Reformed Church for some viewers? Or might it have associated prosperity for others with an earlier era when the church had been used by Catholics? Indeed, the associations no doubt depended upon the religious affiliation of the viewer. In either case, this painting, and others like it showing Dutch cows and the Grote Kerk at Dordrecht, presented a potential site for political thought and affiliation. They may well have appealed to a broader community than the two paintings previously discussed, one that was based not on narrow economic concerns but on nationwide economic and religious interests, interests that were intent on seeing that the treaty concluded with Spain was as favorable as possible for Dutch economic growth and prosperity and for toleration of the viewer's religious affiliation.[81]

Like the two previously discussed paintings, the artist has taken liberties with his site. Dordrecht is actually situated at the junction of two major rivers, the Oude Maas and the Dordtse Kil. As is apparent, Cuyp— like Santvoort and Ruysdael, who also painted the site—has substituted a hilly landscape for the broad river that flows past the church as viewed more accurately in a painting by Jan van Goyen from exactly the same time (1645, Carter Collection, Los Angeles).[82]

My final example, Van Goyen's initially enigmatic painting *River Land-scape with Pellekussenpoort, Utrecht, and Gothic Choir,* from the same decade, makes perhaps a more pointed religious and political statement (1643; see fig. 2.17).[83] In warm brown and yellow tones it represents a large structure surmounting city walls, a few sailboats, and a heavily laden ferry. The most readily identifiable structure in the painting is a Gothic choir surmounting the city wall at the right. While it is generalized enough to be unidentifiable as a specific church, it is of a type frequently found in paintings by the artist and prints by his contemporaries.[84] Such churches dotted the Dutch countryside and small towns, as for example "'t Klooster Aegten" of 1620, illustrated in an early eighteenth-century travel guide in three languages by Abraham Rademaker (see fig. 2.18).[85] The choir in Van Goyen's painting, however, stands without its transept and nave; it abuts, in fact, a civic tower. The prominent tower is an adaptation of an ancient city gate that stood in Utrecht during the seventeenth century, familiarly known as the Pellekussenpoort. Although demolished by the beginning of the eighteenth century, it was a favorite subject of seventeenth-century artists, who repeatedly rendered the gate in paintings, drawings, and prints.[86] It is recognizable by the roofline, where the turret joins the roof, as seen in another print by Rademaker from the opposite side (see fig. 2.19).[87]

Van Goyen, then, has juxtaposed a medieval, formerly Catholic church

2.17 Jan van Goyen, *River Landscape with Pellekussenpoort, Utrecht, and Gothic Choir* (1643). Panel, 76 × 107 cm. Private Collection.

with a historic civic gate. In his article on seventeenth-century images of the gate, Stechow concluded that it represented for the seventeenth-century viewer a pastoral ideal, a romantic celebration of the countryside onto which the ancient gate opened. It seems to me, however, that in this work Van Goyen may have rather been commenting upon the very controversial contemporary issues of the relationship of church and state, a theme that was particularly pressing in the tense 1640s.[88] The Pellekussenpoort was a gate to the city of Utrecht, the former seat of the Catholic bishop. Throughout the seventeenth century the city retained the highest proportion of Catholics in the entire country. Moreover, while sympathizers with the Reformed church politically dominated the country, it has been estimated that up to 40 percent of the nation remained Catholic or sympathetic with the Catholic cause.[89] Such a Gothic church had been built by Catholics long before Holland became a Protestant country. Painted by a Catholic artist (for Van Goyen was Catholic himself), this

2.18 *'t Klooster Aegten* (1620). Engraving from Abraham Rademaker, *Kabinet van Nederlandsche Outheden en Gezichten* (Amsterdam, 1725), vol. 2, pl. CCC. Photograph: reprint Zaltbommel: Europese Bibliotheek, 1966.

2.19 *Pellekussenpoort* (1620). Engraving from Abraham Rademaker, *Kabinet van Nederlandsche Outheden en Gezichten* (Amsterdam, 1725), vol. 2, pl. CCXXIII. Photograph: reprint Zaltbommel: Europese Bibliotheek, 1966.

painting appears to be a nostalgic reflection upon an earlier time, a time before the suppression of Catholics in Holland. Such an association would have resonated most strongly with a Catholic audience, particularly citizens of Utrecht. A time when the fledgling nation would obtain formal recognition of its independent status was also a time for reevaluation of the relationship of the various religious sects within the country to that state.

All four paintings exhibit several elements in common. First, each depicts landscape features that are recognizably Dutch (a landscape formation in the dunescape, a form of transportation in the river ferry) or architectural monuments (the Grote Kerk in Dordrecht or the Pellekussenpoort in Utrecht). Second, the artists of all four works dramatize the landscape sites they represent. In the first two, contemporary economic activity may be linked with their appearance; in the last, contemporary religious and political events. Finally, in all of these works the landscape is a site in which difficult urban preoccupations are naturalized particularly through the conceit of the recently created nation and land having a lengthy history.

The visual preoccupation with the landscape must have served an important function for a population constantly threatened with ruin by the sea, providing a form of imaginative control over nature that daily threatened destruction of all that the people had created. Indeed, Dutch artists imaginatively removed celebrated historic monuments to hillocks safely above the level of the menacing waters. Such control had to be exerted at the level of the community rather than the individual, for only through massive group effort could dikes and polders be maintained. Dutch landscape paintings thus could focus communal attention to the taming and control of a potentially threatening enemy. This visual dramatization of the landscape and its sense of history must also have been reassuring to a citizenry forging new political institutions and to a population constituted by a large number of immigrants. It visually gave this population a sense of stability through a fabricated communal history in the land. (It may also have made this exceedingly flat and, to many immigrants, foreign land more familiar, more like the lands from which they came.)

In each case, however, the images I discussed above would have resonated most strongly with specific urban groups, and in some cases over a very specific communal issue—the picturing of which potentially contributed to the creation of communal identities in a variety of spheres. Newly created and under constant transformation, landscape provided a ready unclaimed site for the negotiation of the potentially fragmenting issues of capital investment, political rivalries, and religious dispute.

The assumption of this chapter has been that viewing an image (here

a landscape) can, through the associations it engenders, create in the viewer a sense of affiliation with or difference from others, an individual identity in relation to a variety of communally held identities. Like social relations that are themselves dynamic and evolve simultaneously on many levels, these paintings of the Dutch landscape simultaneously address multiple values and themes. Barring a lucky find in diaries or letters, we may never know what these themes meant for any individual viewer. More to the point here, however, is that these Dutch landscape paintings reveal some of the social sites and some of the issues around which identities were being constructed.

Dutch society was extraordinarily fragmented.[90] Individuals belonged simultaneously to a variety of communities in the economic, political, and religious spheres, many of which were in potential conflict with each other. These cut across the culture in a variety of ways. Affiliations in one area could be disrupted and shifted in another by friendships and family ties. These paintings offered a communal identity on several levels, legitimizing their themes through naturalizing and historizing them, offering security where none in fact was to be had. At a time when political theory was highly preoccupied with social cohesion, images such as the Haarlem dunescapes or rivers with ferryboats must have broadly appealed to regional audiences, overlooking the potential social disruption caused by private joint economic speculation and land development, a new form of economic activity that certainly had no social location. Images such as Cuyp's *Large Dort* offered the possibility of economic and political warning for citizens on a national scale; that of Van Goyen's *Pellekussenpoort,* a form of nostalgia if not political protest by Catholics. Each of these presented to viewers a different community with which they might imaginatively affiliate or distance themselves.

Dutch landscape painting thus provided a site for the working out, not of rural issues, but of urban ones.[91] As Cosgrove has argued, "Landscape is a subjective formation." It is "an ideological concept. It represents a way in which certain classes of people have signified themselves and their world through their imagined relationship with nature, and through which they have underlined and communicated their own social role and that of others with respect to external nature."[92] Ironically, however, even for Cosgrove, Dutch landscape painting remains "an unadorned, realistic and familiar word . . . recognisable and valuable to the historian or geographer," against which he plays the "subjective" landscapes of other places and other times.[93] Dutch "naturalism" of powerful economic, religious, and political themes has tenaciously resisted further inquiry and remained convincing indeed. In these remarkable transformations of their homeland, Dutch artists visually turned their own country back into God's

country; Nederland becomes Vaderland once again, not only linguistically but also pictorially.

Notes

1. I am indebted to W. J. T. Mitchell for our many productive conversations while team-teaching a graduate seminar, during which the ideas for this paper took shape, and to Becky Chandler for the opportunity to present a preliminary version of this paper at a Midwest Faculty Seminar in the spring of 1990. I am also grateful to Charles Harrison for a thoughtful reading of this text and a discussion about some of its assumptions and implications.

2. As for example Bob Haak, *The Golden Age: Dutch Painters of the Seventeenth Century* (New York, 1984), 134–43. Patinir: inv. no. 1614, Robert Koch, *Joachim Patinir*, Princeton Monographs in Art and Archaeology, no. 38 (Princeton, N.J., 1968), cat. no. 11, figs. 28, 29. See also Walter S. Gibson, *"Mirror of the Earth": The World Landscape in Sixteenth-Century Flemish Painting* (Princeton, N.J., 1989), 11, with additional citations. Molijn: inv. no. 338. Wolfgang Stechow, *Dutch Landscape Painting of the Seventeenth Century* (London, 1966), 23–26, discusses Molijn's work as "one of the corner-stones of Dutch landscape painting." See also Peter Sutton, ed., *Masters of Seventeenth-Century Dutch Landscape Painting*, exh. cat. (Boston, Museum of Fine Arts, 1987), no. 56.

3. In his monumental study of Dutch landscape painting, Stechow pointed out that "while there exist some topographically correct city views (mostly views within a city), the majority of these subjects were used with freedom and even caprice" (*Dutch Landscape Painting*, 8). The point was made earlier by H. van de Waal, *Drie eeuwen vaderlandse geschieduitbeelding, 1500–1800. Een iconologische studie*, 2 vols. (The Hague, 1952), 1:51, and elaborated upon by Wolfgang Stechow, "Landscape Paintings in Dutch Seventeenth Century Interiors," *Nederlands Kunsthistorisch Jaarboek* 11 (1960): 165–84, esp. 165.

4. Dutch landscape imagery has come under extensive consideration in a number of important essays in recent exhibition catalogs. These include essays in Christopher Brown et al., *Dutch Landscape, the Early Years: Haarlem and Amsterdam, 1590–1650* (London, National Gallery, 1986); Sutton, *Dutch Landscape Painting*; Marijn Schapelhouman and Peter Schatborn, *Land and Water: Dutch Drawings from the Seventeenth Century in the Rijksmuseum Print Room* (Amsterdam, Rijksmuseum, 1987); Frederik J. Duparc, *Landscape in Perspective: Drawings by Rembrandt and His Contemporaries* (Cambridge, Mass., Arthur M. Sackler Museum, 1988); Cynthia P. Schneider et al., *Rembrandt's Landscapes: Drawings and Prints* (Washington, D.C., National Gallery of Art, 1990); David Freedberg, *Dutch Landscape Prints of the Seventeenth Century* (London, British Museum, 1980).

5. Salomon van Ruysdael, *Winter near Utrecht*, panel, 75.5 × 107 cm., Enschede, Coll. Mrs. van Keek-van Hoorn in 1966, illus. in Wolfgang Stechow, *Salomon van Ruysdael, eine Einführung in seine Kunst* (Berlin, 1938), no. 13; and

Stechow, *Dutch Landscape Painting*, fig. 6, pp. 8, 190 n. 29, with other examples including (p. 162) Albert Cuyp's location of Utrecht's Mariakerk in an Italian landscape (Toledo Museum of Art). On the latter, see W. Hutton in *Toledo Museum News*, Autumn 1981, 79ff. with color illus.

6. Canvas, 141 × 182.9 cm., Detroit Institute of Arts; Seymour Slive, *Jacob van Ruisdael*, exh. cat. (Cambridge, Mass., Fogg Art Museum, 1981), nos. 20, 21, with extensive discussion.

7. Van Ruisdael: Slive, *Jacob van Ruisdael*, no. 14; for two other paintings of the site, see nos. 12, 13.

8. The photograph is reproduced in Slive, *Jacob van Ruisdael*, 54.

9. Gerard de Lairesse praised landscape because it "is the most delightful subject in the art, and has very powerful qualities, with respect to sight, . . . it diverts and pleases the eye" (*Het Groot Schilderboek* [Amsterdam, 1707], translated as *Art of Painting in All Its Branches* [London, 1778], 203). Stechow asserts that for those Dutch landscape paintings without an obvious "subject," this was the only motivation behind their creation (*Dutch Landscape Painting*, 11).

10. Associations have been suggested between a growing national pride and the rise of the "realistic" style in landscape; see J. G. van Gelder, *Jan van de Velde* (The Hague, 1933), 15. Christopher Brown, "Introduction," in *Dutch Landscape, the Early Years*, 11–34, esp. 24–30; and Simon Schama, "Dutch Landscapes: Culture as Foreground," in Sutton, *Dutch Landscape Painting*, 64–83, are two excellent discussions of the broader cultural context within which Dutch landscapes were created. These two authors raise some of the general political, economic, and religious issues that this chapter examines in greater depth. Schama (ibid., 70–71) discusses some of the problems with the term "realism." See also W. J. T. Mitchell, "Nature for Sale: Gombrich and the Rise of Landscape," in *The Consumption of Culture in the Early Modern Period*, ed. Ann Bermingham and John Brewer (London, forthcoming).

11. Brekelankam: canvas, 66 × 53 cm., Peter C. Sutton et al., *Masters of Seventeenth-Century Dutch Genre Painting*, exh. cat. (Philadelphia Museum of Art, 1984), no. 18, with color illus. Van Mieris: panel, 31.5 × 24.6 cm., Otto Naumann, *Frans van Mieris (1635–1681) the Elder*, 2 vols. (Doornspijk, 1981), vol. 2, pl. 22; known in at least seven versions. Landscapes also appear in the background of portraits of figures in interiors, probably more of which represent actual paintings, including the *Portrait of a Couple* by Eglon Hendrick van der Neer, Boston Museum of Fine Arts, illus. Stechow, "Landscape Paintings," fig. 11, which is signed with the appropriate form of J. Ruisdael's signature. In this article, Stechow points out that while a few of the landscapes pictured in these paintings seem to have been based on actual works, it is likely that many of them never actually existed. The point remains that their prevalence in such interiors, imaginary or not, seems to parallel their numbers in surviving inventories. See John Michael Montias, *Art and Artisans in Delft* (New Haven, 1982), 269–70.

12. Montias, *Art and Artisans*, 242. See also J. M. Montias, "Works of Art in Seventeenth-Century Amsterdam: An Analysis of Subjects and Attributions," in *Art in History/History in Art: Studies in Seventeenth-Century Dutch Culture*, ed. D. Freedberg and J. de Vries (Santa Monica, Calif.: The Getty Center for the History

of Art and the Humanities, 1991), 331–72, esp. 334–37, where the numbers are 20 percent in the 1620s, 25 to 28 percent from 1630 to 1659, and about 35 percent from 1660 to 1689; and Alan Chong, "The Market for Landscape Painting in Seventeenth-Century Holland," in Sutton, *Dutch Landscape Painting,* 104–20.

13. H. Blink, *Geschiedenis van den boerenstand en den landbouw in Nederland,* 2 vols. (Groningen, 1902), 2:112–13, cited by Jan de Vries, "The Dutch Rural Economy and the Landscape," in *Dutch Landscape, the Early Years,* ed. Brown, 79–86, esp. 82. See also Jan de Vries, "Landbouw in de Noordelijke Nederlanden, 1490–1650," in *Algemene geschiedenis der Nederlanden* (Haarlem, 1980): 7:12–43, esp. 36–37.

14. Renee Kistemaker and Roelof van Gelder, *Amsterdam: The Golden Age, 1275–1795* (New York, 1982), 16. See also A. M. van der Woude, *Het Noorderkwartier,* 3 vols. (*A. A. G. Bijdragen,* no. 16; Wageningen, 1972).

15. For the legends that grew up around the flood, see van de Waal, *Drie eeuwen* 1:255–57. Simon Schama, *The Embarrassment of Riches: An Interpretation of Dutch Culture in the Golden Age* (New York, 1987), figs. 14, 16, illustrates a contemporary painting of 1421 (Amsterdam, Rijksmuseum) and a late seventeenth-century engraving by Romeyn de Hooghe after Arnoud van Houbraken for his *Schouburgh der Nederlandse Veranderingen* (Amsterdam, 1684). Chrysostom of Naples, *De situ et de moribus Hollandiae* (1514), was apparently the earliest written account, repeated in such later accounts as Petrus Scriverius's *Batavia Illustrata* (Leiden, 1614), cited by Schama, "Dutch Landscapes," 625, nos. 47, 48.

16. Audrey M. Lambert, *The Making of the Dutch Landscape* (London, 1971), 123. See also Gerhard Werkman, *Kent gij het land der zee ontrukt* (Bussem, 1948), 70–74, cited by Jan de Vries, *The Dutch Rural Economy in the Golden Age, 1500–1700* (New Haven, 1974), 31; and M. K. E. Gottschalk, *Stormvloeden en rivierstromingen,* 3 vols. (Assen, 1974–77).

17. Clara Bille, "Een dijkdoorbraak te Amsterdam ruim 300 jaar geleden," *Amstelodamum, Maandblad* 47 (1960): 204–11; paintings include that by Willem Schellinks, *Collapse of the St. Antonisdyk at Houtewael,* canvas, 47 × 68 cm., Amsterdam Historical Museum, cat. 1975/79, no. 401; illus. Schama, "Dutch Landscapes," fig. 17. Jan Asselijn, panel, 46.5 × 63 cm., Amsterdam Historical Museum, cat. 1975/79, no. 13 (with a list of other paintings of the subject), and C. Steland-Stief, *Jan Asselijn* (Amsterdam, 1971), 81–82, illus. Jan van Goyen made a series of sketches from life of the scene, in H. U. Beck, "Jan van Goyen am Diechbruch von Houtewael (1651)," *Oud Holland* 81 (1966): 20–33.

18. Anonymous pamphlet, *The Dutch Drawn to Life* (London, 1664), 42.

19. Pieter Geyl, *The Revolt of the Netherlands* (London, 1958; 1st ed., 1932, 134–35, 136–38; S. J. Fockema Andreae, "De militaire inundatie van het vaste land van Holland in het jaar 1574," *Tijdschrift van het Koninklijk Nederlands Aardrijkskundig Genootschap* 70 (1953): 307–15.

20. Gregory King, *Natural and Political Observations and Conclusions upon the State and Condition of England* (London, 1696), cited by de Vries, *Dutch Rural Economy,* 242–43.

21. De Vries, *Dutch Rural Economy,* 89–90, 107; for a detailed analysis of the population growth in the northern Netherlands and its sources, see Chap. 3. See also J. A. Faber et al, "Population Changes and Economic Developments in the Netherlands: A Historical Survey," *A. A. G. Bijdragen* 12 (1965): 47–113; A. M. van der Woude, "Demografische ontwikkeling van de Noordelijke Nederlanden, 1500–1800," *Algemene geschiedenis der Nederlanden* 5:102–68, esp. 123–39.

22. J. C. Naber, "Een terugblik," *Bijdrage van het Statistisch Instituut* 4 (1885): 1–48, cited by de Vries, *Dutch Rural Economy,* 50, who also gives (49–67) a detailed analysis from available evidence of peasant ownership of land in the United Provinces in the sixteenth century.

23. *Informacie up den staet Faculteyt ende Gelegentheyt van de Steden ende Dorpen van Hollant ende Vrieslant . . . gedaen in den jaere 1514,* comp. R. J. Fruin (Leiden, 1866), 293–94, 297, cited by de Vries, *Dutch Rural Economy,* 30. In fact the land quality varied enormously, even over short distances; thus the Italian chronicler Ludovico Guicciardini could also praise the fertility of Dutch land in his *Beschrijvinghe van alle de Nederlanden,* trans. Cornelis Kiliaan (Amsterdam, 1613), 9.

24. Kistemaker and Gelder, *Amsterdam,* 38.

25. Paul Limbourg and Jean Limbourg, "March": Jean Longnon, *The Très riches heures of Jean, Duke of Berry, Musée Condé, Chantilly,* trans. Victoria Benedict (New York, 1969), color illus. 4.

26. For an overview of the relationship of peasants to their land and to the nobility in the sixteenth century by region and village, see H. A. Enno van Gelder, "De Hollandse adel in de tijd van de opstand," *Tijdschrift voor Geschiedenis* 45 (1930): 113–50, esp. 130–31; see also his *Nederlandse dorpen in de 16e eeuw. Verhandelingen der Koninklijke Nederlandse Akademie van Wetenschappen, Afdeling Letterkunde,* n.s. 59 (1953), both cited by De Vries, *Dutch Rural Economy,* 25. Enno van Gelder describes seigneurial organization as being increasingly weak as one moved north in the Lowlands.

27. Longnon, *Très riches heures,* color illus. 9.

28. Roy Strong, *Gloriana: The Portraits of Queen Elizabeth I* (New York, 1987), 134–41; idem, *Portraits of Queen Elizabeth I* (Oxford, 1963), no. P72, who illus. the cartographic portrait of Queen Elizabeth no. E32. Bucius's map was reproduced more than ten times in the editions of S. Münster's *Cosmography* published between 1544 and 1600, in the *Itinerarium Sacrae Scripturae* by Heinrich Bünting, ca. 1580.

29. See discussion in Louis Marin, *Portrait of the King,* trans. M. Houle (Minneapolis, 1988), 169–79.

30. Geoffrey Parker, *The Dutch Revolt* (Ithaca, 1977), 146, 191, 197–98, 201, 205–7, 220–21, 225, 241–42.

31. This usage contrasts, for example, with "England," a term originally attached to a people, the Angles, describing the territory that the Angles inhabited. For a discussion of other Dutch place-names derived from land formations, see Lambert, *Making of the Dutch Landscape,* 51–52.

32. Sir William Temple, "An Essay upon the Original and Nature of Government, written in the year 1672," in *Works,* 2 vols. (London, 1740), 1:100. This

idiom contrasts with the English word "country," which originates in the concept "contra," with overtones of noncity, and "view"; see *Oxford English Dictionary* 2, "country."

33. J. W. Muller, "Vaderland en Moedertaal," *Tijdschrift voor Nederlandsche Taal- en Letterkunde* 47 (1928): 43–62, esp. 45.

34. Rubens: canvas, 198 × 297 cm., Christopher White, *Peter Paul Rubens, Man and Artist* (New Haven, 1987), color fig. 252; Van de Venne: Laurens J. Bol, *Adriaen Pietersz. van de Venne, Painter and Draughtsman* (Doornspijk, 1989), 41–42, color illus. fig. 27.

35. "Abraham van der Doort's Catalogue of the Collection of Charles I," ed. Oliver Millar, *Walpole Society* 37 (1960): 4.

36. Stechow, *Dutch Landscape Painting*, 24–25; Haak, *Golden Age*, 240; Sutton, *Dutch Landscape Painting*, no. 98, and p. 35, where he writes, "It is difficult to say what seventeenth-century viewers made of these dun-colored images of sandy tracks in the dune with peasants or goatherds lounging at the side of the road or before crudely thatched cottages."

37. Sutton, *Dutch Landscape Painting*, no. 98.

38. For a selection of paintings by these artists, see entries in Brown, *Dutch Landscape, the Early Years*; and Sutton, *Dutch Landscape Painting*.

39. For diagrams of these land formations and their locations, see Lambert, *Making of the Dutch Landscape*, figs. 33, 34, 36.

40. Published in Antwerp; illus. Günter Schilder, *Monumenta Cartographica Neerlandica*, 3 vols. (Alphen aan den Rijn, 1987), 2:113. On their size, see Kornelis ter Laan, *Van Goor's Aardrijkskundig Woordenboek van Nederland*, ed. A. G. C. Baert, 3d ed. (The Hague, 1968), 98.

41. Canvas, 103.8 × 146.2 cm., illus. Slive, *Jacob van Ruisdael*, no. 18.

42. While some attempts have been made to connect the rise of the "naturalistic" dune landscape with the national pride generated by the Twelve Year's Truce, I believe the connection with economic preoccupation with the land is of greater importance.

43. De Vries, "Dutch Rural Economy," 81; van der Woude, *Noorderkwartier*.

44. Kistemaker, and Gelder, *Amsterdam*, 17; see also J. Bouman, *Bedijking, opkomst, en bloei van de Beemster* (Amsterdam, 1857).

45. For a summary history of the draining throughout the region, see Lambert, *Making of the Dutch Landscape*, 212–20; and the excellent essays in *Het land van Holland. Ontwikkelingen in het Noord- en Zuidhollandse landschap*, exh. cat., special issue of *Holland* 10, no. 3 (June 1978).

46. The flatness of the resulting land is particularly evident in an aerial view of Waterland, a region just to the north of Haarlem and Amsterdam, and in the heart of this reclaimed area; see *Aerophoto Holland: Air-Views of Towns, Villages, and the Countryside* (1982), no. 10.

47. Noted by Denis E. Cosgrove, *Social Formation and Symbolic Landscape* (London, 1984), 152, who adds, "a fact for which we have no convincing explanation." Dutch landscape painting remains for him one of the few "naturalistic" renditions of the world (see below).

48. "Buyte Haerlem aen de wech naer Leyden. 1607": inv. no. 1902 A 4701-e; Schapelhouman and Schatborn, *Land and Water,* no. 5. Drawings were more frequently made out-of-doors and on the spot than paintings that were created in the studio; while not always the case, the former thus have a greater possibility of being closer to the artist's subject; see Stechow, *Dutch Landscape Painting,* 8; and Schapelhouman and Schatborn, *Land and Water,* viii–xi.

49. Salomon van Ruysdael's first dated painting of the theme was created in 1631; see Stechow, *Dutch Landscape Painting,* 34–35; and Stechow, *Salomon van Ruysdael,* 19. For van Goyen, see Hans-Ulrich Beck, *Jan van Goyen* (Amsterdam, 1972–73), 2 vols.

50. Esaias van de Velde's more fanciful *Ferry Boat* of 1622 (Amsterdam, Rijksmuseum) is frequently cited, among others, as an important precedent; see Stechow, *Dutch Landscape Painting,* 50–63. Van Ruysdael: inv. no. A 3983; compare Sutton, *Dutch Landscape Painting,* nos. 93, 94.

51. Jan de Vries, *Barges and Capitalism: Passenger Transportation in the Dutch Economy, 1632–1839* (Utrecht, 1981), 97–120.

52. De Vries, "Dutch Rural Economy," 82; idem, *Barges and Capitalism.*

53. Lambert, *Making of the Dutch Landscape,* 191–92. The most extensive study of the *trekschuit* is de Vries, *Barges and Capitalism;* see also the excellent summary in Kistemaker and Gelder, *Amsterdam,* 146–47.

54. De Vries, "Dutch Rural Economy," 82; examples of published schedules include Jan ten Hoorn, *Reisboek door Amsterdam* (Amsterdam, 1679); or idem, *Reisboek door de Vereenigde Nederlandsche Provinciën* (Amsterdam, eds. 1679, 1689, 1700).

55. De Vries, *Barges and Capitalism,* 24 n. 24, 233, 84–85.

56. Benjamin Silliman, *Journal of Travels in England, Holland, and Scotland,* 3 vols. (New Haven, 1820), 2:293, who continues, "For example Rotterdam to the Hague is four hours or twelve miles; from Amsterdam to Rotterdam is thirteen hours or thirty-nine miles, and this is the universal language of Holland."

57. De Vries, *Barges and Capitalism,* 26–34. Certainly horse-drawn barges were previously known, as shown in a drawing by Jacob de Gheyn II, *View of a Canal,* signed and dated 1598, Coll. Amsterdam, I. Q. van Regteren Altena, illus. in I. Q. van Regteren Altena, *Jacques de Gheyn: Three Generations* (The Hague, 1983), no. 941, pl. 62; see also A. T. van Deursen et al., *Jacques de Gheyn II drawings, 1565–1629,* exh. cat. (Rotterdam, Museum Boymans-van Beuningen, 1986), no. 90, illus.

58. See particularly Chong, "Market for Landscape Painting." In "The Influence of Economic Factors on Style," *De Zeventiende Eeuw* 6 (1990): 49–57, economist Michael Montias argues that the style of these paintings—monochrome in color and rapidly executed in broad brushstrokes—and their production in large numbers may have been driven by market forces; they are cost-efficient to produce and create readily recognizable products. Such pressure for speed is evident, for example, in the contract between Adriaen Delen and the artist Jan Porcellis that stipulated that the artist would produce forty seascapes in twenty weeks. See John Walsh, Jr., "The Dutch Marine Painters Jan and Julius Porcellis," *Burlington Magazine* 116 (1974): 653–62, 734–35, esp. 657. Speed is evident too

in the size of Jan van Goyen's oeuvre, whose total output in the most recent
catalogue raisonné numbers more than 1,200 paintings and 800 drawings; see
Beck, *Jan van Goyen*.

59. Canvas, 71.5 × 109.5 cm., signed and dated "VROOM 1615," Amsterdam
Historical Museum cat. 1975/1979, no. 496. De Vries, "Dutch Rural Economy,"
82, notes that the canal is a later addition to the painting. In an undated painting,
Vroom also depicted a river barge pulled by two men, illus. Stechow, *Dutch
Landscape Painting*, fig. 109.

60. Canvas, 170 × 438 cm., Beck, *Jan van Goyen*, vol. 2, no. 332, illus.

61. De Vries, *Barges and Capitalism*, 185, 192.

62. Egbert Haverkamp-Begemann and Alan Chong, "Dutch Landscape and
Its Associations," in *The Royal Picture Gallery, Mauritshuis*, ed. H. R. Hoetink
(Amsterdam, 1985), 57, assert without citation that contemporary Dutch texts
viewed agriculture as tied to a feudal system that had been cast off. As I noted
above, however, the Dutch never experienced the type of feudal system experi-
enced by the rest of Europe. Brown "Introduction," 29–30, citing De Vries,
Dutch Rural Economy, notes that at the same time a revolution in agrarian tech-
niques enabled Dutch farmers to be more efficient and productive than many of
their European contemporaries. For the revolution in agricultural techniques, see
B. H. Slicher van Bath, "The Rise of Intensive Husbandry in the Low Countries,"
in *Britain and the Netherlands*, ed. J. S. Bromley and E. H. Kossman (London,
1960); in any event, de Vries, "Dutch Rural Economy," 80, notes that agriculture
did not provide an important source of the nation's income.

63. I am indebted to Beatrijs Brenninkmeyer-de Rooij for this observation.
Examples of the former include Lieve Pietersz. Verschuier, *The Whaler, "Prince
William," on the River Maas, near Rotterdam*, canvas, 95 × 140 cm., private
collection; Hendrick Cornelisz. Vroom, *Return of the Second Dutch Expedition to
the East Indies*, canvas, 110 × 220 cm., Amsterdam, Rijksmuseum, inv. A2858;
both illus. in George Keyes et al., *Mirror of Empire: Dutch Marine Art of the
Seventeenth Century*, exh. cat. (Minneapolis Institute of Arts, 1990), nos. 44, 50.

64. Everdingen: canvas, 192 × 254.5 cm., inv. no. A1510, Alice I. Davies,
Allart van Everdingen (New York, 1978), 19–24, 191–200, no. 98, illus., who
notes that the location of the buildings is correctly represented but that the artist
has taken liberties with the landscape site; she adds (195) that Everdingen painted
at least four other pictures of the Swedish cannon industry. Schuylenburgh: canvas
203 × 316 cm., inv. no. A4282; both illus. Kistemaker and Gelder, *Amsterdam*,
118, 77.

65. Rosenberg, *Jacob van Ruisdael*, identified at least eighteen: nos. 38–40,
44, 47–50, 56, 58, 60, 62–63, 63a, 64–67. Of these, James D. Burke, "Ruisdael
and His Haarlempjes," *M. Quarterly Review of the Montreal Museum of Fine Arts*,
Summer 1974, 2–11, identified at least nine with certainty. Linda Stone-Ferrier,
"Views of Haarlem: A Reconsideration of Ruisdael and Rembrandt," *Art Bulletin*
67 (1985): 422, 429, suggests that these were painted in great numbers in Haar-
lem and not elsewhere. Linen was also bleached in Haarlem because the bleaching
industries in that city were unmatched either in quality or in production.

66. I am grateful to Charles Harrison for this suggestion.

67. Notably, images of individuals engaged in actual labor seem to have been reserved during the first half of the century for depictions in prints of the various urban "workhouses," or houses of correction; later in the century, "craft" in the domestic sphere was represented.

68. The cities' progressive economic subjection of the countryside culminated in 1531 when they persuaded Charles V to issue the *Order op de buitennering*, which forbade the new establishment of most industries in the countryside and forbade new bakeries and taverns within 2.26 kilometers of all city walls. See E. C. G. Brünner, *De order op de Buitennering van 1531* (Amsterdam, 1921); and de Vries, *Dutch Rural Economy*, 49.

69. The 1657 inventory of Amsterdam dealer Johannes de Renialme, which included paintings valued up to 500 guilders, listed paintings by Pieter Molijn and Jan van Goyen ranging in value from 12 to 40 gulden; see Abraham Bredius, *Künstler-Inventare: Urkunden zur Geschichte der holländischen Kunst des XVI., XVII., und XVIII. Jahrhunderts*, 8 vols. (1915–22), 1:228–38.

70. By the later half of the century such concepts were more fully articulated; see the political and economic tract by Leiden cloth manufacturer and tradesman Pieter de la Court, *Het interest van Holland ofte Gronden van Hollands Welvaren aangewezen door V.D.H.* (Amsterdam, 1662).

71. Cuyp: Stephen Reiss, *Albert Cuyp* (Boston, 1975), no. 83; Neil Maclaren, *The Dutch School, 1600–1900* (London, National Gallery, 1960), no. 961, pp. 86–88. The subject was enormously popular. For Cuyp's many views of the church, see Reiss, *Albert Cuyp*. Van Goyen painted it at least twenty-five times between 1633 and 1655, more than any other artist; see Beck, *Jan van Goyen*. Other artists who represented the site include A. Willaerts, G. Neyts, J. Peeters, and J. de Grave.

72. See Johan van Beverwijk, *'t Begin van Hollant in Dordrecht* (Dordrecht, 1640); Lambert, *Making of the Dutch Landscape*, 189; E. Haverkamp-Begemann, "Jan van Goyen in the Corcoran: Exemplars of Dutch Naturalism," in *The William A. Clark Collection*, exh. cat. (Washington D.C., Corcoran Museum, 1978), 51–59, esp. 55.

73. As can be seen from an aerial photograph in *Aerophoto Holland*, no. 90.

74. Peter Y. De Jong, ed., *Crisis in the Reformed Churches: Essays in Commemoration of the Great Synod of Dort, 1618–1619* (Grand Rapids, Mich., 1968); Thomas Scott, *The Articles of the Synod of Dort and Its Rejection of Errors* (London, 1818), esp. 1–100. Geeraert Brandt, *Historie der Reformatie*, 4 vols. (Amsterdam, 1677–1704), gives an extensive account of the synod.

75. De Vries, *Dutch Rural Economy*, 127–44, 166–68.

76. See Kaerle Stevens and Jan Libaut, *De veltbouw* (Amsterdam, 1622); and Wouter van Gouthoeven, *D'oude chronijcke end historien van Holland* (The Hague, 1636). Further examples appear in G. J. Hengeveld, *Het rundvee*, 2 vols. (Haarlem, 1865–70), cited by Chong, "Market for Landscape Painting," no. 21.

77. Such paintings include an English satire ca. 1585, *The milch cow: Satire on the exploitation of the Netherlands by the prince of Orange* (Amsterdam, Rijksmuseum, inv. A2684), and the contemporary *Queen Elizabeth Feeding the Cow of the Netherlands*, illus. Roy C. Strong, *Portraits of Queen Elizabeth I* (Oxford, 1963),

no. addenda 9, illus. See van de Waal, *Drie eeuwen*, 1:21–22; Haverkamp-Begemann and Chong, "Dutch Landscape," 63–64, 67; Chong "Market for Landscape Painting," no. 21; Amy Walsh, "Imagery and Style in the Paintings of Paulus Potter (Ph.D. diss., Columbia University, 1985), esp. Chap. 8.

78. See Pieter Quast's allegory of Holland as a bull kicking off Spanish rule, dated 16[41?], black chalk and gray wash on vellum, Sacramento, Crocker Art Gallery, inv. no. 578, cited in Haverkamp-Begemann and Chong, "Dutch Landscape," 67 n. 32. Van de Waal, *Drie eeuwen* 1:22, also cites a play by Samuel Coster on the treaty, "Verklaringh van de ses eerste vertoningen, gedaen binnen Amsterdam . . . 5 Junij 1648," in which he makes the association, "Ruling States of Holland, like the hundred eyed Argus," must not sleep but watchfully guard "the cow (that is her own agreeable Fatherland)." For an extensive discussion of the cow and steer in Dutch painting, see essays by Sjraar van Heugten and Alan Chong in *Meesterlijk Vee. Nederlandse veeschilders, 1600–1900,* exh. cat. (Zwolle, 1988).

79. "Ghy Heeren wachters wel neerstelyck toesiet, Dat Ons gerooft werd' de Hollandse koe neit," Hendrick Hondius II, *"Holland's Prosperity,"* 1644, engraving, one of a series of six landscape subjects, F. W. H. Hollstein, *Dutch and Flemish Etchings, Engravings, and Woodcuts, ca. 1450–1700* (Amsterdam, 1949–78), 9:92, no. 12; van de Waal, *Drie eeuwen*, 1:21–22, illus. vol 2, pl. 4-1.

80. Associations of civic pride with the portrayal of historically important cities, particularly during politically crucial times, have been recognized for some time; see Haverkamp-Begemann and Chong, "Dutch Landscape," 57; Brown, "Introduction," 28; Sutton, "Introduction," in his *Dutch Landscape Painting*, 2, 38. To my knowledge, the association of the church at Dordrecht with the negotiations with the treaty with Spain have not been made in the literature.

81. Cuyp's painting also resonates with a long-standing tradition of georgic imagery that includes Titian's well-known woodcut *Landscape with Milkmaid*, ca. 1520–25, which provided motifs for the work of numerous northern artists, including Rubens and Van Dyck. Its golden light, a characteristic of a generation of Dutch artists known as the Italianates influenced by the work of Claude Lorrain, provide an additional note of prestige and historical importance to the scene. Chong, "Market for Landscape Painting," no. 21, discusses other possible associations with the cow that the viewer may have made; none of these are to my mind as pressing as the political message of the work.

82. John Walsh, Jr., and Cynthia P. Schneider, *A Mirror of Nature: Dutch Paintings from the Collection of Mr. and Mrs. Edward William Carter*, exh. cat. (Los Angeles County Museum of Art, 1982), no. 11. Haverkamp-Begemann, "Jan van Goyen," 55, discusses how van Goyen's views of Rhenen and of Dordrecht represent some monuments accurately but in particular depict the surrounding countryside as wilder and rougher than it is in actuality.

83. Beck, *Jan van Goyen*, vol. 2, no. 693. The subject of this painting was first identified in Ann Jensen Adams, *Dutch and Flemish Paintings from New York Private Collections*, exh. cat. (New York, National Academy of Design, 1988), no. 21.

84. Including a painting now in Prague, dating from two years later (photo

Rijksbureau voor Kunsthistorische Documentatie). A similar choir appears in a Gothic church in reverse in a painting in a private collection in Cologne (Beck, *Jan van Goyen*, vol. 2, no. 190). Van Goyen sketched a number of Gothic churches from this angle, including ibid., vol. 1, nos. 247, 550, 576, 819, and 847–48; the last cited shows a similar city wall.

85. In his *Kabinet van Nederlansche Outheden en Gezichten*, 2 vols. (Amsterdam, 1725), Abraham Rademaker illustrates many other such churches.

86. Wolfgang Stechow, "Die Pellekussenpoort bei Utrecht auf Bildern von J. van Goyen und S. van Ruysdael," *Oud Holland* 55 (1938): 202–8, with numerous examples. Salomon van Ruysdael's paintings of the tower include that in the Museum Boymans-van Beuningen, Rotterdam, cat. 1962, no. 1761, cat. 1972, illus. p. 55; Stechow, *Salomon van Ruysdael*, no. 489. With various modifications Van Goyen placed the city gate in a number of paintings, including one now in Minneapolis dated 1648, Beck, vol. 2, no. 693; others include nos. 74, 639, 640, 760, 762, 765, and 788. The tower appeared in a ruined state in a painting of 1644, no. 659.

87. See also Rademaker, *Kabinet*, vol. 2, pl. CXXIV.

88. H. A. van Gelder, *Getemperde vrijheid. Een verhandeling over der verhouding van kerk en staat in de Republiek der Vereigde Nederlanden en de vrijheid van meinsuiting in zake godsdienst, drukpers en onderwijs gedurende de 17de eeuw* (Groningen, 1972). This is not to say that nostalgic and pastoral associations were not made with some landscapes; see the extensive discussion by Freedberg, *Dutch Landscape Prints*, 1–20.

89. Ivo Schöffer, "Geloof en kerken," in *De Lage Landen van 1500 tot 1780*, ed. Ivo Schöffer, H. van der Wee, and J. A. Bornewasser (Amsterdam, 1978), 212; see also the discussion of the history and situation of the various Catholic communities in the state by Jan Wagenaar, *Amsterdam in zyne opkomst, aanwas, geschiedenissen, voorregten, koophandel, gebouwen, kerkenstaat, schoolen, schutterye, gilden, en regeeringe*, 4 vols. (Amsterdam, 1760–88), 3:207–18.

90. For a good analysis of the fragmented nature of Dutch society at the time of the revolution against Spain, see James D. Tracy, *Holland under Habsburg Rule, 1506–1566: The Formation of a Body Politic* (Berkeley, Calif., 1990).

91. For a similar process in the English eighteenth-century, see Ann Bermingham, *Landscape and Ideology: The English Rustic Tradition, 1740–1860* (Berkeley, Calif., 1986).

92. Cosgrove, *Social Formation*, 15, and chap. 2.

93. Ibid., 153.

THREE

ANN BERMINGHAM

System, Order, and Abstraction

The Politics of English

Landscape Drawing around 1795

Upon reaching the summit of Beechen Cliff, Henry Tilney proceeded to instruct Catherine Morland in the rules of picturesque beauty. "He talked of fore-grounds, distances, and second distances—side-screens and perspectives—lights and shades . . . and by an easy transition from a piece of rock fragment and the withered oak which he placed near its summit, to oaks in general, to forests, the inclosure of them, waste lands, crown lands and government, he shortly found himself arrived at politics; and from politics, it was an easy step to silence."[1] In a landscape where all the signs of picturesque nature lead to politics, politics leads to silence. Henry's description of the scenery around Bath serves to underscore the fact that in eighteenth-century Britain, landscape—even the picturesque landscape—was a mode of political discourse. What is therefore striking about the description is not the inevitable linking of landscape with politics but the silence that follows their connection, which the text also assumes to be inevitable. Jane Austen began writing *Northanger Abbey* in 1797, when anti-Jacobin paranoia was at its height in Britain. Political silence was legislated by Parliament, watched over by government spies, and enforced by the courts. The suppression of radical tracts like Tom Paine's *Rights of Man* and the activities of the corresponding societies through such legal means as the passage of the Treason and Sedition Acts and the suspension of habeas corpus was justified on the grounds that radicalism was a threat to the natural order of civil society.

For the anti-Jacobin Whigs and Tories of the 1790s, the great fallacy of the French Revolution was its attempt to govern people according to abstract principles rather than according to their "natural" habits, in-

stincts, and limitations. Burke put it most simply in his *Reflections on the Revolution in France* (1790) when he wrote: "The science of constructing a commonwealth is not to be taught *a priori*. . . . The nature of man is intricate; the objects of society are of the greatest possible complexity: and therefore no simple disposition or direction of power can be suitable either to man's nature, or to the quality of his affairs."[2] Burke's bias against government by a priori formula and the simple disposition of power was echoed in popular conservative newspapers such as the *Anti-Jacobin or Weekly Examiner,* edited by William Gifford. Writing in 1799, Gifford said, "We have only to trace the progress of French Principles from their first promulgation to the present time. . . . If we have the patience to execute this task, we shall find that these principles rested at first (even in the most plausible view which was given them) on a new theory of government—false visionary, and impracticable; inconsistent with the very nature of man, and with the frame of civil society."[3]

To the minds of men like Burke and Gifford, English government was not based on abstractions but on human nature itself, which in turn was understood to be organic and multidimensional; thus its workings could not be grasped or contained within a single idea or representation. The British Constitution was seen by them as having evolved over the centuries into a body of civil laws, rights, and duties that had been tempered by time, custom, and practical application. Moreover, it was an unwritten constitution, a loose, contractual arrangement of laws and precedents that upheld the political system by the consent of the governed. By contrast, *The Declaration of the Rights of Man* was a fabrication of the moment, a document held to be, as one correspondent to the *Anti-Jacobin* claimed, "the most absurd, the most contradictory, and the most impracticable form of Government which was ever created by 'human wisdom and integrity'; or, what is nearer the truth, the folly or madness of men."[4]

I would like to propose that such attitudes toward abstraction and order had meaning for artistic representation. Embodied in the picturesque landscape aesthetic, they restructured landscape design and the procedures and techniques of landscape drawing. As popular pastimes, gardening and drawing helped to normalize a series of attitudes and values by inscribing them within certain representational operations. They functioned as mediums through which social dispositions toward order, power, and meaning found expression in techniques for rendering nature. In short, landscape gardening and drawing were not ideologically neutral *technē*; rather, in their spatial strategies of composition and perspective, for instance, or, in the case of drawing, instructions as to how to delineate certain objects in a landscape, they actively inscribed or became the sites of specific ideological attitudes and ambivalencies.

I

The change can be summarized in a comparison of John Robert Cozens's watercolor drawing *The Lake Albano and the Castle Gandolfo* (ca. 1779; see fig. 3.1) with Thomas Hearn's drawing *Oak Trees* (ca. 1786; see fig. 3.2). In the Cozens drawing, the placement of the tree in the foreground serves the total effect of the landscape; as a *repoussoir* figure, it frames the distance, sets the scale, and establishes a diagonal direction for the composition. Its isolation makes it a poetic object, and we read the landscape in terms of its singular situation. Set alone in a landscape to which it nevertheless belongs, it suggests humanity's own isolation in nature, a suggestion that is reinforced by the presence of the solitary shepherd with his flock. Thus in Cozens's drawing the mood created by the depiction of natural objects such as trees, rocks, and even staffage is ultimately dependent on the overall spatial configuration of the landscape.

By contrast, Hearn's oak trees are the landscape and are not subservient to some predetermined compositional structure. Unlike Cozens's grand and generalized silhouette, they are a collection of internal details that are carefully, almost obsessively, delineated. Unlike Cozens's tree, Hearn's oaks do not appeal so much to imagination as to sensation. Whereas in Cozens's landscape the incidental figurative elements (the trees, shepherd, castle, etc.) all emphasize the vastness of the space, in Hearn's drawing they problematize the space of the landscape. For instance, the placement of the flock of sheep behind the oaks does not indicate how near or far they are from the trees; as a result, the trees alternate between appearing simply large and gigantic. Our eyes travel through the rich interiors of their convoluted and broken forms rather then through an extensive landscape space. The experience of vastness is thus internalized and contained by the oak trees rather than extended over the landscape as in Cozens's drawing. In Cozens's watercolor, landscape exists as a preconceived spatial organization of receding planes, whereas in Hearn's drawing it is a collection of heroically individualized objects that appear to create their own spatial order.

This change in landscape design can be connected to a reform of the picturesque taste at the end of the eighteenth century that is most often discussed in terms of the attacks by two amateur gardeners, Uvedale Price and Richard Payne Knight, on what they believed to be the vulgar garden designs of Lancelot ("Capability") Brown and his follower Humphrey Repton.[5] In the writings of Price and Knight, which extended over a period from 1794, the date of Price's *Essay on the Picturesque* and Knight's didactic poem *The Landscape,* to 1805, the date of Knight's *Analytical Inquiry into the Principles of Taste,* the picturesque was redefined so that it

3.1 John Robert Cozens, *The Lake of Albano and Castel Gandolfo* (ca. 1779). Watercolor over pencil on wove paper, 44.5 × 64.2 cm. Courtesy the Paul Mellon Collection, the Yale Center for British Art.

referred less and less to the Claudian prospects and panoramas of the Brownian garden and came in time to stand for their antithesis, that is, the smaller-scaled, less obviously designed picturesque garden, which consisted of a variety of intimate occluded views in which nature appeared in its rough, shaggy, and even humble aspects. Their objection to Brown's garden designs was that they did not take into account nature's variety and the individual features of the site. "I own it does surprise me," Price wrote, "that in an age and in a country where the arts are so highly cultivated, one single plan, and such a plan, should have been so generally adopted; and that even the love of peculiarity should not sometimes have checked this method of levelling all distinctions, of making all places alike; all equally tame and insipid."[6]

The difference between the Brownian garden and reformed picturesque garden was illustrated by Hearn for Knight's poem *The Landscape*. The Brownian garden (see fig. 3.3) is depicted as a softly undulating landscape

3.2 Thomas Hearn, *Oak Trees* (ca. 1786). Pen, brown ink, and watercolor, 506 × 343 cm. © The British Museum.

3.3 Thomas Hearn, *A Brownian Landscape Garden*, from Richard Payne Knight, *The Landscape* (London, 1795). Soft-ground etching.

with smooth-shaven lawns. A gently serpentined stream is arched by two "Chinese" bridges, and trees planted in neatly barbered groves frame the Palladian house in the distance. By contrast, the picturesque garden (see fig. 3.4) is a wildly overgrown and derelict version of the former. The ground heaves and breaks, the stream is choked with weeds and fallen trees, and over it has been flung a rough-hewn rustic bridge. Trees and shrubs grow in junglelike profusion and encroach on the newly gothicized house. The spatial effect of all this picturesqueness is to minimize the open expansiveness of the former design and to substitute for its broad horizontality a narrowly focused view that emphasizes the natural incidents of ferns, rocks, and mossy banks in the foreground rather than the distant view of the house.

The point of the picturesque aesthetic was not simply to build new gardens in this "style" but rather to preserve old gardens that were already picturesque. In his *Essay* Price, a conservative Whig landowner, confessed that his motive in promoting this taste had to do with his own regret for having destroyed the old garden at his father's estate, Foxley.

I destroyed it . . . it was a sacrifice I made against my own sensations, to the prevailing opinion. I doomed it and all its embellishments, with which I had

3.4 Thomas Hearn, *A Picturesque Landscape Garden,* from Richard Payne Knight, *The Landscape* (London, 1795). Soft-ground etching.

formed such an early connection, to sudden and total destruction; probably much upon the same idea, as many a man careless, unreflecting, unfeeling good-nature, thought it his duty to vote for demolishing towns, provinces, and their inhabitants, in America: like me (but how different the scale and interest!) they chose to admit it as a principle, that what ever obstructed the prevailing *system,* must be all thrown down, all laid prostrate; no medium, no conciliatory methods were to be tried, but whatever might follow, destruction must precede.[7]

Clearly systematic forms of gardening or government were distasteful, and the connection in Price's mind between the two is a good example of the way in which landscape design functioned as a political metaphor. The practice of Brown and his followers to clear prospects so as to open views and vistas within the garden to the landscape outside it was seen by Price as equivalent to the leveling tendencies of democratic governments and revolutions. Remarking on such distasteful formulations of liberty and their encoding in garden design, he notes, "It has been justly observed, that the love of seclusion and safety is not less natural to man, than that of liberty; and our ancestors have left strong proofs of the truth of that observation."[8]

Such a reaction against the prospect landscape is remarkable, given the

fact that in the early eighteenth century its measured architectonic spaces with their panoptic overtones had served as a basis from which a cultural discourse of liberty, one associated specifically with Whig liberty, had emerged. As early as 1712 the prospect had been designated by Joseph Addison in the *Spectator* as one of the "Pleasures of the Imagination." Addison wrote: "A spacious Horizon is an Image of Liberty, where the Eye has Room to range abroad, to expatiate at large on the Immensity of its Views, and to lose it self amidst the Variety of objects that offer themselves to its Observation. Such wide and undetermined Prospects are as pleasing to the Fancy, as the Speculations of Eternity or Infinitude are to the Understanding."[9] Liberty is precisely the liberty of the beholder's eye to "range abroad" to command a view of the landscape, to subject it to one's vision and imagination. Thus the viewer's experience of nature's expansiveness is in fact an experience of subjecting this expansiveness to visual control. In the evocative spaces of Cozens's watercolor, the thematic opposition between the emancipated and emancipating religion of nature and the immured and immuring one of the popes' is secondary to the beholder's superior viewpoint, which suggests that even nature's liberty is no match for the artist's liberated eye.

Closely tied to this formulation of liberty as panoptic control is Addison's association of the prospect with certain mental faculties. As a means of visual stimulation to the imagination, the prospect becomes equivalent to philosophical speculation. Accordingly the imagination cannot be exercised except when, by following the eye, it can "expatiate at large." In artistic theory, the prospect, as exemplified by the gardens of Brown or the paintings of Claude, could aspire to what Reynolds deemed the "great style" because it literally rose above the individual features of a specific view in order to embrace the general effect. As John Barrell has observed, men who could not abstract general principles from particular objects or events, or in the case of painting, artists who could not create a generalized depiction of nature from its various accidents and deformities, were deemed inferior because they were incapable of abstract reasoning.[10] This inferiority had a social cast insofar as it was assumed that only men removed from the wants of everyday life—through property and education—could take a rationally detached view of the world. The prospect therefore as the sign of liberty, "fancy," and abstract reason embodied not only an aesthetic point of view but a social and gendered one as well.

Addison's pleasure at the immensity of the view and the variety of objects contained within it also implies a particularly urban image of economic abundance. The vastness of nature suggests the freedom of the imagination guided by the eye to *take up* residence in the "wide and undetermined" prospect, without ever having to *take on* the responsibili-

ties of owning and maintaining it. For men of reason and imagination, the prospect becomes a spectacle providing viewers with an experience of domination and possession that transcended simple economy. More important, for literate, urban, middle-class Whigs like Addison, it was an aesthetic that subtly challenged the ancient, and conspicuously rural Tory, right to govern through landed wealth alone.[11]

If the Whigs of Addison's generation recognized that institutionalizing a discourse of freedom and imagination in the landscape garden went along with legitimizing a new form of economic power, the anti-Jacobin Whigs and Tories of the 1790s understood that reformulating that discourse was now a necessary step to maintaining that power. In remarking on the history of gardening in England, Price notes that both gardening and parliamentary politics were institutionalized by William of Orange in 1688. He goes on to say,

> But the revolution in taste differed very essentially from that in politics, and the difference between them bears a most exact relation to the character of their immediate authors. That in politics, has the steady, considerate, and connected arrangement of enlightened minds; equally free from blind prejudice for antiquity, and rage for novelty; neither fond of destroying old, nor creating new systems. The revolution in taste is stamped with the character of all those, which either in religion or politics have been carried into execution by the lower, and less enlightened part of mankind.[12]

Price's disgust with the revolution in taste exemplified by the Brownian garden's "levelling of all distinctions" must be seen as overdetermined by political events in France. Key to reforming the revolution in taste, if not politics, would be a new landscape aesthetic, one that in encoding liberty would now valorize age, custom, individuality, variety, and rank. "A good landscape," Price claimed, "is that in which all the parts are free and unconstrained, but in which, though some are prominent and highly illuminated, and others in shade and retirement, some rough, and others more smooth and polished, yet they are all necessary to the beauty, energy, effect, and harmony of the whole. I do not see how good government can be more exactly defined."[13] Against the leveling tendencies of the French Revolution, individual variety in the landscape came to stand for British liberty, a freedom presumably for the rich to be rich and the poor to be poor.

In a similar spirit of redefining liberty in terms of the picturesque landscape, Knight in his poem *The Landscape* describes the overgrown picturesque garden as a place "where every shaggy shrub and spreading tree / Proclaim'd the seat of native Liberty."[14] Knight ended his poem, which he had composed in September 1793, with a meditation on the

French Revolution ("What heart so savage, but must now deplore / The tides of blood that flow on Gallia's shore!")[15] and on the unhappy condition of the imprisoned queen ("She counts the moments, till the rabble's hate / Shall drag their victim to her welcome fate!").[16] Seen in the context of the 1790s, the picturesque aesthetic was intended to preserve more than just old gardens. The picturesque garden with its variety, individuality, and antiquity was comparable to the British Constitution's slow and natural evolution as opposed to the Brownian garden or the violent imposition of the abstract principles in the *Rights of Man*. The prospect landscape therefore became a sign if not of French principles then at least of their consequences. It is worth recalling that Henry Tilney's silence comes after a train of Addisonian economic associations provoked by the prospect from Beechem Cliff—"forests, the inclosure of them, waste lands, crown lands and government." His arrival at politics was therefore the inevitable result of a departure from a vantage point that was no longer secure. The silence that fell was not only an "easy step" but an inevitable and necessary one that as the decade drew to a close was to lead to a more covert and coercive kind of politics, the politics of silence.

II

It is in this context of the reform of the picturesque landscape aesthetic that we may place the growing hostility voiced in guidebooks and amateur drawing manuals to the landscape sketching style of the original popularizer of the picturesque taste, the Reverend William Gilpin. Gilpin's tours to various parts of Britain, published between 1782 and 1802, sensitized a large audience to the beauties of native, British scenery. They did this by teaching the picturesque tourist how to look at the natural landscape as an ordered, coherent pictorial whole rather than as a chaotic collection of bits and pieces. Gilpin proposed that one study real landscapes as if they were paintings and use the rules of art to compare and judge their aesthetic merits. "Picturesque Beauty," he defined as, "that peculiar kind of beauty, which is agreeable in a picture."[17] What Gilpin defined as "picturesque" was in effect a model of the older prospect landscape. Typically Gilpin's picturesque viewing entailed the imaginative organization of landscape scenery into a foreground, distance, and second distance, a system that followed a simple tripartite compositional recipe that he derived from the study of Claude Lorraine, Gaspar Dughet, and Salvatore Rosa and that any amateur, such as Henry Tilney, might use to transform any view into a picturesque view.

An early reviewer of his *Three Essays on Picturesque Beauty* remarked that no doubt the "ordinary reader . . . was offended to be told, that his

3.5 William Gilpin, from *Observations on the River Wye, and several parts of South Wales, &c. relative chiefly to Picturesque Beauty; made in the summer of the year 1770* (London, 1782). Watercolor over aquatint.

views were misdirected and his sensations of nature's beauty false and ill founded, that he must not judge of beauty till he is grown scientific, and has formed his acquired taste by artificial rules."[18] Nevertheless, as time was to show, many readers were only too glad to become scientific and to view landscape according to Gilpin's artificial rules. Writing to Hannah More in 1789, Horace Walpole reported, "I have been an arrant stroller; amusing myself by sailing down the beautiful Wye, looking at abbey's and castles, with Mr. Gilpin in my hand to teach me to criticise, and talk of foregrounds, and distances, and perspectives, and prominences, with all the cant of connoisseurship."[19] To enable viewers to visualize his descriptions of landscape Gilpin illustrated his tours with aquatinted landscapes (see fig. 3.5), which, like Cozens's view of Lake Albano, were prospect landscapes conceived in terms of a graduated, progressive unfolding of space, and which were intended to bring out the most picturesque aspects of the view.

Unlike the tours, which were enormously popular, Gilpin's picturesque illustrations were generally disliked. Readers, for instance, of the Wye tour complained that when they visited the scenes he described, they

found nothing in the real landscape that corresponded to the illustrations. Another tour guide writer, a land surveyor named James Clark, complained, "Whoever examines those 'abortive nothings,' which Mr. Gilpin calls Landscapes, will hardly be able to trace one view, how well soever he may be acquainted with it: for my own part, they put me in mind of nothing so much as those landscapes and figures which boys fancy they see in the sky at sun-set, or in fire on a frosty evening."[20] In his lectures on engraving (1807), John Landseer warned students of printmaking away from Gilpin's "aquatinted smearings," which he saw as "tarnished with false principles of Art."[21]

The most thorough criticism of Gilpin's drawing style, however, came from drawing master William Marshall Craig. In 1793, Craig published a drawing manual for amateurs called *An Essay on the Study of Nature in Drawing*. In it he linked Gilpin's sketchy style and his formulaic compositions to his perverse indifference to visual fact. Arguing that the "object of the pencil is to imitate nature"[22] and that "no person can make a slight drawing well, that has not previously, been accustomed to make finished drawings,"[23] Craig criticized Gilpin's method as a "disease of the pencil" that "has spread, unresisted, its noxious influences."[24] His criticism of Gilpin touches the same theme that Price had used to condemn Brown's garden designs, namely, a neglect of individuality. "What shall we say," Craig asked, "or how shall we express our gratitude, to one who, having travelled over the whole of an extensive and beautiful kingdom to observe Nature, liberally advises his readers to reject all attempts at a characteristic resemblance of the objects they undertake to deliniate?"[25]

Craig's own recommendations stressed the importance of beginning a landscape drawing with the foreground and then placing objects there that "may conduce to the future composition of the landscape."[26] This method of working from the foreground back into the space of the landscape tended to emphasize the individual features and incidental details of a landscape. Such a landscape, as Hearn's illustration of the picturesque garden makes clear, depends on these details for its compositional structure. It is worth noting that while generally praising Gilpin's work, Uvedale Price faulted Gilpin for not "using painting as more of a model" and neglecting the landscape details such as the "disposition of water, architecture, shapes of animals and birds."[27] For his part, Gilpin treated the foreground as an afterthought. "The foreground," he wrote, "is commonly but an appendage. The middle distance generally makes the scene, and requires the most distinction."[28] In contrast to Craig's insistence on the careful delineation of objects, Gilpin wrote, "We always conceive the detail to be the inferior part of a picture. We look with more pleasure at a landscape well designed, composed, and enlightened."[29]

While obviously offended by Gilpin's cavalier compositional improvements of landscape, his advice to "add altitude to mountains, to manufacture trees and foregrounds where necessary, and even to turn the course of rivers," Craig nevertheless reserved his harshest criticisms for Gilpin's recommendation to "represent only general nature and not her individual features."[30] Moreover, Craig enlarged the scope of his attack to include the theories of Sir Joshua Reynolds. Referring to both Gilpin and Reynolds, Craig wrote, "It appears a matter of some difficulty to ascertain what is meant by general nature, and, consequently, how it is to be imitated. Were it proposed to select, from various individualities of a species, those parts which might be esteemed the best, and thus give a perfect example of their kind, we should commend the method: but this is not general representation—it is a collection of individualities."[31] In contrast to Craig, Gilpin, like Reynolds, held that "Nature should be copied, as an author should be translated. If, like Horace's translator you give word for word, your work will necessarily be insipid. But if you catch the meaning of your author, and give it freely, in the idiom of the language into which you translate, your translation may have both the spirit, and truth of the original. . . . Nature has an idiom, as well as language; and so has painting."[32] Such remarks adhere to the older tradition of the *Discourses* of seeing art as an exercise in abstract reasoning. Craig's attack on generalizing and his insistence on individuality is an attack not only on Gilpin's version of the picturesque but on Reynolds's "great style" as well.

Craig's emphasis on nature's individualities explains his own recommendations to the amateur. Unlike Gilpin, Craig believed that the sketcher's attention should be fixed not on composition but on notation. He accompanied his critique with an illustration (see fig. 3.6) satirizing Gilpin's style of drawing and what he saw as Gilpin's tendency to reduce real matter to a system of abstract signs. "Amongst many practitioners in drawing," Craig wrote, "a certain set of signs has become employed, as by agreement, to represent, or signify, certain objects in nature, to which they have intrinsically little or no resemblance. This is, doubtless, the general imitation so much talked of, and general it certainly is, for . . . these signs are as much like one thing as another."[33] In contrast to Gilpin's "manner of drawing signs," Craig believed, "every different subject or material should be expressed by a different line or touch, which Nature will always point out, if attended to."[34] His study of a willow (see fig. 3.7) is an example of what he called "characteristic representation." Unlike Gilpin, Craig clearly desired there to be a resemblance between the visual sign and the referent, as opposed to an abstract and arbitrary relationship. Accordingly, the signifier (the mark of the pencil on the paper) should ideally be a transparent transcription of the referent (the

3.6 William Marshall Craig, *Plate II*, from *An Essay on the Study of Nature in Drawing* (London, 1793). Soft-ground etching.

3.7 William Marshall Craig, *Plate IV*, from *An Essay on the Study of Nature in Drawing* (London, 1793). Soft-ground etching.

3.8 William Gilpin, *A Waterfall* (ca. 1790). Pen and ink, with wash and bodycolor, 160 × 242 cm. Private collection.

motif). What Craig envisioned was a natural sign, that is, a visual sign that maintains a highly legible and transparent correspondence to the thing it represents. Unlike Gilpin's arbitrary signs, which were open to interpretation and rhetorical applications, Craig's literal, natural sign would be impervious to manipulation, change, and misunderstanding because it would be locked in a mirrorlike relationship to the thing it represented. Gilpin saw Craig's style of drawing to be the enemy of imagination and called artists like him "literalists."

The difference between Gilpin's and Craig's attitudes toward the visual sign is further manifested in their choice of drawing and reproduction media. Gilpin chose aquatint so that his illustrations would approximate the look of his hastily brushed ink drawings. Craig used soft-ground etching, a medium that directly transferred a pencil drawing onto a plate that was then etched. In Gilpin's wash drawing *Waterfall* (see fig. 3.8) from about 1785–89, the individual strokes of the brush are obliterated as they become incorporated into large areas of wash; the few strokes that are visible are limited to the details of the landscape, where they function as calligraphic touches enlivening certain objects—in this case the trees. Gilpin's strokes remind us of the presence of the artist, of the artist's direct response and imaginative appropriation of the landscape. Craig, by

contrast, alters the length, width, and property of each pencil stroke according to the variety of the individual textures and forms of the object (see fig. 3.9), while at the same time he systematizes these different touches into a kind of grammar. Given his interest in naturalistic depiction of detail, there is less subordination of these parts to the larger compositional schemata than in Gilpin. In this landscape from his *Essay* the eye moves from a foreground full of contrasting variety of detail directly into an indistinct distance, encountering along the way none of the self-conscious calligraphic reminders of artistic sensibility that give an emotional inflection to Gilpin's landscapes. The inflection Craig produces is perceptual, one attentive to the look and feel of each object, no matter how lowly; his style of drawing emphasizes the range of nature's individual variety rather than the creative mind of the artist.

The differences between Craig and Gilpin may be summarized as a series of oppositions: that of an analytic, additive method of composition as opposed to a formulaic synthesis; a realistic description as opposed to a generalized translation; and a closed system of signification as opposed to an open one—in short, as an opposition between realism and abstraction. The same dialectic, I believe, was restaged elsewhere as an opposition between nature and French principles, between the true order of civil society and an artificially false one.

III

At the same time that Craig was attacking Gilpin's style of drawing, anti-Jacobin Whigs and Tories were protesting the appropriation and transformation of traditional political discourse by radical elements. Works like *Pigott's Political Dictionary,* published in 1795 before the passage of the Treason and Sedition Acts and suppressed after them, provided radical political interpretations for such common words as the following:

Abuse—the different governments of Europe; privileged orders, church establishments. . . .

Alarm—the tocsin [*sic*] of delusion; plunging Englishmen into all calamities of war, under the falsest pretence of their liberties and properties being endangered, to cover the real designs of hatred, jealousy, despotism, and revenge. A pretext for prosecutions, unconstitutional augmentation of the army, the introduction of foreign troops, barracks, &c. &c. &c. . . .

Aristocrate—a fool, or scoundrel; generally both; a monster of rapacity, and an enemy to mankind. . . .

Rights—those claims which belong to us by nature and justice. They are quite obsolete and unknown here. It has, indeed, been a subject of dispute among learned political antiquarians, whether such things ever existed in this land. . . ."[35]

3.9 William Marshall Craig, *Plate VII*, from *An Essay on the Study of Nature in Drawing* (London, 1793). Soft-ground etching.

The mutability of the verbal sign and the distortion of fact it occasioned were precisely what Gifford's newspaper, the *Anti-Jacobin,* set out to police. Gifford established his weekly in 1798 in order to monitor the regular press by illuminating and refuting their errors. To do so he ran regular columns with the headings "Foreign Intelligence," "Intelligence," "Mistakes," "Misrepresentations," and "Lies," in which he printed news excerpts from papers like the *Morning Chronicle* or the *Morning Post* and corrections based on the "facts" he had gathered. Most often the correction involved clarifying—through a process of verbal definition—the true meaning of a speech in Parliament or a report from the war zone. While liberal in their political sympathies the papers Gifford chose to review were already heavily censored by the government, hence his close attention to their reports indicates the level of his paranoia.

In addition to his corrections of the press, Gifford published letters and poems by readers and subscribers that he felt summed up the present disturbing state of affairs. One such letter published on 26 March 1798, signed "A Sucking Whig," addressed a favorite anti-Jacobin topic, the division within the Whig party between the conservative Pittites and the liberal Foxites:

What is it to be a Whig? Is a man born a Whig, or is he made a Whig? and by what process?

Is he once a Whig, a Whig forever?

Does it go in Families?

Can it be in abeyance?—or lost?—or surrendered?—or forfited?

Can a Whig be divested of the name by other Whigs who are more numerous or better united, and give the ton? . . .

Is every Whig a *Republican* at heart?—Is he, or can he be a *Royalist*? Upon the analogies of contrast, as a Tory must be a zealot in belief, or in other words a High Priest, is it necessary for a Whig to be an Atheist or Freethinker at least? . . .

These are critical questions. . . . I would have the answers, like the explanatory words in Johnson's Dictionary, full as hard of solution as the words be explained.[36]

Clearly the presence of men like Fox, Grey, and Sheridan in the party of Pitt only went to show how unstable and meaningless political terms and designations had become.

For their part too, radicals like Pigott and Paine acknowledged the unstable state of political terminology and discourse, but for the most part they used the arbitrary relationship between the verbal signifier and signified in order to reappropriate political language by undercutting what they saw as anti-Jacobin rhetorical mystification. Pigott's *Dictionary,* for instance, turned on the mutability of verbal meanings and the idea that language could be a source of both political liberation and oppression.

For instance, under the word "association," a key word in the 1790s, we find this definition:

> The meaning of this word has lately undergone a *revolution*. In former times it was deemed legal for Englishmen to associate, for the purpose of discussing political principles and their own rights. Such meetings were once held constitutional and meritorious; Pitt, the Duke of Richmond, and other *Friends of the people,* were chief supporters of them. Now, the government deems them unconstitutional and *seditious,* and the associators stand a good chance of being confined four years in Newgate, or, if in Scotland, of being loaded with *irons,* and transported to Botany Bay. Nevertheless, on the other hand, associations are formed under the immediate sanction of this very identical P———tt, for the supression of these once constitutional meetings, and his associators are regarded by him as the only loyalists, the best friends of their country.[37]

In a very real sense Pigott's *Dictionary* was an education in the arbitrary nature of the sign. It cast the verbal sign as an instrument of power and revealed its functions and determinations to be political rather than natural. It was a lesson in language that anti-Jacobins like Gifford rejected as "misrepresentations" and "lies" and that the government silenced as "sedition."

In order to gauge the changes in the representation of language in the 1790s, it is helpful to compare them with Samuel Johnson's description of the workings of language in his preface to his *Dictionary of the English Language.* Johnson began by lamenting the inaccuracies that had crept into the language. "Language, he wrote, "is only the instrument of science, and words are but signs of ideas: I wish, however, that the instrument might be less apt to decay, and that signs might be permanent, like the things they denote."[38] Like Craig, Johnson's ideal language is one in which signs mirror their referents. Nevertheless, he recognized that as much as one may wish for this kind of stability in language, it is inevitable that as society changes, so too will language. Johnson continued:

> The language most likely to continue long without alteration would be that of a nation raised a little, and but a little, above barbarity, secluded from strangers, and totally employed with securing the conveniences of life. . . . But no such constancy can be expected in a people polished by arts, and classed by subordination, where one part of the community is sustained and accommodated by the labor of the other. Those who have much leisure to think, will always be enlarging the stock of ideas; and every increase of knowledge, whether real or fancied, will produce new words or combinations of words. When the language is unchained from necessity, it will rage after convenience; when it is disused, the words that expressed it must perish with it: as any opinion grows popular it will innovate speech in the same proportion as it alters practice.[39]

Intervening between the verbal sign and "the thing it denotes," in Johnson's account, is the socializing processes of civilization. Language therefore reflects civilization as much as it denotes specific meanings. What Johnson understands by civilization is important. For him it represents a socially and economically diversified society, one in which there are levels and orders, and in which educated men of leisure, who have the time and education to think, enlarge the stock of ideas and direct the course of language. A complex, evolving language is thus the sign of civilization and class privilege.[40]

The danger in the 1790s was that the society mediating between the verbal sign and the referent was no longer one of leisure, education, and property but one deeply divided by social and political differences. Hence the need to police that mediation through such means as the Treason and Sedition Acts or publications like Gifford's *Anti-Jacobin* or, more to the point, to deny it completely by naturalizing the verbal sign. Naturalization denied the sign's arbitrary nature and made it appear to be a pure, immediate, and transparent reflection of the referent. While one would have a difficult time imagining such a linguistic sign or a language composed of them, visual signs could be made to appear to resemble the referent, and for this reason drawing and painting held open the possibility of a universal visual language. Remarking in a series of lectures before the Royal Institution and the Russell Institution on the importance of the arts of drawing, painting, and engraving, Craig declared, "They furnish the means of conveying to the utmost limits of the habitable world, the most valuable information, in any pursuit, and that too in a language which is instantly intelligible; a language which possesses a degree of clearness and precision that words can never reach."[41] It was precisely this utopian dream of a natural, universal pictorial language that drawing manuals of the later eighteenth century and the early nineteenth century pursued. The naturalistic style of drawing set out by Craig and exemplified in the style of Hearn's drawing of oak trees dominated the pages of amateur drawing manuals until about 1820. It can be associated with the work of artists and drawing masters like Samuel Prout, David Cox, John Varley, and John Sell Cotman, and it reached its most profound expression in the early landscapes of John Constable.[42]

In drawing, the naturalistic style helped to map out a new visual field that alternated uneasily between surface and depth and parts and wholes. The popular success of this style can be explained in terms of the ideological implications of its rejection of abstraction and its valorization of individuality, variety, and organic naturalism. Moreover, and most important, such a style could address itself to the views of both conservatives and

liberals, for its ideological and representational power was precisely its ability to reify and reaffirm both political visions of the social order. Its particular brand of naturalism could give visual reinforcement to the conservative views of men like Burke and Gifford, who wished to see the intricate variety of a complex social hierarchy as a reflection of nature, as well as reinforcement to the liberal sympathies of a man such as Wordsworth, who in *Lyrical Ballads* set out to celebrate "low and rustic life." Poems such as "The Old Cumberland Beggar" and "The Last of the Flock," in which the poet gives up his voice to speak the "language of real men," verge on representing the impoverished existence of their subjects as a state of nature. The poems are not simply a celebration of the social hierarchy's most humble members but an unquestioning acceptance of the very idea of a social hierarchy. The untutored tongues of the "simple child" in "We Are Seven" or Susan in "Idiot Boy" bespeak poverty and hardship in the landscape, which in turn becomes the occasion for a poetic display of liberality and fellow-feeling. The *Ballads* are not strictly naturalistic in the way that Craig desired the drawing to be, for finally in the poems the language of "real men" is subsumed by the language of the poet. Their simple and picturesque language calls forth the higher, more synthetic, abstracting consciousness of the poet. The poet's reflections on their discourse serves to contain it. The poems give form to the discourse of the poor, which by its very unreflecting naturalness verifies this need for shaping. The poet's discovery of a personal poetic sensibility in reflecting on the scenes of low and rustic life depends ultimately on a nostalgic, regretful alienation from this life, a alienation that seeks refuge at a safe distance from the loss it regrets. Such structures of feeling and sensibility were perhaps best understood by Blake when he observed, "Pity would be no more / If we did not make Somebody Poor."[43]

The remedy for the simplistic political abstractions of the French revolutionaries and their radical supporters was not simply political repression but a reordering of the representational field into a variety of specialized areas of knowledge and experience in which order was internalized within intricate, multileveled, seemingly organic operations. Such a reordering of representation had important implications not only for garden design and landscape art but for poetic language as well, for it ultimately reconfirmed the need for order without seeming to do so. The effect of this process on landscape art in Britain was long term, for its representational assumptions and structures were in keeping with a society that throughout the early decades of the nineteenth century opposed the radical discourse of government by a priori formula with an appeal to nature's diversity and complex variety in order to legitimate and obscure its own political institutions and social hierarchies.

Notes

1. Jane Austen, *Northanger Abbey,* ed. R. W. Chapman (Oxford, 1980), 111.

2. Edmund Burke, *Reflections on the Revolution in France* (New York, 1973), 73–74. This is an observation also made by W. J. T. Mitchell ("Eye and Ear: Edmund Burke and the Politics of Sensibility," in *Iconology: Image, Text, Ideology* [Chicago, 1986], 135–43), who sees a consistency between Burke's early positive characterization of the sublime and later his anti-Jacobin politics. For the later Burke, the awe and obscurity of the sublime was not embodied by the French Revolution, with its reliance on public spectacles and the clear principles of the *Rights of Man,* but rather was best expressed in the invisible, unwritten, organic, and aural English constitution. To Burke's mind, sublimity therefore was English and not French; it was a noble, masculine mode of government, while the French Revolution was the work of low, feminized beings.

I have no disagreement with this analysis; in fact I find it consistent with my own belief that principles and abstract ideas were perceived by the English at this time as being dangerous and un-English. Where my argument moves in a slightly different direction is in describing a linguistic remedy applied in the 1790s to political discourse, that is, the desire to produce a "natural" linguistic and visual sign. I suggest that Burke's sublime was one semiotic solution to the radicals' appropriation of political terms and language, one that finally privileged a social and patriarchal hierarchy already in place that would continue to manage and suppress certain kinds of political discourse. The other approach, the one I describe, was perhaps more popularly naive and "democratic," for it did not depend on censorship and direction from above, but rather on an idea that linguistic meaning could be fixed, so that it was universally clear and true. This notion of a communal, natural language could speak both to the anti-Jacobins' nationalism and to the more liberal Wordsworthian belief in a shared language of the heart.

3. William Gifford, *The Beauties of the Anti-Jacobin or Weekly Examiner* (London, 1799), 2–3.

4. *Anti-Jacobin or Weekly Examiner,* 19 March 1798, 147. More recently former prime minister Margaret Thatcher felt obliged to point out that representative government was not the invention of the *Rights of Man.* Interviewed by *Le Monde* and the television network Antenne-2 on the eve of the bicentennial of the French Revolution, she remarked that democratic forms of government "date back much futher than that [the French Revolution]. We have our own Great Charter [Magna Carta] of 1215 and the notion of human rights goes right back to the ancient Greeks and even further. . . . We had a peaceful revolution in 1688 in which the Parliament imposed its will on the monarchy. We celebrated this event last year, but discreetly" (as reported in the *Los Angeles Times,* 14 July 1989, pt. 1, pp. 1 and 13).

5. For more on this topic as it applies to the politics of the 1790s and landscape design, see my *Landscape and Ideology: The English Rustic Tradition, 1740–1860* (Berkeley, Calif., 1986), 57–85; and John Murdoch, "Foregrounds and Focus: Changes in the Perception of Landscape c. 1800," in *The Lake District: A Sort of National Property,* ed. John Murdoch (London, 1986), 43–59.

6. Uvedale Price, *An Essay on the Picturesque, as compared with the Sublime and the Beautiful; and, on the Use of Studying Pictures, for the purpose of Improving Real Landscape*, 2 vols. (London, 1810), 1:342.

7. Ibid., 119–20.

8. Ibid., 121.

9. Joseph Addison, *The Spectator*, ed. Donald F. Bond, 5 vols. (Oxford, 1965), 3-540–41.

10. John Barrell, *The Political Theory of Painting from Reynolds to Hazlitt: "The Body of the Public"* (New Haven, 1986), 119–22.

11. For an insightful discussion of the prospect landscape, see, Robert Clark, "The Absent Landscape of American's Eighteenth Century," in *American Views of Landscape*, ed. Mick Godley and Robert Sansen-Pelles (Cambridge, 1990).

12. Price, *Essay* 2:147.

13. Uvedale Price, *Thoughts on the Defence of Property* (London, 1797), 39; quoted in Malcolm Andrews, *The Search for the Picturesque: Landscape Aesthetics and Tourism in Britain, 1760–1800* (Aldershot, England, and Palo Alto, Calif., 1989), 65.

14. Richard Knight, *The Landscape* (London, 1795), 33, lines 39–40.

15. Ibid., 92, lines 393–94.

16. Ibid., 93, lines 404–5.

17. William Gilpin, *An Essay on Prints* (London, 1768), 2.

18. "Account of Book for 1789," *Annual Register* (London, 1789), 170–83.

19. Quoted in William D. Templeman, *The Life and Work of William Gilpin (1724–1804), Master of the Picturesque and Vicar of Boldre* (Urbana, Ill., 1939), 276.

20. Ibid., 290.

21. Ibid., 236.

22. William Marshall Craig, *An Essay on the Study of Nature in Drawing* (London, 1793), 15.

23. Ibid., 18.

24. Ibid., 10.

25. Ibid., 11.

26. Ibid., 17.

27. Price, *Essay* 1:348.

28. William Gilpin, *A Catalogue of Drawings, and Books of Drawings . . . with the Author's Account of the Drawings contained in it: and of the Principles, on which they are executed* (London, 1802), 35.

29. Ibid., 32.

30. Craig, *Essay*, 10.

31. Ibid., 7.

32. Gilpin, *Catalogue*, 20.

33. Craig, *Essay*, 9.

34. Ibid., 21.

35. Charles Pigott, *A Political Dictionary: Explaining the True Meaning of Words* (London, 1795), 1, 2, 3, 119.

36. *Beauties of the Anti-Jacobin*, 26 March 1798, 157.

37. Pigott, *Political Dictionary*, 4–5.

38. Samuel Johnson, *Dictionary of the English Language*, 2 vols. (London, 1805), 1:iii.

39. Ibid., xv.

40. For a more complete discussion of language theories of the period and their political implications, see John Barrell, *English Literature in History, 1730–1780: An Equal, Wide Survey* (London, 1963), 110–75.

41. William Marshall Craig, *A Course of Lectures on Drawing, Painting, and Engraving, Considered as Branches of Elegant Art* (London, 1821), 47–48.

42. In this context it should be remembered that Constable owed his early training to a number of amateurs and drawing masters. He learned landscape painting from the amateur artists John Dunthorne, George Frost, and Sir George Beaumont, and learned the picturesque from the engraver and drawing master John Thomas Smith. His ideas about art were formulated in the 1790s and are not far removed from Craig's. In 1802, after turning down an offer of a post as a drawing master at the military academy at Great Marlow, he wrote to Dunthorne, in what is perhaps his most-quoted letter, of his resolve to spend the summer making "laborious studies from nature," concluding, "There is room enough for a natural painture" (see *John Constable's Correspondence*, ed. R. B. Beckett, 7 vols. [Ipswich, Suffolk], 2:31–32).

43. William Blake, "The Human Abstract," from *Songs of Experience* (ca. 1794), Introduction by Sir Geoffrey Keynes (London and New York, 1967) 1–2.

FOUR

ELIZABETH HELSINGER

Turner and the
Representation of England

From the defeat of Napoleon in 1815 to the middle of the nineteenth century, England was caught up in a great debate over the question of representation. Should Parliament be made more representative, and if so, who should be represented, and by whom? At issue was a definition of the nation itself. The working-class radical in Benjamin Disraeli's 1845 novel *Sybil* speaks of two nations—irrevocably different—"the rich and the poor." The aristocratic hero ultimately claims to unite them: the interests of the poor should be represented by a responsible hereditary aristocracy. By contrast, the middle class, who worked for their own enfranchisement, identified *their* concerns as the national interest. Not only newly emergent classes but also other constituencies competed for the right to represent nineteenth-century England. Was England rural or urban, local or national, agricultural or industrial? In this competition to define the nation and claim the right to represent it, literary and artistic depictions of England were, not surprisingly, often understood as part of the debate. J. M. W. Turner, one of England's two greatest landscape painters, produced a book about England at the moment when this debate was at its height. His *Picturesque Views in England and Wales* was issued in parts between 1826 and 1835 and published in two volumes in 1832 and 1838. Turner's book acknowledges the debate quite directly. As Eric Shanes has pointed out, several of the drawings engraved for the volumes make explicit reference to the reform agitation of the late twenties and early thirties.[1] I want to look, however, at a less obvious relation between Turner's drawings and the question of national representation. By altering the conventions of picturesque views, these drawings unsettle an idea of landscape that had implied an answer to that question.

Turner's work may seem an unlikely subject for an exploration of En-

glish national identity. His style and subjects have suggested no associations with an essential England such as those that have accrued to the landscapes of his contemporary, John Constable.[2] Turner's most famous paintings are of European scenes. Both painters, however, might be characterized as equally nationalistic in their self-presentation as artists. For both, membership in the Royal Academy was central to professional identity (though Constable had to wait many years for his election); both undertook lectures and participated actively in academy affairs. Turner left his vast collection of his works to the nation, requesting that a national gallery be built to house them, and the bulk of his estate for the support of English painters. Constable, making a virtue of what was at first a necessity, restricted his subject matter to "native" scenes and tied his "natural painture" to his immersion in particular rural English places.[3] While Turner traveled constantly across Europe for his material and produced works that participate fully in a European tradition of historical landscape painting, he presented them as English challenges to that tradition. His will specified that two major paintings were to hang next to two paintings by Claude Lorrain in the National Gallery, as lasting testimony, in a national public space, to his and England's cultural achievements. *Sun Rising through Vapour* and *Dido Building Carthage* both make covert references to the rise of a new maritime empire, England, to rival those of Carthage and Venice and Holland. One might argue that Turner participated in the emerging English tendency to see England as rightfully inheriting a European cultural past.

Turner's many representations of English landscapes are less well known, probably because so many of them were undertaken on a much more modest scale as watercolor drawings provided to publishers for books of engraved views. The most important of these were Whitaker's *History of Richmondshire* (1816), Cooke's *Picturesque Views of the Southern Coasts of England* (1816–26), and Heath's *Picturesque Views in England and Wales*. The first two books were small or moderate-sized commissions on particular local subjects; the last, however, was an ambitious project of national scope.[4] In Turner's hands it became, over the years, the occasion not only for some of his most stunning work in watercolor but also for what might be read as a commentary on the intertwined political and aesthetic problems of representing the nation. To understand how these two aspects of national representation intersect in Turner's work, however, we need to look more closely at the ideas of a land and its people implied by the conventional book of picturesque views to which Turner's books refer.[5]

By the late eighteenth century, tours of Britain by the British were well established among the upper and, increasingly, the middle classes.[6] The

sights to which these tourists traveled belonged to private estates; they included ruins and natural wonders as well as contemporary houses, parks, and industries. Their owners were increasingly interested in displaying them to a genteel traveling public. Guides, guidebooks, hours of admission, and all the familiar structures of tourism were already in place. Drawings and paintings of such sights, initially commissioned by owners for their own viewing, developed into a business in its own right. By the early nineteenth century, books reproducing views of England's landscape sights addressed an audience of potential or vicarious tourists.

Two problematic concepts underlie such books: *circulation* and *possession*. The purchaser is offered visual possession of an England whose images have been placed in circulation.[7] For their largely middle-class intended audience, this might be construed as a gesture toward inclusion within the ranks of the landowners, who still retained primary political and social authority in England in the years preceding the enactment of the Reform Bill in 1832. Purchase these books and you too may gain at least visual access to the land. The prints also represent circulation; they provide an analogue for experiences of touristic travel (itself established since the eighteenth century as a means of vicariously possessing England) and for the geographic and social mobility increasingly characteristic of their middle-class, often urban purchasers. Two identities—that of landowners who occupy privileged positions for viewing England and that of middle-class tourists and internal immigrants—are potentially offered by these books of views. And at the same time, a still wider range of possible relations to the national landscape is offered through the figures depicted in these representations of rural England—from rural laborers through the gradations of a provincial middle class to rural gentry and aristocracy, not to mention the professional travelers and tourists occasionally glimpsed along the way. One might say that the genre offers a social identity in terms of a variety of possible relationships to English rural scenery. But it also enforces a distinction between those addressed as viewers of the landscape and those who can only be imagined as subjects in it.[8] Only the first group enjoys the linked privileges of possession and circulation represented by the book of picturesque views. To be the subject, and never the viewer, of these landscapes means to be fixed in place like the rural laborer, circumscribed within a social position and a locality, unable to grasp the larger entity, England, which local scenes can represent for more mobile picturesque viewers.

The aesthetics of landscape, and the activities of viewing and displaying English places through which it was experienced, created for those who could participate in it a claim on England as their national aesthetic property. What began in the eighteenth century with the improvement, dis-

play, and representation of private property quickly gave birth to a con-
cept of public property. William Gilpin, the pioneer picturesque tourist,
qualifies the claims of private property before the "court of taste" by
suggesting that a ruined abbey is "a deposit, of which [the owner] is only
the guardian, for the amusement and admiration of posterity."[9] Twenty
years later, another defender of the rights of the picturesque is ready
to describe "those scenes of Nature . . . which the general voice have
pronounced to be beautiful" as "the common property of the public,"
and by 1810 Wordsworth speaks of the Lake District as "a sort of national
property" for the "persons of pure taste" who admire and visit it.[10] Where
England is "a sort of national property" for the landscape viewer, such
"persons of pure taste" in effect constitute the nation, in a process analo-
gous to that by which the political nation is understood to be constituted
in the persons of property who elect a Parliament.[11]

It hardly needs pointing out that "England" does not belong to all
born "Englishmen" (to say nothing of women) under either concept of
the nation. While the aesthetic nation is potentially all those who have
"an eye to perceive and a heart to enjoy," as Wordsworth would have it,
in practice it is only a little larger than the unreformed Parliament. Its
members, like those of the political nation after 1832, are still men of
property, though that need not mean private ownership of the land itself.
Books like *Picturesque Views in England and Wales* offered middle-class
consumers a way of possessing England (the land) and hence claiming
membership in it (the nation) some years before political reforms rede-
fined the conception of property to admit them to the franchise. But in the
1820s and 1830s, neither the defenders of English landscapes as national
property nor the majority of middle-class political reformers meant to
stretch the meaning of possession to include the working classes.[12]

The extended meaning of property offered by landscape views was not
very stable in a time of increasing pressure for much more radical reforms
of the franchise. To this source of tension within the genre, events of the
1820s and early 1830s added a second: the circulation or mobility to
which landscape views necessarily alluded became an equally charged idea.
In the world of the picturesque view, labor is fixed, as a subject of repre-
sentation, while the viewer is mobile, like the tourist. Moreover, geo-
graphic and social mobility often figure each other, and both are under-
stood as the privilege of private property and a prerequisite for claims on
a national property. Picturesque views reinforce the exclusion of rural
labor from such privileges and claims. The immobility of the rural work-
ing classes contradicts not only experience (there was always some circula-
tion of the rural poor) but also the requirements and the ideology of the
economy in which both viewers and their books participate. England's

already capitalist economy needed a large and mobile labor force, as the political economists recognized, and held out promises of social mobility to fuel it. In this sense, the assumptions of the landscape view had always been at odds with the mode of its production and that of the rural economy it depicted.[13] Economic pressures for a mobile force of wage labor conflicted with desires for social security, symbolized by the older pattern of rural labor attached to local, hierarchical social structures inseparable from particular landholdings. Associations between a mobile labor force and vagrancy, and between vagrancy and criminality have a long history: pedlars, gypsies, and any wandering strangers from the lower classes evoke suspicion and fear among the propertied classes. These fears were given new urgency after 1815 by the combination of hard times and high unemployment, especially in the countryside, which accelerated the transformation of rural labor into wage labor with no rights of use of, and therefore no ties to, the land. The widespread agricultural protests of 1816, 1822, and especially 1830 reinforced the sense of insecurity experienced by the middle and upper classes in the face of the increased circulation of the rural poor.[14] Groups of local men took to the roads and marched from village to village to set fire to hayricks, attack threshing machines, or demand bread and higher wages; familiar local laborers were horrifyingly transformed into wandering strangers. These uncontrollable movements by the rural poor are a kind of shadowy double—frightening or sad, depending on your perspective—of the voluntary circulation of tourism or the free movement of labor appealed to by the political economists. As with middle-class tourists, breaking the bounds of locality is indeed understood as a route to the possession of England, a claim to membership in the nation—but it is a claim that is vigorously resisted.

In little more than a decade after the publication of Turner's book, the structures of exclusion essential to and supported by this landscape aesthetic were crumbling. With the development of the cheap railway day excursion in the later 1840s, the working classes, in Ian Ousby's wonderful phrase, became tourists instead of revolutionaries.[15] Circulating as consumers, they too might lay claim to possess the national property of England; twenty years later their claims on the political nation were recognized in a further extension of the franchise. But in the late twenties and early thirties, those developments scarcely seemed inevitable. The threat of revolution was not yet defused. Turner's book was produced at a moment when the tropes of possession and circulation central to landscape aesthetics were already highly problematic. *Picturesque Views in England and Wales* engages these unstable tropes far more explicitly than his viewers and his critics, past and present, have wished to recognize.

England and Wales was intended by its publisher, Charles Heath, to

be seen within the conventions of circulation and possession created by travel literature. It was meant in some degree to reproduce the experience of touring, and in fact it comes out of that experience. The drawings, based on sketches collected from Turner's professional tours as far back as 1795, recall his more than thirty years of traveling to the picturesque sites of England and Wales.[16] In one sense this is a retrospective book about picturesque tourism and the production of landscape views. The stagecoach is a frequent motif. The letterpress, commissioned from a professional producer of such texts, belongs to the genre of coffee-table books that address readers as travelers. Most of the subjects in Turner's *England and Wales* fit the interests of antiquarian and picturesque tourists. Indeed, as one scholar has pointed out, 58 of the 96 published subjects can be found in Henry Boswell's *Picturesque Views of the Antiquities of England and Wales* (1786), a book whose engraved plates Turner was employed to color as a boy.[17]

Yet the finished pictures depart significantly from picturesque practice and even from Turner's own. These alterations address the present rather than the past. They call attention to the struggles for and through representation preoccupying England in the late 1820s and early 1830s. The point of view adopted and, especially, the activities depicted in many of the drawings form a potentially disquieting commentary on the conventional sights they represent. They suggest different and conflicting ways in which England may belong to the English.

Conventional picturesque views adopted a fairly low point of view— Samuel Prout, Clarkson Stanfield, and J. D. Harding, Turner's contemporaries and major producers of drawings for books of picturesque views, provide a plethora of examples.[18] The low perspective helped to monumentalize the castles, cathedrals, abbeys, or mountains that were the main subject of the picture. It could represent the experience of the awed tourist—often the road from which the view is taken is a prominent feature in the foreground. Even those artists who, following Gilpin's advice, preferred to take their views from a "station" of middle height were careful to locate the spectator on firm ground recognizably accessible to the traveler.[19]

Turner's practice, in both this and earlier books of prints, was much more variable. Low perspectives or references to roads are interspersed among other views that depict the traveler's experience from some other, unidentified perspective or ignore it altogether. Sweeping panoramas recall the "prospects" of late seventeenth- and early eighteenth-century topographical poetry rather than the views of the picturesque traveler. But where even the prospect provided readers with a secure standpoint, detailing the physical and social elevation that made such views possible, some

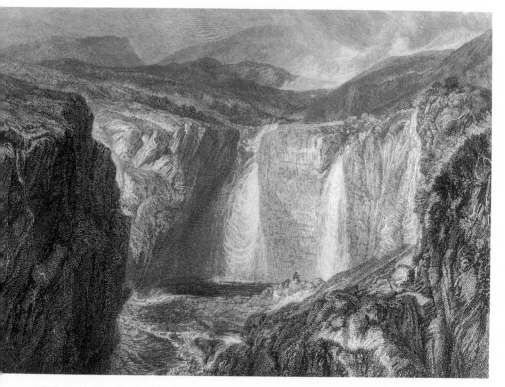

4.1 Engraving by E. Goodall after J. M. W. Turner, *Force of the Tees, Yorkshire* (1827). Reproduced from J. M. W. Turner, *Picturesque Views in England and Wales* (London, 1838), vol. 1.

of Turner's extensive views omit all clarifying references and require imaginative projection into the air. From this literally transcendent perspective, mountains, castles, and cathedrals fade to pale ghosts on the horizon. Such implied distancing from the picturesque tourist and his subjects is especially frequent in *England and Wales*. The drawing entitled *The Upper Force of the Tees* (see fig. 4.1), for example, is based on a sketch made on Turner's 1816 Yorkshire tour. Turner used a different sketch of the same subject from that tour for a drawing engraved for Whitaker's *History of Richmondshire*. The earlier drawing adopts a low perspective. The later drawing, however, is one of Turner's most breathtaking. In the distance the tiny figure of a sketcher is visible at the foot of the falls, near the point from which the earlier view had been taken, but the spectator of Turner's later view, looking down on the falls from an immense height, is given no ground at all to stand on. As a visit to the site today will confirm,

Turner took his stand in imagination, from which he achieved a grasp of the land and its shaping forces much more comprehensive than any available to the picturesque tourist.[20]

For the viewer accustomed to English landscape prints from the preceding half-century, however, the most disconcerting aspect of Turner's *England and Wales* is the relative prominence of the figures. The ostensible picturesque subjects—ruined abbeys, castle-guarded coasts, pastoral prospects, waterfalls, distant towns—are depicted with Turner's usual grandeur and poetry, but his foregrounds are unusually full of human activity that exceeds its nominal function as frame or complement to the view. The landscape, Turner's drawings seem to insist, is never empty; the tourist will discover it is already occupied. Other picturesque artists like Prout or Fielding typically make use of foreground figures, in carefully studied local costumes (Prout) or engaged in characteristic local activities (Fielding). But these place- and time-bound figures of a local, traditional peasantry are always subordinated to the scenes they frame. The juxtaposition enhances the power of the cultural and natural monuments, a power that belongs, implicitly, not to the local figures who ignore them, but to the viewer of educated sensibilities who can appreciate them.[21] Turner's foreground figures, in contrast, possess a complex life that demands attention in its own right. They cannot easily be read to support the cultural superiority of the picturesque viewer and the sights that such a viewer values. Against a background of Turnerian air and water that render the distant monuments of mountain, castle, or cathedral curiously insubstantial, Turner's small figures are caught with a sketchy vividness more like that of the graphic artist or political cartoonist than of the realist painter.

The distracting effect of Turner's figures, experienced in works where they are far less prominent than *England and Wales*, is registered by the dismissive comments they provoke from critics who would prefer to see past them.[22] Ruskin, for example, often passes over Turner's figures in silence when he cannot read them metaphorically, but those attending the horse fair in the foreground of *Louth, Lincolnshire* from *England and Wales* he finds so obtrusive that he must note them as an unfortunate instance of Turner's vulgarity.[23] Other critics have effectively erased Turner's figures by labeling them incompetent or, in Ronald Paulson's perceptive but equally dismissive characterization, as a literary addition or superscription that defaces his own pictures—Turner's "graffiti."[24] Turner's figures, these comments suggest, pose an obscure but violent threat against the aesthetic values that his critics and viewers find so gloriously realized in his landscapes. In many of the drawings for *England and Wales*, the violence

attributed to style seems also to be alluded to in the disposition and the activities of the foreground figures.

Richmond Terrace, Surrey for example, is an apparently peaceful drawing that may raise a potentially disturbing question: whose views are these? Ranged across the top of the terrace, looking out on an extensive view, is a carefully detailed hierarchy of different social classes, from the monarchy down to the exhausted poor.[25] It is evidently a day of leisure, and they are apparently all present to enjoy the view. The engraving was one of the last of the series to be published (1838), but the much earlier *Richmond, Yorkshire [from the moors]* may raise a similar question. The height outside the town that offers this most pastoral of scenes is occupied, not by the picturesque tourist, but by a shepherdess playing with her dog. Throughout the series, in fact, the place of the picturesque viewer is often occupied by figures from the rural working classes who are themselves at leisure—though not necessarily to look at the view. That Turner is aware that such displacements may be contested is strongly suggested in several drawings that arrange figures from different classes not as hierarchical survey but as opposition or contrast. In *Eton College, Berkshire* the river divides the picture starkly in two; on one bank are a couple of fishermen trapping eels, on the other lounge the gentlemen students, with the Gothic buildings of the college behind them. *Carisbrook Castle, Isle of Wight* (see fig. 4.2) is divided diagonally by a bridge leading across a moat and into the castle, which turns its otherwise impenetrable stone bulk to the countryside. The well-dressed riding party making their way along the high-walled bridge to the castle are firmly separated from the laborers at work in the country open to their view beyond and below them. *Blenheim, Oxfordshire* (ca. 1830–31, published 1833; see fig. 4.3), explicitly asks who shall be admitted to the privilege of touristic viewing. In a drawing that Shanes interprets as a direct reference to the agitation for admission to the political nation, a group of middle- and lower-middle-class visitors stand waiting, on the extreme right edge of the picture, at the grand gate of the most visited great house in England, just visible at the upper left.[26] A top-hatted figure holding a brace of hounds and a rifle stands squarely in the left center foreground, confronting the viewer and barring the visitors' way with unknown intent, while a riding party from the estate can be seen on the far left. Centered in the distance and lit by the sun emerging from clouds, a bridge (ironically a purely ornamental bridge, built on appropriated land from the town) links the two otherwise tensely separate sides of the picture. Blenheim, financed out of public funds to reward a national hero, was indeed "a sort of national property" that might appropriately stand for the privileges of

nationality demanded by the middle classes—and, unsuccessfully in 1832, by the lower classes, who are notably not represented in the party at the gate.

These drawings depict English landscapes as contested ground. A few like *Blenheim* suggest that the aesthetic and political questions may be resolved by admitting at least some of those excluded to possession of a national property.[27] Others, however, represent the lower-class figures in the landscape as a more fundamental threat to the conceptions of national property embodied in landscape aesthetics. If Turner's figures deface the views they occupy, it is not just because they are unusually prominent or boldly sketched. They are also engaged in activities that transgress the laws of taste and of property.

In the first place, Turner's working-class figures are more often conspicuously at leisure than at work. In *Lancaster, from the Aqueduct Bridge* (see fig. 4.4), for example, the city is a distant silhouette on the horizon, and tiny figures in the middle distance are haying. The bridge itself, however, carrying a canal and barges across the foreground, is the viewing platform

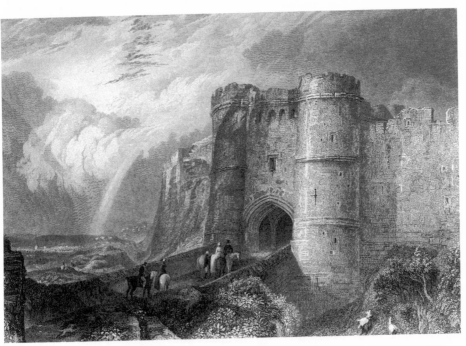

4.2 Engraving by C. Westwood after J. M. W. Turner, *Carisbrook Castle, Isle of Wight* (1830). Reproduced from *Picturesque Views* (see 4.1 above), vol. 1.

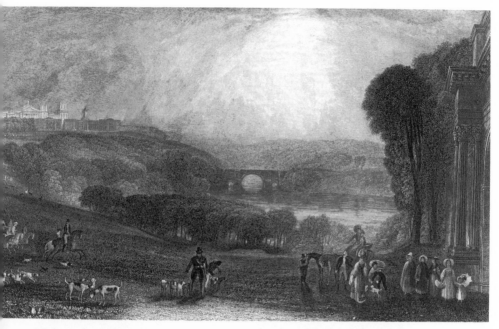

4.3 Engraving by W. Radclyffe after J. M. W. Turner, *Blenheim, Oxfordshire* (1833). Reproduced from *Picturesque Views* (see 4.1 above), vol. 2.

from which the extensive landscape drops away abruptly. It is draped with laborers fishing, resting, and sleeping; their slack, reclining forms contrast sharply with the vigor and solidity suggested by the uprights of the handsome stone balustrade against which one slumbers, or the board of the barge from which another leans to fish, or the long, straight horizontal of the bridge itself.

In the second place, the leisure aggressively foregrounded in *Lancaster* is in other drawings pointedly linked to pleasure, and to forms of pleasure strongly suggestive—to genteel sensibilities—of disorder and excess. A large party of sailors and their women dance, drink, and sprawl across the lower third of *Plymouth Cove, Devonshire* (see fig. 4.5); a bar has been set up in a tent in the middle distance, and the litter of bodies, plates, implements, tankards, bottles, baskets, and shawls spills out of the picture toward the viewer. This scene of litter and license separates the viewer from the tranquil, open expanse of the bay and its surrounding layers of mist-shrouded hills receding into the distance. The sunset-lit, almost transparent walls of *Caernarvon Castle, Wales* (see fig. 4.6), and the delicate silhouettes of masted boats against it, are a triumph of Turnerian atmosphere dissolving all that is solid into air—but the scene is occupied

by a group of working women disrobing to swim from a boat, watched by a second group of men, women, and children on the shore. The women are not yet transformed into the aesthetically familiar bathing nudes of the beautiful *Ullswater, Cumberland*. They retain their identities with their clothes, hot and dusty women of the nineteenth century whose public bathing might well affront the seeker of picturesque views.

These suspect pleasures of the lower classes prominently dispute the rules of morality and taste governing aesthetic pleasure for the viewers of the landscapes they occupy. They are especially concentrated in two drawings of public fairs, the horse fair of *Louth, Lincolnshire* that provoked Ruskin's protest against Turner's vulgarity, and the tumultuous scene at *St. Catherine's Hill, near Guildford, Surrey* (see fig. 4.7). In both pictures, leisure, license, and litter appear in the context of the commercial. That the aggressive presence of commerce threatens to completely take over the site of the picturesque might alone merit Ruskin's accusation of "vulgarity." In *St. Catherine's Hill*, the medieval chapel at its summit is hardly more than a ghostly shape; the tents of the fair and the great crowds

4.4 Engraving by Robert Wallis after J. M. W. Turner, *Lancaster, from the Aqueduct Bridge* (1827). Reproduced from *Picturesque Views* (see 4.1 above), vol. 1.

4.5 Engraving by W. J. Cooke after J. M. W. Turner, *Plymouth, Devonshire* (1832). Reproduced from *Picturesque Views* (see 4.1 above), vol. 2.

milling in confusion around them spread over most of the picture surface, while produce spills out of the tents and a table of pottery—labeled "Staffordshireware" in large letters positioned for the viewer—is tilting into the viewer's lap. A large tent in the foreground advertises the refreshment at two local coaching inns ("Try the RED LION. No better under the SUN"); a barker gestures to the tent of a London showman further up the hill. The urgent disorder of this buying and selling of goods and pleasures is heightened by the black clouds of a storm approaching from the left, and the dark shape of a stagecoach hurtling out of it toward the crowd and the viewer. Picked out in light just in front of this impending darkness, two figures glimpsed above the crowd cudgel each other in the "blood sport" of a backsword fight. Their menacing sticks, echoed by the raised arms of the surrounding crowd, suggest the threat of popular violence—against the persons, the property, and the aesthetic values of picturesque viewers like the better-dressed visitors in the bottom left of the scene—associated with the disorder and excess of lower-class pleasures.[28]

Finally, a large group of coastal scenes depicts activities of the lower classes that transgress laws of property to challenge the physical integrity of the nation. Turner painted coastal scenes, often of storms and ship-wrecks, throughout his life; it's not surprising that *England and Wales* should contain a number of examples. But eight of the ten coastal views in these volumes were drawn in the early 1830s, when the internal political stability of the country was most in doubt. The coastal views obsessively repeat scenes of salvage (from shipwreck) and smuggling—activities that bring goods across the legal boundaries of the nation without recognizing the claims of private or national property (i.e., customs dues). The local working classes depicted in these views lay claim to the salvage from foundered ships as public property and defy the customs officers who guard the borders of the nation. The ruined monuments on the headlands and the wrecked ship in the middle distance of a view like the *Tynemouth, Northumberland* testify not only to the power of natural forces over human enterprises but also to the impotence of a landowning or a mercantile nation to maintain control of its vulnerable boundaries against the trans-gressive activities of the local inhabitants, here salvaging from the wrecks

4.6 Engraving by W. Radclyffe after J. M. W. Turner, *Caernarvon Castle, Wales* (1835). Reproduced from *Picturesque Views* (see 4.1 above), vol. 2.

4.7 Engraving by J. H. Kernot after J. M. W. Turner, *St. Catherine's Hill, Surrey* (1832). Reproduced from *Picturesque Views* (see 4.1 above), vol. 2.

in the foreground. *Coast from Folkestone Harbour to Dover* (see fig. 4.8) makes the point still more clearly. The round, spectral monument overlooking a confrontation of smugglers and officers in the foreground is one of Pitt's Martello towers, the expensive line of fortifications erected to protect the vulnerable English coast from invasion by French troops during the Napoleonic Wars. The radical journalist William Cobbett, at Folkestone on his rural ride of September 1823, read these towers as a telling sign of the charged relations of the state with its restive rural populations in the 1820s: "These very *towers* are now used to keep these *loyal* Cinque Ports *themselves in order!* These towers are now used to lodge men, whose business it is to sally forth, not upon Jacobins, but *upon smugglers!*" (Cobbett's emphases).[29] Turner's repeated scenes of transgressive activities suggest Cobbett's conviction that the limits set to the conception of the nation and its membership cannot long hold.

I have been arguing that the drawings Turner made for *England and Wales* not only allude to contemporary challenges to the representation of the political nation but also allow us to connect those challenges with

less obvious threats to the England constituted by an idea of landscape. We might read Turner's revisions of conventional travel views in this book as an assertion of different modes of possessing England—not simply by owning it or appreciating it as landscape but also by inhabiting and enjoying it through activities that will be viewed as morally, aesthetically, and legally transgressive from the perspective of the dominant culture. In Turner's already occupied landscapes, there are existing cultures that the book of travel views implicitly acts to suppress or repress. Perhaps there is more than one "England." Turner's views represent, as it were, the coexistence in the same space of multiple cultures, undermining the concept of a single aesthetic nation constituted through landscape viewing. For the admirer of English landscape art as it developed in the eighteenth and early nineteenth centuries, his lower-class figures are indeed rightly seen as defacing the drawings in which Turner has placed them.

Does the assertive presence of these transgressive figures mean that Turner claims for them rights of possession and circulation? Or is he rather in sympathy with those who feel profoundly threatened by their

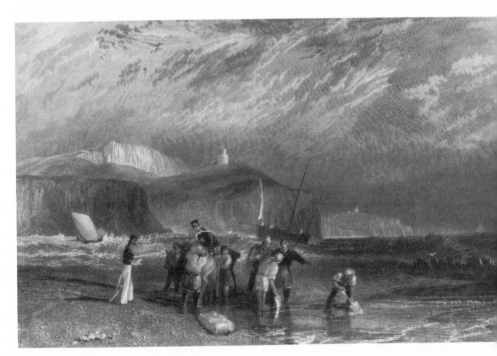

4.8 Engraving by J. Horsburgh after J. M. W. Turner, *Folkestone, Harbour and Coast to Dover, Kent* (1831). Reproduced from *Picturesque Views* (see 4.1 above), vol. 1.

presence? Despite his own origins and deliberate refusal to acquire the dress and manners of a gentleman, Turner's art was, after all, deeply tied to the aesthetics of those who were his patrons, purchasers, and friends. Nor is it certain that his are particularly accurate or sympathetic depictions of rural working-class England. For all the wonderful detail of his observations, his figures also confirm, and perhaps reflect, the expectations and fears of the upper classes. There is a danger in collapsing the two meanings of representation at play in these drawings. The portrait and the proxy are not the same, as Gayatri Spivak reminds us; depicting is not speaking for.[30] We cannot assume that Turner's depictions of rural working-class subjects endorse their political claims to a place within the nation. Moreover, the genre of landscape, structured and directed toward a spectator outside it, limits even the portrayal of subjects within it. Their consciousness of a relation to land or nation—their sense of place, individual or collective—is not accessible easily, if at all.[31]

Yet Turner's transgressive figures strain the genre of landscape to its limits, stressing the disjunction between spectators and subjects whose political existence, and consciousness of their own relation to land and nation, are, precisely, not representable within the idea of landscape. The aggressive presence of the figures in Turner's *Picturesque Views* puts that title in quotation, perhaps too much for anyone's comfort. As Ronald Paulson reminds us, in 1831 Turner gave Hogarth's palette to the Royal Academy in response to Constable's gift of Reynolds's palette, thus installing the artist of satiric cityscapes alongside the defender of the grand style at the center of an English national art.[32] That Turner's figures in the *Picturesque Views* recall Hogarth's cannot be accidental. At this critical moment in national history, Turner uses Hogarth to claim an ironic relation to the genre that had been his avenue to greatness. But the *Picturesque Views* records a more serious challenge to landscape than a recognition of its ironies can contain. Turner's drawings call into question the possibility of an exclusionary sense of landscape as national possession, reminding us that in fact the notions of possession and circulation to which picturesque landscapes refer—those of the spectator as landowner or tourist—are contradicted by new meanings of the same terms demanding recognition in the 1820s and 1830s. Turner's defaced views depict a contested land; they also point toward the imminent collapse of the very idea of landscape as an adequate representation of the nation.

Notes

1. See Eric Shanes, *Turner's Picturesque Views in England and Wales* (New York, 1979), esp. 18; and the commentaries to the following drawings: *Blenheim*

House and Park, Oxfordshire, Northampton, Northamptonshire, Ely Cathedral, Cambridgeshire, and *Nottingham, Nottinghamshire.* Shanes's is the best work on *England and Wales,* superseding W. G. Rawlinson's *Engraved Works of Turner* (London, 1908) both for its factual information and in its commentary; it also reproduces all the watercolor drawings in color.

Note that while I have, for the sake of simplicity, referred throughout to Turner's "drawings" for *England and Wales* (the term designates watercolor drawings, in British usage), they were intended to reach their audience primarily as published engravings; hence, my illustrations are taken from the engravings. Groups of the drawings were exhibited in June 1829, January 1831, and June and July 1833 to promote the sale of the engravings. Turner supervised the translation of his drawings into line engravings on copper in minute detail, often working with engravers he had trained himself and altering or correcting the proofs. For a fuller account of the production, exhibition, and sale of the drawings and engravings of *England and Wales,* see Shanes, *Turner's Picturesque Views,* 10–15.

2. See my "Constable: The Making of a National Painter," *Critical Inquiry* 15 (Winter 1989): 253–79.

3. These are Constable's terms; see *John Constable's Correspondence,* ed. R. B. Beckett, 6 vols. (Ipswich, 1962–68), 2:70 (27 May 1812) and 2:32 (29 May 1802).

4. Initially, 120 engravings were envisioned; 96 drawings were engraved and published before the series was terminated for financial reasons.

5. The term "picturesque" was often but not always applied to books of landscape views of the sort that Turner's publisher commissioned from him. There is no necessarily close connection between the views, however, and picturesque theory as it was debated by writers such as William Gilpin, Uvedale Price, and Richard Payne-Knight in the last quarter of the eighteenth century—or attacked by others, including Wordsworth. I have used it as I think the purchasers of these books must have understood it, to refer in a broad sense to land presented as a picture, an implicitly framed view from a single, fixed perspective, directed at a spectator external to it. "Picturesque" in this sense is nearly synonymous with "landscape." I am not concerned here to differentiate "picturesque" from "sublime," nor do I mean to imply that Constable or Turner were picturesque artists in the more limited (and today, commonly derogatory) senses of the term.

The premise that "landscape imagery is contested political terrain" has been fruitfully explored in a number of recent studies, beginning with Raymond Williams, *The Country and the City* (London, 1973). The 1990 collection of essays edited by Simon Pugh (*Reading Landscape: Country—City—Capital* [Manchester]) from which the above characterization of the topic is taken (4), contains essays by, among others, Williams, John Barrell, David Solkin, and Ann Bermingham, whose books on the political meanings of landscape in eighteenth and early nineteenth-century Britain are seminal. See n. 13 below.

6. On tourism in Britain in the eighteenth and early nineteenth centuries, see Esther Moir, *The Discovery of Britain: The English Tourists, 1540–1840* (London, 1964); Malcolm Andrews, *The Search for the Picturesque: Landscape Aesthetics and*

Tourism in Britain, 1760–1800 (Aldershot, England, 1989); and especially Ian Ousby, *The Englishman's England: Taste, Travel and the Rise of Tourism* (Cambridge, 1990).

7. In this analysis, I have drawn on Carol Fabricant's suggestive arguments about eighteenth-century middle-class tourism, "The Literature of Domestic Tourism and the Public Consumption of Private Property," in *The New Eighteenth Century,* ed. Felicity Nussbaum and Laura Brown (New York, 1987), 254–75; and on Dean MacCannell's provocative book about contemporary travel and consumption, *The Tourist: A New Theory of the Leisure Class* (New York, 1976).

8. Denis Cosgrove makes this point about the idea of landscape in general, as it developed in Western Europe from the seventeenth century. See his *Social Formation and Symbolic Landscape* (Totowa, N.J., 1985), 26.

9. William Gilpin, *Observations, relative chiefly to picturesque beauty, made in the year 1772, on several parts of England; particularly the mountains and lakes of Cumberland and Westmoreland,* 2 vols. (London, 1786), 2:188; quoted in Ousby, *Englishman's England,* 190, as are the passages from Warner and Wordsworth referred to below.

10. Richard Warner, *A Tour through the Northern Counties of England, and the Borders of Scotland,* 2 vols. (Bath, 1802), 2:99; William Wordsworth, *A Guide through the District of the Lakes in the North of England* (London, 1810; 5th ed., 1835; reprint, London, 1970), 92.

11. On the central concept of property in English political theory in the seventeenth to the nineteenth centuries, see C. B. Macpherson, *The Political Theory of Possessive Individualism: Hobbes to Locke* (Oxford, 1962). See also, on the changing concepts of nation and citizenship in this period, E. J. Hobsbawm, *Nations and Nationalism since 1780* (Cambridge, 1990), esp. chap. 1. Raphael Samuels suggests that landscape "has stood as a surrogate for more politicised notions of nationhood" in Britain in the 1980s (Pugh, *Reading Landscapes,* 1, describing Samuels, *Patriotism: The Making and Unmaking of British National Identity,* 3 vols. [London, 1989], introduction to vol. 1). A similar displacement or, alternatively, leakage of contested conceptions of the nation from political to landscape discourse occurred in earlier periods, notably 1815–32. On the highly politicized character of patriotic and national discourse in those years, see Linda Colley, "Whose Nation? Class and National Consciousness in Britain, 1750–1830," *Past and Present* 113 (November 1986): 97–117; and Hugh Cunningham, "The Language of Patriotism," in *Patriotism,* ed. Samuels, 1:57–89.

12. Ousby points out how Gilpin's, Warner's, and Wordsworth's appeals to public or national property all imply a restricted conception of the public. As he notes, the limitations of Wordsworth's apparently democratic reference to the pure of eye and heart emerge when, in the 1840s, he violently objects to a proposed railway through the district because it would give easy access to lower-class tourists. There would be "cheap trains pouring out their hundreds at a time along the margin of Windermere" who would deface the countryside with "wrestling matches, horses and boat races without number" and pothouses and beershops run by "the lower class of innkeepers" ("The Kendal and Windermere Railway"

[1844], in *The Prose Works of Wordsworth*, ed. W. J. B. Owen and Jane Worthington Smyser, 3 vols. [Oxford, 1974], 3:345–46; quoted in Ousby, *Englishman's England*, 192).

13. On the failure of English landscapes to depict the actual relations of property and the laboring poor in the countryside, see especially John Barrell, *The Dark Side of the Landscape: The Rural Poor in English Painting, 1730–1840* (Cambridge, 1980); Ann Bermingham, *Landscape and Ideology: The English Rustic Tradition, 1740–1860* (Berkeley, Calif., 1986); Hugh Prince, "Art and Agrarian Change, 1710–1815," in *The Iconography of Landscape: Essays on the Symbolic Representation, Design, and Use of Past Environments*, ed. Denis Cosgrove and Stephen Daniels (Cambridge, 1988), 98–117. These accounts are less interested than I am in the tensions surrounding the concept of mobility in English landscape scenes.

14. For a compelling account by a contemporary middle-class observer, see Mary Russell Mitford, "The Incendiary: A Country Tale," in *Our Village* (1824–35; new edition in 2 vols., London, 1865), vol. 2. Critical studies of the agricultural protests include A. J. Peacock, *Bread or Blood: A Study of the Agrarian Riots in East Anglia in 1816* (London, 1965); and Eric J. Hobsbawm and George Rude, *Captain Swing* (New York, 1968).

15. *Englishman's England*, 91.

16. Turner made only one new tour to collect material for *England and Wales*, though that was an important one. Thirteen drawings (by Shanes's reckoning) draw on material from the 1830 Midlands sketchbooks (see Shanes, *Turner's Picturesque Views*, 156). These include *Coventry, Warwickshire* and *Dudley, Worcestershire*, which—especially the latter—powerfully register the growing industrial presence in the English landscape. *Blenheim House and Park, Oxfordshire*, which alludes to Reform, and *Northampton, Northamptonshire*, depicting the celebration after the victory of a Reform candidate in December 1830 (shortly after Turner's return from his tour), also draw on Midlands sketchbooks. As I shall argue, however, it is not only the drawings based on his most recent tour that refer to contemporary events or register changes in the social and geographic landscape.

17. Shanes, *Turner's Picturesque Views*, 16.

18. "The *Picturesque Point* is always thus low in all prospects," wrote William Mason (in *The Works of Thomas Gray; Containing His Poems, and Correspondence with Several Eminent Literary Characters. To Which Are Added, Memoirs of His Life and Writings, by W. Mason, M.A.*, 3d ed., 2 vols. [London, 1807], 2:267n; quoted in Ousby, *Englishman's England*, 156).

19. For Gilpin's preference for slightly rising ground as a vantage point, see his *Observations* 1:156.

20. David Hill gives a full account of the various sketches and drawings; see his *In Turner's Footsteps: Through the Hills and Dales of Northern England* (London, 1984), 72–74. Though Hill also visited the High Force to determine Turner's vantage points, he does not seem to have been struck, as I was in 1982, by the apparent impossibility of the view represented in the *England and Wales* drawing.

21. On the tension between local subjects and tourists, and the implied superi-

ority of the latter's culture over the former's asserted by touristic description in the eighteenth century, see Deirdre Lynch, " 'Beating the Track of the Alphabet': Samuel Johnson, Tourism, and the ABC's of Modern Authority," *ELH* 57, no. 2 (Summer 1990): 357–405.

22. Shanes is a notable exception. He praises *England and Wales* precisely because of the "awareness of contemporary life" and "systematic exploration of human beings" manifested in its foreground figures (*Turner's Picturesque Views,* 18). The stylistic affinities with Hogarth, Rowlandson, and Gillray he accepts as a consequence of Turner's interest in the symbolic meanings that might be attached to his figures—his "deep desire to create a figurative metaphor for human vanity and for the rudimentary, unsophisticated personality of the great mass of mankind in the early nineteenth century" (19). As will be evident, I want to resist Shanes's tendency to generalize the meaning of Turner's figures (despite his recognition of the contemporary references the drawings contain) because it seems to me finally to gloss over a real threat to the idea of landscape that more hostile critics have registered.

23. *The Complete Works of John Ruskin* (Library Edition), ed. E. T. Cook and Alexander Wedderburn (London, 1903–12), 13:438. Ruskin's 1878 *Notes on his drawings by Turner* identifies a "new phase of temper," "a strange, and in many ways grievous metamorphosis" in Turner's work beginning about 1825, particularly evident in both the subjects and the manner of his figures. Ruskin singles out a number of *England and Wales* drawings, as well as some mezzotints from the *Liber Studiorum,* as exhibiting "a resolute portraiture of whatever is commonplace and matter-of-fact" (as opposed to beautiful and heroic), rendered with "violent pencilling and often crude and coarse colour." The drawings to which he refers all depict lower-class activities (watercress gatherers, hedging and ditching in *Liber Studiorum*), particularly those involving manners and mores affronting middle-class ideas of propriety ("barrack domestic life," "jockey commerce" [the Louth horse fair], "the general relationships of Jack ashore"). Turner's fascination with the "vulgarity" of these scenes, which "offends us," perplexes Ruskin. On the one hand, he recognizes that "with all this . . . he had in himself no small sympathy" and "took in the midst of it, ignobly, an animal English enjoyment"; on the other hand, he cannot imagine that a Turner who shares the aesthetics of landscape would not also have been "pained" and "disgusted" by it, "acknowledging it all the while to be ugly and wrong." Ruskin ends in bewilderment: "I cannot understand these ways of his" (13:438–39).

24. Objections to Turner's figures go back well into the nineteenth century. Ruskin refers in 1857 to "the usual complaints made about his *bad* figure-drawing"; his comments on Turner's "vulgarity" in 1878 are meant to explain "what the public were most pained by in Turner's figure drawing" (*Works* 13: 152, 438).

W. G. Rawlinson was particularly harsh on the figures in *England and Wales* in his pioneering study *The Engraved Works of Turner* (London, 1908). He calls them "banal and ill-drawn" and thinks them added "at the last" (1; quoted by Shanes, *Turner's Picturesque Views,* 18–19). For Paulson's much more sophisti-

cated version of this reaction, see his *Literary Landscape: Turner and Constable* (New Haven, 1982), pt. 2: "Turner's Graffiti: The Sun and Its Glosses," 63–103.

25. Shanes, *Turner's Picturesque Views*, 48.

26. See ibid., 37–38. On the aggressive promotion of Blenheim as a tourist attraction with great snob appeal, see Fabricant, "Literature of Domestic Tourism," 265–68 and 272.

27. See also *Nottingham, Nottinghamshire* and *Northampton, Northamptonshire*, and Shanes's comments, *Turner's Picturesque Views*, 38–39 and 41–42. In the former, the opening of lock gates and a distant rainbow suggest the admission to a promised land of the working classes on barges just getting under way; smouldering fires beneath the castle surely, as Shanes suggests, refer to the firing of Nottingham Castle by an angry mob after the House of Lords defeated the second Reform Bill in 1831. The drawing was probably made in the summer or autumn of 1832, just after the passage of the bill in June; it was published in 1833. *Northampton, Northamptonshire* was probably intended for the series but never engraved; it shows the triumphant procession celebrating the victory of a reform candidate in December 1830. Shanes argues for sympathetic references to parliamentary reform in *Ely* and *Stoneyhurst* as well.

A case might also be made that *Salisbury from Old Sarum Intrenchment* refers not only to the capacity of the Church to protect its flock (a shepherd covers children with his cloak during a rainstorm in the foreground of a view of the cathedral) when paired with *Stonehenge*, as Ruskin suggested (a shepherd and sheep have been killed by lightning there). Since Old Sarum was probably the most often-cited instance of a rotten borough (the old ecclesiastical town was deserted but still retained its parliamentary representatives), the drawing may make an ironic reference to the alliance between a Church losing its congregants but fighting to retain its political supremacy, and a corrupt Parliament—the real shepherd does a much better job of protecting the people.

28. This was one of the rural "blood sports" that middle- and upper-class reformers, taking it as a sign of a lack of civilized cultural and moral values, worked hard to abolish. On the history of middle-class English efforts to control or suppress the activities at rural fairs, including blood sports, see Peter Stallybrass and Allon White, *The Politics and Poetics of Transgression* (London, 1986), esp. 15–16 and 27–79; and R. W. Malcomson, *Popular Recreations in English Society, 1700–1850* (Cambridge, 1973). For identification of the details of the fair in the Turner drawing, see Shanes, *Turner's Picturesque Views*, 36.

29. *Rural Rides* (London, 1830; reprint, 1983), 194. The passage was first published in Cobbett's widely circulated *Political Register* for 1823. Turner's drawing was made ca. 1829–30 (engraving published 1831). Shanes notes that "smuggling was a major industry in Britain during the 1820s: 120,000 highly trained seamen had been discharged from the navy after 1815 into a labour market already depressed by high unemployment . . . whole villages lived off smuggling. . . . Judging from the number of times he depicted them, Turner knew the ways of smugglers well, and of his other watercolours of Folkestone most show smugglers at their business" (34).

30. For her distinction between the "portrait" (" 're-presentation,' as in art or philosophy") and the "proxy" (" 'speaking for,' as in politics"), see Gayatri Chakravorty Spivak, "Can the Subaltern Speak?" in *Marxism and the Interpretation of Culture*, ed. Cary Nelson and Lawrence Grossberg (Urbana, Ill., 1988), 275.

31. See Cosgrove, *Social Formation*, 26.

32. Paulson, *Literary Landscape*, 21. Noting that "it was difficult for an English landscape painter, with the great tradition of English and continental literature at hand, to paint a landscape without some awareness of the irony underlying the genre" (acknowledged almost from the beginning, when Horace puts the praise of country life into the mouth of a city usurer), Paulson comments that "a Hogarth-influenced painter . . . could make a gesture in the direction of Horace's irony or contemporary reality by adding Hogarth's figures in the rural setting or by painting a cityscape" (28). Paulson's observation seems exactly right as an interpretation of Turner's Hogarthian figures, particularly in light of Turner's donation of Hogarth's palette in the same period; I am grateful to Paulson for drawing my attention to his comments. The effect of this gesture, however, was necessarily magnified by the particular historical conditions to which Turner's drawings refer.

F I V E

DAVID BUNN

"Our Wattled Cot"

Mercantile and Domestic Space in

Thomas Pringle's African Landscapes

> Their *Wives* upon straw-Pillions (black as *Jet*)
> Slow-paced *Oxen* (like Europa) ride:
> *Beasts*, upon which a higher price *they* set
> Than all the *Cattle* of the *Field* beside.
> Sweet *madrigalls* (in *Ryme* or Prose compleat,
> In their own *Tongue*) to *rustick-Reed* apply'de,
> They sing in *Parts*, as gentle *Shepherds* use,
> That imitate of Tytirus the *Muse*.
>
> —Luis de Camões (1572)

When the explorer Richard Burton arrived off the coast of Zanzibar in the 1850s, the prospect of that exotic island port, with its market bustle and spice-laden breezes, caused him to observe that the addition of "a few donjon-ruins upon the hills" would enable East Africa to compare favorably "with the most admired prospects of the Rhine."[1] Implicit in this lighthearted remark is the more serious belief that metropolitan aesthetic conventions have a continued appropriateness in countries previously unknown to European travelers. In this chapter I consider the way landscape—considered as a system of aesthetic, conventional, and ideological ordering useful in the management of political contradictions—is exported from metropolitan Britain to the imperial periphery. I will be referring especially to attitudes toward landscape present in the 1820s in the Cape Colony, Britain's Southern African colonial possession, drawing examples from the poetry of Thomas Pringle, a young journalist, abolitionist, and acquaintance of Coleridge, who led a party of Scots settlers to the Eastern Frontier. What I have to say has wider implications for historians concerned with the representation of resistance, contradiction, and the South African state.

127

At Pampoen-Kraal

Over the past decade, a new school of art-historical writing, represented in part by the contributors to this volume, has begun to reflect on the important role played by landscape painting and poetry in the constitution of gender, class, and national identity. While a number of recent works have aimed at reading symptomatically what Ann Bermingham calls the "class view of landscape . . . to which the painted image gave cultural expression,"[2] few have sought to leap the European fence and consider the important theoretical changes being wrought in the study of nonmetropolitan traditions. Colonial landscapes, I shall argue, respond to local contests over symbolic power on the imperial periphery; at the same time, these struggles are also influenced by metropolitan changes in the relations of production and self-fashioning. To look at representation in the colonies, therefore, is perhaps to have privileged insight into what is most resilient, most dominant, and at the same time most politically constraining in the European landscape tradition.

There are many good reasons why one might expect colonial landscape painting or poetry to be different from its European counterparts. Most obviously, those British landscape conventions that make possible, say, the erasure of working-class or women's meaning confront a different order of representation in the colonies, one in which a rival, indigenous semiotics struggles to assert itself. Even more plainly, the representation of British terrain depends on an important relationship between landscape and vision, a relationship that is complicated on the colonial frontier because of the association between sight and surveillance.[3] The African landscape is conceived as a liminal zone between the self and savagery, and rendering things visible is a necessary prerequisite to administrative control. A further complicating factor is the changing taste for colonial landscape (related to changing political needs) throughout the nineteenth century. By the end of the century, for instance, many who were weary of England's sprawling slums were ready to accompany Rider Haggard's Allan Quatermain back into the arms of "Nature" now displaced into the colonies: "Not the Nature which you know, that waves in well-kept woods and smiles out in corn-fields, but Nature as she was in the age when creation was complete, still undefiled by any sinks of struggling, sweltering humanity. I would go again where the wild game was, back to the land whereof none know the history, back to the savages, whom I love, although some of them are almost as merciless as Political Economy."[4]

For an increasingly jaded urban audience, colonial landscapes, and the South African landscape in particular, came to be perceived as repositories

of romantic subject-matter.[5] Clearly this revaluation is linked to the degradation of experience in metropolitan centers, the expansion of capitalism toward accumulation on a world scale, and the consequent displacement of the country-city dichotomy onto world geography.[6] Finally, it seems self-evident that the economic, political, and cultural forces at work in the colonies, though increasingly tied to world capitalist needs, have a relatively autonomous existence associated with the emergence of the colonial state. These are some of the interesting and complicating conditions that make it difficult to speak of traditions that are exported, unchanged, to the South African frontier.

My primary concern is with the relationship between landscape and the development of settler capitalism. To get to that point, however, we need to glance briefly at the politics of the late eighteenth-century travelogue. The example I propose to use is the frontispiece to François Le Vaillant's *Travels into the interior parts of Africa, by the way of the Cape of Good Hope* (1790), probably the most widely read eighteenth-century account of travel in the Southern African region and a major best-seller in England (see fig. 5.1).[7]

Le Vaillant's copper engraving reveals a theatricality typical of illustrations in many explorer texts. The vegetation has a framing effect, like a proscenium arch; the figure appears to be drawing aside a curtain of bushes, leading the viewer into the landscape and the reader into the book.[8] We are concerned, at such moments, with questions of epistemology and ideology, with the manner in which the presence of a nonindigenous figure in an exotic landscape becomes naturalized. What texts or semiotic systems that help to interpellate the self under metropolitan capitalism can operate under these conditions? Colonial space, remember, is a site of regular ontological shock. It is filled with competing indigenous meaning, a foreign semiotics that does not accommodate class and gender distinctions in the same way, which must consequently be rewritten so that it appears willing to admit colonial appropriations.

The Le Vaillant illustration uses a form of staging that reveals the influence of the popular picturesque.[9] This theatricality serves a dual purpose, for the landscape becomes a place of enactment, able to receive various foreign presences, and the terrain is displayed as though already ordered to European conventions of taste. The semiotics of the picturesque is clearly apparent. There is a high vantage point (the engraver has in fact exaggerated the elevation in Le Vaillant's original watercolor) and a planar logic to the prospect, bracketed by Claudian coulisses; the space is clearly divided into raised foreground, a middle distance with a prominent object of interest, and the light-saturated horizon, toward which the eye returns. But what makes this a *colonial* landscape, apart from the obviously

5.1 "Encampment in the Great Namaqua Country." Reproduced from François Le Vaillant, *Travels into the Interior Parts of Africa* (London, 1790).

African flora and fauna? Perhaps the answer to this question lies in an examination of the systemic overdetermination of the illustration—that is, in an analysis of how a variety of ordering devices are deployed simultaneously so as to stabilize what is a difficult and contradictory process of description.

Consider first how the theatrical framing effect in the picture also enables, in a series of cognitive shifts, the ordering of items according to degrees of familiarity. At the outer edge of the frame there is a Europeanized tree, leading to an exotic palm, with the giraffe (or camelopard) set dead center in the middle distance as the object associated with deepest insecurity for the observer and maximum value for the collector. Giraffe, more than any other African mammal, presented difficulties for Linnaean classificatory systems. That they were also objects of intense rivalry among eighteenth-century collectors is revealed in a recently discovered loose-leaf commentary by the explorer Robert Jacob Gordon found in a copy of Le Vaillant's *Travels*.[10] Colonel Gordon, commander at the Cape in the late eighteenth century, was an obsessive collector and brilliant naturalist who contributed the first giraffe anatomy to Buffon's *Histoire Naturelle*. Outraged by Le Vaillant's casual remarks about shooting a giraffe, he scribbled down the following note: "Barend Vrije shot Vailliant's [*sic*] giraffe. He crossed the Great River only for a short while. Barend Vrije's dogs held the giraffe at bay towards noon and Vailliant took Barend Vrije's horse for a giraffe and stalked it and nearly shot it dead. . . . And Vailliant has never seen a live giraffe and this giraffe was smaller than mine."[11]

The landscape represented in the etching is thus ordered both by the syntax of the picturesque as well as by encyclopedic or ethnographic categories. There is, however, a third grammar operating here, which helps to naturalize the presence of the figure in the foreign landscape, for on closer inspection it is clear that Le Vaillant imagines himself in a parkland environment, pursuing the leisured, aristocratic practice of hunting. Art historians like Ann Bermingham and others have described the representation of such activities in outdoor conversation pieces, but in this instance the trope is given extra emphasis because of its very theatricality. The gestures and stance are quite formulaic, and the figure has its toes turned outward as though toward an implied audience.[12] Such stiffness in illustrations is often the sign of intertextual borrowing. Here the engraver is obviously using an example from one of the familiar etiquette copybooks of the period, such as one from an early eighteenth-century Jesuit theater handbook representing the ideal pose for giving a command (see fig. 5.2).[13] In a way it is inevitable that Le Vaillant's figure directs much of its attention outward. Because the subject, in this foreign landscape, is not being embodied in any recognizably indigenous version of the bour-

5.2 How to issue a command. Reproduced from Franciscus Lange, *Dissertatio de actione scenica* (Munich, 1727).

geois public sphere, it must appeal more generally toward its distant metropolitan readership and their more familiar textbooks of social embodiment. Gesture is therefore also always outward; we are involved in the drama of being led into a book as well as into the South African interior.

Colonial landscapes are often imagined to provide dramatic or romantic contexts for the individual explorer, but they are also frequently emptied of rival human presences.[14] Thus a paradox emerges: if the combination of commanding gesture and a commanding vantage point suggests power over the alien terrain, how are the *human* effects of this power to be figured? For Le Vaillant the solution lies in the use of a mediating device. In figure 5.1, this part is played by the hunting dogs, a metonymic extension of the European explorer's ability to command authority back home. The dogs are unselfconscious presences. They respond to the master by tumbling unembarrassedly into the foreign scene; it is as though the commands from the Prospero-like human figure move outward, plane after plane, rooting the giraffe to the spot and causing workers and herdsmen to go about their daily tasks. The scene before him is under the spell of Le Vaillant's casually commanding hand.

Another unsettling feature of this illustration is the extraordinary buoyancy apparent in the central figure, a characteristic of dress and decorum that carries with it political overtones. Le Vaillant is dressed fashionably but lightly; he is poised and pointed on his toes like a dancer, while his elaborately cockaded hat (repeating motifs in both the ornate palm and the billowing cumulus clouds) and the gun that is carried with studied

carelessness both suggest a flexibility of purpose in sharp contrast to the rooted giraffe and the stolid encampment below. It is revealing that the explorer chooses to place himself at a distance from the actual clutter and tackle of his expedition, from its material conditions. What is being dramatized is the emergence of an enquiring self that is unencumbered, free to enter into exchanges, inhabiting a space full of exotic interest but cleared of obstacles. Significantly, this "free" romantic space is also loosely associated with national rivalries. When Le Vaillant wishes to conjure up, in the reader's imagination, a sense of liberation and aventurous possibility, he resorts to the language of Palladian landscape gardening: "Ye sumptuous grottoes of our financiers! Ye English gardens twenty times changed with the wealth of the citizen! Why do your streams, your cascades, your pretty serpentine walks, your broken bridges, your ruins, your marbles, and all your fine inventions, disgust the taste and fatigue the eye, when we know the verdant and natural bower of the Pampoen-Kraal."[15]

In this diatribe the popular *jardin anglais* is dismissed in favor of a Romantic bower carved out of the undergrowth. By way of negative contrast, the cultivated English landscape seems to "fatigue the eye," not only because of its fussy attention to artificial embellishment, but also because it does not allow for open vistas. Remarkably, allusions to landscape gardening are used here to bolster support for the French presence in South Africa. There is an implied contrast between French political style and the national obsessiveness suggested by the "fatiguing" English garden. In fact, in the etching that accompanies this argument (see fig. 5.3), the explorer is shown centrally posed between two very distinct types of shelter. On one side there are two indigenous Khoikhoi huts, balanced on the other by the two "grottoes" carved into the undergrowth by the white explorer.[16] A mere five years before the first British occupation of the Cape, this subtle piece of propaganda suggests that the French explorer gains his authority for being in Africa by imitating indigenous forms. The hastily constructed shelter at "Pampoen-Kraal" (roughly, "pumpkin-farm") is thus a sign of Le Vaillant's authorship, his ability to respond creatively, benevolently, and unobtrusively to the foreign environment. This is a conceit that is present throughout colonial landscape painting and poetry.

In the context of Le Vaillant's *Travels,* the trope of mobility is also charged with erotic potential. Many of his encounters are read as a sort of erotic dalliance, and one of them, a brief attachment to a Gonaqua woman named Narina, enters into the currency of stories told about South Africa throughout Europe.[17] It is alluded to in virtually every Southern African travelogue for the next fifty years. While Le Vaillant indeed had a relationship with a woman named Narina, their exchanges are decidedly

unequal. In his capacity as a leading ornithologist and botanist, he incorporates her name, like a specimen, into the collector's lexicon. "I found her name difficult to be pronounced, disagreeable to the ear, and very insignificant according to my ideas; I therefore gave her a new one, and called her *Narina*, which in the Hottentot language signifies a *flower;* I begged her to retain this pretty name, which suited her in many respects; and this she promised to do as long as she lived, in remembrance of my visit to her country, and as a testimony of my love, for she was already no stranger to this passion."[18] It is as a specimen, and as a body, that

5.3 "Encampment at Pampoen Kraal."
Reproduced from François Le Vaillant,
Travels into the Interior Parts of Africa
(London, 1790).

Narina is remembered. Not only does colonial landscape provide special voyeuristic opportunities for the male explorer (the scopic drive of the narrative combining readily with the need for surveillance so common in the frontier text), but his libidinal attachment is memorialized in the "pretty name" that circulates in Southern African travelogues for decades to follow.

Le Vaillant's *Travels* describes a landscape in which the subject is embodied as a mobile, erotic presence. As we shall discover, this trope of unobstructed passage through the colonial environment—a conventional

form of staging preferred by many explorers, collectors, and administrators of the period—can be used for different political effects; twenty or thirty years later, it is commonly used to support calls for the abolition of mercantilist restrictions and the establishment of free trade. For a closer examination of this odd association of erotics, economics, and landscape, let us now consider the representation of space on South Africa's Eastern Frontier, exemplified in the work of Thomas Pringle.

Transitional Landscapes

Various historians have attempted to situate the work of Thomas Pringle in an indigenous South African landscape tradition; of these, only J. M. Coetzee makes the connection between the politics of representation and the importation of picturesque conventions. Like most historians, I would regard Pringle as a key figure in the establishment of liberalism in South Africa and in the advance of English as an instrument of linguistic colonization. Because of his important role as one of South Africa's first journalists and his support for print culture, free speech, the abolition of slavery, and reform, Pringle is the narrative beginning both for the myth of origins that enables liberal ideology to dissociate its own history from that of the monster apartheid and for a patriarchal and racist version of South African literary history that often portrays him as the "father of South African poetry."[19]

Taking advantage of the settlement scheme designed by the British government to alleviate unemployment and deflect working-class unrest, Pringle joined a party of Scots settlers emigrating to the troubled South African Eastern Frontier in 1820. This journey was undertaken despite the intense controversy over settlement schemes that raged in England, represented most bitterly and brilliantly by George Cruikshank's 1819 cartoons on the subject (see fig. 5.4). Cruikshank's astute parody of Lord Castlereagh's scheme to get rid of the London poor also contains one of the funniest and most exact depictions of commodity fetishism. In figure 5.4, the productive capacity of the colonial landscape is presented not as a function of labor and social relations but, as Marx was to express it, as "the fantastic form of a relation between things."[20] Moreover, this vision of a land where pigs are not pigs but animated sides of pork and where, according to the Castlereagh figure, "you'll have no occasion to work and victuals will run into your mouth ready chew'd," is also a commentary on aristocratic control over representation *for* the working class. The colonial landscape is fetishized in terms of its sheer use value. An impoverished urban proletariate is offered the utopian vision of being able to move into a new economic system where commodities present themselves without

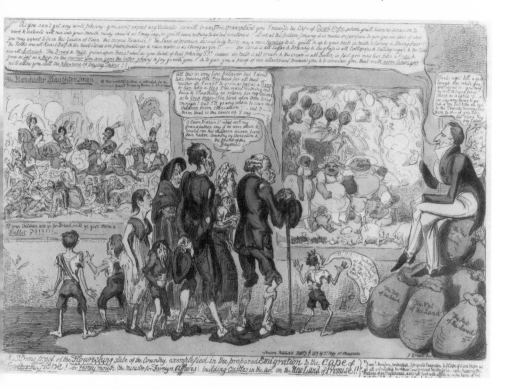

5.4 George Cruikshank, "The proposed Emigration to the Cape of Good Hope."
Courtesy William Fehr Collection, Cape Town.

the intervention of labor. At home the disgruntled workers threaten rul-
ing-class control over the appropriation of surpluses, a control sustained
by brutal legislative measures such as the Black Acts and by military inter-
vention in the form of the Peterloo Massacre; abroad, they are offered
the illusion of classless access to indigenous plenty.[21]

 Cruikshank's savage parody of the link between British colonial policy
and massacres back home was echoed by Shelley's 1819 attack against
Castlereagh in "The Mask of Anarchy" as well as Byron's devastating
portrayal of the foreign secretary in the controversial "Dedication" to *Don
Juan*:

> Cold blooded, smooth-faced, placid miscreant!
> Dabbling its sleek young hands in Erin's gore,
> And thus for wider carnage taught to pant,
> Transferred to gorge upon a sister shore,
> The vulgarest tool that tyranny could want,
> With just enough of talent and no more,

> To lengthen fetters by another fixed
> And offer poison long already mixed.[22]

Despite such formidable warnings, Pringle and his extended family sailed to the Eastern Cape, there to establish a rural community on the Baviaans River. After two years spent helping to establish the settler families on their meager estates, he and his wife returned to Cape Town, where, in 1823, he took up joint editorship of the *South African Commercial Advertiser*, a newspaper subsequently banned by the British governor in a maneuver that guaranteed the poet's financial ruin as well as his prominence in liberal histories.

Turning now to the poetry Pringle wrote about the Albany frontier, let us consider how landscape, an aesthetic and material practice, helps to naturalize the settler subject and establish a local version of the bourgeois public sphere.[23] Unlike the consciousness typically manifested in British landscape poetry and painting, for which landscape is an effect of the present that may also call up memories of the past, the colonial subject must negotiate between two worlds: the recently lost metropolitan home, and the uncoded Otherness of the present. The new prospect is measured against the old familiar order, and it is usually found lacking:

> Nor rippling brook with osiered sides;
> Where sedgy pool, nor bubbling fount,
> Nor tree, nor cloud, nor misty mount,
> Appears, to refresh the aching eye.[24]

In his influential essay on the South African picturesque, J. M. Coetzee argues that the scarcity of reflective surface water in certain areas of South Africa is responsible for a "lacuna in the repertoire of the artist," causing painters or poets to behave as though the earth "is dead or sleeping or insentient."[25] This is precisely what troubles Pringle. But he is also complaining about a prospect that does not allow for the excursiveness of the eye, and for this reason it is as though a new paradigmatic landscape, one reduced in tone and contrast, has to be produced. Thus the settler colonial poet finds it necessary to construct a *transitional object,* a landscape that enables transactions between metropolitan conventions and colonial conditions.[26] Just such a project is apparent in Pringle's most famous work, "Evening Rambles" (see Appendix of this chapter for the full text), a topographical poem that attempts to situate the colonial subject in a prepared and controlled landscape. I shall use this work as my central example, returning to it as the occasion demands, for it is in such attempts to adapt British notions of the picturesque to local conditions that a range of allied contradictions around questions of gender and labor become apparent.

The entire poem is framed by a specific conception of time and place. It is evening, a fragile hiatus threatened by the memory of the harsh African day, on the one hand, and, on the other, the dangerous African night:

> The sultry summer-noon is past;
> And mellow Evening comes at last,
> With a low and languid breeze
> Fanning the mimosa trees,
> That cluster o'er the yellow vale,
> And oft perfume the panting gale
> With fragrance faint: it seems to tell
> Of primrose-tufts in Scottish dell,
> Peeping forth in tender spring
> When the blithe lark begins to sing.

(lines 1–10)

This particular evening is "mellow," with wind reduced to a "low and languid breeze." With the elimination, or blurring, of visible contrasts, the colonial subject is more easily able to entertain exchanges between past and present worlds. In the half-light that breeds memories, the unproductive "Zuurveld"—the Dutch name meaning, literally, "sour pasture"—becomes "Albany," a type of Pringle's Scottish dells. The sharp yellow blossom of the thorny mimosa is displaced, by memory, into the yellow primroses of a Scottish spring.

The metonymic displacement of one landscape into another is not uncommon in locodescriptive poetry; conventional nature lyrics such as Wordsworth's "Yew Trees" allow for the presence of the historical past in particular symbolic objects or topoi. What we are faced with here, however, is as much a problem of origins as it is one of representation. The poet requires two cognitive maps to help order the colonial prospect. The first is called up by memory or sometimes in noonday dreams, moments of sweet hallucination when, as Pringle says elsewhere, "the brown thorny desert, where antelopes stray, / [becomes] a sweet Glen."[27] The second is a sort of negotiated compromise, a transitional landscape that uses a peculiar form of ideological containment. This newly created context also allows the poet to "ramble," rove, or wander, which, in the colonial environment is a massive presumption, since it assumes a form of undirected interest and aristocratic control of leisure time completely at odds with rigorous life and labor on the frontier. Being able to ramble is the ultimate indication of being at home in an environment; having free passage and moving, according to whim, with a naturalness like the passage of breezes or rivers also masks the artificiality of the colonial presence.

What emerges in the early part of "Evening Rambles," therefore, is a form of the picturesque landscape that helps to locate the colonial self in its new context. Crucial to this enterprise, as J. M. Coetzee and a number of other writers have remarked, is the metaphor of an unimpeded excursion of the eye, which in turn reminds one of the painterly technique of eighteenth-century poets such as Thomson. For John Barrell, Thomson's method consists in first rendering landscape features in swift shorthand, as though the eye "is able to move at such speed over the landscape only because it can organise so efficiently the objects in its path into a preconceived structure, which allows them an identity only as landmarks on the journey the eye makes to the horizon."[28]

This is clearly the technique in Pringle's second stanza, where the viewer's attention is directed to a valley prospect below:

> There the spekboom spreads its bowers
> Of light-green leaves and lilac flowers;
> And the aloe rears her crimson crest,
> Like stately queen for gala drest;
> And the bright-blossomed bean-tree shakes
> Its coral tufts above the brakes.

(lines 25–30)

Here the eye darts rapidly over the canopy of vegetation, picking out sharp stabs of color. What distinguishes Pringle from Thomson, though, is that the former is as much concerned with encyclopedic naming as seeing, so the botanical item is first identified before its general appearance is described in the next line. In other words, the trope of the excursive eye combines with the sort of paratactic ordering we find in Enlightenment travelogues. Pringle deliberately imports Dutch vernacular names such as *spekboom*, literally "pork tree," into an English text, and the exotic material is thus subjected to linguistic as well as cognitive authority. The colonial self, in other words, is able to move in a thickened and deepened environment; consequently, the descriptive sequence ends with a powerful image of synthetic reverie: "With the deep-green verdure blending / In the stream of light descending" (lines 33–34). Now that the subject can accommodate itself in a relatively familiar context, a Wordsworthian flash of sympathy between self and landscape is experienced. A reward is, as it were, being offered to the imagination that has succeeded in finding in the unfamiliar terrain a new language or economy of images that can encompass the old.

On Being Indoors on the Frontier

Colonial painting and poetry, I have been arguing, seek to dramatize a context in which the self can act without apparent self-contradiction. Such

a process of naturalization could quite easily be explained away, using the definition of symptomatic ideological practice common since Althusser, Macherey, and Bourdieu. What needs closer examination, however, is the way colonial landscapes are subject to a *plurality* of determining systems, and the connection between this overdetermination and the development of ideological consensus within the colonial state.

Even in its most documentary mode, landscape needs a body. Whether in the abstracted laborers of Constable's "six footer" oils, Gainsborough's rather artificial encounters with rustic types, or in the control over enunciation or focalization marked by descriptive detail in narrative texts, the representation of landscape implies some embodiment of figure and ground. Here Tom Mitchell's rather wry "nine theses" on landscape are applicable, especially when he observes that landscape is "a medium of exchange between the human and the natural" or that it is "a natural scene mediated by culture."[29] What makes colonial landscape so fascinating, perhaps, is that in it we see more nakedly revealed the interdependence between representations of Nature and the emergence of an underdeveloped settler *public sphere.*

Landscape is the genre that marks the emergence of a public attitude claiming to be private reverie. At the heart of the disinterestedness some landscape painters and poets invoke when they claim to be representing Nature lies a rhetoric of embodiment and disembodiment common in eighteenth- and nineteenth-century attitudes to public life. In a persuasive recent critique of Habermas, Michael Warner argues that "the bourgeois public sphere claimed to have no relation to the body image at all":

Public issues were depersonalized so that any person would, in theory, have the ability to offer an opinion about them, submitting that opinion to the impersonal test of public debate without personal hazard. Yet the bourgeois public sphere continued to rely on features of certain bodies. Access to the public came in the whiteness and maleness that were then denied as forms of positivity.[30]

Landscape conventions allow poet and painter to naturalize a particular type of public subject without appearing to refer to its embodiment in a community of opinions, a nation, or a class. In Pringle's poem, private reverie is actually dependent upon a sphere of publicly shared values: that of the bourgeois household extrapolated across the colony. But because this commonality does not yet exist in the colony, the poem turns to other forms of naturalization and finds comfort in the image of paired animals or even in references to animal territorial behavior instead of the ideological harmony normally suggested by the representation of figure and ground.

"Evening Rambles" presents a landscape in which the male colonial self can walk abroad. The listing of indigenous items, their naming and visualization, allows this subject to grow in stature ("And now . . . let me

through the mazes rove") until it appears as an animated presence in the landscape. So a context has, as it were, been won for the self; consequently, in the fourth stanza, there is a pleasurable proliferation of images celebrating the harmony of animals and the natural landscape: bees hum about a blossoming tree, doves inhabit a space echoing with their love calls, and a pheasant moves in a mirror image of perfect reciprocity with its mate. To move with ease through the colonial landscape is to assimilate it through a foreign process of ordering; it is also to set in place a metaphor of free passage, or unimpeded exchange, which is central to the development of precapitalist economies from mercantilism to free trade and wage labor. From the early eighteenth century onward, in fact, the metaphor of flow and fluid circulation is associated with an emergent bourgeois economic order. Sir Robert Clayton, in Defoe's *Roxana*, explains to the heroine "that an Estate is a pond; but that a Trade was a Spring; that if the first is once mortgag'd, it seldom gets clear, but embarrass'd the Person for ever; but the Merchant had his estate continually flowing."[31] Later in the century, the metaphor enters official discourse about Africa and continues well into the period of imperialism. In 1888, for instance, a writer to the *Times* who identifies himself as "An African Explorer" complains that "protectionist powers . . . stifle or cramp our trade with differential duties and irritating restrictions."[32]

Despite the metaphor of free circulation, the process of accommodating figure and ground in a new landscape is beset by contradictions. For instance, the Romantic phenomenology of "Evening Rambles," added to the fact that it is a *prospect* poem, emphasizes the poet's isolation. "My wonted seat receives me now," says Pringle, as he reaches his accustomed lone vantage point above the valley. Nonetheless, what distinguishes this poem from, say, the Le Vaillant prospect or mercantile descriptions, is that *it must go beyond the mercantilist metaphor of individual presence, flow, and circulation* to accomplish another ideological task. As a bearer of *settler* colonial ideology within a mercantile mode of production, the poem also seeks to establish a sense of domestic possibility within the wilderness. What we have already read, in other words, can now be reread. The many references to paired animals, which, because of their conjugal symmetry are also in harmony with the environment, establish a category of "natural families" that anticipates the adapted settler household referred to later in the poem. This same logic would distinguish the settler poem from a host of Romantic topographical works in which the insistent presence of a genius loci calls the poet to a temporary, meditative rest. In "Evening Rambles" and similar works, each moment of thoughtful rest has latent within it the idea of settlement, permanent fixity, and domestic possibility.[33]

If, as I have suggested, settler landscapes function as a sort of transitional symbolic space, enabling the establishment of a noncontradictory colonial presence, then the harmonizing or softening of contrasts we noted earlier serves another function by calling the ideologeme of domesticity into being. Picturesque conventions seem ideally suited to this mediating function, for, in Uvedale Price's definition, "PICTURESQUENESS . . . appears to hold a station between beauty and sublimity."[34] Painterly details—Claudian framing details, for instance—are quite commonly used for a softening effect in Romantic poetry. In Wordsworth's "Ruined Cottage," characteristically, a dreaming figure in a shady grove looks out upon a prospect framed by the limbs of an oak, "By those impending branches made more soft, / More soft and distant."[35] It thus is not surprising that Pringle's poem uses a form of picturesque aesthetic ordering. However, what are we to make of its hostility to landscape elements like mountains, sheer cliffs, and torrents that might under other circumstances be considered sublime? For instance, in the middle section of the poem Pringle draws our attention to a jagged ravine, carved out by brute force of water, and imposes on it the following parable:

> But the swoln water's wasteful sway,
> Like tyrant's rage, hath passed away,
> And left the ravage of its course
> Memorial of its frantic force.
>
> (lines 73–76)

The effect of this metaphor, which combines references to the transformation of sexual aggression, tyranny, and economic profligacy, is to suggest a Nature reduced to quiescence. The only explanation for this change is that the setting is being prepared to accommodate the settler family, conceived of as a center of gentle patriarchal control far removed from the violence associated with the actual colonial process. Because the transitional landscape being built up in the poem is ahistorical, any form of temporal reference—even geologic time, the time of erosion and sedimentation—is potentially threatening because it may remind of prior historical violence that prepared the way for this foreign invasion. Time, in other words, is experienced in a peculiar way. The settler landscape cannot afford the Romantic luxury of bathing in the past, in deep history, because the past is the domain of the Other, and history is the history of dispossession.

If we are to understand the functioning of landscape as, among other things, a category of ideological control, this means we cannot represent settler painters or poets confronting an uninscribed wilderness. Landscape, after all, exists *only* as a form of intertextuality; it is distinguished

as a special form of aesthetic ordering within a tradition. So, too, in the colonial context, the ontological problem of new prospects, new genera, and new races does not result in the formation of new *genres,* but instead in the persistence of what Edward Said calls a "textual attitude."[36] In fact, I would suggest that what we often find in the colonial landscape is an exaggerated form of *anaclisis,* or "propping," of one landscape paradigm upon another. Freud uses the term "anaclisis" to describe the way desires are propped upon instincts,[37] having the same site of articulation; this seems an entirely appropriate way of describing the often unconscious deployment of paradigms, in dependent association with one another and at the same site.

Some of the most interesting instances of the dependency of one paradigm upon another occur in Pringle's journal descriptions of his party's first days in South Africa. One especially pastoral moment in the text is followed by this meditation:

> On this and other occasions the scenery and productions of the country reminded us in the most forcible manner of the imagery of the Hebrew Scriptures. The parched and thorny desert—the rugged and stony mountains—the dry beds of torrents—"the green pastures by the quiet waters"— . . . "the roes and young harts . . . that feed among the lilies"—"the coney of the rocks"—"the ostrich of the wilderness"—"the shadow of a great rock in a weary land"; these and a thousand other objects, with the striking and appropriate descriptions which accompany them, recurred to us continually with a sense of their beauty and aptitude, which we had never felt before.[38]

So the biblical intertext provides a way of accommodating the foreign landscape within a "striking and appropriate" descriptive matrix already familiar to a wide audience. It has the additional ideological advantage of suggesting a biblical appropriateness to the continuance of missionary activity in South Africa; that sentiment, in turn, becomes part of the rhetoric used by the evolving colonial state.[39]

What I have termed "domestic space" in Pringle's landscape poems and descriptions is an effect dependent on the deployment of several landscape rhetorics. Perhaps the most dramatic example of this practice can be found in the lists of animals we commonly find in encyclopedic travels, used in the poem as a precedent for domestic harmony. Once this syntax begins, it can incorporate really surprising items. At one point, for instance, Pringle makes a strange narrative detour to describe what he calls "the loxia," a species of African weaver bird that closes and suspends its young

> In cradle-nests, with porch below,
> Secure from winged or creeping foe—
> Weasel or hawk or writhing snake;

> Light swinging, as the breezes wake,
> Like the ripe fruit we love to see
> Upon the rich pomegranate-tree.
>
> (lines 87–92)

This vignette marks the culmination of an ideological drive in the poem, yet it is also just the sort of detail one would expect in a travelogue. The pendant, woven nests of the African weaver were objects of intense fascination to many English travelers. For John Barrow, an employee of the first Cape Colony administration in the 1790s charged with surveying the territory won from the Dutch, weavers' nests occasion a lengthy discourse on reason, environmental conditioning, and the limits of Linnaean categories. "The same kind of birds in Northern Europe," he says, "having nothing to apprehend from monkeys, snakes, and other noxious animals, construct open nests."[40] Woven nests epitomize an adaptation to the environment so superior that Barrow speculates that there is perhaps a spirit in some animals "less a blind impulse of nature than a ray of reason."[41] For Pringle, in contrast, the contained, protective cradle that swings gently above floods and danger suggests an embowered "natural" family anticipating the white settler household adapted to South African conditions. Ironically, the desire for such a dwelling is a literalization of a common conceit found in many eighteenth-century topographical poems. In Cowper's *Task*, for instance, the observant wanderer regards a peasant's cottage with studied envy:[42]

> 'Tis perch'd upon the green hill-top, but close
> Environ'd with a ring of branching elms
> That overhang the thatch, itself unseen
> Peeps at the vale below; so thick beset
> With foliage of such dark redundant growth,
> I call'd the low-roof'd lodge the *peasant's nest*.
> And hidden as it is . . .
> Oft have I wish'd the peaceful covert mine.[43]

Whereas in *The Task* the speaker's enthusiasm fades upon discovering that the cottager has to trudge up the hill with buckets of water, Pringle's enthusiasm for "natural" dwellings continues through his poetry and journals. No such actual architecture predates the arrival of the settlers, so the figure of the peasant's cottage is replaced, literally, by the emblem of the weaver's nest.

"Evening Rambles" is an excursive poem, and a prospect poem, which, through a series of ideological shifts, produces a landscape apparently willing to admit the colonial presence. This presence is also figured as a patriarchal image of man free to roam and build his home in Nature, for

the place the wanderer returns to at the end is called "*our* wattled cot." Here the intrusion of the collective pronoun, for the first time in the poem, emphasizes the gendered nature of what has gone before, and woman on the colonial frontier as a site and locus of ideology rather than a presence that needs a landscape against which to act. The only significant portrait of Pringle's wife that I can find is Landseer's engraving to "The Bechuana Boy" (see fig. 5.5). In this illustration she peeps from the folds of the tent, almost an extension of that dwelling, hidden by its flaps and her cloak and bonnet. She has been called into the landscape because the narrative requires a maternal presence (the poem describes an orphaned Tswana boy who is to be adopted by the Pringle family). Whereas the men in the illustration appear in various states of picturesque repose, pipes lit, weapons at rest, a campfire audience for the boy's pathetic tale, it is to the woman as a maternal presence that the appeal is made.

Pringle's wife inhabits that space at the doorway of the tent precisely because she is associated with a sharpened sense of the gendered distinction between domestic interiors and the public sphere that the British settlers (as opposed to the older Dutch residents) carried with them. Without wanting to resurrect problematic connections between South Africa and some vaguely construed international order of "frontier" repre-

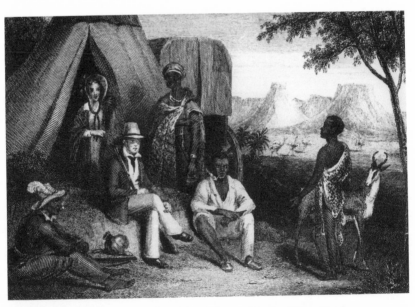

5.5 "The Bechuana Boy." Reproduced from Thomas Pringle, *African Sketches* (London, 1834).

sentation, it is probably true that women 1820 settlers were as much subject to the sharpening sexual division of labor as their American and European sisters. As Stephanie Coontz argues, the changes that by the 1830s resulted in a European and American "cult of domesticity" depend also on a greater fixity in gender relations: "The assignment of women to domesticity could be justified in a society [such as the American republic] that denied the social need for hierarchy only by an ideology that stressed the natural or organic origins of female roles."[44] What needs closer examination, therefore, *is the role played by landscape in the reproduction of a gendered distinction between domestic interiors and a male public sphere.* Pringle's wife inhabits the doorway of the tent. Other women have refused to submit passively to this assignment. Emily Brontë's *Wuthering Heights,* for instance, marks out domestic space as a place of claustrophobia and containment, and doors, windows, thresholds, lintels, and even the wind that is able to leak through broken panes are charged with significance, for they mark the point at which women break out of the house and begin to reassert their claim to represent themselves in the landscape.

I am always struck by the ease with which a gendered division of labor brings Pringle's poem to a close. The wattle-and-daub colonial home marks the end and the beginning of the male excursion, as the ego is drawn back into its object. A perhaps dramatic way of understanding this motif of easy passage through a tonally reduced landscape is to compare "Evening Rambles" with the most famous English poem that traces the return of a male wanderer to a rustic cottage—Wordsworth's "Strange Fits of Passion." Wordsworth's landscape depends on an intense libidinal cathexis, an imaginative projection onto the moon looming above the cottage in which the lover waits. When, in an effect of perspective, the moon drops below the cottage roof, the shock is of such intensity that the speaker imagines Lucy has died.

> What fond and wayward thoughts will slide
> Into a Lover's head!
> "O Mercy!" to myself I cried,
> "If Lucy should be dead!"[45]

Barbara Johnson tries to explain this uncanny moment by claiming that there is an attempted personification in the poem and that the moon "must be seeable as a correlative . . . of Lucy."[46] This reading cannot give a politics to Wordsworth's landscape. "Strange Fits of Passion," it seems to me, situates a male subject within a landscape system consisting of the moon (an object of cathexis), the wash of moonlight, and the cottage. It is *the cottage*—the stable, domestic site toward which the male journey bends—and not the moon, that is associated with the woman. Lucy *is*

the dwelling. The three elements—moon, moonlit landscape, and cot-tage—exist in a secure relation that temporarily supports and sustains the movement of the male subject; the shock of the moon's disappearance marks a moment of contradiction between constancy and inconstancy, the domestic and unbound libidinal investment. Whereas in Wordsworth's poem the journey through the countryside is associated with pent-up sexual and imaginative energy that is suddenly discharged, the entire proj-ect of Pringle's poem, which is focused on domesticity and the bourgeois family, is to create a landscape swept clear of such intensities.

Colonial Rusticity

Colonial landscape, considered either in painting or the picturesque sub-jects of poetry, is influenced by a set of economic conditions different from those experienced in the metropolis. Nonetheless, it does mark the expansion of a European aesthetic order into the world periphery during a period when capitalism was beginning to revolutionize its capacity to reproduce itself. Let us now turn to one aspect of the imported pictur-esque tradition that, more than any other perhaps, relies on class inflec-tions: the incorporation of references to rustic architecture.

When Pringle talks about his "wattled cot" (line 148), he is using a trope of rustic retirement common in the late eighteenth and early nine-teenth centuries. The difference is that this conceit has a real referent. Parts of Pringle's *Narrative of a Residence in South Africa* were serialized in the *Penny Magazine,* and in a descriptive article entitled "A Settler's Cabin in South Africa," he explained that the choice of a location for his first South African dwelling was influenced mainly by aesthetic consider-ations and only secondarily by the agricultural potential of the region. In this priority, he was not unique; almost without exception, the 1820 Albany settlers describe themselves as choosing sites with a view,[47] prompting one dour observer to remark: "The men of sentiment sought picturesque spots, where the beauties of nature might be seen to advan-tage, forgetting, however, sometimes to enquire whether they were within reach of water or not."[48] When they refer to dwellings, these settler jour-nals reveal an unyielding belief in the intimate connection between certain forms of cottage architecture and political privilege. Allusions to the sim-ple settler cottage, in other words, provide a surprising source of evidence for incipient class consciousness in Albany.

On the colonial frontier everyone is in a sense working within the rustic tradition of wattle-and-daub architecture.[49] Nevertheless, the class symbolism within the tradition does not disappear. Pringle himself de-cides to follow "the mode practised by the natives in their constructing

5.6 "The Emigrant's Cabin." Reproduced from Thomas Pringle, *African Sketches* (London, 1834).

their simple habitation," building a wicker-framed dwelling "in the shape of a bee-hive or sugar loaf."[50] (Significantly, in the frontispiece to his *African Sketches* the hut dominates the prospect and there is no white presence; romantic banditti are organized in a group portrait, fringed by aloes, under the gaze of the house; see fig. 5.6.) The wattle-and-daub method is eminently practical; moreover, through the incorporation of local architectural styles, it also allows the naturalization of an intrusive white presence. Yet the very tenuous nature of this dependency on local systems and indigenous forms is all too easily overlooked. Colonial settle-

ment, it should be stressed, first took place under a regime of mercantilism, a mode of production that depended, in Africa, on merchants inhabiting the interstices of local productive systems. Though the 1820 settlers could (and did) call down upon their enemies the wrath of British regiments, most of their dealings on the frontier were hesitant, insinuating, dependent, and parasitical, and their vernacular architecture bears traces of this tendency.

Once completed, Pringle's cottage continued to have a symbolic force that derives from the class semiotics of the metropolitan rustic tradition. In Humphrey Repton's Red Book for Blaise Castle, for example, we are reminded that cottages on large estates were associated with aristocratic control. A cottage, he says, must look like "the habitation of the labourer who has the care of the adjoining woods, but its simplicity should be the effect of Art and not of accident, it must seem to belong to the proprietor of the mansion and the castle, without affecting to imitate the character of either."[51] Viewed from outside, therefore, Pringle's cottage appears to be an indigenous and appropriate part of the landscape; from inside, its occupant is reminded of the architecture of a more leisured class: "The cabin and its rude furniture had somewhat the aspect of a rustic summer house or grotto."[52] This is an ideal of upward mobility secretly cherished by many settler patriarchs.

Cottage architecture is a key signifier in the rustic tradition. That the class semiotics associated with this form of architecture and celebrated in Gainsborough and Constable continues to operate in the colonies is perhaps not surprising. What is especially interesting, though, is the manner in which such symbolic pre-texts are used in newly political ways. George Thompson, a traveler whose *Travels and Adventures in Southern Africa* introduced Pringle's poetry to a wide audience, including an admiring Coleridge, seems fascinated by Albany cottages. "The vignette prefixed to this chapter," he says, "will give the reader some clearer idea of the scenery of Albany, and of the picturesque cottages with which *the superior class of settlers* have now, in some places, embellished it" (emphasis mine; see fig. 5.7).[53] Underlying this description is the common stereotype of the resilient English yeoman. What Thompson seems to forget, however, is that by 1822 many artisans had given up the idea of scratching a living from the earth and had moved to towns.[54]

While for Thompson, Albany cottages are symbols of rustic retirement and class distinction, they are also sites of ideological dissemination, points from which the English standards of taste and civility radiate out into the loneliness. Unlike their Dutch counterparts, it is common for eighteenth- and early nineteenth-century British writers to behave as though public opinion begins with a select group of enlightened men

5.7 "A settler's cottage in Albany." Reproduced from George Thompson, *Travels and Adventures in Southern Africa* (London, 1827).

and then is disseminated outward; public opinion is, as one Georgian commentator described it, "that sentiment on any given subject which is entertained by the best informed, most intelligent and most moral persons in the community, which is gradually spread and adopted by nearly all persons of any education or proper feeling in a civilized state."[55] But on the frontier, no such community exists. Discharged upon the beach at Port Elizabeth, various classes of people, including gentry "seated . . . with books in their hands," "fishermen and sailors, from the Thames, and English seaports, with the reckless and weatherbeaten look usual in persons of their perilous and precarious professions," as well as "pauper agricultural labourers," were mingled roughly together.[56] Anticipating the problems of consensus bound to arise from this remarkably confused new class dispensation, Pringle goes to pains in poems like "The Emigrant's Cabin" to describe a community of civilized opinion in the surrounding district that might make up an incipient public sphere. Answering the complaint that he has come to side with "insane Rousseau" by taking literally a Virgilian trope of retirement meant originally to keep the sequestered poet "always within reach of Books and Men," Pringle enumerates the various men of cultured mind within a day's ride of his cottage. With such cultivated friends, he muses, one might establish a model com-

munity of Whiggish sensibility. In a spirit of class and gender solidarity, the men might then roam the savage landscape

> From Winterberg to Gola's savage grot,
> Talking of Rogers, Campbell, Coleridge, Scott,
> Of Fox and Mackintosh, Brougham, Canning, Grey;
> And lighter themes and laughter cheered the way—
> While the wild-elephants in groups stood still,
> And wondered at us on their woody hill.[57]

Finding friends with whom one shares a taste for literary subjects is the first step toward establishing a coherent body of public opinions upon which the emergent colonial administration depends.

Settler dwellings, I have been arguing, are symbolically associated with the emergence in South Africa of a bourgeois public sphere, that realm that Habermas associates with "public discussions that are institutionally protected and that take, with critical intent, the exercise of political authority as their theme."[58] Most important of all, perhaps, cottages are the ultimate marker of secure domesticity, figured in the image of the woman enclosed within. Consider the widowed Mrs. Campbell, settled, according to Thompson, in a "neatly ornamental cottage [that], though constructed only of wattle and plaster, had a most pleasing and picturesque appearance, surrounded by luxuriant woods and copses of evergreens, in the disposal of which the wanton hand of nature seemed to have rivalled the most tasteful efforts of art."[59] One might even go so far as to suggest that the widowed Mrs. Campbell, as a commodity with sexual value in the predominantly masculine colony, is represented by her dwelling; she is synecdochally associated with domestic space, while sexuality is displaced into the "wanton" gestures of nature, themselves settling into the picturesque when they approach the house. Thus the cottage tradition assures the gendered division of symbolic space, with white males controlling access to the public domain and to the exchange of women.

Conventions of rusticity, with all their ideological baggage, are used to distinguish and stabilize class and gender distinctions in the potentially volatile Albany district. But apart from their potential for masking contradictions, they can also be used to *add* value to what does not yet participate in a symbolic system. George Thompson's description of the farm Thornhill, for instance, refers to the overall situation "with lawns and copsewoods, laid out by the hand of Nature, that far surpass many a nobleman's park in England" (see fig. 5.8).[60] This observation reveals Thompson's interest in the new possibilities for class mobility on the frontier. Nature itself appears to have marked the landscape with copses and lawns, signs of the aristocratic landowner's improving hand. This

gradual intrusion of a grammar of class is also characteristic of British settler landscapes in Australia. "The picturesque," says Paul Carter, "and trees in particular, were endowed with the newcomers' own highest aspirations."[61]

Even in Thompson's parkland prospect, the ideal of rustic retirement is not so much forgotten as displaced. Referring the reader to his drawing of Thornhill, he tells us that it is the hilltop cottage belonging to the son-in-law that is the true wonder of the estate, commanding "a prospect scarcely, I think, to be rivalled in Africa for rich and romantic scenery."[62] Many of the contradictions contained within the transplanted rustic tradition are neatly arrayed in this description. The picturesque surrounds are gentrified, as though by the hand of nature, but *the cottage,* as a site of rustic retirement and Whiggish value, survives beside the house in a displaced form. Symbolic power is thus also transmitted in patrilineal fashion from the landowning father to the son. Once again (for the third time, in fact, in the set of illustrations used for this chapter), we see in this etching a house on a prospect dominating a foreground in which there are rural figures, arranged as though we are chancing upon them. Like its British counterpart, the colonial picturesque depends in complicated but historically specifiable ways on the control of labor.

The Place of Slaves

Let us consider the relationship between the popular picturesque, which became part of the traffic of representations between core and periphery in the late eighteenth century, and changing economic conditions in Britain's colonies. Not surprisingly, these changes are most visible at the point of maximum attrition, in the contradiction between capital and the extraction of labor power.

Why did the British government embark upon the 1820 colonial settlement scheme? There are a number of conflicting answers to this question, most of them wittily highlighted by Cruikshank's cartoons. Britain first gained control of the Cape from the Dutch state in 1795, ceded it back to the Batavian republic under the Treaty of Amiens, then retook it by force in 1806 in what was to be one of the most protracted of the African colonial occupations. To oversimplify massively, we may say that the Albany settlement scheme was influenced by three factors. First, a severe recession in the post–Napoleonic War economy in England led to widespread unemployment and working-class unrest; this plus reform agitation presaged the Peterloo Massacre of 1819. To many, therefore, colonial settlement schemes were a vent for working-class frustration. Second, the proposed Eastern Cape settlement area was a place of serious strife that

had pitted frontier farmers and British regiments against disciplined but lightly armed Xhosas, who died by the thousands. Without their knowledge, the settlers were to be placed in Albany to act as a sort of *cordon sanitaire* against the displaced Xhosa communities. The third related reason for encouraging settlement—through direct funding, free passage, and grants of land—was to try to alleviate the serious shortage of colonial labor. White working-class settlers would, it was hoped, provide additional labor power, while the better class of settler would help shore up and Anglicize a culture that up to then had been predominantly Dutch.

The importation of settlers was thus an attempt to establish British hegemony in the new colony and an effort to solve contradictions in a system based on the exploitation of indigenous labor that was always drifting away from the land. Consciously or unconsciously, this influx of

5.8 "Thornhill, near Port Frances."
Reproduced from George Thompson,
Travels and Adventures in Southern Africa
(London, 1827).

whites was supposed to stimulate changes in social relations that would make the appropriation of labor power easier. A first step in that direction had to be the confrontation between the older feudal patriarchy that had predominated in Cape agriculture since the Vereenigde Oost-Indische Compagnie (Dutch East India Company) arrived, and the developing laissez-faire ideology of the merchant classes.[63]

The colonial economy in the 1820s was at a point of considerable stress. Relying as they did upon indigenous trade systems, and depending on inhabitants of the region for raw materials, stock, and, above all, labor, the settlers were in an extremely vulnerable position.[64] The problem of labor was a massive one. No economy of the day, least of all one dependent upon a Khoisan population that could drift away and form alliances with the aggrieved Xhosa nation, could develop simply with a system of

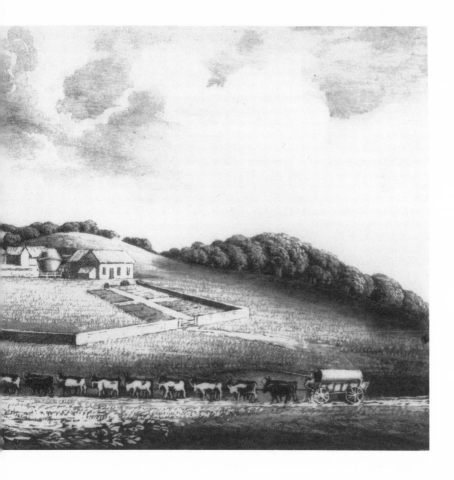

indentured, coerced labor, or debt peonage, such as existed on Boer farms. Workers had to be relatively free to sell their labor power as a commodity, at the same time being encouraged to do so by ideological constraints and conditions of dependency. In this crucial transitional period, a series of legislative changes became necessary:

[The] new thinking was embodied in the so-called Commission of Eastern Enquiry, appointed in 1822, to root out the mercantilist detritus of the former Dutch colonies. They produced a series of wide-ranging recommendations designed to break the feudalistic hold of the Cape Dutch oligarchy; to liberalise production, trade and land tenure; and to create a rational and impartial bureaucracy capable of administering a free market economy. They vigorously condemned all forced labour practices, believing that these rendered the Afrikaner masters indolent and unenterprising and discouraged the Khoikhoi working classes.[65]

British antislavery rhetoric was used to justify the attempt to control farm labor in a more sophisticated way. Consequently, in the Cape Colony at this time (and also, I might add, in other settler economies such as Australia and New Zealand) the twin concepts "labor" and "freedom" are themselves heavily overdetermined.[66] This overdetermination is clearly visible in the management of rustic figures in the colonial landscape tradition.

Let us now return for the last time to Pringle's "Evening Rambles" as an exemplification of the colonial landscape poem. We have already seen how the manipulation of the metropolitan landscape tradition enabled the naturalization of the settler presence. However, a real sense of domestic possibility and existential rootedness is possible only through the violence done to competing indigenous meaning. For this reason, rival human presences are a problem in the colonial landscape; the management of representative rural laborers such as those we see in Pringle's poem is revealing of other complicated attempts to reach ideological consensus on control over the labor process.

When Pringle reaches his high vantage point on a Romantic cliff overlooking the Glen-Lyndon valley, he is reminded of the earlier displacement of humans from this locale. His meditative seat, he reminds us, is overlooked by the "Bushman's Cave / (His fortress once, and now his grave)" (lines 55–56). In picturesque landscapes such as this, human presences are admitted only in a controlled and coded way, but a complication is represented by the "Bushman" (the common racist appellation used to describe Khoisan hunter-gatherer communities of the Cape) because he is a reminder of genocide against a people who competed with the Dutch free burghers and trekboers for hunting grounds.[67] The point of the description is to control its value as a political symbol. Although Pringle himself ordered armed expeditions against actual Khoisan commu-

nities on his property,[68] the Bushman is only a felt presence here, a ghost of a past epoch rather than part of present history, reminiscent of the many spectral presences that animate Wordsworth's landscapes or statues of hermit figures dotted about aristocratic landscape gardens.[69]

Why is this not a Wordsworthian landscape, in which, after all, the felt presence of the past crowds in upon consciousness? Perhaps the best answer to this difficult question lies in Geoffrey Hartman's account of the "epitaphic origins" of the Romantic lyric: "There is, moreover, a general convergence of elegiac and nature poetry in the eighteenth century. Poems about place (locodescriptive) merge with meditations on death so that landscape becomes dramatic in a quietly startling way. . . . Not only is the graveyard a major locus for the expression of nature sentiment, but Nature is herself a larger graveyard inscribed deeply with evidences of past life."[70]

The Romantic nature lyric is based on an association of place and inscription best represented in epitaph. Whereas in Wordsworth it is possible for History to take the form of *memento mori,* in the discovery that "the corpse is in the poet himself, his consciousness of inner decay,"[71] it is not possible for settler consciousness to manage landscape in the same way. Death, for Wordsworth, may be internalized; for Thomas Pringle, confronted by the "Bushman grave," death must be deflected. Similarly, because locodescriptive poetry is poised between narration and epitaph, it often describes the poet's trajectory back to a previously inscribed place—a familiar seat with "lines" on it, for instance. Colonial landscapes are far less tolerant of this metaphor, as they are, for all intents and purposes, *at war* with the idea of prior inscriptions.

Pringle's "Bushman," or rather his eerie, echoing cave, reminds of two other elements: it is a habitation that rivals the enclosing cottage at the end of the poem, and it is a sign, like the jagged ravine earlier in the poem, of a destructive force that has now passed. By denying the Bushman coeval existence and by seeing him through a veil of nostalgia, the poet displaces blame for the problem backward in time toward the Dutch past while at the same time removing a rival consciousness from the present dramatic context. Most ironic of all, even though we know from his journal that there were caves with San paintings in them on Pringle's farm, the poet performs another act of containment by placing the Bushman outside symbolic systems through his contiguous association with the "grim satyr-faced baboon" that now occupies the site.

Several writers on landscape have sought to provide generalized psychological explanations for the recurrence of "habitats" such as shady bowers and caves in landscape painting. Jay Appleton, for example, suggests that orifices such as caves or chasms "which allow a creature to enter physically into the fabric of the earth, are obviously potent refuge

symbols."[72] This claim is part of Appleton's now-famous "prospect-refuge" theory of landscape, which postulates that "because the ability to see without being seen is an intermediate step in the satisfaction of many . . . [biological] needs, the capacity of an environment to ensure the achievement of *this* becomes a more immediate source of aesthetic satisfaction."[73] My discussion of Pringle's cave will, I hope, reveal the inherent danger in such approaches. To relegate elements of landscape to some vaguely construed theory about the archetypal past is to ignore the political functioning of such topoi. Caves and refuges mark an attitude toward property as well as aesthetics as much apparent in Coleridge as it is in South African colonial landscapes. When Le Vaillant traveled up the west coast of South Africa, he stayed in a cave known as the Heerenloge-ment (Gentleman's lodging), and he painted his name in white lettering visible to this day on the walls of the shelter. Later explorers followed his example. Similarly, Pringle's remarks on the "bushman" cave inspired later artists and visitors to South Africa. Thomas Baines, a professional expedition painter who visited the Eastern Cape in 1849, depicts himself in the same site, sketching the Khoisan rock drawings. Clearly visible in the upper left-hand corner of the cave is the name "T. Pringle" (see fig. 5.9). It is not "man the predator" who has an innate need to occupy the various dark crannies depicted in landscape painting. Rather, the view from on high, or from inside a cave, or between the trees, remains unmistakably that of a historical subject concerned to write his or her symbolic presence, despite previous inhabitants.

Once the colonial landscape has been domesticated in the form of a benevolent prospect, it can be repopulated with representative laborers coded according to older pastoral conventions. The "Bushman" is the first of three allegorical portraits in the poem. Next in the managed parade of representative types is the "brown Herder," set in deliberate contrast to the pastoral archetype of a Scottish shepherd: "For crook the guardian gun he bears, / For plaid the sheep-skin mantle wears" (lines 103–4; see fig. 5.10). There is a dangerous ambiguity here between the colonial landscape as a secure pastoral retreat, on the one hand, and a place of material danger and real labor, on the other. Pringle is certainly referring to a Khoikhoi herder here, someone he would have called a Hottentot.[74] The ostensible purpose of the portrait is to awaken antislavery sentiment:

> No flute has he, nor merry song,
> Nor book, nor tale, nor rustic lay,
> To cheer him through his listless day.
> His look is dull, his soul is dark;
> He feels not hope's electric spark.

(lines 106–10)

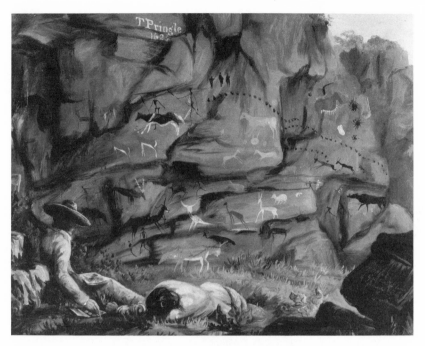

5.9 Thomas Baines, "Bushmans Krantz, Baviaans River." Courtesy Africana Museum, Johannesburg.

Sympathy is encouraged through the use of litotes, the listing of negative features to distinguish the herdsman from conventional pastoral portrayals. Not surprisingly, the effect is also to drain him of life and remove him as a competitive presence from the phenomenological field in which the colonial self, and the colonial eye, is excursive.[75] Moreover, no rival music, oral tradition, or representation is tolerated, and it is only at the expense of this dramatic *elision of all other thought* that the speaker continues his "thoughtful strain" till the end of the poem.[76] Thus the living tradition of Khoikhoi song and poetry acknowledged by Comões in his sixteenth-century epic *The Lusiads* is completely effaced.

To be fair, Pringle was an ardent abolitionist concerned to encourage sympathy for exploited labor. Nevertheless, an economic imperative moves like a hidden undertow through much of his poetry. "Evening Rambles" attempts to control a variety of contradictions by linking Whiggish conceptions of liberty and free passage of the eye to a conception of landscape reminiscent of Addison. As I have already suggested, the valorization of circulation and movement in the colonial prospect poem usually acts as a form of support for liberal ideology. Later in the century,

it may serve to bolster laissez-faire and free-trade rhetoric, for precapitalist economies can advance only after workers are freed, so that surpluses can be expropriated in the labor process.[77] A change in the rhetoric of mercantilism, however, does not account completely for contradictory attitudes toward freedom of movement or the critical labor shortage experienced in the colonies. Pringle and his party would have been prevented by statutes like the Caledon Code from owning slaves, and indentured

5.10 "The old Hottentot herdsman." Reproduced from George Thompson, *Travels and Adventures in Southern Africa* (London, 1827).

labor was "largely restricted to Boer employers."[78] The problem for the settlers boils down to how to acquire a stable labor force *without at the same time appearing to enslave people*. For Pringle and his party, a solution was found through political sleight of hand. A group of Khoisan workers on a neighboring farm were released onto the market because the Boer landowner to whom they were indentured suddenly died. "By this means," Pringle boasts, "we greatly strengthened our own hands, while at the same time the satisfaction of protecting and benefiting these oppressed and despised people."[79] So the Scottish party literally takes over an older, paternalistic form of tenant labor, and the new relationship is justified through proabolitionist rhetoric.

Albany settlers could not themselves provide a solution to the labor problem. Indeed, the speculative settlement scheme that had brought them to the Cape was riddled with a variety of contradictions, not least of which was a hundred-acre limit placed on land grants meant to prevent their shifting away from agricultural production to stock farming.[80] Yet despite laws that restricted their movement, settlers left the territory in droves, while those who remained looked desperately at indentured Khoisan labor or the untouched Xhosa reserves across the borders. In sum, the popular rustic landscape tradition was used in the colonies to give ideological support to the notion of free settlement and labor; at the same time, this masked a mass of legislation that bound both settlers and their work force to narrow terrain. The longing for some sort of compromise, figured as a labor force that is somehow both free and bound to service by noncoercive forces, is a fantasy that can be fulfilled only by real changes in capitalist relations. These start to emerge first with the introduction of Ordinance 49, which permitted limited influx of African labor from beyond the frontier, and Ordinance 50 of 1828, which granted the Khoikhoi freedom to own land and not carry passes.[81] Even more crucial, ironically, was the transition to sheep farming, the very practice that had displaced so many Scots peasants from their Highland farms in the previous century.

Before these crucial changes took place, colonial landscapes often represented control over laborers as an extension of paternal care (see fig. 5.11). In Samuel Daniell's wonderfully languid painting of a Dutch homestead, the house is in a controlling position on a rise. It is a pleasantly rustic scene, with farm implements, wagons, and reflective water. But the laborers are figured in ambiguous fashion. They are very much the evening-returning herders of Gray's elegy and the rustic painting tradition; this is also a family group, however, and they are using an indigenous means of transportation—the riding ox. Indigenous labor, in such landscapes, inhabits a liminal zone between being under paternal control and exhibiting the freedom of migrant pastoralism. In other words, Daniell's land-

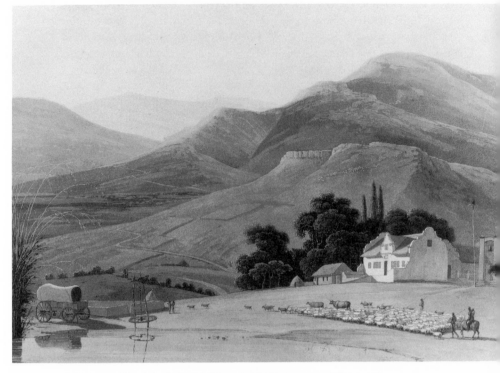

5.11 Samuel Daniell, "A Boor's House" (1805). Courtesy Africana Museum, Johannesburg.

scape portrays another one of those transitional moments between bound and free wage labor. It is an unconscious meditation on deep structural contradictions inherent on the frontier.

One last puzzle remains, in this explanation of how the rustic landscape tradition in the colonies differs from its British counterpart. The final herder Pringle refers to in his typology is someone described as a "poor heathen Bechuan" and a "naked, homeless exile . . . not debased by Slavery" (lines 119, 121–22). The origin of this portrayal is complex. Clearly Pringle is referring to refugees from the Difaqane wars in the North, an increasing number of whom were beginning to encroach on the Cape Colony. Colonial state officials viewed this tremendous historical upheaval as a potential source of labor, and in fact refugees were encouraged to head for Albany.[82] Whether we agree with the conventional understanding of this period—that is, an understanding that the highly militarized Zulu state burst upon the interior in a series of terrible raids (the *mfecane*), triggering waves of civil war between peoples displaced by Shaka—or

whether we follow the more radical new Cobbing thesis that describes the motor force behind this upheaval as a combination of slave-raiding expeditions from the Eastern Frontier itself and westward slave raiding by the Delagoa Bay whites, either way, large numbers of refugees began to enter the Cape Colony during the early 1820s. Previously, all trade and exchanges with Africans—then called *caffres*—were strictly forbidden, but in 1828 (after the promulgation of Ordinance 49), these laws were lifted.[83] Pringle's portrayal of the herder "not debased by Slavery" is therefore significant because the poem sets up a scale of value in which the Tswana laborer is accorded a high degree of relative value because he "serves the Colonist for bread."[84] In other words, the parade of pastoral laborers, which seems at first to acquire value from meanings embedded in the rustic tradition, is also coded according to a scale of *economic* distinction that placed a high premium on labor that was free to enter into contractual relationships with the British settlers and that valued workers unsullied by contact with feudal Dutch labor practices. It is at this level of abstraction that the imported landscape tradition exhibits both anaclitic reliance on painterly conventions and a historically identifiable attitude to indigenous production.

The ostensible purpose of the laws against dealing with Africans was to defend colonists from the depredations of the Xhosa nation, forced after years of bloody strife to desert their lands and occupy an area east of the Fish River. There again, however, an economic logic underwrote what on the surface seemed to be an innocent form of protectionism. It was also argued that Africans represented a rival pastoral mode of production that had been disrupted, one that would now seek to reconstitute itself by appropriating settler livestock. Art historians dealing with the question of race could well draw a lesson from this example. When considering the representation of Africans in the colonial landscape, we should not restrict ourselves to identifying stereotypes or racist portrayals. To make any progress at all, says Homi Bhaba, "the point of intervention should shift from the *identification* of images as positive or negative, to an understanding of the *process of subjectification* made possible . . . through stereotypical discourse."[85] Across a broad range of articles, colonial discourse theorists now agree that it is necessary to analyze the articulation of race, gender, and class asymmetries rather than describe their functioning in isolated instances. The rivalry between different relations of production, for instance, is clearly linked to the problem of race in the colonial landscape poetry and landscape painting of the time. When it deals with the problem of Xhosa dispossession and rival subsistence economies, colonial verse like "Evening Rambles" tends to react quite sharply. Even Pringle, the most liberal commentator of the period, views the *caffre* primarily

as a problem of surveillance and hence associated with dark places in the landscape and restricted vision:

> Lo! where he crouches by the cleugh's dark side,
> Eyeing the farmer's lowing herds afar;
> Impatient watching till the Evening Star
> Lead forth the Twilight dim, that he may glide
> Like panther to the prey.[86]

The interplay between darkness, race, and visibility is a continuing tension in colonial painting; it is perhaps also anaclitically related to the compositional habit in English landscape painting that relegated rural laborers to the shadowy side of the canvas.[87] However, this metonymic association of Africans and dark, rough, or wild elements of the landscape goes beyond painterly conventions as well as the Manichean rhetoric of embodiment so commonly alluded to in studies of colonial discourse.[88] Even in the most domesticated settler landscapes, one is reminded of Foucault's assertion that power "has its principle not so much in a person as in a certain concerted distribution of bodies, surfaces, lights, gazes."[89] In l'Ons's "Settler Encampment," significantly, the placement of the black servants in a thicket, with aloes in the background, echoes another separation—the gendered division of labor (see fig. 5.12). In fact the space in this painting is quartered according to race and gender asymmetries, with the highest value accorded to white male sociality; male and female spheres are carefully delineated according to various symbolic practices such as drinking, tea making, guarding, and cooking. Women are excluded from the field of productive labor, while the black servants are completely excluded from all forms of exchange other than the metonymic association of the man's loneliness and the dark little fire into which he stares. This painting reminds us that in order to understand settler racism, we need to see its connection with incipient class formation on the colonial frontier; that in turn means we should examine relations of production, reproduction, and consumption, and the connection between domesticity and labor, within the colonial household itself.

After his years in the Cape and his brush with the power of the colonial authorities, Pringle returned to London a ruined man. With him were his wife and the young "Bechuana" boy they had adopted, who died soon after of a pulmonary complaint. The manipulation of landscape conventions such as the picturesque, the prospect poem, the excursion, and the depiction of rustic life that we see throughout Pringle's *African Sketches* is fundamental to the development of liberalism and laissez-faire rhetoric in South Africa. Even more pertinent, though, is the patriarchal structuring of gender relations and the management of images of labor that we

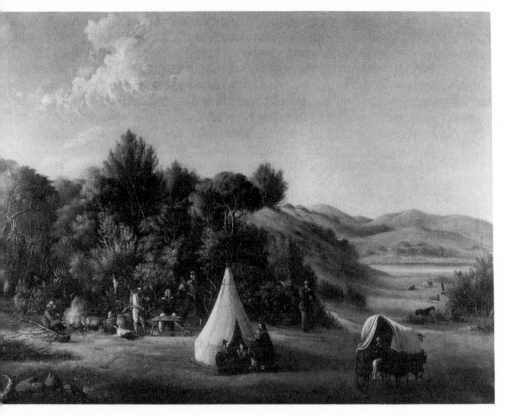

5.12 F. T. I'Ons, "1820 settlers camped on the Great Fish River." Courtesy William Fehr Collection, Cape Town.

see throughout his work. The Albany settlement marked the first stage of a story that had its next chapter set in Natal. Working hand in glove with British settlers, the colonial state helped to develop a highly efficient system of management, surveillance, and repression of the Zulu labor force that for many historians signals the beginning of apartheid's labor practices and modern racial capitalism. Natal is a repetition of the Eastern Cape in that the emerging colonial state depended heavily on liberal rhetoric and the ideology of free trade. The pictorial tradition that emerged in this region was very different from the picturesque landscapes of the 1820s. Nonetheless, it too relied upon the manipulation, for political effect, of metropolitan landscape conventions. Having dwelt on the complexity of these transmitted traditions and their role in the transformation of colonial consciousness, it is our task now to trace their displacement

into canvases hung in settler homes as far afield as Sydney, Mauritsstad, Batavia, New Delhi, and Curaçao,[90] or wherever the work of landscape spreads.

Appendix: Thomas Pringle, "Evening Rambles"

The sultry summer-noon is past;
And mellow Evening comes at last,
With a low and languid breeze
Fanning the mimosa trees,
5 That cluster o'er the yellow vale,
And oft perfume the panting gale
With fragrance faint: it seems to tell
Of primrose-tufts in Scottish dell,
Peeping forth in tender spring
10 When the blithe lark begins to sing.

But soon, amidst our Lybian vale,
Such soothing recollections fail;
Soon we raise the eye to range
O'er prospects wild, grotesque, and
 strange;
15 Sterile mountains, rough and steep,
That bound abrupt the valley deep,
Heaving to the clear blue sky
Their ribs of granite, bare and dry
And ridges, by the torrents worn,
20 Thinly streaked with scraggy thorn,
Which fringes Nature's savage dress,
Yet scarce relieves her nakedness.

But where the Vale winds deep
 below,
The landscape hath a warmer glow:
25 There the spekboom spreads its
 bowers
Of light-green leaves and lilac
 flowers;
And the aloe rears her crimson crest,
Like stately queen for gala drest;
And the bright-blossomed bean-tree
 shakes
30 Its coral tufts above the brakes,

Brilliant as the glancing plumes
Of sugar-birds among its blooms,
With the deep-green verdure
 blending
In the stream of light descending.

35 And now, along the grassy meads,
Where the skipping reebok feeds,
Let me through the mazes rove
Of the light acacia grove;
Now while yet the honey-bee
40 Hums around the blossomed tree;
And the turtles softly chide,
Wooingly, on every side;
And the clucking pheasant calls
To his mate at intervals;
45 And the duiker at my tread
Sudden lifts his startled head,
Then dives affrighted in the brake,
Like wild-duck in the reedy lake.

My wonted seat receives me
 now—
50 This cliff with myrtle-tufted brow,
Towering high o'er grove and
 stream,
As if to greet the parting gleam.
With shattered rocks besprinkled
 o'er,
Behind ascends the mountain hoar,
55 Whose crest o'erhangs the
 Bushman's Cave,
(His fortress once, and now his
 grave,)
Where the grim satyr-faced baboon
Sits gibbering to the rising moon,
Or chides with hoarse and angry cry

60 The herdsman as he wanders by.

Spread out below in sun and
 shade,
The shaggy Glen lies full
 displayed—
Its sheltered nooks, its sylvan
 bowers,
Its meadows flushed with purple
 flowers;
65 And through it like a dragon spread,
I trace the river's tortuous bed.
Lo there the Chaldee-willow weeps,
Drooping o'er the headlong steeps,
Where the torrent in his wrath
70 Hath rifted him a rugged path,
Like fissure cleft by earthquake's
 shock,
Through mead and jungle, mound
 and rock.
But the swoln water's wasteful sway,
Like tyrant's rage, hath passed away,
75 And left the ravage of its course
Memorial of its frantic force.
—Now o'er its shrunk and slimy
 bed
Rank weeds and withered wrack are
 spread,
With the faint rill just oozing
 through,
80 And vanishing again from view;
Save where the guana's glassy pool
Holds to some cliff its mirror cool,
Girt by the palmite's leafy screen,
Or graceful rock-ash, tall and green,
85 Whose slender sprays above the
 flood
Suspend the loxia's callow brood
In cradle-nests, with porch below,
Secure from winged or creeping
 foe—
Weasel or hawk or writhing snake;
90 Light swinging, as the breezes wake,
Like the ripe fruit we love to see
Upon the rich pomegranate-tree.

But lo, the sun's descending car
Sinks o'er Mount-Dunion's peaks
 afar;
95 And now along the dusky vale
The homeward herds and flocks
 I hail,
Returning from their pastures dry
Amid the stony uplands high.
First, the brown Herder with his
 flock
100 Comes winding round my
 hermit-rock:
His mien and gait and vesture tell,
No shepherd he from Scottish fell;
For crook the guardian gun he
 bears,
For plaid the sheep-skin mantle
 wears;
105 Sauntering languidly along;
Nor flute has he, nor merry song,
Nor book, nor tale, nor rustic lay,
To cheer him through his listless
 day.
His look is dull, his soul is dark;
110 He feels not hope's electric spark;
But, born the White Man's servile
 thrall,
Knows that he cannot lower fall.

Next the stout Neat-herd passes
 by,
With bolder step and blither eye;
115 Humming low his tuneless song,
Or whistling to the hornèd throng.
From the destroying foeman fled,
He serves the Colonist for bread:
Yet this poor heathen Bechuan
120 Bears on his brow the port of man;
A naked, homeless exile he—
But not debased by Slavery.

Now, wizard-like, slow Twilight
 sails
With soundless wing adown the
 vales,

125 Waving with his shadowy rod
The owl and bat to come abroad,
With things that hate the garish sun,
To frolic now when day is done.
Now along the meadows damp
130 The enamoured fire-fly lights his
lamp;
Link-boy he of woodland green
To light fair Avon's Elfin Queen;
Here, I ween, more wont to shine
To light the thievish porcupine,
135 Plundering my melon-bed,—
Or villain lynx, whose stealthy tread
Rouses not the wakeful hound
As he creeps the folds around.

But lo! the night-bird's boding
scream
140 Breaks abrupt my twilight dream;
And warns me it is time to haste
My homeward walk across the
waste,
Lest my rash tread provoke the
wrath
Of adder coiled upon the path,
Or tempt the lion from the wood,
That soon will prowl athirst for
blood.
—Thus, murmuring my thoughtful
strain,
148 I seek our wattled cot again.

Notes

1. Richard Burton, "Zanzibar; and Two Months in East Africa," *Blackwoods Edinburgh Magazine* 83 (1858): 282.

2. Ann Bermingham, *Landscape and Ideology: The English Rustic Tradition, 1740–1860* (Berkeley, Calif., 1986), 3.

3. An influential formulation of this thesis is Homi Bhaba's argument that "in order to conceive of the colonial subject as the effect of power that is productive—disciplinary and 'pleasurable'—one has to see the *surveillance* of colonial power as functioning in relation to the regime of the *scopic drive*" ("The Other Question," *Screen* 24, no. 6 [1983]: 28).

4. H. Rider Haggard, *Allan Quatermain* (New York, 1951), 421.

5. The massive proliferation of missionary accounts of Southern Africa and, after mid-century, imitative adventure stories eventually flooded the market. Writers like Haggard and Joseph Conrad were conscious of having to pander to the public taste for superficial adventure tales, and both drew extensively on their African experiences. This is, most crucially, a question of commodities and changing markets under imperialism. By the turn of the century, Haggard complained that the "butterfly Romance" had ceased to be a rare capture: "Now travelling is cheap, hundreds handle the net, and all come with something that is offered for sale under the ancient label" (*The Days of My Life* [New York, 1926], 2:95).

6. Raymond Williams, *The Country and the City* (London, 1973), 284.

7. The reference here is to the Robinson edition of 1790, generally regarded as a more reliable translation than the William Lane edition of the same year (François Le Vaillant, *Travels into the interior parts of Africa, by the way of the Cape of Good Hope; in the years 1780, 81, 82, 83, 84 and 85,* 2 vols., anonymous translation [London: G. G. J. and J. Robinson, 1790]).

8. Carole Fabricant makes the interesting claim that eighteenth-century gardens "were divided up into discrete pictures or dramas readily apprehendable by

the eye" ("Binding and Dressing Nature's Loose Tresses: The Ideology of Augustan Landscape Design," *Studies in Eighteenth Century Culture* 8 [1979]: 114). Despite Le Vaillant's hostility to the landscape gardening tradition, his sense of the theatrical in Nature is clearly influenced by a European habit of mind that understands landscape in terms of manufactured views.

9. This is Ann Bermingham's term (*Landscape and Ideology*, 83–85). Whereas she is referring particularly to the influence of Gilpin's guidebooks, I mean here to suggest a form of landscape convention that lends itself to commoditized and easily reproducible views. In Le Vaillant's case, the engraver leans heavily on conventions of spatial organization that have their origins in shorthand versions of the Claudian landscape.

10. Patrick Cullinan, *Robert Jacob Gordon, 1743–1795: The Man and His Travels at the Cape* (Cape Town, 1992), 104. In this discussion I am reliant on Patrick Cullinan's meticulous scholarship, fieldwork, and detection skills. For an intriguing account of Enlightenment travel in Southern Africa, see his *Robert Jacob Gordon*, which includes a fuller explanation of the squabble between Le Vaillant and Gordon (104–5).

11. Ibid., 104. Later English explorers hostile to Le Vaillant also tried to undermine his claim that he shot a giraffe. Part of the problem stems from his illustrator's reliance on the inaccurate representation of giraffe anatomy in Buffon's *Histoire naturelle*. There was widespread plagiarism of illustrations during this period, but the controversy was an important one because it epitomized the Enlightenment belief in the objective transmission of knowledge from field experience to the encyclopedias. For a fuller discussion of this subject, see Jurgens Meester, "Le Vaillant's Mammal Paintings," in *François Le Vaillant, Traveller in South Africa*, 2 vols., ed. J. C. Quinton and A. M. Lewin Robinson (Cape Town, 1973), 2:1–26; Vernon S. Forbes, "Le Vaillant's Travels in South Africa, 1781–4," in ibid. 1:31–110; Cullinan, *Robert Jacob Gordon*; and idem, "Robert Jacob Gordon and Denis Diderot: The Hague, 1774," *Quarterly Bulletin of the South African Library* 43, no. 4 (June 1988): 146–51. Foucault's *Order of Things* (New York, 1970) still provides the definitive account of the relationship between taxonomies and epistemology.

12. See Bermingham, *Landscape and Ideology*, 14–33.

13. I am grateful to Joseph Roach, who alerted me to this connection, a more selfless gesture than one might at first imagine, since Roach uses the illustration on the cover of his fascinating book. His comments on neoclassical stage images of the universal passions are especially helpful for understanding the coding of gesture in Enlightenment travels. See especially Roach, *The Player's Passion: Studies in the Science of Acting* (Newark, Del., 1985), 66–92.

14. Mary Louise Pratt, "Scratches on the Face of the Country; or, What Mr. Barrow Saw in the Land of the Bushmen," in *"Race," Writing, and Difference*, ed. Henry Louis Gates, Jr. (Chicago, 1986), 146.

15. Le Vaillant, *Travels* 1:165.

16. The term "Khoikhoi" refers to self-identified groups that Dutch and British colonists called by the disparaging name "Hottentot." See n. 69.

17. Stephen Gray provides a useful summary of contemporary responses to

Le Vaillant (*Southern African Literature: An Introduction* [Cape Town, 1979], 49–50).

18. Le Vaillant, *Travels* 1:363.

19. Inexplicably, contemporary literary histories continue to perpetuate this myth. Among a host of examples, one typical misrepresentation is contained in David Adey, Ridley Beeton, et al., eds., *Companion to South African English Literature* (Johannesburg, 1986), 162.

20. Karl Marx, *Capital*, vol. 1, trans. Samuel Moore and Edward Aveling (London, 1887; reprint, New York, 1967), 165.

21. Much of my discussion on the relationship between landscape and Whig legislation is indebted to conversations with Jane Taylor.

22. Lord George Gordon Byron, *The Complete Poetical Works*, ed. Jerome McGann (Oxford, 1986), "Dedication" to *Don Juan*, lines 89–96.

23. The notion of a "public sphere" that mediates between the state and society is of course first advanced by Habermas. Later in this chapter it will become apparent that I am equally reliant on Michael Warner's critique of the definitions Habermas employs in *The Structural Transformation of the Public Square: An Inquiry into a Category of Bourgeois Society*, trans. Thomas Burger with Frederick Lawrence (Cambridge, Mass., 1989). See Warner, "The Mass Public and the Mass Subject" (Unpublished paper).

24. Thomas Pringle, *Poems Illustrative of South Africa* (1834; reprint, Cape Town, 1970), 11.

25. J. M. Coetzee, *White Writing* (Johannesburg, 1989), 44.

26. One might consider such landscapes "transitional" in two senses. First, as I have suggested, it seems necessary for the settler to create a kind of intermediate, often muted landscape that helps bridge the gap between the present context and the country of the past; second, these forms function in a manner similar to the "transitional objects" described by Winnecot in his explanation of how children use "neutral [areas] of experience which will not be challenged" in their early attempts at reality testing (quoted in J. Leplanche and J. B. Pontalis, *The Language of Psycho-Analysis*, trans. Donald Nicholson-Smith [New York, 1973], 465). For a concise and lucid explanation of this process, see ibid., 464–65.

27. Pringle, *Poems*, 57.

28. John Barrell, *The Idea of Landscape and the Sense of Place, 1730–1840* (Cambridge, 1972), 22.

29. See W. J. T. Mitchell's "Theses on Landscape," at the beginning of his chapter "Imperial Landscape" in this volume.

30. Warner, "Mass Public and Mass Subject," 7.

31. Daniel Defoe, *Roxana* (Harmondsworth, 1982), 211. My thanks are due to Jane Taylor for alerting me to this reference.

32. An African Explorer, "Great Britain's Policy in Africa," *Times*, 22 August 1888, 8.

33. An early work that draws attention to this settlement drive evident in colonial description is Wayne Franklin, *Discoverers, Explorers, Settlers: The Diligent Writers of Early America* (Chicago, 1979).

34. Quoted in John Dixon Hunt and Peter Willis, eds., *The Genius of the Place* (London, 1975), 354.

35. William Wordsworth, *The Poetical Works of William Wordsworth* (Oxford, 1944), "The Ruined Cottage," lines 16–17.

36. Edward Said, *Orientalism* (New York, 1979), 93.

37. So, for instance, the breast is associated with the hunger instinct, upon which is "propped" desire for the breast as an erogenous zone (Sigmund Freud, *On Sexuality: Three Essays on the Theory of Sexuality and Other Works*, Pelican Freud Library vol. 7, trans. James Strachey [Harmondsworth, 1977], 98).

38. Thomas Pringle, *Narrative of a Residence in South Africa* (London, 1835; reprint, Cape Town, 1966), 38.

39. Jean Comaroff and John Comaroff, "The Colonization of Consciousness in South Africa," *Economy and Society* 18, no. 3 (August 1989): 289.

40. John Barrow, *An Account of Travels into the Interior of Southern Africa in the Years 1797 and 1798*, 2 vols. (London, 1801), 1:323.

41. Ibid., 322.

42. Jane Taylor first alerted me to this extraordinary example, and I am indebted to discussions with her on the figure of circulation in Cowper.

43. William Cowper, *Poetical Works* (London, 1874), 224 (Cowper's emphasis).

44. Stephanie Coontz, *The Social Origins of Private Life* (London, 1988), 155.

45. Wordsworth, *Poetical Works*, "Strange Fits of Passion," lines 25–28.

46. Barbara Johnson, *A World of Difference* (Baltimore, 1987), 96.

47. See Guy Butler, ed., *The 1820 Settlers: An Illustrated Commentary* (Cape Town, 1974), 123.

48. Henry Dugmore, *The Reminiscences of an Albany Settler* (Grahamstown, 1871). This passage is highlighted by Ronald Lewcock in his invaluable discussion of settler architecture (*Early Nineteenth Century Architecture in South Africa* [Cape Town, 1963], 147).

49. Butler, *1820 Settlers*, 128; Lewcock, *Architecture*, 142.

50. Thomas Pringle, "A Settler's Cabin in South Africa," *Penny Magazine of the Society for the Diffusion of Useful Knowledge* 2 (27 July 1833): 282.

51. Quoted in Hunt and Willis, *Genius of the Place*, 363.

52. Pringle, "Settler's Cabin," 283.

53. George Thompson, *Travels and Adventures in Southern Africa* (London, 1827; reprint, Cape Town, 1967), 333.

54. See Butler, *1820 Settlers*, 146.

55. Mackinnon, quoted in Philip Corrigan, ed., *Capitalism, State Formation, and Marxist Theory* (London, 1980), 46.

56. Thomas Pringle, *Narrative of a Residence in South Africa* (London, 1835; reprint Cape Town, 1966), 12.

57. Pringle, *Poems*, 41.

58. Jürgen Habermas, "The Public Sphere," in *Jurgen Habermas on Society and Politics*, ed. Steven Seideman (Boston, Mass., 1989), 232.

59. Thompson, *Travels and Adventures*, 18.

60. Ibid., 20.

61. Paul Carter, *The Road to Botany Bay* (London, 1987), 253.

62. Thompson, *Travels and Adventures,* 20.

63. Stanley Trapido, "The Emergence of Liberalism and the Making of 'Hottentot Nationalism,' 1815–1834" (Seminar paper, University of London Institute of Commonwealth Studies, 23 February 1990), 36.

64. Susan Newton-King, "The Labour Market of the Cape Colony, 1807–1828," in *Economy and Society in Pre-Industrial South Africa,* ed. Shula Marks and Anthony Atmore (New York, 1980), 175.

65. J. B. Peires, "Matiwane's Road to Mbholompho: A Reprieve for the Mfecane?" (Conference paper, University of the Witwatersrand, 1991), 27–28.

66. Henry Reynolds, *The Other Side of the Frontier* (Harmondsworth, 1982), 40.

67. Martin Legassick, "The Frontier Tradition in South African Historiography," in *Economy and Society in Pre-Industrial South Africa,* ed. Marks and Atmore, 262.

68. Jane Meiring, *Thomas Pringle: His Life and Times* (Cape Town, 1968), 115.

69. As Newton-King and others have pointed out, terms such as "Hottentot" and "Bushman" are inaccurate and racist in their attempt to constitute tribal divisions where there was in fact only a loosely defined Khoisan community. Nevertheless, these names do have an important legislative function during the period, and they point as well to colonial opinions about the relative value of hunter-gatherer communities and pastoralists *as laborers* (Newton-King, "Labour Market of the Cape Colony," 200–201 n. 4).

70. Geoffrey H. Hartman, *The Unremarkable Wordsworth* (London, 1987), 33–34.

71. Ibid., 42.

72. Jay Appleton, *The Experience of Landscape* (London, 1975), 103.

73. Ibid., 73.

74. Mary Louise Pratt comments on a similar form of attenuation in Barrow's *Travels,* a work that "does everything possible to minimize all human presence" ("Scratches on the Face of the Country," 123). See also Clifton C. Crais, "The Vacant Land: The Mythology of British Expansion in the Eastern Cape, South Africa," *Journal of Social History* 25, no. 2 (1991): 255–75.

75. This process is reminiscent of the way conditions for the emergence of a (male) subject position are managed in Baudelaire's "Le cygne." Here I am thinking of Gayatri Spivak's superbly original description, in "Imperialism and Sexual Difference," of the "clearing of a subject-position in order to speak or write" *Oxford Literary Review* 8, no. 1 (1986): 229.

76. This point, too, touches on the extremely complicated recent debate about the origins of the *mfecane.* Whereas Cobbing has recently argued that Ordinances 49 and 50 had the effect of justifying what was effectively British slave raiding, his opponents have argued that the labor shortage on the Frontier was caused by the British. Peires, for instance, suggests that British authorities were keen to encourage free labor but were deeply wary of the security risk posed by allowing

too many Xhosa into the Eastern Cape. See two papers from a 1991 conference at the University of the Witwatersrand: Julian Cobbing, "Rethinking the Roots of Violence in Southern Africa, *ca* 1790–1840," 19–22; and Peires, "Matiwane's Road to Mbholompho," 26–35. My understanding of these issues was deepened and complicated by exchanges with Keith Breckenridge, Catherine Burns, and Mark Auslander at Northwestern University and the University of Chicago.

77. Marx, *Capital,* 168.

78. Trapido, "Emergence of Liberalism," 6.

79. Pringle, *Narrative,* 109.

80. Lynne Bryer and Keith Hunt, *The 1820 Settlers* (Cape Town, 1987), 49.

81. Cobbing's thesis was first developed in an unpublished seminar paper, "The Case against the Mfecane" (University of Cape Town, 1983). The argument was expanded in "The Mfecane as Alibi: Thoughts on Dithakong and Mbolompo," *Journal of African History* 2 (1988): 487–519. In September 1991, the University of the Witwatersrand hosted an important conference on the subject "The 'Mfecane' Aftermath: Towards a New Paradigm." The papers of this conference, which have added considerably to our understanding of the period, include Peires, "Matiwane's Road to Mbholompho"; Carolyn Hamilton, "'The Character of Chaka': A Reconstruction of the Making of Shaka as Mfecane 'Motor'"; Elizabeth A. Eldredge, "Sources of Conflict in Southern Africa, *ca* 1800–1830"; and Cobbing, "Rethinking the Roots of Violence."

82. Newton-King, "Labour Market of the Cape Colony," 193.

83. Limited trade was allowed at specially designated trade fairs, but this relaxing of rules was at times vehemently opposed by Governor Lord Charles Somerset (Roger Bearden Beck, "The Legalization and Development of Trade on the Cape Frontier, 1817–1830" [Ph.D. diss., Indiana University, 1987], 113–14).

84. Pringle refers to the individual as a Bechuana, that is, a Tswana speaker. With this portrait he perhaps had in mind the significant missionary influence felt by Tswana communities in the early nineteenth century. For a vastly illuminating account of this process, see Jean Comaroff and John Comaroff, *Of Revelation and Revolution* (Chicago, 1991).

85. Bhaba, "Other Question," 18.

86. Pringle, *Poems,* "The Caffer," 96.

87. John Barrell, *The Dark Side of the Landscape: The Rural Poor in English Painting, 1730–1840* (Cambridge, 1980), 22.

88. Abdul R. JanMohamed, "The Economy of Manichean Allegory: The Function of Racial Difference in Colonialist Literature," in *Race, Writing, and Difference,* ed. Gates, 61.

89. Michel Foucault, *Discipline and Punish,* trans. Alan Sheridan (New York, 1977), 202.

90. Recently, I have had the good fortune to be introduced to Martin Hall's work on the historical archaeology of Dutch colonial settlement. See, for instance, his "High and Low in the Townscapes of Dutch South America and South Africa: The Dialectics of Material Culture," *Social Dynamics* 17, no. 2 (1991): 41–75.

S I X

JOEL SNYDER

Territorial Photography

The establishment of a variety of photographic landscape practices in the period between the 1850s and the late 1870s occurred in parallel with the elaboration of a set of ideas about the character of photography itself. The initial critical response to photography, beginning with the announcement of its invention in 1839 and extending into the 1850s, was marked by a mind-numbing puzzlement about what photography was and how photographs stood in relation to the picture-making tradition. By the mid-1850s photographs came to be thought of as being different in kind from pictures made by all other means, owing almost exclusively to a fascination with the peculiar "mechanical" character of photographic genesis. This perceived difference had consequences—it was active in the shaping of photographic practice, which in turn provided further verification of the singularity, or otherness, of photography. The evolving belief that photographs were different from other types of pictures guided the technical changes in photographic practice that led, by the late 1850s, to the production of prints that could no longer be mistaken for pictures made in other media. Changes in the technical practice of photography resulted in photographic prints that looked machine-made because of their high finish and endless detail, and that consequently were thought to be precise, accurate, and faithful to the objects or scenes they represented.

It is obvious that the characterization of photographs as inherently mechanical and technological in origin helped give definition to the belief in the ultimately spiritual or imaginative springs of handmade pictures. It might seem at first glance that the motive for distancing established pictorial practice from the daily production of photographers by, say, critics and painters was their perception of a threat to their immediate economic interests, but photographers weren't competitive with artists or illustrators

175

in the established media. It is far more likely that the response to photography by professionals in the art world was a reflexive spasm aimed at industrialization in general and the growing urban middle class with its attendant and burgeoning popular culture.

The more intriguing question is why photographers themselves were so eager to accept the characterization of photography as mechanical, and why they worked to make photographic prints look less and less like handmade prints and increasingly like the highly finished products of machines. The answer here seems to be that the profession served a community that was itself primarily middle class and that allied itself with the culture of technological progress. Photographers embraced the otherness of photography because the consequent divorce of photographs from the culture of handmade pictures established a distinctive field of activity for them, a realm—better, a market—that could not be served by picture makers in other media. Theirs was the territory of the unimagined, the earthbound, and the factual. Over the span of a little more than a decade (beginning roughly in 1842), the photographic portrait evolved from being a picture in imitation of painted miniatures to a "likeness," a recording of the integument of a sitter. On this view, photographic portraits were limited to the realm of the superficial and the apparent and could not pretend to be, for example, an evocation of the sitter's character. A similar definition of audience belief and expectation accompanied the growth of photographic trade in travel, architectural and landscape production. These photographs too came to be thought of as integumental likenesses—as passive *recordings* of preexisting sights.

It is ironic, then, that a genre such as photographic landscape, which plays so prominent a role in recent histories of photographic practice, has been addressed almost exclusively in aesthetic terms—that is, in terms previously thought to be inapplicable to photographs.[1] The special oddity here is that little critical attention has been given to the variety of functions assigned to landscape work in the period between 1860 and 1880, the period in which many of the still-dominant approaches to scenic photography were invented and refined.

My aim in this essay is to probe the motivating factors behind two American western landscape practices of the 1860s and 1870s in order to come to some understanding of why these photographic landscapes look the way they do. I shall assume, unquestioningly, that the practices under investigation were successful in terms of satisfying the needs or interests of the specifiable audiences that they served. I do not propose, however, that their pictorial quality, assuming they possess such quality, is reducible in any straightforward or uncomplicated way to the satisfaction of the interests of any particular audience (including, say, the patrons who com-

6.1 R. Howlett, *In the Valley of the Mole*. The Metropolitan Museum of Art (1988.1033).

missioned them).[2] Most important, I want to emphasize the specificity of approaches to photographic landscape in the period between 1860 and 1880. By "specificity" here, I mean separateness and irreducibility. An understanding of the pictures I will discuss requires that we discriminate between their functions and attend to the grounds of these functions as well.

The first generation of landscape photographers—those who worked with paper negative systems from the early 1840s through the early 1850s—were almost completely dependent upon the pictorial conventions of the genre. These conventions were shared by picture makers who worked in the other print media—lithography, engraving, the various etching processes—as well as those who worked with paint on canvas. The tendency to fall back onto the inherited, customary, habitual conventions of subject matter selection and the manner of representation is especially apparent in the production of the early French and British photographers, who were for the most part educated by artists or were thoroughly familiar with a relatively broad and refined pictorial culture (see figs. 6.1, 6.2).

6.2 P. H. Delamotte, *Evening*. The Metropolitan Museum of Art (52.524.7).

To a great extent, the work of the early landscape photographers was personal work, or work intended for a rather small audience of dedicated amateurs and educated professionals, and it was devoted to structuring landscapes in familiar terms. There was no market for these photographic pictures, no way of bringing them to the attention of a large audience, since there was as of yet no mass production techniques of photographic printing or inexpensive means of printing photographs in ink for use in books.

The creation of a large and definable market for landscape photographs began in the mid-to-late 1850s by means of the incorporation of localized photographic businesses, in the form of combined photographic and publishing houses, that were dedicated to the production and sale of travel, architectural, and landscape prints and stereographic views to incoming tourists. Prints were initially sold at or close to points of geologic or geographic interest, either one at a time or in multiples arranged in the form of photographic albums. These photographic publishing houses first appeared in Europe in the 1850s and in the western United States by the early 1860s. In the United States, these houses extended their reach by selling each others' work and by selling to print and stationery shops, so that by the early 1870s it was possible to visit, say, Denver and buy prints made in Yosemite Park by Carleton Watkins, landscapes made in Utah by Charles Savage, photographs of the land adjacent to the tracks of the Transcontinental Railroad by Andrew Joseph Russell, and so on. By the mid-1860s, two photographic supply houses (i.e., companies selling photographic equipment and supplies to photographers) in New York State began marketing landscape and stereographic views under license to local photographic publishing houses, through the mail, to a reasonably broad national audience. In a period of less then ten years, photographers thus managed to patch together a network of outlets for their own landscape work and came increasingly to guide their photographic production in terms of their most popular prints or in terms of the most popular prints sold by their competitors.

I am purposely framing the issue in commercial or business terms, concentrating on the relationship of the producer to the consumer, because it exposes, rather than hides, some of the motives guiding photographic production in this period. I could adopt a more academic vocabulary and speak in the terms of rhetorical analysis (i.e., of the relations between, artist, work of art, and audience), but I prefer, at least for the time being, to suppress these in order to focus in a more homely manner on the question of why these photographs were made at all and how they came to look the way they did. I am suggesting that they were produced to meet the demands of a growing middle-class audience, but saying this

does not begin to specify very much at all about why they came to look the way they did.

I began by noting that the first generation of photographers came from the privileged classes and were generally quite familiar with the tropes of landscape depiction. They were unable and probably unwilling to discard their inheritance of a naturalistic manner of depiction, one that emphasized suggestion, random variety of natural forms, and, in general, a devotion to the picturesque with all that notion entails. One of the things it does entail is the belief that a picture, at least a picture with aesthetic merit, implicates the maker of the picture, expresses his or her sensibility, represents something essential about how a scene was experienced. I bring this up here because this belief in naturalism ultimately undermined the practice of the first generation of landscape photographers. According to Lady Elizabeth Eastlake, a writer on art and photography in the 1850s, a picture has aesthetic merit only insofar as it is true to what she calls "our experience of nature."[3] It follows on Eastlake's assumption that photographs, being the product of an inhuman mechanism, cannot be true to our experience of the world. If this is so, photographs making use of picturesque tropes will, as Eastlake insists, inevitably fail nonetheless to suggest our experience and will consequently fail to possess genuine aesthetic merit. This meant that photography could make no claims as a medium with an artistic potential.

Eastlake spoke on behalf of artists and critics of art, but in fact she was voicing as well the currently forming opinion of a far broader audience. The mid-1850s marked a turning point in the practice and definition of photography. Until this time, photographic societies had been dominated by aristocrats, gentlemen, educated and successful businessmen, artists, and photographers who had trained as artists (the first president of the Royal Photographic Society, elected in 1853, was Sir Charles Eastlake, the president of the Royal Academy of Art and also the husband of Lady Elizabeth Eastlake), who shunned commercial photographers. Increasingly, however, photographers came from less-educated ranks, and the new professionals transformed photography both technologically and in terms of the values they and their audience hoped and expected to find in photographs. One feature of the change in practice they brought about can be seen quite clearly in their preference for highly articulated, well-resolved pictures in which the suggestiveness and the relative absence of finish so much favored by devotees of the picturesque was replaced by an absolute precision of delineation through all represented planes. Additionally, the characteristic look and feel of photographic prints was completely changed; whereas photographic prints had previously been matte surfaced and were toned to various hues that conformed to those found in other

print media, by the late 1850s, they came to have a lustrous gloss, and their color was restricted to a rather distinct set of sepia hues. The ideal of photographic printing, which was first formulated in the mid-1850s but wasn't achieved for another few years, was a print with a highly glossed, glasslike surface that looked as if it had been machined on a production line. In other words, the ideal photographic print was supposed to look like a mass-produced item, like the infinitely replicable product of a technologically or industrially controlled mechanism.

By the mid-to-late 1850s, photography came to be separated in conceptual terms from the other depictive arts, and this separation was described increasingly not in terms of the differences between media but in ontological terms. Painting and the graphic arts were conceived as representing the realm of the imaginative, cognitive, and the ideal, while photography was, depending upon the interest of the writer, consigned or elevated to the realm of the factual, the material, the physically real. In his "Salon of 1859," Charles Baudelaire vented his spleen upon photography, noting that the photographic "industry," as he called it, had "ruined whatever might remain of the divine in the French mind." Baudelaire's attack on photography is really an attack on the emergence of the commodities of popular culture and the increasing importance of a growing taste for—in his words, the "purely material developments of culture." He then adds, "If photography is allowed to supplement art in some of its functions, it will soon have supplanted or corrupted it altogether, thanks to the stupidity of the multitude which is its natural ally." Conversely, the American essayist Oliver Wendell Holmes, writing four years later, noted, "It is well enough for some Baron Gros or Horace Vernet to please an imperial master with fanciful portraits of what they are supposed to be. But the honest sunshine [i.e., photographic mechanism] is nature's sternest painter, yet the best, for always true."[4]

This division in opinion about the relative value of photography as a medium for the production of artworks had a singular effect; arguing from opposed positions, Baudelaire the dandy and Holmes the Yankee inventor agreed on one major issue: photographs were in some respect transparent and true (at least to the material, superficial aspects of the visible), and their pictorial features were understood, accordingly, to have been derived not from conventions of illustration or from the photographer's unfettered imagination but from physical facts about the world as it appeared before the camera at the time of exposure. By the mid-1860s, photography had entered into popular culture, characterized as a utilitarian medium, primarily useful for purposes of documentation because of its contingency upon nature and natural processes.

As photography came to be distanced from the fine arts, the goals of

photographic depiction shifted away from the aesthetics of suggestion and moved toward articulation, high finish, and the precise rendering of detail. The new generation of photographers came to the practice of landscape photography aware of what landscapes in other media looked like (they had, after all, some general familiarity with landscapes through illustrated journals, travel books, and the kinds of paintings that were routinely displayed in hotels and public buildings), but without, they believed, an ingrained commitment to these forms. Freed from the obligation to make works of art, or pictures that would be compared to such works, they were, *they said*, free to record what they saw, unconstrained by convention. Thus, the myth of photographic contingency led to the creation of pictures that were thought to be free of all convention, perhaps wanting when judged against the standard provided by painting, but always honest, truthful, and, above all, disinterested. Accordingly, photographer's practice was understood to be discontinuous with the practice of all other picture makers; its standards were accuracy to nature and "lifelikeness"; to the extent that a viewer was moved to address a photograph in aesthetic terms, these were understood to have been derived from the physical qualities of the scene and the technical genius of the photographer (i.e., the ability to employ flawlessly the chemistry and physics of the process).

In practical terms, then, photographers were caught in a double bind: they had to devise an approach to the production of landscape pictures that *appeared* to escape the generally sanctioned motifs and formulae of landscape depiction, while emphasizing, at the same time, those qualities that were increasingly taken by their audience to be indices of photography—qualities that convey aspects of singularity, factuality, and materiality. By the early 1860s, the rhetorical question facing any would-be landscape photographer was a rather difficult one: how to make a picture that was resolutely photographic yet, at the same time, beautiful or stunning or, for want of a stronger word, attractive—but that nevertheless could be convincingly experienced as aconventional, a product of scientific laws and photographic craft.

The San Francisco photographer Carleton Watkins established an answer to the problem by merging a remarkable and heretofore unmatched technical virtuosity with formulas derived from, but not coextensive with, the picturesque and sublime modes of landscape depiction. This blend came to typify his work by the mid-1860s. Watkins produced flawless and mammoth 20-by-24-inch negatives, from which he printed highly finished, unrelentingly detailed views of Yosemite Park, the Pacific Coast, and the sparsely settled areas of Utah and Nevada. His first great success, the 1861 views of Yosemite, earned him an international reputation and

set the standard for commercial landscape photographers of the American West. His photographs were well known through the turn of the century, and his approach was emulated by nearly every important photographer of the American West up to and including Ansel Adams.

It is difficult to speak clearly about pictorial issues in this formative period of American landscape photography because they were initially set out in an oddly contorted—one could even say, incoherent—manner. Watkins's photographs from the 1860s can be addressed today in the ancient and opposed terms of art-historical analysis (i.e., in the vocabulary of origins and influence), but neither Watkins nor his audience were prepared to think of them in this way. In 1863 Oliver Wendell Holmes reviewed Watkins's Yosemite photographs (see fig. 6.3) and noted, "The three conical hill tops of Yosemite taken, not as they soar into the atmosphere, but as they are reflected in the calm waters below—these and others are shown, clear, yet soft, vigorous in the foreground, and marvelously delicate and barely distinct in the distance—appearing on the print *just as they looked in the mirror surface of the water* . . . a perfection of photographic art rivaling that of the best European technicians."[5] The photographer's achievement here has twin aspects: it is, at the level of craft, a mechanical or technical one; but Holmes also insists that the standard of perfection involves reference to what *we* (and presumably, he means what anyone) would inevitably have seen while standing near the camera. Accordingly, the implication is that the picture is a recorded *sight,* something that would have been available to anyone who came upon this spot.

The assumption is that photographs stand in a special relation to vision, but vision detached from any particular viewer. It is a distributed vision, one that transcends individual subjectivity and, accordingly, individual interest. These photographs are to be understood as disinterested reports. Thus the photographer's achievement does not involve the sensitivity of an artist's eye or the use of an artist's imagination or the intelligent choice of the right depictive conventions; rather, it rests on the technical capacity to record a sight that is understood to be a natural image of nature. Watkins's fascination with the mirrored surface of Lake Tenaya is emblematic of his rhetorical posture as a photographer. He views his job as the fixing or recording of an evanescent reflection of physical reality and not as the construction of an idealized landscape. The standard against which his photograph is judged, according to Holmes, is its likeness to yet another likeness that nature provides of itself—the reflection in a natural mirror—the glasslike surface of Lake Tenaya. Neither Watkins nor his audience could see that the manner in which he organized his pictures

6.3 Carleton Watkins, *Washington Column, 2052 ft., Yosemite* (ca. 1861).
Courtesy Fraenkel Gallery, San Francisco.

and his concern, say, for soft and vigorous foregrounds combined with marvelously delicate and barely distinct backgrounds were adaptations of existing landscape practice in other media.

The irony is that with photography playing the role of mechanical and nonartistic outsider to established and evolving landscape practices that seem internal to painting, painters of western America such as Albert Bierstadt, William Keith, and Thomas Moran could point to Watkins's photographs for scientific corroboration of the way in which they constructed their painted landscapes of the West. And so, a way of painting landscapes and viewing them became (for a photographer with Watkins's interests) *the* way of looking at nature, which in turn guided photographers in making purportedly honest, scientifically sanctioned pictures of nature that somehow were supposed to escape artifice, personal interest, and subjective response.

This view of photography grants Watkins's photographic enterprise immense power, for it allows the photographer to make pictures that seem not only to have escaped his response to the world but to have escaped the constraints operating on all picture makers in all other media. My claim here is that the emerging rhetoric of photography in the 1860s suppressed—perhaps overwhelmed would be a better word—any viewer's ability to understand Watkins's photographic landscapes as being landscape pictures at all. These photographs did not escape landscape conventions; they adopted and reformulated them. This is clear not only from comparing photographs like those made by Watkins to drawings, prints, and paintings by Keith and Bierstadt but from the critical literature of the period, which continually commends photographers for having achieved pictures faithful to nature that *coincidentally* share specific compositional and pictorial features with landscapes wrought in other media. In other words, such criticism congratulated photographers not for their use of landscape conventions but for their coincidental scientific or mechanical corroboration of them.

By the time Watkins made his first views of Yosemite in 1861, eastern American and European travelers had already written about its "picturesque pleasures" and its combination of gardenlike grace with breathtaking grandeur. Watkins's photographs address these expectations by formulating the valley in terms that are familiar and that emphasize its accessibility and, at the same time, its grandeur (see fig. 6.4). The great success of his first Yosemite series encouraged him to adapt this way of making photographs to other places in the West. His views of the Pacific Coast from California to Oregon often cast it as an unspoiled and unspoilable Garden of Eden—as places to visit, but also to live in. In other

6.4 Carleton Watkins, *Sentinel (View Down the Valley), 3270 ft., Yosemite* (1861). Courtesy Fraenkel Gallery, San Francisco.

words, Watkins's landscapes address the Pacific Coast as potential real estate and as a site for eastern investment and development.

In addition to publishing his own views of the natural grandeur of the West, Watkins also worked on commission for the California State Geological Survey, for mining and lumber interests, and, by the end of the 1860s, for the Pacific railroads. If the depictive agency, photography, was itself an insignia of industrial and technological progress, so too was the content of his commissioned pictures. Watkins's mining and railroad photographs—especially the latter—attempt to portray a visual harmony between the land and the new tokens of progress symbolized by the industrialization of the land itself. The mining photographs often emphasize a kind of orderliness in the face of what we would now see as the brutalization of the environment, or concentrate on the juncture between the natural and the man-made that derives its interest from the contrast of natural variety and wildness to the geometric regularity of industrial forms. Where the scene before him contained few of the raw materials needed to make a picturesque or beckoning view, Watkins generally managed to aestheticize and overwhelm the apparently ugly or nonnatural by playing man-made designs against a ruined natural environment and then reducing the highlights and shadows to a smooth continuum of rich middle tones that, in a manner of speaking, become the subject of the picture. If this is too modernist a description, then we can say, at the very least, that these tonalities become a major source of pleasure in looking at the photograph. The smoothness and seamlessness of tonal gradation in the photograph of the Malakoff Diggins, together with the remarkable resolution of detail, is intended to please the eye in a way that the scene itself never could (see fig. 6.5). Some recent critics of such pictures see Watkins's delight in photographic tonalities as being at the core of his work. I'm not sure we need to make him into an early photographic modernist to appreciate his ability to find a source of an aesthetic response in the smooth rendering of middle tones irrespective of the character of the objects he photographed.

Watkins's photographs of the railroads, like the view of Cape Horn in Oregon, again seek quite successfully to harmonize the landscape with industrial progress in the form of the tracks of the new rail line (see fig. 6.6). The view is grand, sublime, quiet. The regular tracks drive the eye toward the background, where they disappear into the land, without a trace. There is an equilibrium suggested by this picture, a balance between the controlled regularity of the rails and the immensity of the land. Watkins found here an effective means of obliterating the division between what he called "natural wildness" and the hard-edged, linear forms of industrial technology. The appearance of the land is left undisturbed

6.5 Carleton Watkins, *Malakoff Diggins, North Bloomfield, Nevada County* (1871).
Courtesy Department of Special Collections, Stanford University Libraries.

by the rails, unscarred, in its original condition. The predominant issue
here seems to be one of showing the scene *just as it looked* by emphasizing
pictorial coherence and integrity, but it masks the broader enterprise of
harmonizing nature and industry.

 I don't mean to suggest that Watkins was a self-conscious propagandist
for mining or railroad interests, but only that the evolving character of
photographic practice and reception allowed him to think of himself as an
entrepreneur whose job was to record preexisting scenes in a thoroughly
disinterested manner. Watkins's photographs are monumental, but they
were not understood to be monumentalizing. He was a champion of
development and, like most American businessmen of his time, was de-
voted to the idea of progress—understood in terms of ownership and
industrial development of the land and its resources. His pictures neatly
avoid questions about whose land it is that is being developed and judged
by his photographs; he seems never to have wondered about the original
inhabitants of California, Oregon, Utah, and Nevada, who lived on mean

reservations, removed from the land that had been theirs less than forty years before.

Watkins's photographs reinforce the commitment of his audience to a belief in a western American Eden, but it represents the Garden in a way that encourages the audience to see it as a scene of potential exploitation and development. This representative scheme, then, presents the possibility of a double salvation—a return to unspoiled innocence and an opportunity to profit from the violation of innocence. It offers, furthermore, a reassurance that this untouched West can withstand endless mass immigration and industrial exploitation.

Watkins's photographs earned honors at international expositions and praise from painters and eastern photographers because they are essentially invitational in character and because they address the expectations of an

6.6 Carleton Watkins, *Cape Horn near Celilo, Oregon* (1867). Courtesy Department of Special Collections, Stanford University Libraries.

audience that was exposed continually to stories and pictures romanticizing the frontier and inflating the promise of wealth and self-sufficiency that lay just beyond the frontier. But at precisely the same time another photographer, Timothy H. O'Sullivan, photographed parts of the American West in a manner that might best be termed "contrainvitational."

The block of years from 1867 through 1879 marks a transitional period in the exploration of the western United States—a transition from army surveys and management of the largely unknown and uninventoried interior (unknown, that is, to non–Native Americans) to civilian surveys managed by the rapidly expanding class of scientists and engineers. O'Sullivan served as the photographer for two major western expeditions: Clarence King's Geological Explorations of the Fortieth Parallel (1867–70 and 1872), and the Geographical and Geological Explorations West of the One Hundredth Meridian (1871 and 1873–74), under the direction of George Montague Wheeler.

O'Sullivan began as an apprentice photographer in the New York studio of Mathew Brady in late 1858 at the age of eighteen. In 1860 he moved to Brady's studio in Washington, D.C., and at the outset of the Civil War in April 1861, he began working in the field as a maker of battlefield and war-related views. In 1863 he left Brady and joined Alexander Gardner, who worked as the civilian photographer for the Army of the Potomac. By April 1865, O'Sullivan had photographed most of the major battlefields of the war and was regarded as one of the best field photographers in the country.

In the year following the end of the war, the geologist Clarence King, a twenty-five-year-old recent graduate of the Sheffield School at Yale, argued before Congress that the unexplored interior of the country had to be mapped and inventoried scientifically and systematically and that expeditions to the West could no longer be entrusted to the direction of a scientifically untrained military. King, who belonged to the first generation of scientists to be educated entirely at American institutions, was convinced that the kind of education available at West Point made it unlikely that the military could effectively undertake a genuinely scientific survey. Until 1866, all western expeditions sponsored by the federal government had been run by the military and were organized primarily to map what were known as "hostile lands" and to establish forts and supply bases for the protection of incoming white settlers and prospectors.

King argued that it was time for America to demonstrate its native scientific "genius" by sponsoring studies on a par with the best geologic and geographic work produced in Germany, France, and Great Britain. In part, he owed his success in convincing Congress to place him, late in 1866, in charge of the Geological Exploration of the Fortieth Parallel to

his combination of a competitive, nationalistic bravado and his exotic scientific education, which he used effectively to persuade his congressional questioners. King presented himself as scientifically disinterested, driven by a desire first to understand the vast contents of America and then to put whatever knowledge he gained into the hands of those who could best use it—scientists, land management experts, and mining company engineers. King brought O'Sullivan to the West as his expeditionary photographer when fieldwork began in the summer of 1867.

Working almost continually from the spring of 1867 through the end of the field season of 1874, O'Sullivan produced a large group of photographs, taken primarily in the Great Basin areas of Nevada, Arizona, Utah, and New Mexico. His photographs are singular when compared with the work of other western photographers of the period. They repeatedly deny what Watkins's photographs characteristically confirm, namely, the possibility of comfortable habitation, of an agreeable relation of humans to the natural landscape. They portray a bleak, inhospitable land, a godforsaken, anesthetizing landscape.

Unlike Watkins and the businessmen-photographers who followed him, O'Sullivan was unconcerned with selling his prints or with addressing the expectations of a large audience. Some historians of photography have argued that his major assignment was to provide incentives, in the form of pictorial plums, that would satisfy Congress and provide it with the motive to vote ongoing funds for the two expeditions he served. This notion, however, is in error, since both King and Wheeler were funded from the outset for the duration of their work in the field. Moreover, the librarian of Congress spent years requesting photographs from both King and Wheeler, with only occasional responses from the survey directors.

Given their jarring pictorial character, O'Sullivan's photographs have proved to be difficult to place within a historical context. Since the late 1930s, historians of photography have addressed them as precursors of modernist photographic practice and have removed them from the context of their production, ascribing their pictorial density and complexity to O'Sullivan's precociously modern "photographic vision." Rosalind Krauss has responded to this claim by countering that O'Sullivan's work was essentially scientific, that he was a maker of scientific "views" and not of landscapes (as if this were an immediately perspicuous distinction).[6] Krauss is primarily interested in showing that O'Sullivan's photographs cannot be legitimately incorporated into a contemporary museum context and cannot legitimately be compared to the work of painters who were O'Sullivan's contemporaries. She claims that the "discursive space" of an expeditionary photographer was not the same as the "discursive space" of

a Parisian painter. If the claim here is that O'Sullivan did not conceive of his work in the way that Courbet or Monet conceived of theirs, she is surely correct.[7] But the claim is broader than this, since Krauss maintains that the *scientific* nature of O'Sullivan's photographs somehow precludes an investigation of their pictorial character.

The problem with a view like Krauss's is that it assumes what needs to be proved. It assumes that O'Sullivan went to the West as a scientist, or at least that his enterprise was scientific in character. But both of his chiefs argued forcefully that photography was incapable of producing pictures useful for the purposes of measurement and quantification and that, accordingly, each needed a band of topographical draftsmen, since O'Sullivan could not provide scientifically accurate pictures.[8]

Dismissing Krauss's major assumption is not without an unhappy consequence, however, since it leaves us without an explanation of what O'Sullivan was doing in the West. If he was not making purely documentary, or scientific photographs, or if he wasn't functioning as a publicist for his expeditions, what was he doing? The short answer to the question is that he was making illustrations for the interim and final reports published by the surveys. The longer answer is that he was making pictures for the only audience from which he ever received guidance or advice— the two chiefs of his surveys; of the two, it was Clarence King who had the most impact upon O'Sullivan. O'Sullivan's job was to provide "generally descriptive" photographs of the places he visited, which functioned, in King's words, to "give a sense of the area," but which were not used as evidence for the findings of the various authors of the reports.

Both the King and Wheeler surveys used photographs as the basis for lithographs that were bound into their interim and final reports. Each of the surveys also produced bound volumes of original photographic prints as well as sets of stereographic views that were sent to selected government agencies, universities, and foreign governments. Very few of O'Sullivan's photographs reached an audience of nonprofessionals, except for those that went to Congress and the army.

After the publication of the expeditionary final reports, which were completed in 1879, O'Sullivan's name and photographs dropped from sight until 1939, when a handful of them were discovered by Ansel Adams, who sent them to Beaumont Newhall, then acting curator of the Department of Photography at the Museum of Modern Art in New York City. Adams, the master technician, described the pictures as "technically deficient, even by the standards of the time, but nonetheless, surrealistic and disturbing."[9] Newhall saw the photographs as prototypical modernist photographic landscapes and published some of them in his histories.

6.7 Timothy H. O'Sullivan, *Sand Dunes near Carson City, Nevada Territory* (1867). Courtesy National Archives and Records Service.

Thus, they entered into the modernist history of photography and have remained there ever since.

It is easy to see why Newhall popularized some of O'Sullivan's photographs. Thanks to Newhall, *Sand Dunes near Carson City, 1867,* one of the first made by O'Sullivan as he entered the Great Basin in the first days of his first season in the West, is one of two most well-known prints by O'Sullivan (see fig. 6.7). The wagon is O'Sullivan's portable darkroom, and it is shown in the midst of a boundless desert. The footprints leading to the foreground are O'Sullivan's own, made as he set up the camera and raced from the wagon with the plate he sensitized in it. It is easy to see why a modernist would find this picture appealing—it seems to be centered on the conditions of photography and the craft of a photographer. The footprints in the sand might even suggest the impressions left on the plate by the light exposing it. The photograph heroizes the photog-

rapher, and it heroizes his work; one man in the great vastness of the
Great Basin, working alone in solitude. But it is about something else as
well. It is about this place and its incapacity to support life, about its
inhospitability. The land supports little in the way of growth; the tracks
left by the wagon wheels are evanescent.

It is important to know, however, that this picture is misleading. It
was made in the midst of a great flat, red-earth plateau in which dunes
like this occasionally dot the plain. O'Sullivan dragged the wagon, with
great effort and the help of a member of the expedition, onto the dunes
and then moved his camera in close so that the edges of the picture
cropped off the barren flatness of the plains. As a bit of scientific informa-
tion (understood as a "representative sample" of the region), its sugges-
tion of a boundless desert is entirely inaccurate.

O'Sullivan's photographs are often populated, but he denies human
figures their function in picturesque landscapes—they do not mediate
between the viewer and the depicted scene; they are not guides placed in

6.8 Timothy H. O'Sullivan, *Fissure Vent of Steamboat Springs, Nevada* (1867).
Courtesy National Archives and Records Service.

6.9 Timothy H. O'Sullivan, *Hot Springs Cone, Provo Valley, Utah* (1869).
Courtesy National Archives and Records Service.

the foreground or midground who can help the viewer construct an imaginary experience of the land. Figures function most often as indices of a precarious and frightful relationship between explorer and the object of exploration. In one, a sheet of sulfurous steam floats across the figure of an observer and nearly obliterates it, leaving only the ghostlike adumbration of a human being (see fig. 6.8). The photograph suggests the impossibility of maintaining all but the most fundamental conditions of personhood in this place, which does not merely lack the capacity to support human habitation but actively obliterates human presence.

The grotesque, disembodied human head that seems to sit atop a tufa cone is similarly grotesque and contrainvitational (see fig. 6.9). The "scientific" point of the picture is clear; the cone is hollow, which O'Sullivan sought to show by having an assistant stand inside it. Whatever the intention, however, the effect of the conjunction of a human head at the apex of the hollow mound is chilling, discomforting, weird. Part of the figure has disappeared into the earth; it seems to have been swallowed whole by nature and is incapable of resisting.

O'Sullivan repeatedly placed figures in the far midground or background, dwarfed by immense vistas or geologic forms that obliterate indi-

viduality (see figs. 6.10 and 6.11). Rather than functioning as yardsticks for the conveying of information about size relationships in the depicted field, these figures serve to underscore the unhappiness of the relation between human beings and the vast and barren landscape. They are counterparts to the small and featureless figures that dotted the tower in eighteenth-century prints of the Tower of Babel.

By contrast with Watkins's photographs, O'Sullivan's representation of the West is an awed stare into a landscape that is unmarked, unmeasured, and wild, a place in which man is not yet—and not without an immense future effort—the measure of all things. This interior is presented as a boundless place of isolation, of contrasts of blinding light and deep, impenetrable shadows. It is astonishing, often alienating, at times gruesome. The pictures seem to offer a glimpse of nature prior to naturalization (or perhaps of a denatured nature), something like a "freak" show of unnatural forms that are at the same time entirely natural—to be addressed as

6.10 Timothy H. O'Sullivan, *Black Canyon, Looking Below Near Camp 8, Colorado River, Arizona* (1871). The Metropolitan Museum of Art (1986.1054.20).

6.11 Timothy H. O'Sullivan, *Ogden, Utah* (1874). Courtesy the National Archives and Records Service.

geologic monstrosities and grotesqueries. O'Sullivan's photographs stand to Watkins's landscapes in much the same way Mathew Brady's cabinet photographs of Barnum's freaks stood to a well-crafted celebrity portrait of the time. Like Brady's photographs of the three-legged man or the bearded woman, O'Sullivan's photographs are both fascinating and mysterious. They work against popular conceptions of nature and the natural by defamiliarizing nature, by refusing to formulate the land of the Great Basin in the accessible and reassuring terms of the picturesque.

O'Sullivan's photographs are antipicturesque in most of their details. They often achieve a sublime, breathtaking character and doubtless can be analyzed formally, in terms of some of the tropes of the sublime. My interest here is not to provide such a formal analysis but to suggest how photographs that refuse so steadfastly to bow to the organizational principles of contemporary landscape photography, or to exemplify the values

found in the work of many other western photographers of this time and of these places, in fact served the interests of the expeditionary leaders.

The photographs of Watkins and William Henry Jackson, the other well-known photographer of the American picturesque-sublime, were calculated to play to the expectations of their audience, to reassure and reconfirm beliefs about the American landscape and to portray it as a scene of potential habitation, acculturation, and exploitation. The land was portrayed as God's country and, coincidentally, that of the railroads, real estate, and mining interests as well. It was a land of the main chance and the second chance. It was not without cause that William Henry Jackson's single most famous and popular photograph was of the Mountain of the Holy Cross in the Colorado Rockies—a mountain towering above all that stood near it and bearing the distinct impression of an enormous, eternally snow-covered cross.

O'Sullivan's photographs deny all this view of the land, but to what end? They were made for the first modern surveys of the American interior—the first surveys managed and directed by civilians working for the government. Unlike the commercially produced work of well-known western photographers, they present the interior not in the terms of the expected or the anticipated, the known or the acknowledged, but as terra incognita, as a world different from ours, unfamiliar, inhospitable, and terrifying.

In describing his first descent into the Great Basin in 1866, Clarence King wrote:

Spread out before us lay the desert, stark and glaring, its rigid hill chains lying in disordered groupings, in attributes of the dead. The bare hills are cut out with sharp gorges, and over their stone skeletons, scanty earth clings in folds, like shrunken flesh: they are the emaciated corpses of once noble ranges now lifeless, outstretched as in a long sleep. Ghastly colors define them from the ashen plain in which their feet are buried. Far in the south were a procession of whirlwind columns slowly moving across the desert in spectral dimness. A white light beat down, dispelling the last trace of shadow, and above hung the burnished shield of hard, pitiless sky.[10]

King describes the basin as if it were a deserted battlefield, a place of destruction and death. Two years later, after riding three days with O'Sullivan to explore the Great Falls of the Snake River in Idaho, the so-called Shoshone Falls, he contrasted Yosemite with the falls:

The Yosemite is a grace. It is an adornment. It is like a ray of light on the solid front of the precipice. We come to the valley expecting it and somehow already knowing it. But no sheltering pine or delicately softened mountain distance of uppiled Sierras announce the approach of Shoshone. You ride upon a waste—the

pale earth stretched in desolation. Suddenly you stand on a chaotic brink. As if the earth has yawned, black walls flank the abyss. Deep in the bed a great river fights its way through the labyrinth of blackened ruins and plunges in foaming whiteness over a cliff of lava. You turn from the brink as from a frightful glimpse of the unknown Inferno, and when you have gone a mile the earth seems to have closed again. Every trace of the cañon has vanished and the stillness of the desert reigns.[11]

The contrasts here are telling. Yosemite is a grace, expected and somehow already *known,* while Shoshone is unexpected, frightening, and unknown. Yosemite is described in terms of sheltering pines and delicately softened distant mountains—words straight out of a manual of the picturesque, while Shoshone is the frightful chaos of the unknown.

Clarence King's dedication to professionalism, to a new attitude toward the scientific study and management of the land, provides a very good ground for representing the western American interior in terms of the unknown and the frightening. The difference between the photographs of Watkins and Jackson and those of O'Sullivan is the difference between the familiar, known, and understood and the alien, unknown, and unintelligible.

What O'Sullivan's photographs do is to mark off the Great Basin as unaddressable in terms of the evolving practices of photographic landscape—as a place that is not yet known. In so doing, they begin to outline a field of potential scientific inquiry. They underscore the difference between the developed and developing property of the Far West and the exotic and obscure land of the basin.

This land, which King believed was the last place on earth upon which God had stood, is properly the jurisdiction of experts—scientists, engineers, perhaps even theologians—people with special skills for the acquisition of special knowledge. It is, at least until it is explored, mapped, inventoried, and comprehended, the province of King and his young, knowledge-hungry, acquisitive, and aggressive scientific-professional class. If I am correct in this assessment, then O'Sullivan's photographs work not so much to delineate a territory of potential American states as they do to define a very different kind of territory—one that we would now call a field, a discipline—that could properly be investigated only by the new elite, to the exclusion of the old military caretakers. This field of investigation may be hostile, but King believed that the army could only hold it, never coming to know, understand, and manage it. That was work for a new class of professionals. O'Sullivan's illustrations provide visual, photographic proof of the unknown character of the land and imply the need to gain power over it by coming to know it. The job is to probe the territory, subject it to scientific examination, thus under-

standing what it can tell us about its past and how it can be used in the future.

Representing the Great Basin in Watkins's terms would have suggested a prior understanding of the land, but as I see it, O'Sullivan's role was to furnish pictures of an area that resisted understanding in familiar terms. O'Sullivan's photographs thus introduced their audience to a new domain—it is not a geographic region but the territory of modern science and its attendant professionals. These pictures are territorial, but they adumbrate a territory unapproachable in terms of representational schemes that are the common property of the propertied, or would-be landed, class. O'Sullivan's photographs function by refusing to formulate the land in the most readily available terms, by blocking habitual routes of imaginative access.

O'Sullivan's photographs, then, are not to be understood as scientific documents, but as something like pictorialized "No Trespassing" signs. They mark the beginning of an era—one in which we still live—in which expert skills provide the sole means of access to what was once held to be part of our common inheritance.

Notes

1. The idea that photographs are essentially records implies that aesthetic valuation can be applied to them only equivocally. To say a photograph is beautiful really means that it is a record of a beautiful scene—the beauty has been recorded, not made. Modernist historians of photography have shaped their histories by subscribing to a belief in a unique photographic aesthetic and have attempted to show that terms of aesthetic valuation can apply to a photograph in virtue of the inherent qualities of the picture and not of the scene.

2. Simply put, a photograph—say a picture made to sell real estate—isn't said to be beautiful because it works effectively as an aid to the realtor. It seems more congenial to common sense to suppose that its effectiveness is a consequence of its beauty. The question of how we account for its beauty isn't the same as how we account for its effectiveness.

3. Lady Elizabeth Eastlake, "Photography," in *Classic Readings on Photography*, ed. Alan Trachtenberg (New Haven, 1980). Eastlake doesn't say who is covered by "our," but the tone of her essay makes it clear that it extends to educated gentlemen and women who have an appreciation of the fine arts.

4. Charles Baudelaire, "The Modern Public and Photography," in *Art in Paris 1845–1862* (London, 1967); Oliver Wendell Holmes, "Doings of the Sunbeam," *Atlantic Monthly*, April 1863 (emphasis mine).

5. Holmes, "Doings of the Sunbeam."

6. Rosalind Krauss, "Photography's Discursive Spaces," in *The Originality of the Avant Garde and Other Myths* (Cambridge, Mass., 1983).

7. If O'Sullivan should properly be thought of as an artist, I have no doubt

that it is for reasons very different from those we adduce for painters like Monet. This, incidentally, is not a major issue for me.

8. This is an important point but is outside the scope of this chapter. Popularly held beliefs about the mechanical and worldly origins of photographs were well established by 1867, but experts who sought quantifiable data from pictures were aware that photographs could not provide the kind of information they needed. Thus, there was a division between scientists and popular opinion about photography—laypeople holding that photographs were essentially factual and scientific, while scientists used handmade drawings for their work because photographs could not provide them with the facts they needed.

9. Unpublished letter from Ansel Adams to Beaumont Newhall (presently in Newhall's files).

10. Clarence King, "The Range," *Atlantic Monthly* 28, no. 159 (May 1871).

11. Clarence King, "The Falls of the Shoshone," *Overland Monthly* 5, no. 4 (October 1870).

S E V E N

CHARLES HARRISON

The Effects of Landscape

Prologue

If we conceive of landscape as a genre of *painting,* what does it mean to concatenate "landscape" with "power"? Can we talk of a power or powers specific to landscape painting—that is, power specific to painting as distinct from other modes of signification, and specific to landscape as distinct from other genres of painting? Probably not, at least in the painting of the modern period, with which this chapter is principally concerned.[1]

Landscape, however, perhaps has or has had a particular role to play in enabling the distinction between the power of picturing and the picturing of power that has been a characteristic concern of Modernist criticism (criticism that, in its emotivist form not least, has itself been a means of exercise of power).[2] To inquire into the nature of this role, I suggest, is to inquire into the concept of effect.

In pursuing this inquiry, I make three methodological assumptions. The first is that an interest in the power of painting is not to be satisfied either by an account of the relations of power by which the production of paintings may be seen to be decided or by an account of the same or other relations of power that the figurative contents of paintings may be thought to picture or to reflect. As already proposed, if we are to talk to any purpose about a form of power specific to painting, we must be prepared to talk about the effects of paintings.

But an effect is a mere idealism if it is not an actual or potential effect on some spectator. My second assumption, therefore, is that, to the extent that paintings are things made to be seen, any talk about the effect of an individual painting must presuppose a believable spectator in whom some relevant experience is produced.

The need for a third methodological assumption (or caution) is indicated by the qualification introduced into the second. I propose that the practice of art—and a fortiori the modern practice of art—allows for a degree of resistance to the protocols of vision. An inquiry that conceives of paintings as things made to be seen will in most (perhaps all) substantial cases leave some form of remainder to be addressed. To the extent that this is so, the supposed experience of the exemplary spectator will be revealed as inadequate—and possibly misleading—grounds on which to base interpretation. This is to say that painting is not just a "visual art," that effects are not just visual effects, and that no interpretation can be adequate if it does not recognize what it is that any given painting significantly *withholds* from vision. Though interpretation will tend to involve the presupposition of a spectator, it will have to be allowed that the spectator in question may be one whom the painting intentionally *disqualifies*. The role of exemplary spectator is not one that can be adopted without risk of jeopardy. Nor should it be assumed that this risk can safely be calculated by any person on the basis of sociological self-image. The question of what paintings are supposed to do may be inseparable from the question of who it is that they are supposed to do it to and for. It is no more true, however, that the second question must be answerable in terms of an identifiable constituency than that the first must be answerable in terms of functions already tracked and named in a given sociology.

To speak in the voice of Art & Language, "In *Painting as an Art,* Richard Wollheim anatomises a truism, viz., that not only does a painter paint *with* the eyes she also paints *for* the eyes. . . . I can't think of an interesting painting that doesn't in some way ask if the truism is true, or otherwise offer the truists some irrecoverably nasty moments."[3] To conceive of (certain) paintings as things that may not primarily be painted either with or for the eyes is not only to question the nature and priority of pictorial effects. It is to question the assumption of the power and primacy of vision that the development of landscape painting has conventionally been taken to support. It may be true (or a truism) that landscape painting tends to naturalize ideology. But the interesting problem posed by landscape as a modern genre is how painting can be "landscape painting" and still serve to pursue the icy finality of criticism in the dialectic.

Effects and Effectiveness—I

To consider landscape as a modern genre is immediately to confront a form of apparent difficulty that deserves to be explicitly stated. On the one hand, the emergence of landscape may be associated with the apparent

loss of a certain kind of effectiveness in painting—the kind of effectiveness that goes with the picturing of figures, with the representation of certain forms of social hierarchy and so forth, and (thus) with the concept of paintings as things that may be used in pursuit of noncognitive ends (i.e., of ends that are irrelevant to the qualitative assessment of painting "as an Art"). On the other hand, the development of the genre of landscape painting played a decisive role in the development of a qualitative modernism in painting as a whole. It is certainly the case that during the later nineteenth and early twentieth centuries, discussion of the effects of painting was often conducted with specific regard to developments in the genre of landscape. How are landscape painting's agency and centrality in the development of modernist painting to be conceptualized and explained without idealism, that is, without divorcing the matter of effects and effectiveness from all attempts to quantify the spectator for whom effects *are* effects—attempts that must inevitably treat of forms of social life and of their contingency?

The normal protocols of Modernist criticism offer a form of resolution of this apparent difficulty. Effectiveness is identified as a property primarily associated with *what* is pictured (crudely, a given painting's imagery) rather than *how* a picture is painted (crudely, a given painting's surface), while the qualitatively modern in art is identified with a sustained critique of effectiveness. The cognitive or aesthetic ends of *painting* are thus strategically prized apart from those functions of *pictures* that are supposedly the focus for noncognitive or nonaesthetic interests. But this pretended resolution of the apparent difficulty merely leaves two further problems to be addressed. The first is a consequence of the Modernist tendency to autonomize art's self-critical development. Insofar as change in art is allowed to be associated with any form of human agency, it is attributed to a kind of unascribed and transcendental fastidiousness vis-à-vis pictorial images, and not, for instance, to the antipopulist tastes of those persons articulate in a discourse of aesthetic effects. The second problem follows from the identification of landscape as a medium by reference to which traditional forms of pictorial figuration were critically disparaged and downgraded. If the genre is thus put in place as a vehicle for the implementation of a kind of Modernist "purity" in painting, how are we to explain landscape's apparent loss of status during the twentieth century, when Modernism has been the dominant critical regime?

It may be that these problems can be addressed by examining the relations between effects and effectiveness. Inquiry into these relations may help both to explain the growth of landscape as a distinct modern genre in the nineteenth century and to characterize the interests that such

growth appeared to serve. It may also enable us to connect the apparent decline of the genre in the twentieth century with a historically specific form of challenge to those interests.

To anticipate. It is now part of the conventional wisdom of the social history of art that the historical emergence of landscape as a vehicle for major art entailed a convergence between claims for the autonomy of pictorial effects and claims for the disinterestedness of vision. The coincidence of these claims supposedly marks a moment of acquisition of authority—the coming to cultural power of that literate empiricistic gentleman, Wollheim's "adequately sensitive, adequately informed, spectator."[4] It can be argued that his is the constituency whose interests are represented throughout the long regime of Modernist theory and criticism.

It can further be argued that the critique of Modernism, whether conducted in the name of the Postmodern or under some other banner, is nothing if it is not an attempt to unseat the person of vision from a position as arbiter of the primordial conventions of art. We have moved on. The consequence for the genre of landscape is that its modern pursuit becomes increasingly problematic. What if we can uncover radical discontinuities between the experience of pictures that are seen as landscapes and the "disinterested" visions of land on which these pictures were supposed to be based? Or what if it can be shown that within Modernism's own black heart there lies concealed an interested agency?[5] If landscape is the genre most powerfully associated with the case for the cultural (rather than cognitive) primacy of vision, what better territory upon which to challenge that case? And what better way to do so than thus to demonstrate either the inappropriateness or the fraudulence of the claim to disinterestedness upon which that case is based? And yet the very terms of the challenge presuppose a critical resistance to the effects of the pictorial, and a deep skepticism about their supposed grounding in the recognizable appearances of landscape.

It seems that inquiry into the changing fortunes of effects and effectiveness may not simply help to explain the development of landscape as a genre. It may also help us better to understand the etiology of certain of modern painting's persistent problems and possibilities, even if new paintings that are pictures of land are not nowadays among the forms of art that those problems and possibilities tend generally to animate.

Effects and Effectiveness—II

The changing fortunes of the concept of effect serve to trace a history of landscape painting under the regime of Modernism. I single out three moments from this history as means to typify a set of relevant concerns.

7.1 Claude Monet, *Effet de neige à Vétheuil* (1878–79). Oil on canvas (shown with this title at the fourth Impressionist group exhibition in 1879). Courtesy Musée d'Orsay, Paris. Photograph: Réunion des Musées Nationaux.

The first is the moment of the 1870s, when the sobriquet "effet de . . ." was frequently used in the titles of paintings by Camille Pissarro and Claude Monet—as in *effet de neige* (snow effect; see fig. 7.1), *effet de brouillard* (mist effect), *effet de soleil* (sunlight effect), and so forth. For these painters the successful painting was a harmonious composition that produced or reproduced in the spectator the specific effects that the natural world had had on their own sensibilities. "Effet" was thus a term by which they signified the intention both to capture a naturalistic atmosphere and to render a painting technically consistent—to render it consistent in capturing an atmosphere, or to capture an atmosphere in rendering it consistent. The point of "effet" was precisely that it was not quite clear in which direction the determining was being done. To put it another way, it was not clear whether priority was to be accorded to conditions

of correspondence (to the world) or of coherence (as a painting). Was it its ability to represent the naturalistic effects of the world that secured painting's distinctive form of power, or was the "effect" that mattered the effect of the painting on the responsive viewer, irrespective of naturalistic causes?[6]

The dubbing of paintings with the label "effet" was by no means an unprecedented move in French painting of the 1870s. Nor, as I shall aim to show, was the dialectic between a mimetic atmospheric naturalism and a factitious consistency of technique unknown to major landscape painting before that date. What was new in the 1870s was the self-conscious conceptual weighting that was accorded in practice to this questioning of priorities. We gain some measure of the nature of this practice from the observation that the "effets" in question were never of the order of *effet d'orage* or *effet de tempête*. On the contrary, the emotional effects in question were relatively restrained and untheatrical. As such, they were significant both of a sense of cultural purpose and of the technicalities at issue. This is to say that the range of effects at issue serves both to characterize the disposition of a form of bourgeois audience and to indicate the kinds of technique that the painters considered appropriate to the job of attracting that audience's attention.

The second moment is located some ninety years later; at least it has its terminus ante quem in 1960. For the Clement Greenberg of "Modernist Painting," writing in that year in a now-notorious passage, there was no longer any serious doubt about the relative autonomy of pictorial effects. In his view, the defining dynamic of Modernism was that "the task of self-criticism became to eliminate from the effects of each art any and every effect that might conceivably be borrowed from or by the medium of any other art."[7] In other words, the task was to discover just which effects were properly and uniquely the effects of painting, irrespective of the aspiration to naturalism. In view of the discussion so far, it should be noted that the task in question was identified without any particular address to what might be thought a crucial question, namely, Effects on whom?

Under this critical regime landscape seemed to fare badly. It transpired that "flatness, two-dimensionality, was the only condition painting shared with no other art, and so Modernist painting oriented itself to flatness as it did to nothing else."[8] If this orientation did not entail abandonment of the representation of "recognizable objects," it nevertheless entailed abandonment of "the representation of the kind of space that recognizable, three-dimensional objects can inhabit."[9] But what is the space of landscape if it is not just such a space as this? As Greenberg had proposed in another major essay published two decades earlier, the paradigmatic

Modernist painting of the mid-twentieth century is abstract painting.[10] It would seem that landscape must either be relegated once again to the secondary genres or fall even further into the trough of kitsch.

The Modernist critic, however, accords an important developmental role to later nineteenth-century French landscape, and particularly to the work of Cézanne. Greenberg's own writing of the later 1940s and 1950s is sprinkled with passages in which the moment of supposed transition from landscape to abstract painting is variously highlighted. "The paradox in the evolution of French painting from Courbet to Cézanne is how it was brought to the verge of abstraction in and by its very effort to transcribe visual experience with ever greater fidelity."[11]

And of Cézanne's work in particular:

A vibration, infinite in its terms, was set up between the literal paint surface of the picture and the "content" established behind it, a vibration in which lay the essence of the Cézannian "revolution." . . .
. . . the path of which Cézanne said he was the primitive, and by following which he hoped to rescue Western tradition's pledge to the three-dimensional from both Impressionist haze and Gauguinesque decoration, led straight, within five or six years after his death, to a kind of painting [i.e., analytical cubism] as flat as any the west had seen since the Middle Ages.[12]

My third moment is the moment at which some significant body of critical opinion decided that what was actually entailed in Modernism's self-critical project—at least as Greenberg represented it—was a form of damaging reduction in the power of painting to represent the world for and to a broad constituency; a concentration upon the autonomy of art at the expense of any consideration of the conditions of its reception; an abnegation, in fact, of the requirement of effectiveness or, worse, a masking of modern painting's actual effectiveness on behalf of a small minority. This perception was expressed in much crude rhetoric about the need for relevance, for Realism, for purpose. It was also very much more sensibly voiced in such questions as the one that T. J. Clark asked in 1980 about the initial reception of Manet's *Olympia*: "It is an open question whether what we are studying here is an instance of subversive refusal of the established codes, or of a simple ineffectiveness; and it is an important question, given *Olympia's* canonical (and deserved) status in the history of avant-garde art."[13]

The question that I take Clark here to be addressing to the critical apparatus of Modernism is whether or not the autonomizing of effects amounts to the construction of a form of alibi; that is, whether the pursuit of flatness as perceived in Greenbergian theory is rightly understood as

the pursuit of a critical virtue, or whether what is really being celebrated in the name of the aesthetic may actually be a form of willful ineffectiveness in the face of the world.

When he comes to consider Monet at Argenteuil, Clark certainly views that painter's "insistence" on landscape as characterized by a pattern of exclusions, a pattern in which the seductive power of painterly effects serves to mask a lack of purchase on the real—in that sense, we might say, an abnegation of the possibility of effectiveness in the modern world.

If the tour de force was successful, the play of paint would absorb the factories and weekend villas with scarcely a ripple. Surface would replace substance; paint would *perform* the consistency of landscape, in spite of everything a particular landscape might put in its way; there was nothing that could not be made part of a picture—of a picture's fragile unity—if the painter confined himself to appearances and put aside questions of meaning or use.[14]

Insofar as I intend my various "moments" to be related in chronological terms, it should be said that the third moment followed hard on the heels of the second. In fact, they were virtually coincident.[15] That is to say that the sense of "effect" as the measure of a decorative vividness underwritten by technical specialization and the sense of "effect(iveness)" as the measure of an agency underwritten by some form of embeddedness (an ideological agency, for example) are the two mutually opposed faces that go to define a single historical coin.[16] It is a condition of late-modernist culture that any strong statement that presupposes one sense of effect will tend to elicit a countering assertion that presupposes the other.

For a notable and extended example, consider the dialogue between Michael Fried and T. J. Clark initiated by Clark's essay "Clement Greenberg's Theory of Art."[17] Fried's claim that the "convincingness" of a specific sculpture by Anthony Caro depends on "the sheer rightness of *all* the relevant relations at work in it"[18] elicited from Clark the following rejoinder: "One of the reasons I cannot see Caro's . . . work very well any longer is that I have become more aware over time of the ground of interests and arguments it serves."[19] This case furnishes an opportunity for a review of our discussion so far. Fried claims that the effects of Caro's sculpture are fully cognitive—or aesthetic—effects. In speaking of the rightness of that sculpture's relations, he presupposes that the relations at issue are those between the work's formal components. Clark's riposte impugns Caro's work as *effective* for those whose noncognitive interests it actually serves. For him, the relations at issue are those that define the sculpture's connection to other features of the world.

Over the past thirty years, however, insofar as the art of landscape painting has been implicated in the dialogue or dialectic between these

two voices, it has been implicated as a subject of art-historical interpretation and reinterpretation, not generally as a concern of current artistic practice. So far as concerns the art of painting, the contemporary "effects" that have generally been matters of dispute have been the supposedly autonomous effects of abstract art on the one hand and the supposedly displacing and ironizing effects of pop art and its antecedents and derivatives on the other. To the extent that it has been of critical moment, modern argument over the "effectiveness" of landscape painting has almost entirely been argument about how the landscape painting of the eighteenth and nineteenth centuries should and should not be interpreted. Among those advancing strong and strongly contested cases have been John Barrell on the "dark side of the landscape" as readable from eighteenth- and early nineteenth-century English paintings (by which he means to refer to the historical face of rural poverty behind the mask of the pastoral),[20] Michael Fried on the mutual implication of automatism and realism in Courbet's landscapes,[21] and Paul Tucker on the putative role of nationalistic themes in Monet's series paintings of the 1890s.[22] In their very different ways, each of these authors has sought to reclaim some sense of the possible effectiveness of nineteenth-century landscape painting from the grip of a standard Modernist aesthetics. The landscape painting of the twentieth century, in contrast, has generally been regarded as too marginal to be worth contesting, except by those concerned to reassert traditional—which is to say provincial—values.

This may change. A wholesale unraveling of the fringes of the Modernist canon is both a cause and a consequence of transformation in the meaning of modernism itself. It is the contention of this essay that inquiry into landscape as a modern genre helps to locate the dialectic between "effect" and "effectiveness," not only as crucial to the etiology of Modernism, but also as pertinent to the formation of notions of the Postmodern. What follows is intended to sketch out some possible preliminaries that such an inquiry might address.[23] In particular it is suggested that neither the matter of the effects of paintings nor the matter of their potential effectiveness can properly be addressed without consideration of two key issues. First, it will be necessary to consider the forms of technical development that have been particularly associated with landscape, notably the apparent sharpening of the contrast between painterly surface and pictured depth that I propose is a form of revision of more conventional figure-ground relations. Second, we will need to give some consideration to the ways in which landscape paintings have tended to function (metaphorically) as kinds of metaphor. I aim to bring together these distinct avenues of inquiry, for it is precisely at those moments when distinctions between the technical and the metaphoric become hardest to sustain that

the effects of landscape are most vivid and the legacies of landscape most pertinent.

Landscape as Background

One way to bring the Modernistic and the sociohistorical senses of effect into some form of initial collision might be to treat the (typically Modernist) question (1) What is the effect of this painting? as actually implying the (typically sociohistorical) question (2) Who is it for? where the sense of this second question is not (or not only) Who is the painting made for? and not (or not only) For whom is the effect an effect? but, more significantly, Who—what kind of viewing person, equipped with what kind of disposition—is presupposed by the painting's composition? The strategy here is to prevent the question of effect either from going directly to talk of essential qualities or from going directly to the sociology of the proprietor or the subjectivity of the viewer of the painting. The aim is to concentrate rather on the framing of a subject by the painting—the framing, that is, not simply of a view but also of an exemplary if imaginary viewer.[24]

I don't mean to dismiss the sociological implications of Who for?—as if a sufficient concentration on matters of "composition" could serve to dispel the awkward considerations of ownership, patronage, and constituency that inhabit the margins of all the genres, not least the genre of landscape. Nor do I mean to dismiss the problems, both sociological and psychological, that cluster around the question of the viewer's subjectivity. On the contrary, the reexamination of the question Who for? is of explicit relevance both to the sociological and to the psychological aspects of a given painting's reception. The point is that maintenance of the possibility of a distinction between imaginary viewer and actual consumer may at least serve to protect us against two crude but pervasive methodological errors: the first is the tendency to reduce paintings to forms of reinforcement of given property relations and "ideological frameworks"; the second is the tendency to confuse the problem of competing interpretations with the problem of the different interests of multiple viewing subjects (so that problems of interpretation are reduced to mere incidents and functions of social and psychological divisions and differences).

It may be best to start at a point—and with a form of picture—where the power of picturing and the picturing of power might be said to go hand in hand. If we can sketch out some hypothetical grounds of their apparent convergence, it may become clearer by contrast just how—under what kinds of conditions—we might have to acknowledge that interest in the one had clearly diverged from an interest in the other. My example,

therefore, is drawn from the English portrait painting of the mid-eighteenth century, when if artists extended their competence to the display of landscape, it was normally either to record the extent and quality of their patron's estates, or to locate their sitters within a world that was proposed as the sitters' rightful cultural domain, or both. In Arthur Devis's picture of the James family (see fig. 7.2), the skill that the artist exercised in establishing and decorating a deep illusionistic space—the propitious space of landscape—must once have seemed comfortably reconcilable with such authority as was accorded to the depicted patriarch, who stands clearly enclosed by that space, yet detached from it. After all, the power of patronage was supposed to be practically sustained by what the space was seen to contain.

To say that the power of representation is here employed in the interests of representation of power is to discern in the painting what may be thought of as a form of thematic content, or—to recall the second of my methodological assumptions—of effect. According to this view, Devis's picture does not simply present an image of the patron, with his wife and children. Effect is effect upon some viewer. The painting also represents what is seen by someone who sees the family as members of the landed gentry. Although the painting as a decorative object was made for the patron, its execution thus presupposes the type of another spectator, one who is disposed to view the actual landscape as rightful property—which is to say, a spectator disposed to attribute a certain stability to the relationship of pictured figure to pictorial ground, and thus, in a sense, to make the picture work. To speak of a man's "background," after all, is to speak of the referents of his class.

Thus to conceive of the effect on an exemplary spectator is to associate the power of the painting not simply with the picture it presents but more tellingly with the manner of its symbolic eliciting and implementation of this act of recognition—a manner that entails adherence to certain norms of delineation and gradual modeling, so that a sharp focus is maintained on foreground figures while the pictorial signifiers of atmosphere are relegated to background and to distance, and so on.

In the same spirit, it might be said that acknowledgment of this order and in these terms was a large part of what the patron was paying for, which is to imply that, in the absence of any substantial disagreement as to the painting's effect, there are no strong grounds on which to distinguish between its effect and its effectiveness. Of course it takes no great imagination to conceive of viewers unable or unwilling to make such an acknowledgment. But such viewers would not conform to the type of viewer presupposed, so that we can fairly say that they remain unrepresented either *by* the painting or *in* its composition.

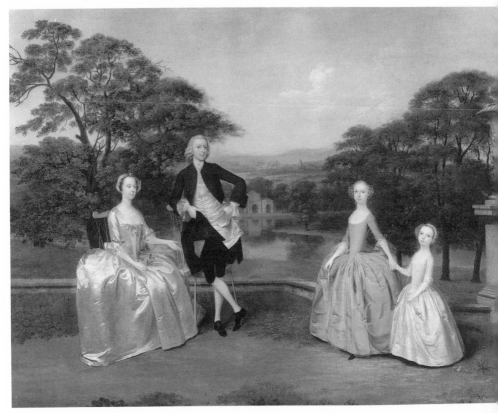

7.2 Arthur Devis, *The James Family* (1751). Oil on canvas. © Tate, London 2000.

A reservation needs to be entered here. This reservation concerns the question of power and of the relations between its various forms. Though it is called up by discussion of this specific painting, it is of general relevance to the concatenation of painting with power. We need to distinguish between a power established as it were de jure, the actual grounds of which may be weak, and the strength of those mechanisms which may be used to secure that power. A strong police force may be employed to bolster a weak authority. That a given painting is powerfully convincing in its picturing of certain hierarchical relations is by no means a guarantee that what is being pictured is a securely established power.

Devis's picture was painted on the threshhold of what is normally regarded as the period of establishment of landscape painting in England.[25] My point in citing it, though, is not to reinforce the antique

art-historical truism that landscape grew to significance (or "into Art") from the margins of other genres. This truism itself requires a brief discursus, since it rests upon two defeasible assumptions that are endemic to much generalizing discussion of landscape as a genre. First, it presupposes a kind of inexorable and ahistorical gradualism in the development of art; second, it presupposes that the meaning of landscape as an artistic category overrides the specific conditions of land use and landownership in different countries and at different periods. Assent to the truism licenses such absurdities as that the "landscape" in the corner of a fifteenth-century Italian altarpiece can be reconciled with the "landscape" in the background of an eighteenth-century English portrait insofar as both represent stages on the route to Constable. Thus employed, landscape stands for a space in which history disappears.[26]

In fact English landscape is not significantly a form of growth out of portraiture. Rather, I suggest, it represents a form of alternative to portraiture or even of resistance to what portraiture tends to picture. The mechanisms of this resistance are not to be understood in terms of gradual artistic processes. Landscape achieves autonomy as an artistic genre in England only when the countryside can be viewed as other than the property of the landed gentry—or rather, to be precise, only insofar as the task of representation of the countryside comes to be distinguishable from the business of reinforcement of title. The act of imagination required is clearly not primarily artistic.[27] What it entails is not necessarily that the countryside should be viewable as the property of others than the landed gentry. (After all, Constable's father was the proprietor of the land on which Constable largely painted during the second decade of the nineteenth century.)[28] More significantly, it entails that the countryside is viewable under some aspect other than its aspect as property. What this tends to mean in the practice of art is, on the one hand, that landscape is conceived of as a paradigmatic site of individual experience—in other words, that response to landscape is taken as a measure of individuality (with all the various forms of value for which that term becomes a focus during the period in question); and on the other, that the representation of landscape is conceived of in terms of *painterly* effects.[29] We might say that what distinguishes a painting by Constable is that he is concerned to maintain an empirically justifiable relationship between his painting and the world, if necessary at the expense of a secure relationship between the painting and painting's paradigmatic consumers. This world is conceived of, that is, as an autonomous repository of conditions for painterly effects. Its autonomy is relative to normal meanings of "land," which meanings the technical dynamics of Constable's painting tend increasingly to evacuate.

According to the traditional presumptions of art history, to talk of

painterly effects is indeed to talk the language of artistic development and of "intrinsic concerns." It is therefore all the more important to establish that, at the time of the growth of landscape painting during the late eighteenth and nineteenth centuries, the conditions of possibility of the relevant conceptions were not just artistic conditions, nor were they gradually established. It's also important not to mistake the significance of a relative diminution in the size of pictured figures—or even of a total absence of human figures from landscape paintings. It should hardly need saying that the genre of landscape is a resource for the symbolization of an already represented world, which is inescapably the world of human concepts and values.

My suggestion, then, is that the development of landscape painting as a modern form of art involves displacement of the forms of figure-ground relations that characterize the Devis painting, and that the mechanisms of this displacement are historically specific. What ensues (and this is the burden of the next section) is that the emphasis upon painterly effects that is associated with the nineteenth-century development of landscape imposes a different form of imaginary activity—and thus of identity—upon the viewer of any relevant painting.

The Individuality of Landscape

As I suggested at the outset, the instance of the *James Family* serves to establish the grounds of contrast. It is neither modern nor a landscape but a relatively conservative portrait group. I don't pretend to have offered a sufficient account of the painting. Indeed I've deliberately approached the very form of reading I cautioned against earlier—a reading that, in failing to distinguish between viewer and consumer, or to engage with the peculiarities of Devis's work, virtually reduces the painting to the status of reinforcement of a prevailing ideology. My intention has been simply to thematize a form of apparent coincidence between the type of painting it is and the interests of readings such as the one I've sketched. I don't mean to rule out the possibility of a critically alert viewer of the painting for whom its status as reinforcement of property relations is significantly subordinate to some other noticeable aspect, such as its aesthetic interest, or even the possibility of a competent viewer for whom the implicit claim to title fails on other grounds to be effective.

It should by now be clear that the point I mean to call attention to in using Devis's painting as example is that to call a painting modern is both to say something about what is is like and to express a kind of belief about how it is to be seen. It is to say, among other things, that its "content" is not to be specified either in terms of a comfortable reconcilia-

tion between skill and property or in terms of a stable relationship of figure to ground. In other words, if we stick with the notion of an exemplary spectator whom the painting presupposes, whose viewpoint the artist adopts in order to paint the picture, then we would have to say that the painter of a modern picture conceives of a spectator differently disposed to the notional viewer of Devis's picture. In fact it transpired at various moments of development of the modern tradition that one way to signify the different disposition of the relatively modern viewer was to conceive of him or her as a viewer of the landscape.[30]

Clearly the significance of figure-ground relations in painting is not restricted to the matter of how human figures are represented in pictorial spaces. (If it were, the genre of landscape would form an inappropriate subject of study.) What is at issue is the relationship of the notional spectator to that which the picture shows—or to that which is conceived of as picturable. The conventional wisdom of art history tells us that in the modern form of this relationship, a certain priority is accorded to the *how* of the painting of a picture, at the expense of interest in the *what* of its figurative content (which is not to say that the distinction is without its ambiguities and complexities). In this view, modern spectators pride themselves on their awareness that the viewing of a painting is not an experience that establishes imaginative access or equivalent to the viewing of the actual scene pictured. Modern viewers are supposed to demonstrate their sophistication, like the precocious child at a conjuring show, by refusing to be taken in by illusions.

If the significance of a shift in figure-ground relations is to be adequately established, this conventional view will need to be amended in two respects. The first is that the notion of the painting as a world one might walk about in was never much more than a matter of literary conceit. *Any* pictorial space, by definition, is "a space into which one can only look, can travel through only with the eye." This is the formula that Greenberg used to distinguish the "illusion created by a Modernist" from the space of the Old Masters, "into which one could imagine oneself walking."[31] It has to be said that the difference between imagining oneself walking through a space and traveling through a space "with the eye," even if it is an empirically demonstrable difference, is a far from reliable guide to empirical differences between individual paintings. What it does testify to is a difference in the ways one might *conceive* of the activity of looking at a painting. If the sophistication of the Modernist is to be established by contrast with a type of naive viewer, however, it must be supposed of this viewer that he or she is so far persuaded of the power of illusion as to act upon it. What actual viewer of an actual painting could be referred to as satisfactorily exemplifying this type? The second

reservation to the conventional self-image of Modernist viewers is that the form of skepticism that they claim for themselves is nothing if it is practiced only upon paintings.

To sum up, then, it may be said that the achievement of modernity is irreconcilable with unquestioning acceptance of the illusion of deep space. But this is to say virtually nothing unless the statement is made in recognition of the relativity of any response to illusion and unless what it entails is that that achievement is incommensurable with acceptance of (what may have come to be seen as) a conservative order of property and power relations. To put this point the other way round, an inclination to question the relations of figure to ground can be considered a telling qualification for the spectator of a modern painting *only to the extent that figure-ground relations serve pictorially to symbolize real relations*. For the spectator thus qualified, the pictorial figure that rests stable and secure against its pictorial ground is a sign deprived of vitality. In the words of Voloshinov: "A sign that has been withdrawn from the pressures of the social struggle—which, so to speak, crosses beyond the pale of the class struggle—inevitably loses force, degenerating into allegory and becoming the object not of live social intelligibility but of philological comprehension."[32]

The apparent paradox of modern landscape, then, is that to be viewable as a picture within the limits of the genre it must establish reference to a relatively deep space, while to be viewed as significantly modern it must undercut that very form of figure-ground relationship in terms of which the illusion of deep space is traditionally established. It was the force of this paradox, I suspect, that gave landscape its particular pertinence to the process of self-identification of a modern sensibility. That is to say, it was in landscape above all that the dialectic between a requirement of effectiveness and an interest in effects was most vividly experienced as a practical and technical issue by advanced painters during the nineteenth century. Greenberg's puzzling over Cézanne was no doubt puzzling at a historically substantial issue—albeit some of the same problems are posed by Constable's major landscape paintings of the mid-to-late 1820s, when it could be said that what was to be called Modernist Painting got off to a form of false start.[33]

The Body in the Landscape—I

If we are to discover forms of power specific to modern landscape painting, then, what we must be looking for is not some tendency to imaginary conservation of established forms of order (not even the form of self-sufficiency or autonomy that is predicated of the solitary contemplating subject) but, on the contrary, some species of effect by means of which

any *picturable* kind of order, however deeply or poignantly indexed to the observable world, is liable to be negated or obscured or displaced by an effect of some other order.[34]

As the meanings of painting and picture have tended to pull apart, the former has come increasingly to be conceptualized in terms of individuality of experience and effect, while it is with the latter that the concept of effectiveness has remained principally associated. The consequence for the genre of landscape is that a gap has opened between the question of the intensional and autonomous character of the given painting and the question of the psychological or sociological characterization of that notional spectator from whose position the modern world—including the actual landscape—is supposed to be viewed, and who is thus assumed to constitute its authority, if not its author. The wider this gap has seemed to grow, the less useful it has appeared to be to associate paintings with the exercise of any sociologically identified power. It is an ethical implication of modern art thus represented that the requirement of effectiveness, *whatever may be the position from which it issues,* is always and only a conservative requirement when it is made a condition of vividness and value in the experience of art.

To talk of the effects of paintings, in contrast, is to consider a form of potential for resistance to ideology that is specific to painting as a form of art, and specific to individual paintings as things that are not just conceived but made. As regards the genre of landscape, to consider the nature of these effects is, on the one hand, to examine the technical characteristics of relevant paintings and, on the other, to ask what pictures of landscapes contain or express *other* than what they literally picture.

I will try to explain what I mean by reference to a relatively straightforward example. My purpose is to illustrate a form of gap between that which is overtly pictured and that which might be considered as latent content (a form of content we might under certain circumstances want to refer to as unconscious). In the gap, as it were, there will be questions raised about the significance of technical qualities.

Georgia O'Keeffe's *Red and Yellow Cliffs* pictures a scene presumably set in the American Southwest (see fig. 7.3). It was painted in 1940, which means that its execution coincided with the publication of Greenberg's "Towards a Newer Laocoon," and thus with the beginnings of an explicitly Modernist theorization of the autonomy of effects (not that O'Keeffe was an artist of whose work Greenberg approved). The absence of a horizon is a distinctive feature of the composition. Since the painting appears relatively naturalistic, it might be thought that this absence is to be accounted for by the nature of the motif. A moment's thought—or comparison with another subject such as Ferdinand Hodler's

1909 view in *La Schynge Platte* (see fig. 7.4)—serves to make clear that the positioning of a horizon is always relative to the composition of pictorial space and to the establishment of pictorial illusion. That is, it is relative to some notional viewpoint and to some intended effect. In the case of O'Keeffe's painting the absence of horizon helps to produce an effect of containment that seems at odds with the illusion of distance and space established by other features of the picture.

To acknowledge this effect is to achieve some emancipation from the grip of the painting's apparent naturalism—that is, it is to enable the seeing of it as other than a painting of a landscape (and if anyone wants to apply a Lacanian loading to that "other," I think both my sentence and the painting will support it). In particular, there are now two kinds of observation we are more likely to be able to make: the first kind of observation concerns the painting's figurative resemblance to features of the world other (again) than landscapes; the second concerns the nature

7.3 Georgia O'Keeffe, *Red and Yellow Cliffs* (1940). Oil on canvas, 61 × 91.4 cm. The Metropolitan Museum of Art, Alfred Stieglitz Collection, Bequest of Georgia O'Keeffe, 1986 (1987.377.4).

7.4 Ferdinand Hodler, *La Schynge Platte, Alpes Suisses* (1909). Oil on canvas. Courtesy Musée d'Orsay, Paris. Photograph: Réunion des Musées Nationaux.

of its relationship to its literal edge. The two observations are mutually implicated and need not to be held apart if the painting is to be kept in view as a painting.[35]

First, then, if the work resembles cliffs, it also at least in part establishes a relationship of resemblance to mounds and folds and furrows of flesh, and specifically to the human vulva, an association that the ambiguity of scale serves to keep in play. (By what I take to be an accident of circumstance, the resemblance is underscored by the presence within the same museum collection of Egon Schiele's *Beautiful Girl I Saw in a Dream* of 1911 [see fig. 7.5], in which the spread labia of its subject are pictured in a manner strikingly similar to the way in which the central clefts are pictured in O'Keeffe's landscape. It may be acknowledged that similarity is a potentially distracting relationship.[36] What we can at least say, how-

ever, is that for anyone who had the Schiele in mind, the association of cleft with vulva in the O'Keeffe would be rendered virtually inescapable.)[37]

The second observation we are in a position to make about O'Keeffe's painting, once the illusion of distance has been relegated, concerns the evenness and obtrusiveness with which the painting fills out its frame. From top to bottom and edge to edge, the literal body of the painting as object appears to swell out into the viewer's imaginary space, giving a particular weight to its evocation of the figurative body. It is as if the ground of the painting advances and *becomes* figure.

In citing this work as example, I have not meant to advertise its merit but simply to dramatize a form of contrast between overt and latent content.[38] That is, I have meant to insinuate the suggestion that in the form of the dialectic between painting and picture that characterizes landscape, there is a tendency for specifically human content to appear at the level of the latent, and to appear, moreover, through a form of effect that is not so much unaccountable for in terms of the given figure-ground relations as contradictory of those relations.

I should make clear that in using *Red and Yellow Cliffs* as example, I don't mean to suggest that the latent content of modern landscape need be associated with the kind of translatable imagery to be found in O'Keeffe's painting. On the contrary. Equation of the power of painting with the *translatability* of metaphoric content is a methodological error courted by those forms of the social history of art which shirk the problems of relative quality. It needs to be borne in mind that pictorial metaphors are only metaphorically metaphors. In the case of *Red and Yellow Cliffs,* though the painting's overt naturalism is haunted by its latent content, and though a certain stereotype of picturesqueness is thus rendered unstraightforward, once the iconic connection to the body is registered, it is as if another and equally emphatic stereotype were simply installed in place of the first. The representation of nature as a kind of female body is, after all, ideologically normative.

It is at the level of technique that this failure of resistance and of originality is most clearly discernible. In writing of paint "performing the consistency of landscape," Tim Clark was referring to the ways in which the alliance of taste and technical ability in Monet's work might be used to keep certain forms of evidence at bay. In O'Keeffe's painting a different "consistency of landscape" is performed by analogy with the photographic. It is the very transparency and ordinariness of this analogy that serves to generate metaphor as cliché. It may be noted how very similar in kind the effects of O'Keeffe's painting are to those of a more widely and more recently celebrated painter of landscapes, Anselm Kiefer. In Kiefer's work a powerful sense of latent content similarly operates to

7.5 Egon Schiele, *Beautiful Girl I Saw in a Dream* (1911). Watercolor and pencil on paper, 18⁷⁄₈ × 12⁵⁄₈ in. The Metropolitan Museum of Art, Bequest of Scofield Thayer, 1982 (1984.433.311).

destabilize the insistent photographic naturalism of dramatic landscapes, only to usher in the very stereotypes of profundity that are the normal currency of the culture.

The Body in the Landscape—II

We need an example of latent content working in concert with a more successfully inventive technique. An earlier painting may serve better to advertise and to elaborate on the range of effects that attend on the modern development of landscape. Corot's *Souvenir of Lake Nemi* was shown at the French Salon in 1865 (see fig. 7.6). The largely imaginary landscape is notable for two distinctive features. The first is the dramatic evening light, timed, it seems, after the sun has dropped below the horizon but before it has sunk too far for its glow still to tinge the undersides of the clouds. Effects attributable to the quality of light include the sharpening of the silhouettes of buildings at the left and the deft merging of mist and reflections that establishes the surface of the lake. The second notable feature is the faunlike male bather in the right foreground, braced for the sudden movement in which he will pull himself out of the water. Though his position puts him well out of reach of the source of light, the curve of his back is made to shine out against the darkness of the bank.

The concept of painting as "souvenir" serves to advertise the status of the work as an attractive memento of a well-known and picturesque location in Italy (one Corot had in all probability not visited himself for over twenty years). But the distinctive effect of the painting, I suggest, derives from Corot's subtle inversion of the conventional figure-ground relationship and from the effect that this inversion produces. It is not simply that the figure appears completely absorbed by the ground; what is remarkable is the way Corot has reversed the normal thematic order, so that where we expect the ground to serve as context for the figure, it is here the figure that serves to enhance the meaning and the atmospheric charge of the world that includes it.

At one level Corot draws upon a classical tradition that allows nymphs and fauns to stand as forms of animus loci in an imaginary world insulated against change. But he draws on this tradition only to divert it with naturalistic effects. In *Souvenir* he establishes a subtle metaphoric relation between a moment of anticipation conceived in paradigmatically visual terms—the moment of impending loss of light—and a moment of anticipation of sudden physical movement, a movement that the imaginative viewer may come to experience in virtually kinesthetic terms through its effect upon the psychomotor reflexes. It is as if the condition of preservation of what the picture shows—of the "souvenir" defined in painterly

7.6 Jean Baptiste Camille Corot, *Souvenir of Lake Nemi* (1865). Oil on canvas, 98.4 × 134.3 cm. Bequest of Florence S. McCormick, 1979.1280. © 1991 The Art Institute of Chicago. All Rights Reserved.

terms by a remembered quality of light—were the continual suspension of the bather's impending trajectory. This suspension is experienced immediately to the extent that it involves a prolonging of the engaged spectator's own muscular anticipation.[39] The eliciting of this form of sympathetic response is in general crucial to the qualitative character of the painting.

To say this is to say something quite specific about the effect of Corot's work and about the mechanisms of production of its effect. It does not follow, however, that the effect in question is itself either finite or appropriately reducible to a linguistic proposition or set of propositions. In Davidson's succinct formulation, "Seeing as is not seeing that."[40] It is a powerful lesson of Corot's painting that the forms of response elicited by the metaphoric structure are not such as can either be exhausted by mere acts of recognition or channeled into assertions about what is or is not the case.

In the light of these examples a form of axiomatic framework might be established for the purposes of inquiry into the effects of landscape, as follows. It is claimed in respect of a certain category of paintings:

1. that they are "landscapes" insofar as they refer to landscape motifs and insofar as they establish their distinctive effects in part through an illusion of relatively deep space, but that they are nevertheless also invested with a latent content of a different order;
2. that this content is unaccountable for by simple reference either to the naturalistic motif or to the system of illusion by which that motif is represented; it is a function of what the painting *does*, not just of how it *appears;*
3. that it is nevertheless a necessary condition for disclosure of this content that the spectator of the *painting* be able to adopt the imaginary position of viewer of the represented *scene*, as that position is constructed by the composition of the painting; and
4. that the adoption of this position and the disclosing of this content are necessary conditions of a defensible interpretation.

One further point needs to be made. Discussion of landscape painting as a form of metaphorization of the body and of the sensation of the body evokes the work of Michael Fried on Courbet's Realism, mentioned earlier. Fried writes of what he sees as Courbet's attempt—bound of course to be frustrated, but all the more significant for that—to "transport" himself bodily into his painting, and thus in imagination to obliterate the painter-spectator who stands separate from the canvas as notional viewer of the scene it represents. Fried also discusses what he sees as the anthropomorphism of Courbet's landscapes, the tendency for the forms of the body to be present in rocks and screens of leaves, rather (if I read him correctly) as recognizable forms of effect than as recognizable forms of picture.

Fried is not the first person to notice this tendency in Courbet's work, but he gives the tendency an inflection that makes it pertinent to my argument. To try to clarify what I take Fried to mean, I illustrate two versions of the same composition, Courbet's *Le ruisseau couvert* or *Le puits noir* of ca. 1865 (see figs. 7.7 and 7.8). Fried finds a face at the left-hand side of the composition (though he illustrates this perception by reference to a third version of the composition, in Baltimore.)[41] I find a torso at the right (in a part of the scene omitted from the Baltimore picture). I see it as embedded up to the thighs in the margins of the stream in the foreground and turning back into the picture space so that it merges at the level of the neck with the large boulder in the bottom right-hand corner. I find this torso only in the Chicago version of the scene (fig.

7.8), however, even though the Paris version follows exactly the same topography, and although virtually all the same formal components are present.

Now I don't believe that the issue of who sees what is of much moment. The claim I would be concerned to defend is that the Chicago picture is far more markedly haunted by the sense of physical human presence than the Paris painting. In "discovering" a torso in the former, I doubt that I am doing very much more than seeking an ostensive token in terms of which to register my sense of this difference of effect. It would seem unnecessary, and indeed misleading, to proceed too far into the comparison between rocks-seen-as-face, rocks-seen-as-torso, and rocks-seen-as-rocks. At a certain point the question of intention would inevitably intrude, and I suspect that, Wollheim notwithstanding,[42] the question is undecidable, if not beside the point, particularly where what is concerned is a highly metaphoric form of expression. What seems to me fertile in Fried's thesis is precisely that he is concerned, on the one hand, with the priority of the effects of the paintings in question and, on the other, with the automatism or involuntariness of the process by means of which he sees these effects as achieved.

I assume that I am following the spirit of this thesis in saying that while I may see a transformation of rocks into torso in the Chicago painting, and while I may see—or rather experience—the two versions of the composition as different, I do not see this difference as consciously intended. For Fried, it is precisely the involuntariness of the effects he discusses that stands as the guarantee of their critical realism. It is the "automatism"—the possibility, as it were, of not seeing what one is doing—that secures the possibility of abolition of the artist-spectator as a presence determining upon the painting. To conscript this thought to the purposes of the present essay, I would want to say that it is in the involuntary effects of physical presence that we find the signs of the body's resistance to ideology. In other words it is a condition of the involuntary effect of the painting that it abjures the pursuit of a deliberate and figuratively ascertainable effectiveness.

It remains to connect this point to the question of the dialectic between picture and painting. To this end I return to the work of Cézanne. The painting I have in mind is *In the Park of the Château Noir* (see fig. 7.9). Though this is in most significant respects a very different kind of painting from O'Keeffe's *Red and Yellow Cliffs*, it has one important point of similarity. It combines an effect of spatial recession with an effect of literal fullness or density. My contention would be that the painting establishes the illusion of a relatively deep space—the space of a landscape; that the composition positions a notional viewer as it were on the threshold of

7.7 Gustave Courbet, *Le ruisseau couvert/Le puits noir* (1865). Oil on canvas. Courtesy Musée d'Orsay, Paris. Photograph: Réunion des Musées Nationaux.

the scene the picture represents; and that this viewer is qualified in terms of certain cognitive activities involving the reading of mass, light, distance, and so forth. Indeed, these activities are imaginatively proposed as the very means by which the notional spectator achieves a position and an orientation in the landscape.

It is at this point—or from this position—that a different kind of order might be said to work upon the viewer of the painting. For to adopt in imagination the position of one doing the looking at the represented scene is also to be faced in actuality with the complex practical mechanisms by which the illusion is established—the planes and touches and contrasts on the literal surface of the painting, which register the factitious activity of the artist with great vividness, and which thus establish the details of the painted surface inescapably as the constituents of something *made*.

It is as if the notional spectator were equipped with highly tuned cognitive competences in the form of a full sensory apparatus and set of kinesthetic responses, so that the depicted scene is not simply apprehended as

an ordered set of visual details but is also sensed as that series of literal edges and intervals, projections and hollows, from which it is itself constructed as a form of spatial illusion. This is emphatically not to say that the surface is perceived as a kind of relief, as if there could be such a reconciliation between the painting's literal flatness and its pictured depth. Rather, it is to say that while the surface in its factitious aspect offers an experience that is in certain respects irreconcilable with the same surface in its "optical" aspect, the two aspects nevertheless come together in what is sensed as a simultaneous picture, or painting.

Cézanne's painting is thus marked by a profound and critical form of thematization of the relations between making and seeing that are the

7.8 Gustave Courbet, *The Valley of Les Puits-Noir* (1868). Oil on canvas, 60 × 73 cm. Gift of Mr. and Mrs. Morris Kaplan, 1956.762. Photograph by Kathleen Culbert-Aguilar, Chicago. Photograph © 1993, The Art Institute of Chicago. All rights reserved.

7.9 Paul Cézanne, *In the Park of the Château Noir* (c. 1900). Oil on canvas. Reproduced by courtesy of the Trustees, the National Gallery, London.

practical conditions of all painting. What is it like to see? Is it to take the thing seen as forming a totality outside oneself, and as being that in relation to which one orients oneself? Or is it to take the act of looking as the means to decide one's cognitive being in the world? The painting is not *designed* to pose this problem, as if it were a philosopher's object. Rather it is the contingent and specialized product of a mode of existence that the problem has come to dominate. The painting does not exactly stand as a form of metaphor for this mode of existence. Rather, the painted landscape makes the problem palpable as a condition of its own effect upon the viewer.

It is now easier to explain the sense of relative disappointment that is a secondary effect of *Red and Yellow Rocks*. The initially dramatic effect of O'Keeffe's painting resides partly in its virtual supplanting of one reading or even one icon by another. The effect of Cézanne's painting, in contrast, is to resist relocation in some imaginary space apart from the world of the depicted scene and thus to keep the viewer as it were at work in its actual presence. To put this another way, in face of the Cézanne the imaginary position of viewer of the scene is never abandoned, but the consequence of its being maintained is that, as one aspect of the painting "corrects" the other, that position is rendered at every point subject to correction from the position of maker of the painting. The technical character of the O'Keeffe, in contrast, is simply not such as to produce a spectator who goes on working at the painting.

In Conclusion

If there is a form of power specific to landscape painting, its measure will surely not be taken by a survey of what it is that landscape paintings show, however well explained that showing may be. To inquire adequately into the power of landscape painting, we will need to explore and to reexamine critically the kinds of metaphors for which the genre has historically furnished occasions and to which it has given rise—among them metaphors of integration and dislocation, of presence and absence. That is, we will need to take special account both of the forms of self-consciousness with which the concepts of nature and of vision have inescapably been invested and of the ways in which that self-consciousness has itself been topicalized. And then we will need to connect these to such particular forms of the dialectic between illusionistic depth and factitious surface as the genre of landscape has had distinctively to offer. And finally we will need to face the full implication of the register of effects with which landscape has been associated in the modern period, some of which

are forms of practical derogation of clichés of integration and dislocation, of presence and absence.

And what, then, of the Postmodern? I conclude with *Hostage XIX,* a form of landscape painting produced by Art & Language in 1989 (see fig. 7.10). The painting shows the interior of an imaginary museum, sealed in, as it were, behind a sheet of glass. Over the glass is pasted a printed text. The text declares the intention to paint a picture. It proposes a landscape to be produced at some point in the future, a landscape that will be amateurish and manifestly local, "homely and priggish," too awkwardly and unsuccessfully passionate even to be recuperated as naive. Viewed from the perspective that the image of the museum may be taken to represent, the prospective painting will be the most abysmal and embarrassing of failures. The text is clear enough about the inevitability of this failure. What lies in the forbidden margins is not the romantic integrity of the oppositional, not the dogged virtue of Modernism's excluded Others, but irredeemable and inescapable incompetence.

The landscape this text specifies is no doubt a landscape that cannot be painted, or at least it is a painting that cannot be painted and meant—unless it were to be done by someone to whom the very possibility of such a thing is an effect of a kind: a means to express some almost unendurable discomfort with the métier of modern art. Some real prospect of jeopardy does indeed seem to haunt the work—does seem to be a part of its effect—and this jeopardy is associated with a possible actual marginality, with the prospect of exclusion from the world that the figurative museum represents, a world in which questions of meaning and use are paramount and in which answers to those questions are coercively established. This is a world that is not just a physical but a historical and an ideological place—a kind of dreadful here and now. The landscape proposes a form of escape from this place, but the risk entailed by the prospect of landscape, the text implies, is that where "we" situate ourselves will turn out not to be modern. And it is further implied that, however unappealing the modern may now turn out to be, to fail to be modern is to commit cultural suicide.

The effect of the work, it seems, is to make explicit—to make into the self-conscious materials of an ironic practice—the very conditions of "ineffectiveness" that Clark worried about in face of the modernist landscape. When the discourse of effects is itself subject to a bureaucratic entrenchment, landscape is no refuge. What follows, however, is not a descent into pathos. The bare possibility is raised that the landscape that the text proposes might indeed one day be painted—painted, moreover, by someone blind to the interdictions of the modern.

We aim to be amateurs, to act in the unsecular forbidden margins. We shall make a painting in 1995 and call it Hostage; A Roadsign Near the Overthorpe Turn. The work will be executed in oil on canvas. It will measure 60 cm. x 40 cm. The white roadsign will occupy about half the picture. It tells us we are 7 miles from Brackley, 2 from Overthorpe and 2 from Warkworth. These names will be scarcely visible in a tangle of lines. The professional may cast a colonising eye, but the tangle will go to a corporeal convulsion beyond her power. The painting will be homely and priggish. We may hide behind our speech at this appalling moment.

7.10 Art & Language, *Hostage XIX* (1989). Photostat text on paper, glass, oil on canvas on wood. Courtesy Lisson Gallery, London. Photograph: Michael Goodman, New York.

It seems there is a fifth axiom to be added to the four I proposed earlier.

5. that the effect of the painting is not necessarily to be identified either *from* the position of the imaginary viewer or *with* the latent content disclosed when that position is adopted. It may rather derive from some coincidence between thought and making that is a derogation both of the protocols of viewing and of the supposed significance of latent content. It may be that the painting in which the genre of landscape is critically continued is one in which traps are set for the unwary. Those making claims about the latent content of such paintings may expect to experience a familiar difficulty in a new form. In their attempts to distinguish between the literal and the metaphoric indices of their own interpretative acts, they will have as little cause for confidence as their predecessors—that is, as those in whose readings plastic figures were picked out against pictorial grounds.

What may be of sharpest critical interest about the legacy of the genre of landscape, both *to* the continuing practice of painting and *in* the continuing practice of painting, lies not in the intentional forms of picturing by which it has been defined. It lies rather in the precedents that the genre provides for a continued engagement, in the context of the visible, with that which is contingently excluded from the possibility of being seen and represented.

Notes

1. My interest in the problems of landscape as a modern genre was fueled by the long series *Hostages* painted in 1989–91 by Michael Baldwin and Mel Ramsden of Art & Language. The present chapter commits me to another essay that is specifically addressed to these paintings. I am also greatly indebted to students in the Department of Art at the University of Chicago, and to Martha Ward of the same department, in whose company some of the ideas advanced here were tried out during the 1991 spring quarter. A first draft of this chapter was read by Paul Smith and by W. J. T. Mitchell. The critical attention they paid it both confirmed the need for wholesale revision and stimulated the further work that this entailed. They are not answerable for the deficiencies of the present text. Michael Baldwin read a draft of the revised essay. His criticisms and suggestions were, as always, pertinent and thought provoking, and I have tried to do them justice in the essay as it now stands. Finally, my thanks go to Ann Jensen Adams. Her close and sympathetic reading stimulated a last attempt to deal with inconsistencies and obscurities in what I had unwisely considered a finished text.

2. In this chapter I use "modernism" with a lower case to refer to modern art viewed under a qualitative aspect, but without commitment to any specific form

of theorization of that aspect. I use a capitalized "Modernism" to refer to any critical position that purports to represent that qualitative aspect on grounds reconcilable with Clement Greenberg, "Modernist Painting," in *Arts Yearbook* (New York, 1961), reprinted in *Art in Theory 1900–1990*, ed. C. Harrison and P. Wood (Oxford 1992).

3. These are respectively the opening and closing remarks in a broadsheet text published to coincide with an exhibition of paintings, most of which were forms of deformation of landscape motifs (*Art & Language Paints a Picture (VI)*, Arnolfini Gallery, Bristol, August 1991). The reference is to R. Wollheim, *Painting as an Art* (Princeton, 1987).

4. Wollheim uses this formula to personify the minimum condition for the recovery of (polite) meaning from art; see, e.g., his *Painting as an Art*, 22.

5. This is the point at which the critical response to Modernism has tended to diverge into two separate tendencies, underwritten by different forms of historical investment and analysis. I am here concerned with the form of response that seeks to continue a critical strain of modern art understressed in standard Modernist theory and to enliven it through forms of reinterpretation. The alternative, not unconnected, tendency asks, If Modernism's own interests can be revealed, what price the Modernist critique of painting's traditional effectiveness? What resistance is left to the reconnection of painting to an agenda of explicitly political ends? As an expression of this desire to see around the historical obstruction of Modernism and to rejoin the past of painting to a transformed present, consider the following. "Power—no word could be more inappropriate, more absurd, now, when we talk of art. Which is if anything the reason for this book: it tries to reconstruct the conditions in which art was, for a time, a disputed, even an effective, part of the historical process." The writer is T. J. Clark, at the commencement of his *Image of the People: Gustave Courbet and the 1848 Revolution* (London, 1973), 10.

6. There is a nice example of this confusion at work in the contemporary criticism of the first Impressionist exhibition in 1874. Philippe Burty is writing about Pissarro's picture *La Gelée blanche* ("Hoarfrost"). "One effect of *Gelée blanche*, by Pissarro, reminds us of Millet's best themes. We believe that he intentionally eliminates shadows, even though he merely selects those sunless, gently luminous days that leave the tones all their color values and soften planes" (from *La République Française*, 25 April 1874, quoted in *The New Painting: Impressionism, 1874–1886* [San Francisco, Fine Arts Museum, 1986], 138). Burty here remarks on a distinctive and artificial effect of the *painting*, which he then represents as naturally enabled by the conditions of actual light.

7. Greenberg, "Modernist Painting," 755.

8. Ibid., 756. Greenberg's concept of the essence of painting serves to keep abstract painting in place as the destiny of an asymptotic curve. Yet it could be said that the uniqueness of painting must have something to do with its traditional function as a means of picturing—that is, with the depiction of three-dimensional things on a flat surface. If painting now shares this characteristic with photography, the mechanisms of production of the picture in painting still are unique to painting. It is also the case that abstract painting that was devoid of all possibility

of engagement with these mechanisms would be devoid of all possibility of significance as painting.

9. Ibid.

10. See his "Towards a Newer Laocoon," *Partisan Review* 7, no. 4 (July–August 1940): 296–310.

11. "On the Role of Nature in Modernist Painting" (1949), in *Art and Culture* (Boston, 1961), 171.

12. "Cézanne" (1951), in *Art and Culture*, 52–53 and 57.

13. T. J. Clark, "Preliminaries to a Possible Treatment of *Olympia* in 1865," *Screen* 21 no. 1 (Spring 1980): 18–41; reprinted in *Modern Art and Modernism*, ed. F. Frascina and C. Harrison (London, 1982), 260.

14. From *The Painting of Modern Life: Paris in the Art of Manet and His Followers* (London, 1985), 180–81.

15. If the moment of Greenbergian autonomizing of effects can be located in the period between the publications of "Towards a Newer Laocoon" and "Modernist Painting," respectively, the art-historical development of a concern with effectiveness might be indexed, on the one hand, to Meyer Schapiro's writings of the later 1930s and, on the other, to the publication of T. J. Clark's *Image of the People* in 1973.

16. Part of the burden of this essay is that the concept of effectiveness has been open to various forms of interpretation. I do not mean to capitalize on vagueness, however, and should therefore offer some kind of relatively fixed sense of the term in relation to which other usages may be tried. I take a work to be effective when it is construable as an intentionally signifying thing, such that it bears critically or heavily upon the existing methods or theories that it powerfully calls up.

17. Originally published in *Critical Inquiry* 9, no. 1 (September 1982): 139–56.

18. "How Modernism Works: A Response to T. J. Clark," *Critical Inquiry* 9, no. 1 (September 1982): 217–34.

19. "Arguments about Modernism: A Reply to Michael Fried," in *The Politics of Interpretation*, ed. W. J. T. Mitchell (Chicago, 1983), 239–48.

20. John Barrell, *The Dark Side of the Landscape: The Rural Poor in English Painting, 1730–1840* (Cambridge, 1980).

21. Michael Fried, *Courbet's Realism* (Chicago, 1990), esp. chap. 7.

22. Paul Hayes Tucker, *Monet in the '90s; The Series Paintings* (New Haven, 1989).

23. I suggest some predictable growth areas for scholarly revision: the conservative tendency in "modern" French landscape painting between the wars (Vlaminck, de Segonzac, Derain); the modernization of English landscape painting during the same period (Paul Nash, Ben and Winifred Nicholson, Christopher Wood), on which see my *English Art and Modernism, 1900–1939* (London, 1981); and in America the full spectrum from abbreviated Modernistic landscape (Dove) through interpretive psychologized landscape (O'Keeffe) to regionalist landscape (Grant Wood, Curry). If there is little here that has yet been seen to belong securely within the international canon of twentieth-century artistic achievements,

there's plenty to prompt interesting questions about what that canon has been made of. An international show of landscape painting from 1920 to 1945 would be very intriguing.

24. In employing the concept of an exemplary or imaginary viewer, I have in mind two fertile resources of relevant speculation and analysis: Michael Fried's *Absorption and Theatricality: Painting and Beholder in the Age of Diderot* (Berkeley and Los Angeles, 1980) and Richard Wollheim's *Painting as an Art,* esp. chaps. 1–3.

25. "c. 1750" is the *terminus post quem* of Leslie Parris's standard catalog *Landscape in Britain* (London, Tate Gallery, 1973).

26. This point is fully argued in W. J. T. Mitchell's article "Nature for Sale: Gombrich and the Rise of Landscape," in *The Consumption of Culture in the Early Modern Period,* ed. Ann Bermingham and John Brewer (London, forthcoming).

27. This argument might be considered to crumble in the face of the powerful apparent exceptions furnished by classical landscape painting and topographical landscape. But as regards the former, it could be said that the derogation of those very canons that gave it its special status was a condition of the development of landscape as a modern genre; as regards the latter, it was precisely its presupposition of an unquestioningly authoritative form of relationship to what was depicted that prevented topographical landscape from participating in or contributing to the technical development that characterized the genre of landscape as a whole during the nineteenth century. As with battle painting (and for similar reasons), the destiny of the subgenre of topographical painting was to become a useful repository of technical conservatism.

28. When Constable wrote that "the Great were not made for me, nor I for the Great," he was saying something important about the position of his work relative to the wide gulf that existed in the 1830s between the landed aristocracy and the copyholding middle-class, of which his father was a member. He continued, "My limited and abstract art is to be found under every hedge, and in every lane, and therefor nobody thinks it worth picking up, but I have my admirers, each of whom I consider a host" (from a letter to C. R. Leslie, 14 January 1832, quoted in Lesie Parris and Ian Fleming-Williams, *Constable* [London, Tate Gallery, 1991], 34).

29. Constable's letter to Leslie was received at Petworth. Turner's near-contemporary landscapes of Petworth Park might at first glance be considered as kinds of celebration of the property of the "Great" and thus as exceptions to the generalization I have offered. On the one hand, though, it may be said that Turner's work provides a degree of conservative resistance to the development of landscape as an *independent* genre. On the other, it can be said that the outward-facing panoramas and the virtuoso orchestration of effects in the Petworth pictures tend to suppress recognition of the views in question as views of property. If there is a notional viewer presupposed, it is one united with others in wonder at the sublimity of Nature. An image of Lord Egremont is actually included in the Tate Gallery sketch for the view of Petworth Park at sunset. He is shown not as a figure standing proud against its ground, however, but as a minuscule patch of brushstrokes chased by dogs.

30. I don't here mean that the term "modern" should carry an evaluative weight; I merely mean to draw attention to its implication of forms of sociohistorical qualification. It could be said, though, that Devis's painting was conservative even in 1751 from the point of view of a type of spectator then already thoroughly conceivable. I have in mind an imaginary personification of some form of the theory of Possessive Individualism: the paradigmatic liberal spectator, who is first and foremost the proprietor of himself or (in theory) herself.

31. In his "Modernist Painting," 758.

32. V. N. Voloshinov, *Marxism and the Philosophy of Language* (1929), trans. L. Matejka and I. R. Titunik (Cambridge, Mass., 1986), 23.

33. Of the finished and exhibited works, I think in particular of the Royal Academy's *Leaping Horse* of 1825. The claim for Constable's "premature modernism" receives more emphatic support if one takes account of paintings made as sketches, notably the Philadelphia sketch *The Lock* (1823) and the Chicago *Stoke-by-Nayland* (ca. 1835–37). The complex paint surfaces of these works manifestly serve both to secure the possibility of mimesis and to sustain an overall decorative order. Not until Pollock's works of 1943–44 do we again find tension of this degree sustained by surfaces that are at once so richly detailed and so painterly. It is no accident that both painters were driven to the same technical expedient in the attempt to establish some "optical" control of this tension, namely, the distribution of flecks of white paint evenly across the surface. (On the significance of this "snowing," see "On the Surface of Painting," in my *Essays on Art & Language* [Oxford, 1991].)

34. Again, this comes close to a familiar Modernist injunction, namely, that modern landscape requires that the spectator both submit to the effectiveness of the painting under its aspect as a picture and also counter that submission by being alert to the effects of the painting qua painting. The tendency of Modernist criticism, however, has been to justify this requirement in terms of painting's increasing preoccupation with its own "intrinsic" concerns. I mean, on the contrary, to suggest that it is only by attending to painting's critique of the picturable that we discover how deeply modern painting—and a fortiori modern landscape painting—has been engaged with those problems of valuation of experience and identity that we tend to think of as the proper business of philosophy, psychology, and politics. The dialectic between artistic effect and the effectiveness of art, in other words, is a matter of some political and philosophical moment.

35. I am following the sequence of a reconstructive "logic," not meaning to suggest that these forms of observation follow one upon the other in real time, or even that they are necessarily separable in the actual encounter with this or any work of art.

36. On the vagaries of similarity, see Nelson Goodman, "Seven Strictures on Similarity," in his *Problems and Projects* (Indianapolis, 1972), 437–46.

37. There's no claim here that co-occurrence serves in itself to demonstrate a causal connection. There's no use pretending, however, that the binding force of such associations is not a determinant upon the production of meaning. We can say that the O'Keeffe resembles the Schiele in a particular respect, and we can go on from this observation to make other inquiries, among which might be inquiries

into possible historical and causal links, inquiries concerning O'Keeffe's intention, psychological inquiries that might invoke questions of causal connectedness or questions of intention or both, and so forth.

38. Indeed, I would not wish to quarrel with a word of the judgment upon O'Keeffe's work that Greenberg offered in his review of her 1946 retrospective at the New York Museum of Modern Art. "I know that many experts . . . identify the opposed extremes of hygiene and scatology with modern art, but the particular experts at the museum should have had at least enough sophistication to keep them apart" (*Nation*, 15 June 1946, reprinted in *Clement Greenberg: The Collected Essays and Criticism*, ed. J. O'Brien, vol. 2 [Chicago, 1986], 87).

39. There is some evidence that the possibility of a response of this order may have been a part of the self-conscious apparatus of advanced French painters at the time in question. Millet's biographer Sensier quotes remarks the painter made regarding his memory of a drawing of a fainting man by Michelangelo. "The expression of his slack muscles, the planes of his body, the modeling of that figure collapsed under physical suffering, gave me a whole series of impressions; I felt wracked with pain just as he did. I pitied him. I suffered in [or from] that same body, in [or from] those same limbs" (as cited and translated by Michael Fried in his *Courbet's Realism*, 306 no. 61).

40. Donald Davidson, "What Metaphors Mean," in *On Metaphor*, ed. Sheldon Sacks (Chicago, 1981), 45. Davidson continues: "Metaphor makes us see one thing as another by making some literal statement that inspires or prompts the insight. Since in most cases what the metaphor prompts or inspires is not entirely, or even at all, recognition of some truth or fact, the attempt to give literal expression to the content of the metaphor is simply misguided."

41. Fried, *Courbet's Realism*, 238–41.

42. For Wollheim, "there is a right way and a wrong way" to look at a painting, and "the right way ensures an experience that concurs with the fulfilled intentions of the artist," given that "intentions must be understood so as to include thoughts, beliefs, memories, and, in particular, emotions and feelings, that the artist had and that, specifically, caused him to paint as he did" (*Painting as an Art*, 86).

EDWARD W. SAID

Invention, Memory, and Place

Over the past decade, there has been a burgeoning interest in two over-lapping areas of the humanities and social sciences: memory and geography or, more specifically, the study of human space. Both of them have spawned an extraordinary amount of interesting work, work that has in effect created new fields of study and inquiry. The concern with memory, for example, has branched out to include such increasingly prevalent forms of writing as personal memoirs and autobiography, which nearly every fiction writer of note has attempted, to say nothing of the outpourings of academics, scientists, public figures, and so forth. The national fixation on recollection, confession, and witness has run the whole gamut from public confession—as in the Clinton-Lewinsky scandal—to various studies of the meaning of collective memory, extended reflection and analyses of instances of it, plus numerous chronicles embodying it. I shall have more to say about that later. In addition, and somewhat on the margins, has been a serious, sometimes bitter inquiry into the authenticity of certain memories, as well as, at the other, calmer end of the spectrum, a remarkable academic analysis of the role of invention in such matters as tradition and collective historical experience.

Some examples of intense and even anguished controversy are the following: Was Anne Frank's diary really hers, or was it so altered by publishers, members of her family, or others in its published form so as to conceal the disturbances in her domestic life? In Europe there has been a great and often acerbic debate over the meaning of the Holocaust, with a whole range of opinions as to what happened, why it happened, and what it tells us about the nature of Germany, France, and several other involved countries. The celebrated French classicist Pierre Vidal-Naquet wrote a powerful book some years back called *Assassins of Memory* about French deniers

241

of the Holocaust, and more recently the Papon trial in Bordeaux raised uncomfortable questions related not just to memories of the Occupation but the centrality of French collaborators with the Nazis and what it said about French selective memories of the Vichy regime. In Germany of course debate on the testimonials of the death camps and their philosophical as well as political meaning periodically receives new infusions of controversy, fuelled most recently by the publication of the German translation of Daniel Goldhagen's book *Hitler's Willing Executioners*. In the United States consider the anger provoked by representatives of the official culture and members of the government by the Smithsonian Institution—seen correctly as a sort of embodier of official memory in the country—in its unsuccessful attempts to mount exhibitions, one about the *Enola Gay* and another on the African American experience. Earlier there was a furor over an impressive exhibition at the National Gallery of American Art, *America as West,* which set out to contrast representations of the land, the Indian natives, and the conditions of life in the Western U.S. during the 1860s with the way the land was being forcibly settled and the Indians destroyed, and the transformation of a once peaceful rural environment into a predatory urban one. Senator Ted Stevens of Alaska decried the whole thing as an attack on America even though he avowed that he himself had not seen the exhibit. In any event these controversies raise the question not only of what is remembered but how and in what form. It is an issue about the very fraught nature of representation, not just about content.

Memory and its representations touch very significantly upon questions of identity, of nationalism, of power and authority. Far from being a neutral exercise in facts and basic truths, the study of history, which of course is the underpinning of memory, both in school and university, is to some considerable extent a nationalist effort premised on the need to construct a desireable loyalty to and insider's understanding of one's country, tradition, and faith. As is well known, there's been a robust debate in the U.S. on the matter of national standards in history, in which issues such as whether George Washington or Abraham Lincoln should be allowed more time than they have at present in history curricula have generated very angry arguments. Similarly, as Howard Zinn has suggested in his work, there has been skepticism expressed as to why the study of American history should glorify only the big deeds of big people and neglect to mention what happened to the small ones, the people who built railroads, worked the farms, sweated as laborers in the enormous industrial companies that lie at the heart of this country's immense wealth and power. (He redresses this imbalance in his impressive *People's History of the United States,* which

has already sold well over half a million copies.)[1] In a recent article he goes even further. Having been asked to participate in a symposium on the Boston Massacre, Zinn reflected to himself that he wanted

to discuss other massacres because it seemed to me that concentrating attention on the Boston Massacre would be a painless exercise in patriotic fervor. There is no surer way to obscure the deep divisions of race and class in American history than by uniting us in support of the American Revolution and all its symbols (like Paul Revere's stark etching of the soldiers shooting into the crowd).

I suggested to the people assembled at Faneuil Hall (the wall around us crowded with portraits of the Founding Fathers and the nation's military heroes) that there were other massacres, forgotten or dimly remembered, that deserved to be recalled. These ignored episodes could tell us much about racial hysteria and class struggle, about shameful moments in our continental and overseas expansion, so that we can see ourselves more clearly, more honestly.[2]

These remarks immediately transport us to the vexed issue of nationalism and national identity, of how memories of the past are shaped in accordance with a certain notion of what "we" or, for that matter, "they" really are. National identity always involves narratives—of the nation's past, its founding fathers and documents, seminal events, and so on. But these narratives are never undisputed or merely a matter of the neutral recital of facts. In the United States, for example, 1492 was celebrated very differently by people who saw themselves as victims of Columbus's advent— people of color, minorities, members of the working class, people, in a word, who claimed they had a different collective memory of what in most schools was celebrated as a triumph of advancement and the collective march forward of humanity. Because the world has shrunk—for example, communications have been speeded up fantastically—and people find themselves undergoing the most rapid social transformations in history, ours has become an era of a search for roots, of people trying to discover in the collective memory of their race, religion, community, and family a past that is entirely their own, secure from the ravages of history and a turbulent time. But this too has provoked very sharp debate and even bloodshed. In the Islamic world, how one reads the orthodox tradition (*sunnah*) is being debated, as are the questions of how one interprets stories about the Prophet, which are, basically, memories reconstructed by disciples and friends, and how one can derive an image of contemporary Islamic codes of behavior and law that is consonant and in accordance with those precious, early, in fact aboriginal, memories. Similar questions arise in interpretations of the Christian Gospels, as well as the Judaic prophetic

books; these questions have a direct impact on matters of community and politics in the present. Some of this lies behind the much-touted controversy over family values that have been vaunted by political candidates, moral philosophers, and public scolds.

To this whole matter of memory as a social, political, and historical enterprise has been added a complication, to which I referred above, namely, the role of invention. In 1983 two distinguished British historians Eric Hobsbawm and Terence Ranger edited a book of essays by various other well-known historians entitled *The Invention of Tradition*.[3] I won't try to summarize the ideas in this subtle and rich collection except to say that what was being studied was the way rulers—social and political authorities in the period since about 1850—set about creating such supposedly age-old rituals and objects as the Scottish kilt or, in India, the *durbar*, thereby providing a false, that is, invented memory of the past as a way of creating a new sense of identity for ruler and ruled. In India, for example, the *durbar*—whose status as "tradition" was a total fiction—was said to be a great ceremonial pageant designed to be implanted in the Indian memory though it served the British colonial authorities to compel Indians to believe in the age-old history of British imperial rule. "In Africa, too," writes Ranger, "whites drew on invented tradition in order to derive the authority and confidence that allowed them to act as agents of change. Moreover, insofar as they were consciously applied to Africans, the invented traditions [such as compelling Africans to work as laborers on European gentlemen's farms] of nineteenth century Europe were seen precisely as agents of 'modernization.'"[4] In modern France, according to Hobsbawm, the demise of Napoleon III's empire and the emergence of a politicized working class as evidenced in the Paris Commune convinced the "moderate Republican bourgeoisie" that only it could head off the dangers of revolution by producing a new kind of citizen, "turning peasants into Frenchmen . . . [and] all Frenchmen into good Republicans." Thus the French revolution was institutionalized in education by developing "a secular equivalent of the church . . . imbued with revolutionary and republican principles and content." In addition, there was "the invention of public ceremonies. The most important of these, Bastille Day, can be exactly dated in 1880." Thirdly, there "was the mass production of public monuments," of two main kinds—images of the Republic itself such as Marianne—and images of the "bearded civilian figures of whoever local patriotism chose to regard as its notables."[5]

In other words, the invention of tradition was a practice very much used by authorities as an instrument of rule in mass societies when the bonds of small social units like village and family were dissolving and authorities needed to find other ways of connecting a large number of people to each

other. The invention of tradition is a method for using collective memory selectively by manipulating certain bits of the national past, suppressing others, elevating still others in an entirely functional way. Thus memory is not necessarily authentic, but rather useful. The Israeli journalist Tom Segev shows in his book *The Seventh Million* that the Holocaust was consciously used by the Israeli government as a way of consolidating Israeli national identity after years of not paying much attention to it.[6] Similarly, historian Peter Novick, in a recently published study of the image of the Holocaust amongst American Jews, shows that before the 1967 war and the Israeli victory against the Arab states, American Jews paid very little attention to that appallingly horrible episode (and in fact tried consciously to deemphasize it as a way of avoiding anti-Semitism).[7] It is a long way from those early attitudes to the construction of the Holocaust Museum in Washington. Similarly the controversy surrounding the memories of the Armenian genocide is fuelled by the Turkish government's denial of its role.

My point in citing all these cases is to underline the extent to which the art of memory for the modern world is both for historians as well as ordinary citizens and institutions very much something to be used, misused, and exploited, rather than something that sits inertly there for each person to possess and contain. Thus the study and concern with memory or a specifically desirable and recoverable past is a specially freighted late twentieth-century phenomenon that has arisen at a time of bewildering change, of unimaginably large and diffuse mass societies, competing nationalisms, and, most important perhaps, the decreasing efficacy of religious, familial, and dynastic bonds. People now look to this refashioned memory, especially in its collective forms, to give themselves a coherent identity, a national narrative, a place in the world, though, as I have indicated, the processes of memory are frequently, if not always, manipulated and intervened in for sometimes urgent purposes in the present. It's interesting to contrast this more modern, and somehow loosely malleable form of memory with the codified, rigorous art of memory in classical antiquity described by Frances Yates.[8] Memory for Cicero was something organized and structured. If you wanted to remember something for a speech you were about to give, you imagined a building with all sorts of rooms and corners, and in your mind's eye you subdivided the parts of the memory you wished to recall and placed them in various sections of the building; as you spoke you walked through the building in your head, so to speak, noting the places and the objects and phrases as you went along. That way order was maintained in the memory. The modern art of memory is much more subject to inventive reordering and redeploying than that.

As for geography, or geography, as I want to use the word, as a socially

constructed and maintained sense of place, a great deal of attention has been paid by modern scholars and critics to the extraordinary constitutive role of space in human affairs. Consider, as an easy instance, the word *globalization*, which is an indispensable concept for modern economics. It is a spatial, geographical designation signifying the global reach of a powerful economic system. Think of geographical designations like Auschwitz, think of what power and resonance they have, over and above a particularly specifiable moment in history or a geographical locale like Poland or France. The same applies to Jerusalem, a city, an idea, an entire history, and of course a specifiable geographical locale often typified by a photograph of the Dome of the Rock, the city walls, and the surrounding houses seen from the Mount of Olives; it too is overdetermined when it comes to memory, as well as all sorts of invented histories and traditions, all of them emanating from it, but most of them in conflict with each other. This conflict is intensified by Jerusalem's mythological—as opposed to actual geographical—location, in which landscape, buildings, streets, and the like are overlain and, I would say, even covered entirely with symbolic associations totally obscuring the existential reality of what as a city and real place Jerusalem is. The same can be said for Palestine, whose landscape functions in the memories of Jews, Muslims, and Christians entirely differently. One of the strangest things for me to grasp is the powerful hold the locale must have had on European crusaders despite their enormous distance from the country. Scenes of the crucifixion and nativity, for instance, appear in European Renaissance paintings as taking place in a sort of denatured Palestine, since none of the artists had ever seen the place. An idealized landscape gradually took shape that sustained the European imagination for hundreds of years. That Bernard of Clairvaux standing in a church in Vezelay, in the heart of Burgundy, could announce a crusade to reclaim Palestine and the holy places from the Muslims never fails to astound me, and that after hundreds of years of living in Europe Zionist Jews could still feel that Palestine had stood still in time and was theirs, again despite millennia of history and the presence of actual inhabitants. This too is also an indication of how geography can be manipulated, invented, characterized quite apart from a site's merely physical reality.

Simon Schama's book *Landscape and Memory* chronicles the to-ing and fro-ing between specific geographical locales and the human imagination. Surely the most compelling aspect of Schama's book is that he shows in dozens of different ways that forests, villages, mountains, and rivers are never coterminous with some stable reality out there that identifies and gives them permanence. On the contrary, as in the example he gives of his family's original village in Lithuania, most of its traces disappeared; he finds instead through the poetry of Adam Mickiewicz how Jews and Poles

"were snarled up. . . . in each other's fate" despite his contemporaries' belief that they were "necessarily alien to each other." Geography stimulates not only memory but dreams and fantasies, poetry and painting, philosophy (as in Heidegger's *Holzwege*), fiction (think of Walter Scott's Highland novels), and music (as in Sibelius's *Finlandia* or Copland's *Appalachian Spring*).[9]

But what specially interests me is the hold of both memory and geography on the desire for conquest and domination. Two of my books, *Orientalism* and *Culture and Imperialism,* are based not only on the notion of what I call imaginative geography—the invention and construction of a geographical space called the Orient, for instance, with scant attention paid to the actuality of the geography and its inhabitants—but also on the mapping, conquest, and annexation of territory both in what Conrad called the dark places of the earth and in its most densely inhabited and lived in places, like India or Palestine. The great voyages of geographical discovery from da Gama to Captain Cook were motivated by curiosity and scientific fervor, but also by a spirit of domination, which becomes immediately evident when white men land in some distant and unknown place and the natives rebel against them. In the modern era Defoe's *Robinson Crusoe* is the essential parable of how geography and conquest go together, providing an almost eerie prefiguration of historical figures like Clive and Hastings in India, or scientific adventurers and explorers like Murchison in Africa decades and decades later. These experiences enable complicated memories for natives and (in the Indian case) Britishers alike; a similar dialectic of memory over territory animates the relationship of French and Algerian accounts of the 130 years of French rule in North Africa. We should never have left or given up India or Algeria, say some, using strange atavistic sentiments like the Raj revival—a spate of TV shows and films like *The Jewel in the Crown, A Passage to India, Gandhi,* and the fashion of wearing safari suits, helmets, desert boots—as a way of periodically provoking nostalgia for the good old days of British supremacy in Asia and Africa, whereas most Indians and Algerians would likely say that their liberation came as a result of being able after years of nationalist struggle to take hold of their own affairs, reestablish their identity, culture, and language, and, above all, reappropriate their territory from the colonial masters. Hence, to some extent, we witness the remarkable emergence of an Anglo-Indian literature by Anita Desai, Salman Rushdie, Arnandhati Roy, and many others, reexcavating and recharting the past from a postcolonial point of view, thereby erecting a new postimperial space.

It is easy to see the fact of displacement in the colonial experience, which at bottom is the replacement of one geographical sovereignty, an imperialist one, by another, native force. More subtle and complex is the unend-

ing cultural struggle over territory, which necessarily involves overlapping memories, narratives, and physical structures. No one has studied this more powerfully than the late Raymond Williams in his classic book, *The Country and the City*. What he shows is that literary and cultural forms such as the ode, the political pamphlet, and different kinds of novels derive some of their aesthetic rationale from changes taking place in the geography or landscape as the result of a social contest. Let me explain this more concretely. The mid-seventeenth- to eighteenth-century genre of the country-house poem, with its emphasis on the house's calm stateliness and classical proportions—"Heaven's Centre, Nature's Lap"—is not the same thing in Marvell, Ben Jonson, and, later, in Pope. Jonson draws attention to the way the house was won from disturbing, encroaching peasant populations; Marvell in a more complicated way understands the country house as the result of a union between money, property, and politics; in Pope the house has become a sort of moral center; and later in Jane Austen's *Mansfield Park* it is the very embodiment of all that is benign and actively good in England. Property in all four writers is being consolidated; what we watch is the gradual triumph of a social dialectic celebrating the virtues and necessities of a propertied class, which itself seems to stand for the nation at its best. In each case the writer remembers the past in his own way, seeing images that to her or him typify that past, preserving one past, sweeping away others. Later writers, say, urban novelists like Dickens and Thackeray, will look back to this period as a sort of rural paradise from which England has fallen; the beauties of the field are replaced by the grimy, dark, sooty, industrial city. Both the retrospective image and the contemporary one, says Williams, are historical constructs, myths of the social geography fashioned in different periods by different classes, different interests, different ideas about the national identity, the polity, the country as a whole, none of it without actual struggle and rhetorical dispute.[10]

All of what I have been discussing here—the interplay between geography, memory, and invention, in the sense that invention must occur if there is recollection—is particularly relevant to a twentieth-century instance, that of Palestine, which instances an extraordinarily rich and intense conflict of at least two memories, two sorts of historical invention, two sorts of geographical imagination. I want to argue that we can go behind the headlines and the repetitively reductive media accounts of the Middle East conflict and discern there a much more interesting and subtle conflict than what is customarily talked about. Only by understanding that special mix of geography generally and landscape in particular with historical memory and, as I said, an arresting form of invention can we begin to grasp the persistence of conflict and the difficulty of resolving it, a difficulty

that is far too complex and grand than the current peace process could possibly envisage, let alone resolve.

Let us juxtapose some relevant dates and events with each other. For Palestinians 1948 is remembered as the year of the *nakba*, or catastrophe, when 750,000 of us who were living there—two-thirds of the population—were driven out, our property taken, hundreds of villages destroyed, an entire society obliterated. For Israelis and many Jews throughout the world 1998 was the fiftieth anniversary of Israel's independence and establishment, a miraculous story of recovery after the Holocaust, of democracy, of making the desert bloom, and so on. Thus, two totally different characterizations of a recollected event have been constructed. What has long struck me about this radical irreconcilability at the origin of the Palestinian-Israeli conflict is that it is routinely excluded from considerations of related subjects concerning ethnic or collective memory, geographical analysis, and political reflection. This is most evident in studies of the German catastrophe as well as of ethnic conflicts in former Yugoslavia, Rwanda, Ireland, Sri Lanka, South Africa, and elsewhere.

Take Germany first. There is little doubt that it is important to prevent assassins of memory from denying or minimizing the Holocaust; but it is also important not to forget to show the link, well-established in contemporary Jewish consciousness, between the Holocaust and the founding of Israel as a haven for Jews. That this link also meant the disestablishing of the Palestinians from their homes and farms is practically never stated, although for Palestinians it increases the agony of their plight: why, they ask, are we made to pay for what happened to the Jews in Europe by what was in effect a Western Christian genocide? The question never emerges out of the debate in or about Germany, even though it is directly entailed by such facts as the enormous amount of money paid by Germany to Israel in Holocaust reparations and has surfaced again in the claims against Swiss banks. I have no hesitation in saying, yes, Germany and Switzerland ought to pay, but that also means that Palestinians over the past fifty years whose own losses are staggering deserve a hearing, too, especially since to us these payments to Israel go to consolidate Israel's hold not only what we lost in 1948 but on the territories occupied in 1967. The Palestinians have never received even the slightest official acknowledgement of the massive injustice that was done to them, much less the possibility of staking material claims against Israel for the property taken, the people killed, the houses demolished, the water taken, the prisoners held, and so forth. There is also the complex, almost equally dense and far-reaching matter of Britain's responsibility. What strikes me as more significant is the refusal in the Israeli official narrative to take account of the state's complicity and

responsibility for the Palestinian dispossession. For years and years an assiduous campaign to maintain a frozen version of Israel's heroic narrative of repatriation and justice obliterated any possibility of a Palestinian narrative, in large part because certain key components of the Israeli story stressed certain geographical characteristics of Palestine itself. Take the key notion of liberation: so strong was the story of Jewish independence and reemergence after the Holocaust that it became virtually impossible to ask the question, Liberation and independence from whom? If the question was asked it was always answered as liberation from British imperialism. Or, as the story got elaborated, it was defense against invading Arab armies that wanted to crush the young state. The Palestinians thus faded into the encircling and menacing obscurity of "the Arabs," the fact that they were actual residents occluded and simultaneously denied.

Perhaps the greatest battle Palestinians have waged as a people has been over the right to a remembered presence and, with that presence, the right to possess and reclaim a collective historical reality, at least since the Zionist movement began its encroachments on the land. A similar battle has been fought by all colonized peoples whose past and present were dominated by outside powers who had first conquered the land and then rewrote history so as to appear in that history as the true owners of that land. Every independent state that emerged after the dismantling of the classical empires in the post–World War Two years felt it necessary to narrate its own history, as much as possible free of the biases and misrepresentations of that history by British, French, Portuguese, Dutch, or other colonial historians.

Yet the fate of Palestinian history has been a sad one, since not only was independence not gained, but there was little collective understanding of the importance of constructing a collective history as a part of trying to gain independence. To become a nation in the formal sense of the word, a people must make itself into something more than a collection of tribes, or political organizations of the kind that since the 1967 war Palestinians have created and supported. With a competitor as formidable as the Zionist movement, the effort to rewrite the history of Palestine so as to exclude the land's peoples had a disastrous effect on the quest for Palestinian self-determination. What we never understood was the power of a narrative history to mobilize people around a common goal. In the case of Israel, the narrative's main point was that Zionism's goal was to restore, reestablish, repatriate, and reconnect a people with its original homeland. It was the genius of Herzl and Weizmann to draft thinkers like Einstein and Buber, as well as financiers like Lord Rothschild and Moses Montefiore, into giving their time and effort in support of so important and historically justified a scheme. This narrative of reestablishment and recovery served its purpose

not only amongst Jews but also throughout the Western (and even in some parts of the Eastern) world. Because of its power and appeal the Zionist narrative and idea (which depended on a special reading of the Bible) and because of the collective Palestinian inability as a people to produce a convincing narrative story with a beginning, middle, and end (we were always too disorganized, our leaders were always interested in maintaining their power, most of our intellectuals refused to commit themselves as a group to a common goal, and we too often changed our goals) Palestinians have remained scattered and politically ineffective victims of Zionism, as it continues to take more and more land and history.

Just how deliberate and sustained has been the assault on the history and consequently the dominant public memory of Palestine, and how much attention has been paid over the years to the reconstruction of Jewish history to suit the purposes of Zionism as a political movement, is made stunningly clear by the Scottish historian of the ancient Near East, Keith W. Whitelam, whose book *The Invention of Ancient Israel: The Silencing of Palestinian History* is of paramount importance. Not being myself a scholar of the ancient world generally, nor of ancient Palestine in particular, I cannot make a judgement about every one of the points that Whitelam makes; but I am able to judge what he says about modern scholarship on ancient Israel, and there I was very impressed with his careful, but nevertheless extremely audacious argument. In effect Whitelam is talking about two things: one, the politics of collective memory, and, two, the creation by Zionist scholars and historians of a geographical image of ancient Israel that is shaped by the ideological needs and pressures of the modern Zionist movement.[11]

As I suggested above, collective memory is not an inert and passive thing, but a field of activity in which past events are selected, reconstructed, maintained, modified, and endowed with political meaning. In her 1995 book *Recovered Roots: Collective Memory and the Making of Israeli National Tradition,* the Israeli-American historian Yael Zerubavel shows how before the late nineteenth century the story of Masada was unknown to most Jews. Then in 1862 a Hebrew translation of the Roman sources of Masada in Josephus's *Wars of the Jews* was published, and in a short time the story was transformed by reconstruction into four important things: "a major turning point in Jewish history, a locus of modern pilgrimage, a famous archeological site, and a contemporary political metaphor."[12] When General Yigael Yadin excavated Masada after 1948 the expedition had two complementary aspects: an archeological investigation and "the fulfillment of a national mission."[13] In time the actual place was the site of Israeli army ceremonies, a commemoration of Jewish heroism, as well as a commitment to present and future military skill. Thus was a dim, rela-

tively unknown incident in the past reformulated consciously as a major episode in the nationalist program of a modern state; Masada became a potent symbol of the Israeli national narrative of struggle and survival.

Whitelam presents a remarkably analogous picture of how the history of ancient Palestine was gradually replaced by a largely fabricated image of ancient Israel, a political entity that in reality played only a small role in the area of geographical Palestine. According to Whitelam, ancient Palestine was the home of many diverse peoples and histories; it was the place where Jebusites, Israelites, Canaanites, Moabites, Philistines and others lived and flourished. Beginning in the late nineteenth century, however, this more complex and rich history was silenced, forced aside, in order that the history of invading Israelite tribes, who for a time suppressed and dispossessed the native peoples, became the only narrative worth considering. Thus the extinction of the indigenous population of Palestine in the late Bronze Age became an acceptable and gradually permanent feature of a sort of triumphalist *Jewish* history for scholars like W. F. Albright, the leading historian of ancient Palestine during the early twentieth century, and made it possible to silence native Palestinian history as it was supplanted by the history of the incoming Israelites. Albright goes so far as retrospectively to condone the destruction of the native inhabitants of ancient Palestine in favor of superior people: "From the impartial standpoint of a philosopher of history," he says, "it often seems necessary that a people of markedly inferior type [that is, the ancient Canaanite Palestinians] should vanish before a people of superior potentialities [the Israelites], since there is a point beyond which racial mixture cannot go without disaster" (quoted in *I*, p. 83).

In its remarkably frank expression of racist attitudes this statement by a supposedly objective scholar, who also happened to be the most influential figure in modern biblical archeology, is chilling. But it suggests how in its desire to overcome obstacles in its path, even to the point of retrospectively condoning dispossession and even genocide, modern Zionism also imposed a sort of teleology retrospectively. Whitelam proceeds to show how scholars like Albright and many others went on in their writing to construct "a large, powerful, sovereign and autonomous . . . state [which was] attributed to its founder David" (*I*, p. 124). Whitelam shows how this state was in effect an invention designed to accompany the Zionist attempt in the twentieth century to gain control over the land of Palestine; thus "biblical scholarship, in its construction of an ancient Israeli state, is implicated in contemporary struggles for the land" (*I*, p. 124). Whitelam argues that such a state was far less important than its champions in the present day say it was: The invented ancient Israel "has silenced Palestinian history and obstructed alternative claims to the past" (*I*, p. 124). By inventing an an-

cient Israeli kingdom that displaced Canaanite Palestinian history, modern scholars have made it nearly impossible for present-day Palestinians to say that their claims to Palestine have any long-term historical validity. Indeed such pro-Zionist scholars have gone on to assert that ancient Israel was qualitatively different from all other forms of government in Palestine, just as modern-day Zionists said that their coming to Palestine turned an "empty" desert land into a garden. The idea in both ancient and modern cases is identical and of course violently contradicts the far more complex, pluricultural identity of the place.

Whitelam is quite right to criticize my own work on the modern struggle for Palestine for not paying any attention to the discourse of biblical studies. This discourse, he says, was really a part of Orientalism, by which Europeans imagined and represented the timeless Orient as they wished to see it, not as it was, or as its natives believed. Thus biblical studies, which created an Israel that was set apart from its environment, and supposedly brought civilization and progress to the region, was reinforced by Zionist ideology and by Europe's interest in the roots of its own past. Yet, he concludes, "this discourse has excluded the vast majority of the population of the region." It is a discourse of power "which has dispossessed Palestinians of a land and a past" (*I*, p. 235).

Whitelam's subject is ancient history and how a purposeful political movement could invent a serviceable past that became a crucial aspect of Israel's modern collective memory. When the mayor of Jerusalem a few years ago proclaimed that the city represented 3,000 years of unbroken Jewish dominance, he was mobilizing an invented story for the political purposes of a modern state still trying to dispossess native Palestinians who are now seen only as barely tolerated aliens.

Along with the idea of Israel as liberation and independence couched in terms of a reestablishment of Jewish sovereignty went an equally basic motif, that of making the desert bloom, the inference being that Palestine was either empty (as in the Zionist slogan, "a land without people for a people without land") or neglected by the nomads and peasants who facelessly lived on it. The main idea was to deny the Palestinians not just a historical presence as a collectivity but also to imply that they were not a people who had a long-standing peoplehood. As late as 1984 a book by a relative unknown called Joan Peters appeared from a major commercial publishing house (Harper and Row) purporting to show that the Palestinians as a people were an ideological, propaganda fiction; her book *From Time Immemorial* won all sorts of prizes and accolades from well-known personalities like Saul Bellow and Barbara Tuchman, who admired Peters's "success" in proving that Palestinians were "a fairy tale." Slowly, however, the book lost credibility despite its eight or nine printings, as various critics,

Norman Finkelstein principal among them, methodically revealed that the book was a patchwork of lies, distortions, and fabrications, amounting to colossal fraud. The book's brief currency (it has since practically disappeared and is no longer cited) is an indication of how overwhelmingly the Zionist memory had succeeded in emptying Palestine of its inhabitants and history, turning its landscape instead into an empty space that, Peters alleged, was flooded in the middle 1940s with Arab refugees from neighboring countries attracted to the place by the hope of prosperity under Jewish settlers.[14] I remember my rage at reading a book that had the effrontery to tell me that my house and birth in Jerusalem in 1935 (before Peters's flood of "Arab" refugees) to say nothing of the actual existence of my parents, uncles, aunts, grandparents, and my entire extended family in Palestine were in fact not there, had not lived there for generations, had therefore no title to the specific landscape of orange and olive groves that I remembered from my earliest glimmerings of consciousness. I recall also that in 1986 I purposefully published a book of photographs by Jean Mohr, *After the Last Sky: Palestinian Lives* for which I wrote an elaborate text whose effect with the interconnected pictures I hoped would be to dispel the myth of an empty landscape and an anonymous, nonexistent people.[15]

All along then the Israeli story, buttressed both subliminally and explicitly with memories of the horrors of an anti-Semitism that ironically took place in an entirely different landscape, crowded out the Palestinian history taking place in Palestine and out of it because of Israeli geographical and physical displacement of the people. The justified feeling of "never again," which became the watchword of Jewish consciousness as, for instance, the massively publicized Eichmann trial revealed the scope of the awfulness of the Holocaust, pushed away the deepening sense of the need for Palestinian assertion that was developing in that community. There is something almost tragically ironic about the way in which the 1967 war on the one hand intensified the assertiveness of a triumphal Israeli identity and, on the other, sharpened the need among Palestinians for organized resistance and counterassertion. Only this time Israel had occupied the rest of Palestine and acquired a population of almost two million people that it ruled as a military power (20 percent of Israel's citizens are Palestinians). Newly excavated memories from the Jewish past emerged—the Jew as warrior, militant, vigorous fighter—replaced the image of the Jew as scholarly, wise, and slightly withdrawn. The change in iconography is brilliantly chronicled by Paul Breines in his book *Tough Jews*.[16]

With the rise of the PLO, first in Jordan then after September 1970 in Beirut, a new Palestinian interest arose in the past, as embodied in such disparate activities as organized historical research and the production of

poetry and fiction based upon a sense of recovered history, formerly blot-
ted out but now reclaimed in the poetry of Zayyat, Darwish, Hussein,
and al-Qassem, in the fiction of Kanafani and Jabra, as well as in painting,
sculpture, and historical writing such as Abu Lughod's collection *The
Transformation of Palestine*. Later work like the compilations of Walid
Khalidi—*Before Their Diaspora* and *All That Remains*—Rashid Khalidi's
study *Palestinian Identity*, Sabry Jiryis's *The Arabs in Israel*, Bayan al
Hout's study of the Palestinian elites, Elia Zureik's *The Palestinians in
Israel*, and many others, all by Palestinian scholars, gradually established
a line of dynastic descent, between the events of 1948 and before and after
the catastrophe, that gave substance to the national memory of a Palestin-
ian collective life that persisted, despite the ravages of physical disposses-
sion, military occupation, and Israeli official denials.[17] By the middle of
the 1980s, a new direction had begun to appear in Israeli critical histories
of the canonized official memories. In my opinion their genesis lay to some
considerable extent in the aggravated, but close colonial encounter be-
tween Israelis and Palestinians in the occupied territories. Consider that
with the accession to power of the right-wing Likud in 1977 these territo-
ries were renamed Judea and Samaria; they were onomastically trans-
formed from "Palestinian" to "Jewish" territory, and settlements—whose
object from the beginning had been nothing less than the transformation
of the landscape by the forcible introduction of European-style mass hous-
ing with neither precedent nor basis in the local topography—gradually
spread all over the Palestinian areas, starkly challenging the natural and
human setting with rude Jewish-only segregations. In my opinion, these
settlements, whose number included a huge ring of fortresslike housing
projects around the city of Jerusalem, were intended visibly to illustrate
Israeli power, additions to the gentle landscape that signified aggression,
not accommodation and acculturation.

The new trend in Israeli critical history was inaugurated by the late
Simha Flaphan, but then continued in controversial scholarly monographs
and books by Bennie Morris, Avi Shlaim, Tom Segev, Ilan Pappe, and
Beni Beit Halahmi. Much of this work I believe was fuelled by the Palestin-
ian *intifada*, which laid to rest the idea of Palestinian silence and absence.
For the first time a systematic critique of the official version programmati-
cally revealed the crucial role played by invention in a collective memory
that had ossified into unyielding, almost sacralized, and, with regard to
Palestinians, dehumanized representation. Far from Palestinians having left
or run away because they were told to do so by their leaders (this had been
the prevalent argument for the suddenly depopulated landscape in 1948),
these historians showed that according to Zionist military archives there
had been a cold-blooded plan to disperse and exclude the native popula-

tion, spiriting them away so that Palestinians would not clutter Israel with their non-Jewish presence. Far from the Jewish forces having been a small, outnumbered, and truly threatened population, it was shown that these forces were greater in number than the combined Arab armies, they were better armed, and they had a common set of objectives entirely lacking among their opponents. As for the Palestinians, they were effectively leaderless, unarmed, and in places like Jerusalem—which I recall vividly myself, since I was twelve at the time—completely at the mercy of the Hagganah and the Irgun, whose undeflected purpose was to clear them out unequivocally, as we were indeed. And far from there being a policy of "purity of arms," the stock-in-trade phrase for Israeli military policy, there was a series of massacres and atrocities designed specifically to terrorize the greatly disadvantaged Palestinians into flight and/or nonresistance.

More recently, the distinguished Israeli social historian Zeev Sternhell has revisited the official state archives to show with extraordinary force that what was presented to the world as a socialist democracy was not in fact that at all, but what he himself calls a nationalist socialism designed above all to create a new community of blood, to redeem the land by conquest, and to submit the Jewish individual to a collectivity of almost messianic fervency.[18] Thus in fact Israel was profoundly antisocialist and, rather than encouraging individual rights and an egalitarian concept of citizenship, in fact created a theocracy with a rigorous limit to what the individual was and could expect from the state. The Kibbutzim—long heralded as a unique social experiment in egalitarianism and innovative sharing—were, says Sternhell, window-dressing, extremely limited and circumscribed in their membership (no Arabs were ever allowed to be members). Israel is now the only state in the world that is not the state of its citizens but of the whole Jewish people wherever they may be. Not only has it never had until the present any international boundaries, Israel also has no constitution, but a set of Basic Laws, one of which, the Law of Return, entitles any Jew anywhere the right to immediate Israeli citizenship, whereas Palestinians whose families were driven out in 1948 are allowed no such right at all. Ninety-two percent of the land is held in trust by an agency for the Jewish people; this means that non-Jews, especially Palestinian citizens of Israel who constitute a population of one million people and are almost 20 percent of the state, are simply forbidden to buy, lease, or sell land. One can imagine the outcry in the United States if land was only permitted to Christian whites, for example, and not to Jews or nonwhites.

Thus the dominant pattern in thought about the geography of Palestine, for a millennium and a half inhabited by an overwhelming majority of non-Jews, has been the idea of return: to return to Israel for Jews who have never been there was to return to Zion and an earlier state from which

Jews had been exiled. Carol Bardenstein notes in a sensitive study the way the same images of prickly pears, oranges, trees, and return thread their way into discourses of memory for both Jews and Palestinians. But the Jewish discourse eliminates from the landscape the former Palestinian presence:

I had the opportunity to visit a number of sites of former Palestinian villages that have been variously reshaped through tree-planting and related JNF projects, in ways that would appear to promote "collective," if selective, forgetting. If one visits the site of the destroyed village of Ghabsiyah in the Galilee, for example, upon closer scrutiny the trees and landscape themselves yield two very different and contesting narratives converging on the same site. One has to rely on landscape readings, because little else remains. What is most readily visible to the first-time visitor are the JNF trees planted on the site—the recognizable combination of pine and other trees that have grown over the past four decades in a manner that makes it seem as if perhaps that is all that was ever there.[19]

Let me note in a very brief conclusion what the interplay among memory, place, and invention can do if it is not to be used for the purposes of exclusion, that is, if it is to be used for liberation and coexistence between societies whose adjacency requires a tolerable form of sustained reconciliation. Again I want to use the Palestinian issue as my concrete example. Israelis and Palestinians are now so intertwined through history, geography, and political actuality that it seems to me absolute folly to try and plan the *future* of one without that of the other. The problem with the American-sponsored Oslo process was that it was premised on a notion of partition and separation, whereas everywhere one looks in the territory of historical Palestine, Jews and Palestinians live together. This notion of separation has also closed these two unequal communities of suffering to each other. Most Palestinians are indifferent to and often angered by stories of Jewish suffering since it seems to them that as subjects of Israeli military power anti-Semitism seems remote and irrelevant while their land is taken and homes are being bulldozed. Conversely most Israelis refuse to concede that Israel is built on the ruins of Palestinian society, and that for them the catastrophe of 1948 continues until the present. Yet there can be no possible reconciliation, no possible solution unless these two communities confront each's experience in the light of the other. It seems to me essential that there can be no hope of peace unless, the stronger community, the Israeli Jews, acknowledges the most powerful memory for Palestinians, namely, the dispossession of an entire people. As the weaker party Palestinians must also face the fact that Israeli Jews see themselves as survivors of the Holocaust, even though that tragedy cannot be allowed

to justify Palestinian dispossession. Perhaps in today's inflamed atmosphere of military occupation and injustice it is perhaps too much to expect these acknowledgements and recognitions to take place. But, as I have argued elsewhere, at some point they must.

Notes

1. See Howard Zinn, *A People's History of the United States* (New York, 1980).
2. Zinn, "The Massacres of History," *The Progressive* 62 (Aug. 1998): 17.
3. See *The Invention of Tradition,* ed. Eric Hobsbawm and Terence Ranger (Cambridge, 1983).
4. Ranger, p. 220.
5. Hobsbawm, "Mass-Producing Traditions: Europe, 1870–1914," pp. 271, 272.
6. See Tom Segev, *The Seventh Million: The Israelis and the Holocaust,* trans. Haim Watzman (New York, 1993).
7. See Peter Novick, *The Holocaust in American Life* (New York, 1999), pp. 146–203.
8. See Frances A. Yates, *The Art of Memory* (Chicago, 1966).
9. Simon Schama, *Landscape and Memory* (New York, 1995), p. 30.
10. See Raymond Williams, *The Country and the City* (London, 1973).
11. See Keith W. Whitelam, *The Invention of Ancient Israel: The Silencing of Palestinian History* (New York, 1996); hereafter abbreviated *I.*
12. Yael Zerubavel, *Recovered Roots: Collective Memory and the Making of Israeli National Tradition* (Chicago, 1995), p. 63.
13. Ibid.
14. See Edward W. Said, "Conspiracy of Praise" and Norman G. Finkelstein, "Disinformation and the Palestine Question: The Not-So-Strange Case of Joan Peters's *From Time Immemorial,*" in *Blaming the Victims: Spurious Scholarship and the Palestinian Question,* ed. Said and Christopher Hitchens (New York, 1988), pp. 23–31, 33–69.
15. See Said and Jean Mohr, *After the Last Sky: Palestinian Lives* (New York, 1986).
16. See Paul Breines, *Tough Jews: Political Fantasies and the Moral Dilemma of American Jewry* (New York, 1990).
17. See *The Transformation of Palestine: Essays on the Origin and Development of the Arab-Israeli Conflict,* ed. Abu Lughod (Evanston, Ill., 1971); Walid Khalidi, *Before Their Diaspora: A Photographic History of the Palestinians* (Washington, D.C., 1984); *All That Remains: The Palestinian Villages Occupied and Depopulated by Israel in 1948,* ed. Walid Khalidi (Washington, D.C., 1992); Rashid Khalidi, *Palestinian Identity: The Construction of Modern National Consciousness* (New York, 1997); Sabri Jiryis, *The Arabs in Israel,* trans. Inca Bushnag (New York, 1976); Bayan al Hout, *Political Leadership and Insti-*

tutions in Palestine, 1917–48 [Arabic] (Beirut, 1984); and Elia Zureik, *The Palestinians in Israel: A Study in Internal Colonialism* (London, 1979).

18. See Zeev Sternhell, *The Founding Myths of Israel: Nationalism, Socialism, and the Making of the Jewish State,* trans. David Maisel (Princeton, N.J., 1998).

19. Carol Bardenstein, "Threads of Memory and Discourses of Rootedness: Of Trees, Oranges, and the Prickly Pear Cactus in Israel/Palestine," *Edebiyât* 8, no. 1 (1998): 9.

NINE

W. J. T. MITCHELL

Holy Landscape: Israel, Palestine, and the American Wilderness

Landscape "is of all kinds of painting the most innocent, and which the Divill himselfe could never accuse of Idolatry."
—Edwin Norgate, *Miniatura*[1]

A person is more holy than a land, even a holy land, since faced with an affront made to a person, this holy land appears in its nakedness to be but stone and wood.
—Emmanuel Levinas, in "Ethics and Politics"[2]

Everyone that lives in the land of Israel is like the man that has a god and everyone that lives abroad is like the man that has no god.
—Saying quoted by Martin Buber[3]

Holy Landscape. The very phrase evokes images of paradise, the land of milk and honey, the blessed isles, the promised land, the Elysian fields, the Beulah land that Blake and Bunyan identify as the suburban, pastoral surroundings of the holy city of Jerusalem. The holy land is the land made whole, unified in peace and harmony, or the healthy land, cleansed of all impurity and sickness. It is the innocent landscape, literally the harmless place where violence is unknown.

But every holy landscape seems to be shadowed by evil. The tempter looks with an evil eye on the goodly prospect, ready to pounce. The holy place is a paradise from which we have been expelled, a sacred soil that has been defiled, a promise yet to be fulfilled, a blessed site that lies under

261

a curse. The perverse logic of holy landscape seems to turn it from god's gift into an obscene idol that demands human sacrifice. The sacred groves are watered by blood, and the fields are fertilized with human flesh and bones. Palestine/Israel, the sacred territory of the three great religions of the Book, the object of several millennia of conquest, crusade, and holy war, has seen its share of sanctification by blood. Kosovo, Ireland, the Americas, South Africa, and innumerable other "promised lands" around the globe have mimicked this logic with varying degrees of ferocity and religious fervor.

The purpose of this paper is to explore the concept of holy landscape, with special emphasis on the paradoxical relation between landscape and idolatry. My argument is that landscape, on the one hand, is a medium of representation that, historically, has been thought to be innocent of idolatry, even associated with an iconoclastic prohibition on graven images, an escape from the kind of figurative representation forbidden by the Second Commandment. On the other hand, it seems obvious that landscape is quite capable of becoming an idol in its own right—that is, a potent, ideological representation that serves to naturalize power relations and erase history and legibility. I will argue further that landscape can become an idol, not just in some modern, extended sense—as ideology, for instance—but in the very terms by which idolatry is defined in the Bible— a false god that displaces the true one with a material image, and leads inexorably to the violation of every commandment, not just the prohibition on idolatry.[4]

1. Specular Surfaces: Landscape and Forgetting

It may be important at the outset to clarify one thing: the landscape I will be talking about here is not the analytic tool that cultural geographers such as J. M. Wagstaff have made the centerpiece of their interdisciplinary research, a conceptual tool for the archaeological, anthropological, and historical excavation of human ecology.[5] I must also contrast my approach here to that of Simon Schama, whose book *Landscape and Memory* "is constructed as an excavation below our conventional sight-level to recover the veins of myth and memory that lie beneath the surface."[6] These approaches to landscape, what one might call the depth model, while clearly of great importance, are exactly antithetical to my notion of landscape in terms of a surface model. That is, I am concerned with images, representations, and stereotypes of the landscape that, while often demonstrably false and superficial, nevertheless have considerable power to mobilize political passions. In contrast to Schama, I want to explore landscape as a place of amnesia and erasure, a strategic site for burying the past and veiling history

with "natural beauty." I take seriously Adorno's remark that "the beautiful in nature is history standing still and refusing to unfold."[7]

In fact, it is the very falseness and superficiality of the images I will discuss that gives them their potency, their virulence as icons of national and imperial destiny. Even more insidious is the remarkable capacity of the surface of landscape to open up false depths, selective memories, and self-serving myths. Schama, for instance, recalls his own memories of childhood participation in the program of tree-planting in Israel:

The trees were our proxy immigrants, the forests our implantation. And while we assumed that a pinewood was more beautiful than a hill denuded by grazing flocks of goats and sheep, we were never exactly sure what all the trees were *for*. What we did know was that a rooted forest was the opposite landscape to a place of drifting sand, of exposed rock and red dirt blown by the winds. The diaspora was sand. So what should Israel be, if not a forest, fixed and tall? [*LM*, pp. 5–6]

One has to be struck by the selectiveness of memory and history that is brought to the holy landscape. There is no mention, for instance, that the new Israeli forests often concealed the marks of Palestinian habitation, or that the landscape they covered was not sandy desert, but cultivated olive groves and rural villages. Schama notes that he is recalling "a child's vision of nature," one that is "already . . . loaded with complicating memories, myths, and meanings," and suggests that this indicates "how much more elaborately wrought is the frame through which our adult eyes survey the landscape" (*LM*, p. 6). Indeed, the holy landscape is an elaborately wrought image, but its truth is not to be found either in myths or memories that can be so straightforwardly dug up from the depths and laid open to view. One has to ask: Whose myths? Whose memories? What was erased, rendered invisible in order that this landscape might present the face it does? How does this face betray the signs of contestation and struggle between rival myths, disparate memories?

While it is clearly important, then, to retrieve the memories and excavate the depths of landscape, one must register as well the sense in which landscape is all about forgetting, about getting away from the real in ways that may produce astonishing dislocations. If Schama had dwelled a bit longer on his vision of Israel as a desert become forest, he might have connected it with his later discussions of "tree cults" in Europe and the debates between the "radical iconoclasts, intent on extirpating idolatry root and branch" and the pragmatists who "grafted" Christian holy places onto the sites of pagan groves (*LM*, p. 216). The "innocent ritual" of tree-planting by children grows, Schama remarks, out of "a long, rich, and pagan tradi-

tion that imagined forests as the primal birth-place of nations" (*LM*, p. 6), an especially potent figure in the landscape imagery of romantic German nationalism. The sacred groves are the natural home both of idols and of a racially pure nation. As Tacitus wrote in *Germania* (in a passage that was noted, as Schama points out, with approval by the Nazis), "in the peoples of Germany there has been given to the world a race unmixed by intermarriage with other races, a peculiar people and pure, like no-one but themselves" (quoted in *LM*, p. 82). Like the forest, this race (and its idols) sprang out of "the black earth of their native land" (*LM*, p. 82). In this light, the forestation of Palestine as a way of transforming it to the nation of Israel looks a bit less innocent.

While the "elaborately wrought" image of the holy land may be readily exposed as an idol, it is important to remember that the critical exposure of idols to the light of historical analysis is rarely enough to disenchant or dethrone them. No one has ever been argued out of an ideology or persuaded by reason to give up an idol. What is required, in my view, is a working through of the idols, striking them, as Nietzsche put it, with a "hammer as with a tuning fork," so as not to smash them, but to make them sound, and resonate, divulge their own hollowness, and vomit up the human sacrifices they have demanded.[8]

My "superficial" understanding of Palestinian landscape is not, needless to say, that of the Middle East expert who understands the deep history of every geological and archaeological feature, but that of the tourist, the traveller who passes through the landscape as an outsider and sees only its surface. The tourist is, of course, one of the most hypertheorized figures in contemporary cultural studies. Since Dean MacCannell's classic study of tourism, it has been impossible to think of tourism without irony and the double-binds of an impossible quest for authentic experience.[9] The tourist has been staged as nomad, detective, seer and prophet, cultural theorist, and ignoramus. I like to think of my own form of tourism as that of the *gastarbeiter*, the migrant worker who brings nothing but some skills developed elsewhere, skills that may or may not be useful. I find "pure" tourism, in fact, to be very difficult work, overwhelming, overstimulating, and finally enervating in its impossible demand for total attentiveness and recall. (Have you ever found yourself caught up in that competitive game known as "but did you see . . . ?" with someone who has toured a place and has clearly seen everything of importance that you, in your ignorance, overlooked?) As a guest-worker, on the other hand, one has the advantage of being invited (with the clear implication that the stay is temporary), led around by the hand, being asked to serve some more or less specific function. While the guest-worker in the landscape may offer relatively little in the way of positive information or deep-rooted memories of the place, this

figure may have a certain potential for witnessing and testifying to a surface experience of landscape, a comparative experience that has to be understood in autobiographical terms, as inescapably private, personal, and ignorant. Whether this ignorance is capable of playing a philosophical role remains to be seen.

That ignorance, a certain kind of wilful unknowing, is central to the concept of landscape, seems undeniable. I have made this argument elsewhere and will simply recapitulate its main features here.[10] The concept of landscape that dominates the discourse of Western art history is one that is resolutely focussed on visual and pictorial representation, the scenic, picturesque, and superficial face presented by natural terrain. Landscape is something to be seen, not touched. It is an abstraction from place and a reification of space, a reduction of it to what can be seen from a distant point of view, a prospect that dominates, frames, and codifies the landscape in terms of a set of fairly predictable conventions—poetic, picturesque, sublime, pastoral, and so on. I think of *place* and *space* in the terms made familiar by Michel de Certeau: a place is a specific location; a *"space is a practiced place,"* a site activated by movements, actions, narratives, and signs.[11] A landscape, then, turns site into a sight, place and space into a visual image.

But the specular construction of landscape is not merely an inert, static foil to the vitality of the place and space. If holy landscape, in particular, is an image and an idol, then it is an *animated* image, an icon that has a life of its own. Secular landscape perception, while generally contrasted to the contemplation of sacred sites, nevertheless mimics their rituals of "purification"—landscape as a liberation of the visual consumption of nature from use-value, commerce, religious meaning, or legible symbolism of any sort into a contemplative, aesthetic form, a representation or perception of nature for its own sake. This purification, finally, is almost invariably described as a modern and Western discovery, a revolutionary liberation of painting from narrative and ecclesiastical symbolism that can be dated quite precisely in the seventeenth century. Non-Western cultures with traditions of landscape aesthetics (the Chinese, for instance) are routinely characterized as attributing a religious significance to the landscape that prevents a pure appreciation of nature for its own sake. Other non-Western cultures, especially ones that do not have a developed tradition of realistic or naturalistic pictorial representation, are seen as oblivious to the aesthetic value of landscape. The primitive or aboriginal dweller on the land (the "pagan" or "rustic" villager) is seen as part of the landscape, not as a self-consciously detached viewer who sees nature for its own sake as the Western observer does. In addition, the native dweller is seen as someone who fails to see the material wealth and value of the land, a value that is obvious

to the Western observer. The failure of the native to exploit, develop, and "improve" the landscape is, paradoxically, what makes it so valuable, so ripe for appropriation. The failure to exploit the land, its "undeveloped" character, also seems to confer a presumptive right of conquest and coloni- zation on the Western observer, who comes armed both with weapons and arguments to underwrite the legitimacy of his appropriation of the land (according to Tertullian, the pagan or rustic country-dweller is under- stood to be contrasted with the *miles*, the soldier, and especially the Chris- tian, crusading soldier).[12] Landscape thus serves as an aesthetic alibi for conquest, a way of naturalizing imperial expansion and even making it look disinterested in a Kantian sense.

I took my presence at a recent conference on Palestinian landscape to be a statement about the importance of this superficial landscape as such, a topic to be considered seriously in its own right.[13] This meant that a certain kind of formalism, an aesthetic attitude, was to be entertained, that the point of view of what Mark Twain called "the innocent abroad"—the tour- ist, the nomad, or the pilgrim—was to be welcomed. It indicated that we were not talking (only) about *land*, about territorial disputes, real estate claims, land and house seizures and demolitions, and all the other depreda- tions that have been visited on Israel/Palestine in the name of political, racial, or religious purity. It meant stepping back from the interminable disputes over zones A and B and C, over partitioning and sectioning and restrictions on travel, over the 3 percent parcel of desert that may hold a key to the negotiations, over the archaeological digs that penetrate the land's surface to raise up the ghosts of its embattled past.[14] It meant think- ing about the land comparatively and globally, as a *passage*, an imaginary and symbolic as well as a real entity, a land*scape*, a visible, perceptible shape that is freighted with so many associations and conflicting representations that it is a wonder that the earth's crust does not buckle under their weight (fig. 9.1). It meant, as Edward Said has argued, that thinking about the politics of landscape could not be conducted in an aesthetic vacuum, that politics had to engage in complex dialectical negotiations with questions of form, affect, and sensibility, with cultural formations. We were called upon, in short, to think of Palestine as a work of landscape art in progress, to ask what vision of this land can be imagined, what geographical poetry can be recited over it, to heal, repair, unite, understand, and commemorate this place. We were asked to think simultaneously of topology and typol- ogy, the typicality and exemplariness of place, the codification of site, the repetition of landscapes as pictorial, geographic, and poetic tropes. We

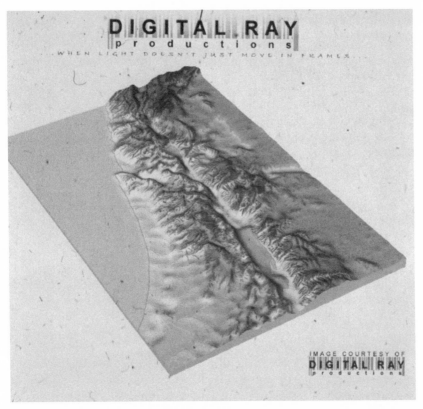

9.1 An overall view of Israel, snatched from the Alta Vista search engine while tracking "Landscape Israel." This image, it should be noted, makes the occupied Palestinian territories a seamless part of Israel.

were enjoined, therefore, to think comparatively of landscapes, of what we see and hear and read not only when we take "landscape perspectives *on* Palestine," looking upon the nascent landscape of an as-yet-unborn nation (Palestine), but what we see when we look out upon the world from the landscape perspective *of* Palestine. How does a country look to the world? How does the world look to a country? And how can the landscape itself be said to have a perspective? Does this not suggest, quite literally, that the landscape looks back in some way at its beholders, returning their gaze with a blank, impassive stare, its face scarred with the traces of violence and destruction and (even more important) with the violent *constructions* that erupt on its surface?

2. The Desert, the Idol, and the Iconoclast

I want to turn now to the desert. Not, at least at first, the desert in which the Israelites wandered for forty years. Not the desert in which Jesus fasted for forty days and forty nights. Not the wilderness where the desire to have a visible god generated a Golden Calf and a terrible vengeance from a jealous and invisible god. Not the vastness of the Arctic tundra, where a single tree or a stone marker *(nukchuk)* punctuates the apparent emptiness like a solitary witness. Not the high places of abstract contemplation, the prospects that, from the Garden of Eden to the Maori totem surveying the New Zealand coastal scenery, offer up the world as a map, an infinite plane.

No: the desert I have in mind is a real place in my own memory. It is the desert of western Nevada, the foothills of the Sierra Nevada mountains, the sagebrush plains of Carson Valley, and the ruined, irradiated soil of Yucca Flats, the site of nuclear testing during my boyhood. This desert is also imaginary, of course. It is the desert that my father, a geologist and mining engineer, assured me was once an ocean bed, now littered with the fossil traces of marine animals and dinosaurs. Far from a trackless waste, this desert is one where the past rises up in fantastic collages that juxtapose history with prehistory and even with the "deep time" of geological events, mirages of vanished races locked in combat (see fig. 9.2). It is the scenery that flashes by in thousands of Hollywood Westerns, the endless pursuits on horseback, the flight into the badlands, the canyons and gulches, or into the high country of pinyon and ponderosa pine, or the highest country of naked peaks beyond the timberline. It is the landscape where, as a boy in the 1950s, I hid myself in the wilderness, seeking deeper and deeper refuges from civilization. I imagined that when the Communists invaded the United States they would come last to Carson City, Nevada, and they would never find me in the labyrinthine gullies and abandoned mine shafts in the foothills. I ran in the foothills with my Paiute neighbors and played cowboys and Indians with them on the school playground. We scorned the tourists from Cali*fornia* (a word that was pronounced in a tone that rhymed with "porn" and "scorn" for its softness, decadence, and our envy at California's obvious wealth and superior sophistication) who came to photograph the rodeos and the powwows, red and white boys united in the frame of the tourist gaze. These fantasies of flight and safety in the wilderness were mixed with visions of horror and violent death: falls from cliffs, the bites of scorpions, rattlesnakes, Gila monsters, burial alive in a caved-in mine shaft, cruel rites of initiation—all these prospects mixed with the sense of safe refuge.

I still carry this landscape with me as memory, fantasy, and recurrently

9.2 Robert F. Walters, *The Last Thunder Horse West of the Mississippi*, 1988.
© 1988 Robert F. Walters.

visited dream place. What does it have to do with Palestine? What does the
American wilderness, with its Judeo-Protestant "errands"—wanderings,
ordeals, treks across the desert in search of the Promised Land—have to
do with Palestine? Everything, clearly. Since the beginning, Americans
have been turning toward their own Western frontier as a wilderness to
be traversed in search of a promised land, a Zion.[15] The "Great American
Desert" was an *idée fixe* imposed on the reality of the fertile Western plains
for several generations, as if Americans needed a desert to wander in, a
diasporic ordeal to purify them for the promised Canaan of California.[16]
This Canaan had, of course, its Canaanites in the form of the Indians, the
Lost Tribes of Israel according to some accounts, aboriginal dwellers on

the land who had to be dispossessed, removed, or sentimentalized as the vanishing remnants of a lost Eden. George Catlin remarks on this common fable: "I believe, with many others, that the North American Indians are a mixed people—that they have Jewish blood in their veins, though I would not assert, as some have undertaken to prove, *'that they are Jews,'* or that they are *'the ten lost tribes of Israel.'"*[17] When Twain visited Palestine, after his post-Civil War sojourn as a newspaperman in the frontier mining town of Carson City (later described in *Roughing It*), he compared, in *Innocents Abroad* (1869)—a "New Pilgrim's Progress" that traces his "excursion to Europe and the Holy Land"—the "Canaanites" to the Indians of the American west.[18] Since these "Canaanites" or Arabs, for Twain, were ancestors to the Jews of Jesus's time, he, like Catlin, linked the Indians to the Jews.[19] Twain, however, perceived the poverty and disease of the Arabs as an inherent condition of their culture, awaiting redemption by the forces of Western modernization. Catlin, by contrast, saw the degradation of the Indians as a product of the *"blasting frontier"* that has "crowded upon them . . . like the fire in a prairie, which destroys everything where it passes."[20]

Something of this comparative "recognition" must have been working in my own tourist experience as well. The first time I visited Israel, in 1970, I recognized it with a flash of déjà vu, as a frontier culture, with all the rough energy and optimism of my mythical and remembered Nevada, the home of the Gold Rush, the Comstock Lode. The second time I visited Israel in 1987, to attend a conference on landscape at Bar-Ilan University, it reminded me more of Los Angeles in the sixties, a suburb gone sour, a promised land gone to seed. Since that visit, my sense of Israel has been overlaid by other frontier landscapes, from the Australian outback and the solitary Bushranger to the South African veldt and the legend of the Vortrekkers.[21] It has been overlaid by the raw avid faces of pioneers, settlers, and colonists turned toward their promised lands, and by the haunting, persistent faces of the dispossessed aborigines—the Paiute and Washoe Indians, the Zulu and the Xhosa, the Bushmen, the Palestinians.

But isn't it wrong, somehow, perhaps sentimentalizing or aestheticizing, to merge and juxtapose all these diverse exiles, refugees, colonized, dispossessed peoples into a kind of montage? Doesn't landscape tourism of this sort actually narrow the mind, a "comparison of scene with scene" as Wordsworth put it, flattening these places into a kind of picturesque victim's procession, with all historical particularity and specificity erased?[22] Doesn't the landscape perspective itself reduce a place to an image, a representation? And isn't landscape, in fact, one of the great "Idols which beset men's minds," condensing national and imperial ideologies, naturalizing them into a potent stereotype for mass consumption and mass hysteria?

These were the questions that forced themselves on me during my second visit when I came to the conference on landscape as artifact and text at Bar-Ilan University, and saw a new Israel revealed, even to my passing, touristic gaze, as an occupying, colonial power, a police state that seemed determined to violate every moral, legal, and political principle one might have hoped for from the first modern Jewish state. On that visit we were taken on an excursion to Masada, and treated to the recitation of a mantra over that landscape by our Israeli guide. Masada, we were told, is an emblem of ancient Israel's determination to die rather than surrender to the Roman idolaters. But it has taken on a new meaning in the modern world. The next time fortress Israel is surrounded by enemies, our guide assured us, it will not commit suicide alone. It will take the whole world with it into the final conflagration.[23]

This apocalyptic reading of the landscape is, needless to say, quite congenial to the American Christian fundamentalists who have now entered into an unholy alliance with Orthodox Jews on the meaning of the Holy Land. In the symbolic landscape of Palestine, the most intense concentration of holiness for all three religions of the Book is, not surprisingly, the cityscape of Jerusalem, and especially the site of the Dome of the Rock. As Lawrence Wright notes, "the mystical concept of sacred space that shrouds the Temple Mount—and, beyond that, Jerusalem and Israel itself—has for centuries served as an impenetrable barrier to peace." Wright documents the plans of the ultra-Orthodox Temple Institute in Jerusalem (what he characterizes as "a Jewish version of the Taliban") to work with a Pentecostal Christian cattle breeder from Mississippi to breed a "red heifer," a sacrificial animal that is crucial to the rapidly approaching Second Coming.[24] As the millennium arrives, sacred space and time seem to converge in one contested place, a site of what Martin Buber calls " 'pressing the end' " and "heaven-storming" (*OZ*, p. 91). The landscape becomes a magical object, an idol that demands human sacrifices, a place where symbolic, imaginary, and real violence implode on an actual social space.

It is hardly an exaggeration to say that the landscape perspective is one way of grasping the totality of what Said calls "the question of Palestine." Palestine has been reduced to the status of a landscape: framed, hedged about, shaped, controlled, and surveilled from every possible perspective. As I wrote these words, a piece of "landscape" was being discussed as the key to peace between Israel and the Palestinians (fig. 9.3). The famous 3 percent of arid land, now occupied by a few Bedouins and many lizards, is to be "given" to the Palestinians, with one catch. It is not to be developed. It is to be left as a "nature preserve"—in short, a landscape to be seen but not touched, not dwelled upon. While Israel proceeds apace, building new housing everywhere, it bestows a gift of landscape on the

NEW YORK TIMES **INTERNATIONAL** WEDNESDAY, SEPTEMBER 9, 1998

Patch of Desert Is Key to Mideast Talks' Next Step

By DEBORAH SONTAG

IN THE JUDEAN DESERT, West Bank, Sept. 8 — Here is the parcel of land that has been mired in the most recent stalemate between the Israelis and the Palestinians: undulating dunes laced with scrub, starkly beautiful if desolate, and barren but for the lizards and an occasional Bedouin encampment.

Southeast of Hebron and barely more than an hour from Jerusalem, this is the latest 3 percent of the West Bank that the Israelis have been loath to surrender and the Palestinians hesitant to accept.

It is expected to become a so-called nature reserve within the 13 percent of territory that Israel would turn over to the Palestinians if the long-stalled second withdrawal were to move forward.

Dennis B. Ross, the United States special envoy to the Middle East, is to arrive in Jerusalem on Wednesday, his first trip since May, when not only the size and location but also the very notion of a final parcel of land was a deal-breaking issue.

Over the summer the Israelis have quietly agreed to surrender 13 percent of the West Bank, provided that they retain security control over the last parcel. The Palestinians have tentatively agreed to accept, although they have balked at Israel's demand for zoning control over the nature reserve.

Not even two weeks before the Jewish High Holy Days, when Israeli diplomacy effectively shuts down for a month, Mr. Ross's trip comes at a critical moment for all parties to the peace negotiations.

The Americans are eager for a foreign policy success, or at least eager to avert failure. Prime Minister Benjamin Netayanhu is feeling new political pressure as serious talk

Bedouin nomads are the only residents of a portion of desert that Israel has offered to turn over to the Palestinian Authority under certain conditions. An American mediator is to resume talks this week.

A nature reserve for lizards may be a West Bank compromise.

a package that addresses, among other things:

¶Israel's demands for a Palestinian crackdown on illegal weapons and for a large police force, possibly using the local Central Intelligence Agency station for inspectors.

¶Israel's demand that Mr. Arafat convene the Palestine Liberation Organization leadership — or some

9.3 "Patch of Desert Is Key to Mideast Talks' Next Step," *New York Times,* 9 Sept. 1998.

Palestinians, a poisoned gift of empty space, with strings tied to it everywhere.[25] It will be a Palestinian landscape, a landscape perspective on Palestine. They can look at it, take a perspective on it, but not live in it.

Perhaps travel does broaden the mind, awakening it to the repeatability of landscape as poetic geography, scenes of terror and territory "by distance ruralised," as Wordsworth would say (*P,* bk. 1, l. 89, p. 195). The scenes of diverse "lands of opportunity" are to be opened up, developed, the desert made to bloom by chosen people who bear the white man's burden, the manifest destiny, a historic civilizing mission, the Word of God to the soon-to-be expelled or annihilated aborigines. The original, savage, pagan dwellers must make way for the settlers; idolatry will not be tolerated, and any territorial negotiations with pagans will be regarded as idolatry. The false but efficacious etymology of *territory* is "terror," the enforcing of boundaries with violence and fear.[26] This is poetic geography. Melville halts in the desert to read it as a text written with stones and bones:

Stones mention find in hallowed Writ:
Stones rolled from well-mouths, altar stones,
Idols of stone, memorial ones,
Sling-stones, stone tables; Bethel high
Saw Jacob, under starry sky,
On stones his head lay—desert bones:
Stones sealed the sepulchers—huge cones
Heaved there in bulk; death too by stones
The law decreed for crime.[27]

The law, the instrument of punishment, the crime of idolatry, the altar of sacrifice, the remains of the sacrificed victim, and (need we say it?) the hardened heart of the pious fanatical sacrificer are all made of stone. Voltaire had already witnessed this scene in his *Philosophical Dictionary*, when he is transported from his celestial "contemplation of nature" by a genii "into a desert covered all over with bones piled one upon another," the remains of " 'the twenty-three thousand Jews who danced before a calf, together with the twenty-four thousand who were slain while ravishing Midianitish women . . . the bones of Christians, butchered by one another on account of metaphysical disputes . . . the twelve millions of [Native] Americans slain in their own country for not having been baptized.' " It does not escape Voltaire's notice, of course, that it is the monotheists, the iconoclasts, the "Peoples of the Book," Christians, Jews, and Muslims, who have been principally responsible for the very concept of the Holy War: "As for other nations, not one of them, since the beginning of the world, has ever made a purely religious war."[28]

I think of the Nevada landscape as a place in the backwash of the desert frontier, after its violence has receded and left behind petrifying, desiccated relics. Ghost towns, abandoned mines, forsaken homesteads, dry wells, lost arrowheads, and the bones of everything from cattle to dinosaurs constituted my own primal scene of nature. Central Nevada, Ely, Elko, and Tonopah are godforsaken landscapes where the eye gives up trying to estimate distance in endless emptiness (fig. 9.4). They are places of radical loneliness where the only image is likely to be a mirage or a hallucination brought on by thirst. It is a place of visions, in short, but not of figures, features, or forms. The image presented by this landscape is abstract, aniconic, punctuated only by the lone tree, the solitary witness. This is the landscape of monotheism photographed by Timothy O'Sullivan on Clarence King's U.S. Geological Survey (1867–1874), the land of the abstract, invisible god who speaks and writes, but does not show his face, who leaves his catastrophic footprints on the earthquake riven terrain and retreats into the invisible distance (see fig. 9.5).[29] This emptying and abstracting tendency is endemic to the very concept of landscape. The history of European land-

9.4 Robert Frank, *Highway 364, New Mexico.* © Robert Frank, courtesy Pace/McGill Gallery, New York.

9.5 Timothy O'Sullivan, *Alkaline Lake, Nevada*, 1868.

scape painting is generally told as a story of the disappearance of the figure, the erasure of narrative, allegory, and legibility in favor of a "pure" icon of nature as such.[30] This is the landscape whose purification makes it innocent of all possible idolatry. The idol, we suppose, must appear as a figure, a statue that surveys the landscape. The empty landscape, the waste or wilderness or void, is an iconoclastic icon; it throws down the high places and smashes the traces of indigenous or aboriginal dwelling. The desert is, as Roland Barthes might put it, landscape degree zero.

In his *General History and Comparative System of the Semitic Languages*, Ernst Renan reiterates a commonplace of geographical theology: "the semitic peoples," he says, "never had a mythology." They were monotheists because the "monotonous desert landscapes led the dwellers in these deserts to develop a concept of an abstract divinity and prevented them from acquiring the imagination needed for creating myths."[31] By contrast, Giambattista Vico suggests in his *New Science* that "the gentile nations," the vast majority of the human race who did not receive the divine revelation

of the one, abstract, invisible god, were "forest-bred" and thus shut off from each other and from the open spaces of desert wandering. For the gentiles, the "order of human institutions" is rooted in the dwelling place: "first the forests, after that the huts, then the villages, next the cities, and finally the academies." The gentiles, living in fear of the natural forces surrounding them, created gods out of poetical figures for these forces and idols out of their visible, graven images. They also created a "science" of "divination" to interpret the meaning of the idols and predict the future— the very science, Vico suggests, "on the prohibition of which the Hebrew religion was founded by the true God."[32] The world is radically divided, for Vico, between the polytheistic, idolatrous gentiles and the Hebrews, whose religion he sees as the root of both Christianity and Islam. Idolatry in the Talmud is principally "a formulation of the types of contact between Jews and pagans," between the militant monotheists and the idolatrous rustics.[33]

What came first? The Forest or the Desert? The question makes no sense from the standpoint of empirical, historical geography. In poetic and theological geography it invites reflection on contrasting origin myths in the creation and history of the world: is the first landscape an emptiness, a void, waste, or wilderness? Or is it the arboreal, garden world of abundance, the land of milk and honey. Blake calls these landscapes Ulro, the indefinite, homogeneous space, Generation, the Jungle with its Tygers, and Beulah land, the garden.[34] His originary landscape is, of course, Jerusalem, the Four-Gated City of the fully liberated human productive powers, that is to say, of an Imagination that re-creates nature in its own image. Blake understood that the God of what Nietzsche called "monotonotheism" (Nobodaddy) lived in the desert, the empty places. As Vincenzo Vitello says of Moses, "His only land and home is the desert—the absence of home."[35]

In my second visit to Israel I purchased a postcard (since lost) designed to lure American tourists. It depicted a Bedouin on a camel crossing sand dunes in the middle distance, framed in the foreground by palm trees suggesting a perspective from the oasis. A perfectly ordinary postcard, I'm sure, an appeal to the fantasy of the Holy Land as a kitsch icon in which the figure of the Arab serves as a stand-in for the wandering Israelite in the wilderness. But this particular one had a feature that only became evident on closer inspection: in the shadow of the palm tree, a coil of barbed wire. Perhaps this is what Israel has in mind with its "nature preserve"— a kind of theme park of primitive Judea or Samaria, where the primal, originary desert can be permitted to lie fallow, and nomads can be kept under the benign surveillance of the tourist gaze.

Here the process called making the desert bloom turns back on itself.

" 'The desert grows,' " says Nietzsche: "The desert of our history is created by values," echoes Vitello.[36] This desert is not a product of nature, but of culture, the cultivation of waste, emptiness, the man-made aboriginal wilderness. The paradox here resides in the temporality of landscape (figs. 9.6–9.8). We can now create what artist Alan Sonfist calls a *Time Land-scape*, a primitive site enframed entirely by modernity. Sonfist's *Time Land-scape* is a tiny patch of primeval Manhattan ecology that stands in the shadows of NYU's Silver Towers. It shows what the forest of Manhattan Island looked like before white men arrived, perhaps even before the Indians. A window into the aboriginal past, it is younger and newer than the apartments that tower over it. It seems to foreshadow a future in which the wilderness has become a tiny inaccessible refuge surrounded by a concrete and steel desert, the urban landscape. One can look into this past, but not touch it.

A similar double temporality governs the mythic image of the holy landscape. It is both the place of origin and the utopian prospect of the future, always fleeting beyond the present. This doubleness then defines a third space—the space between, of wandering, errancy, diaspora, and trial. Whether forty years, forty days, or forty centuries, it is the space that must be crossed by the pilgrim, the prophet, or the nomad. The promised land is the greatest collective landscape mirage the human imagination has ever projected for itself. It is the promising of a land, as Wordsworth says, "evermore about to be" (*P*, bk. 6, l. 608, p. 268). At each misstep, each error along the way, Israel is punished by a jealous God who, far from offering a land of milk and honey, is a producer of desert where there once was garden, laying waste the land. Ezekiel lets this god speak for himself: "In all your dwelling places the cities shall be laid waste, and the high places shall be desolate; that your altars may be laid waste and made desolate, and your idols may be broken and cease, and your images may be cut down, and your works may be abolished" (Ezekiel 6:6). The god named Baal, particularly, who is the presiding deity of the oasis, the cultivated, watered place, must be destroyed. "In Semitic religion," remarks W. Robertson Smith, " the relation of the gods to particular places . . . is usually expressed by the title Baal."[37]

If one searches the internet under the key words "Landscape Israel," one encounters a website called Neot Kedumim, a window into one fantastic realization of Zionism (see figs. 9.9–9.10). Zion is not just an abstract concept: it is a place, a land, and a landscape.

Zion is the name God gave to His everlasting dwelling place. It is His name for Jerusalem, His throne. God was the first Zionist. He invented the concept. It was God who promised the land of Israel to the descendants of Abraham,

9.6–9.8 Alan Sonfist, *Time Landscape*, 1978.

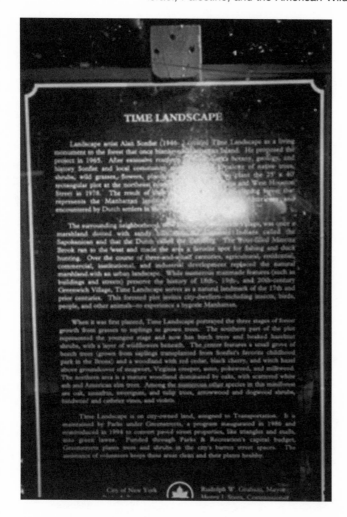

Isaac and Jacob (not Ishmael & Esau), and it was God who promised that He would regather the Jews and restore them to the land of Israel in the last days. For centuries, Palestine (as named by the Romans) was a land of desert and swamp. When the Jews began to return, they once again tilled the soil and the land began to bring forth its produce.

This text, "What Is Zionism and Should We Support It?" lays out the program of Neot Kedumim, a theme park devoted to "Biblical landscape." "In Hebrew," the website tells us, "*neot* means places of beauty; *kedumim* means ancient. At *Neot Kedumim*, you can tour landscapes of beauty, all planted

9.9–9.10 Neot Kedumim, www.virtual.co.il/travel/neot/

within the last twenty-five years, to learn the connection between the Land of Israel and the Judeo-Christian tradition." If the silent absence of Arabs and Muslim tradition is not eloquent enough, the biblical texts that underwrite *Neot Kedumim* speak loud and clear: Numbers 33:52–53 tells the arriving settler, "When you cross the Jordan into Canaan, drive out all the inhabitants of the land before you. Destroy all their carved images and their cast idols, and demolish all their high places. Take possession of the land and settle in it, for I have given you the land to possess." Obadiah 19–21 is even more specific: "People from the hill country will occupy the mountains of Esau, and people from the foothills will possess the land of the Philistines. They will occupy the fields of Ephraim and Samaria, and Benjamin will possess Gilead. This company of Israelite exiles who are in Canaan will possess the land . . . And the kingdom will be the Lord's."[38]

The iconoclastic program of conquest, colonization, and expulsion of original inhabitants is quite explicit and literal. Buber lays out the justification of conquest by faith in the most unambiguous terms:

The essential point is that Israel heard the will of the Lord of the world at the beginning of its expedition to Canaan and conquered the land in the perfect and well-founded faith that it was accomplishing His will. With however little or much right in each case the nations can accuse each other of being robbers, their charge against Israel is totally unjust for it acted under authority. . . . No other people has ever heard and accepted the command from heaven as did the people of Israel. [*OZ*, p. 49]

The beautiful, cultivated promised land of milk and honey, where "the Bible speaks in the language of nature" is an imperial landscape in both its ancient and modern forms. The actual wilderness of destruction and laying waste is the passageway to this promise. This is a land that is inalienable in two senses: in that it belongs to the Israelites in an unbreakable contract with God and in its expulsion of what will now be seen as indigenous or aboriginal aliens who can be subjugated or exterminated, but above all must be driven out, as they were formerly in ancient times, and now in the "last days," their land laid waste so that the desert can bloom.

The detail that is most telling, however, is the destruction of the idols of the inhabitants. The text from Numbers suggests that these idols and graven images and "high places" are being destroyed not only because they violate the Second Commandment but also because they constitute a rival covenant, a land deal made between the Canaanites, the Philistines, and the local gods who presided over their territories. "High places" as sites of strategic surveillance, aesthetic contemplation, and prophetic vision are especially crucial in a contested landscape. The idols, one surmises, are

markers in the wilderness that indicate indigenous divisions of territory. When territory becomes the site of terror, it is not enough to drive out the inhabitants; the very landscape must be purged of their traces, their claims, their history, their idols.

Zionist iconoclasm has little to do with religious piety or moral disapproval of idolaters, then. It is strictly a strategy of conquest, the appropriation of territory under the cover of a moral crusade. The moral, as distinct from political, condemnation of idolatry is reserved for the Israelites themselves, who are in danger of being seduced by idols. The idolatrous Israelite is characterized as an adulterer and the idol as a "strange god" or rival lover who lures Israel into whoredom and abomination. The picture of idolatry as sexual transgression, promiscuity, whoredom, and abomination can then be "exported" as it were to characterize pagans and gentiles. (It is sometimes difficult to tell whether idolatry is being compared to adultery, a mere figure for the revolt against the authority of God as the sovereign husband of a sluttish Israel, or whether the prophets are really attributing immoral sexual practices to the Egyptians and the Philistines.)

A recent study of the concept of idolatry by Israeli scholars Moshe Halbertal and Avishai Margalit argues that adultery is mainly a metaphor for any kind of intercourse with foreigners insofar as it involves covenants, contracts, and political agreements. "The gods of different nations," they point out, "were the guarantors of the treaties" (*I*, p. 139). Polytheists, with their genial tolerance of local and national deities, have no problem with this sort of covenant based in oaths sworn in the name of different gods. "Monolaters" or "henotheists," peoples who worship a single national deity, can find ways to respect the fact that other peoples will also have their version of the one god. But monotheism sets a much more demanding standard; its god is not just the one, but the only. Either the monotheist can adopt a nominalist attitude, as the early Mesopotamians did, and stipulate that "the Hittite god and the Babylonian god" are really to be understood as "the same god" by "the signatories to a treaty" (*I*, p. 139). Or one can regard any such treaty as an act of adulterous treason, a whoring with strange gods, even worse, as a direct attack on the unity and purity of God himself, insofar as it confuses his identity with alien deities. A contract or covenant with an idolater is thus the worst form of idolatry because it doesn't just involve a straying off to a strange god but a defilement of the one true god. This defilement is most concretely and literally realized when the idolatrous agreement concerns land, the sacred, inalienable territory that God has given to Israel. Even to negotiate over one inch of the sacred soil is to commit the sin that God will not forgive and to invite upon oneself the direst of punishments. As Halbertal and

Margalit put it, "The ban on idolatry is an attempt to dictate exclusivity, to map the unique territory of the one God" (*I*, p. 5).

The irony here is that the extreme version of this monotheism turns out to be a form of idolatry itself, not just in its "ideological" construction of a natural landscape in which history is erased, but in the very terms set down by the Second Commandment. *Neot Kedumim* is an image and likeness of the holy land, a simulacrum, a fabricated landscape. In it, landscape is quite literally being turned into an idol, and the invisible, unrepresentable God is being made visible and material. The self-deception is perfect because there is no figural idol, no graven image or Golden Calf visible in the landscape, only some contented, grazing cows—perhaps ultimately a herd of red heifers awaiting sacrifice. "The image of the land," as Buber puts it, is "within them," not graven in stone (*OZ*, p. 23). Or the landscape is rendered abstractly, as the Israeli artist Larry Abramson describes it, providing a "camouflage net with which to conceal the reality of a landscape full of deserted ('depopulated') Palestinian villages."[39] The landscape cannot be accused of being a "likeness" of God; it is merely a substitute, a metonymic symbol, the place of God. Like an altar or temple, it is the place where he appears and speaks, not an icon of him—except in a curious logic of negative representation. The invisible, the unrepresentable, the transcendent is "represented" by shaping a space devoid of figures, history, and legibility. The idol is the empty, depopulated landscape itself, the "natural scene" in which "the Bible speaks in the language of nature," the altar on which the human sacrifice can be carried out.

The line between fanaticism and cynicism is a thin one here. Who is worse, the "true believers" who have erected the holy landscape as an idol? Or the secular, national security mavens who exploit the faith of the ultra-Orthodox and use them as a trip wire for Palestinian "provocations"? Breaking the Second Commandment, the prohibition on idolatry, is the most serious sin a believer in the Bible can commit. God spends more time explaining, emphasizing, and repeating himself with this commandment than with any other. Simple moral commandments—against killing, adultery, stealing, and lying—concerned with the relations of people to one another, are clearly negotiable.[40] All of them will be justified, even encouraged or commanded by God, sooner or later, given the right circumstances. But idolatry is the one sin God will not forgive under any circumstances. It is the absolute crime, not a sin against other people, but against God himself, and the idolater must be stoned to death for his violation of the stoney law.

Given the intransigence of these beliefs, it may seem something of a miracle that any negotiated settlement over the land of Israel could ever

take place, and it foreordains how fragile such agreements will be. I don't present these reflections with any hope, of course, of persuading Israeli settlers that their relation to the land is not only a violation of international secular law but also a violation of their most important commandment under the pretense of absolute fidelity to that commandment. I don't expect them to be moved by the revelation that they have rendered Jehovah as a Baalim, a local lord of the place. What then is the use of my wanderings into the wilderness of landscape theory?

3. The Bulldozer and the Fist

Some directions for political, artistic, and intellectual work that might follow from these reflections on the idolatrous character of landscape in Israel/Palestine may be suggested by the following image from a leaflet circulated in the city of Jaffa in recent years to protest the Israeli program of urban renewal in that ancient city (fig. 9.11). It shows an arm with a clenched fist, rooted in the soil, and the buildings of Jaffa, rising out of the earth to oppose the oncoming bulldozer, a machine that has become an icon of Israeli land appropriation and "desertification" in recent years.[41] The significant thing about this image is that the accompanying texts are inscribed in both Hebrew and Arabic and express the common resistance of the poor and working-class Jews and Arabs who have lived together in Jaffa for many years to the "urban renewal" that is displacing them from what is called their slum housing to make way for luxury condos and resort hotels. This is an all-too-rare image of Jewish-Arab solidarity in Israel, and I don't want to overestimate its significance. But sometimes a humble image can project a future far in advance of its power in the real world of its present address. This image projects not just working-class solidarity (something that one hopes would have an appeal to those segments of Zionism that still profess an allegiance to socialism or at least social justice) but also a kind of agency within the landscape itself, a resistance to destruction and modernization that is deeper than the divisions between Jews and Arabs.[42] It also projects, ideally, a future state of Israel/Palestine that would be bilingual, bicultural, and binational, a civil society that would guarantee equal rights to all citizens regardless of ethnicity, race, or religion. Admittedly, this is a highly utopian vision in the current climate of nationalist fervor on both sides of the struggle, and the dominance of an American-sponsored "peace process" that seems destined to lead only to an indefinite state of apartheid, with the West Bank and Gaza given a nominal independence that will amount in fact to the creation of Palestinian bantustans providing both cheap labor and an unending cycle of violence to their Israeli masters. The long-range future of Israel/Palestine must be

9.11 Poster of Jewish/Arab resistance to urban renewal in Jaffa.

a way out of this wilderness to a land that is not merely binational or bi-anything else but a holy landscape of reconciliation among all the contending parties.

This can only happen, of course, if a third language (at minimum) is added to the image of Hebrew and Arabic voices. That language is ours, the English and American tongue that speaks invisibly in the contours of the holy landscape, projecting fantasies of a Zion that is all too close to the national imaginary of the United States as a promised land for God's chosen people—white, Christian, and English speaking. I hope it is clear by now why the land of Israel is such a potent cultural icon in the American imagina-

tion, well beyond any realistic assessment of its strategic importance.[43] I trust that it is a bit clearer now why the ultra-Orthodox "colonizing settler" model, which is at the cutting edge of Israel's appropriation of the West Bank, is such a potent image for U.S. consumption, even among non-Jews. One could write another essay elaborating the image of the Jewish frontiersman in the landscapes of Judea and Samaria, the promised land of greater Israel. The fact that the majority of these settlers are American immigrants only serves to literalize their symbolic appeal to an American self-image mediated through Hollywood and Madison Avenue scenes of wild frontiers to be penetrated by oversized, off-road vehicles—Broncos, Cherokees, Range Rovers, Blazers, and Safaris. The fact that many of the Orthodox settlers are transplanting themselves to walled hilltop suburbs whose lawns are kept green with a disproportionate share of the West Bank water supply only heightens the irony of their fulfillment of an American dream. But the landscape of Israel/Palestine is a part of our national dream, and it is no mere image, but a nightmarish reality from which we need to awake.

It may be too easy for me to say these things, a tourist in the landscape of Israel/Palestine. So let me conclude with the difficult words of Emmanuel Levinas, whose passionate belief in the historic rightness of Israel cannot be doubted. In his essay on Yuri Gagarin and Heidegger, Levinas contrasts the first Soviet cosmonaut, the first man projected into "the absolute of homogeneous space" to Heidegger, with his mysticism of place, space, and landscape. "Judaism," says Levinas, "has always been free with regard to place."[44] "One's implementation in a landscape, one's attachment to *Place*, without which the universe would become insignificant and would scarcely exist, is the very splitting of humanity into natives and strangers" (*DF*, p. 232). For Levinas, the idolatry of place and landscape must give way to the Face of the Other. Judaism cannot achieve its destiny as a universal humanism dedicated to social justice unless it is willing to sacrifice its attachment to the idols of landscape and place. It is on this point that Levinas sees Judaism's greatest distance from Christianity, with its local cults, saints, and household gods. "Judaism is perhaps no more than the negation of all that." All that "eternal seductiveness of paganism, beyond the infantilism of idolatry, which long ago was surpassed. *The Sacred filtering into the world*—Judaism is perhaps no more than the negation of all that. To destroy the sacred groves—we understand now the purity of this apparent vandalism. The mystery of things is the source of all cruelty towards men" (*DF*, p. 232). Does this put Levinas on the side of the bulldozer? Or the enrooted tree with the human fist? Levinas's preference for Gagarin, the modern, technological man, over the earth-mysticism of Heidegger, would seem to make this choice inevitably go to the bulldozer. But the landscapes Levinas wanted to destroy were imaginary, not real. They were the holy landscapes, the lands of milk and honey, the fantasies

of the destiny of Judaism as the possession of a physical place, rather than as an ideal of universal human value. This fantasy has now been realized in an idolatry of place, a territorial mysticism enforced by bullets and bulldozers. The challenge is to sound out this idolatry, to unbind its fascination. Perhaps now that the Palestinians have deleted from their charter the call for the destruction of Israel, the Israelis can find a way to repeal the second commandment.

Notes

I wish to acknowledge the help of Arnold Davidson, Bill Brown, Homi Bhabha, Lauren Berlant, Sander Gilman, Larry Abramson, Daniel Monk, Gannit Ankori, Rashid Khalidi, Joel Snyder, and Jonathan Bordo with various aspects of this essay.

1. Quoted in Ernst Gombrich, "The Renaissance Theory of Art and the Rise of Landscape," *Norm and Form: Studies in the Art of the Renaissance* (Chicago, 1966), p. 107.

2. Emmanuel Levinas, in Levinas and Alain Finkielkraut, "Ethics and Politics," interview with Shlomo Malka, trans. Jonathan Romney, *The Levinas Reader*, ed. Seán Hand (Oxford, 1989), p. 297.

3. Martin Buber, *On Zion: The History of an Idea*, trans. Stanley Godman (1952; Syracuse, N.Y., 1997), p. 53; hereafter abbreviated *OZ*.

4. On the relation of ideology to idolatry, see W. J. T. Mitchell, "The Rhetoric of Iconoclasm: Marxism, Ideology, and Fetishism," *Iconology: Image, Text, Ideology* (Chicago, 1986), pp. 164–68.

5. See J. M. Wagstaff's classic study, *The Evolution of Middle Eastern Landscapes: An Outline to* A.D. 1840 (Totowa, N.J., 1985).

6. Simon Schama, *Landscape and Memory* (New York, 1995), p. 14; hereafter abbreviated *LM*.

7. Theodor Adorno, *Aesthetic Theory*, trans. C. Lenhardt (London, 1984), p. 105.

8. See the foreword to Friedrich Nietzsche, *"Twilight of the Idols"* (1889), *"Twilight of the Idols" and "The Anti-Christ,"* trans. R. J. Hollingdale (Harmondsworth, 1968), p. 22: "as regards the sounding-out of idols, this time they are not idols of the age but *eternal* idols which are here touched with the hammer as with a tuning fork."

9. See Dean MacCannell, *The Tourist: A New Theory of the Leisure Class* (New York, 1976). For an excellent critique of "tourist theory" since McCannell, see Meaghan Morris, "At Henry Parkes Motel," in *Too Soon Too Late: History in Popular Culture* (Bloomington, Ind., 1998), pp. 31–63.

10. See Mitchell, "Imperial Landscape," in *Landscape and Power*, ed. Mitchell (Chicago, 1994), pp. 5–34 and "Gombrich and the Rise of Landscape," in *The Consumption of Culture, 1600–1800: Image, Object, Text*, ed. Ann Bermingham and John Brewer (New York, 1995), pp. 103–18.

11. Michel de Certeau, *The Practice of Everyday Life*, trans. Steven F. Rendall (Berkeley, 1984), p. 117.

12. *Oxford English Dictionary*, 2d ed., s.v. "pagan": "Tertullian, *De corona militis* xi, 'Apud hunc [Christum] tam miles est paganus fidelis quam paganus est miles infidelis.'"

13. The conference, "Landscape Perspectives on Palestine," was held at Bir Zeit University, 11–14 November 1998.

14. See Keith W. Whitelam, *The Invention of Ancient Israel: The Silencing of Palestinian History* (New York, 1996) for a discussion of the ideological selection process that resurrects some ghosts and leaves others wandering in the wilderness.

15. See Sacvan Bercovitch, "The Biblical Basis of the American Myth," in *The Bible and American Arts and Letters*, ed. Giles Gunn (Philadelphia, 1983), pp. 219–29.

16. See Martyn J. Bowden, "The Great American Desert in the American Mind: The Historiography of a Geographical Notion," in *Geographies of the Mind: Essays in Historical Geosophy*, ed. David Lowenthal and Bowden (New York, 1976), pp. 119–48. Compare *OZ*, p. 88, for a discussion of the "purifactory influence of the Exile."

17. George Catlin, *North American Indians*, ed. Peter Matthiessen (1841; New York, 1989), p. 464.

18. See Mark Twain, *The Innocents Abroad, or The New Pilgrim's Progress: Being Some Account of the Steamship "Quaker City"'s Pleasure Excursion to Europe and the Holy Land*, 2 vols. in 1 (New York, 1911). Herman Melville's epic poem, *Clarel* (1876), narrating his "Pilgrimage in the Holy Land," links the "Arabian waste" with the sublime seascapes of American seafaring: "Sands immense / Impart the oceanic sense" and the "Pillars of sand which whirl about / . . . True kin be to the water-spout." Melville also quotes from Darwin, who "quotes / From Shelley, that forever floats / Over all desert places known, / Mysterious doubt—an awful one" (Herman Melville, *Clarel: A Poem and Pilgrimage in the Holy Land*, ed. Walter E. Bezanson [New York, 1960], 2:xi:39–43, 2:xi:13–15, pp. 178, 177).

19. Sander Gilman, "Mark Twain and Hysteria in the Holy Land," *Picturing Health and Illness: Images of Identity and Difference* [Baltimore, 1995], p. 104:

Twain's mid-nineteenth-century Palestinian Arabs . . . were not biblical Jews. He stresses the fact that he is speaking in the present about the Arabs of the Holy Land. . . . Nevertheless Twain sees 'this poor, ragged handful of sores and sin' now inhabiting the Holy Land as identical in all respects with the Jews who dwelt there at the time of Jesus. Their physiognomy is unchanged and this is also reflected in the unchanged nature of their diseased bodies.

20. Catlin, *North American Indians*, p. 61.

21. David Bunn informs me that

Afrikaner nationalism depended very heavily on a founding myth of Promised Land ("Geliefde Land"). Throughout the country, there is evidence of

the influence of this tropology. In the Transvaal, for instance, the town of Nylstroom (literally "the Nile River") is evidence of how early nineteenth-century Calvinist trekkers thought that the vast wetland system they discovered might be in Egypt. Elsewhere, there is evidence of wave after wave of peasant trekkers seeking Paradise. One of the most famous was a group that ended up dying in the Namibian desert (the "dorsland trekkers" or thirstland trekkers) while another called itself the Jerusalemgangers"—those on their way to Jerusalem (David Bunn, correspondence with author, 19 Aug. 1999).

22. William Wordsworth, *The Prelude*, in *Selected Poems and Prefaces*, ed. Jack Stillinger (Boston, 1965), bk. 12, 1. 115, p. 342; hereafter abbreviated *P*.

23. See Said, "Invention, Memory, and Place," chapter 8 in this volume.

24. Lawrence Wright, "Letter from Jerusalem," *The New Yorker*, 20 July 1998, pp. 48, 43.

25. One can hope, however, that the defeat of Netanyu and Likud in the spring of 1999 will bring a halt both to the development of new settlements and the expansion of existing ones.

26. The *Oxford English Dictionary*, 2d ed., glosses *territory:* "1. Also 5 teri-, tery-. ad. L. *territo+ri-um* the land round a town, a domain, district, territory. Etymology unsettled: usually taken as a deriv. of *terra* earth, land (to which it was certainly referred in popular L. when altered to *terra+to+rium*); but the original form has suggested derivation from *terre+re* to frighten, whence *territor frightener, territo+rium* '? a place from which people are warned off' (Roby *Lat.* Gr. ?943). So Fr. *territoire* (1278 in Godef. *Compl.*): see also terroir."

27. Melville, *Clarel*, 2:10:2–10, p. 170.

28. Excerpted in *The Rise of Modern Mythology, 1680–1860,* ed. Burton Feldman and Robert D. Richardson (Bloomington, Ind., 1972), pp. 153–54.

29. See Joel Snyder's superb discussion of the theological assumptions behind the O'Sullivan photographs in "Territorial Photography," in *Landscape and Power*, pp. 175–201.

30. See Bordo on the figure of the witness in the wilderness landscape in this book. John Dixon Hunt, *The Figure in the Landscape: Poetry, Painting, and Gardening during the Eighteenth Century* (Baltimore, 1976), also discusses the emergence of the hermit and figure of solitude in eighteenth-century landscape aesthetics.

31. Ernst Renan, *General History and Comparative System of the Semitic Languages* (Paris, 1858), p. 7.

32. Excerpted in *The Rise of Modern Mythology, 1680–1860,* p. 56; compare the discussion of the forest in *LM*. For a good discussion of Vico and the history of habitats, see Robert Pogue Harrison, *Forests: The Shadow of Civilization* (Chicago, 1992).

33. Moshe Halbertal and Avishai Margalit, *Idolatry*, trans. Naomi Goldblum (Cambridge, Mass., 1992), p. 5; hereafter abbreviated *I*.

34. See Northrop Frye, *Fearful Symmetry: A Study of William Blake* (Princeton, N.J., 1947) for a magisterial account of Blake's symbolic landscapes.

35. Vincenzo Vitello, "Desert, Ethos, Abandonment: Towards a Topology of the Religious," in *Religion,* ed. Jacques Derrida and Gianni Vattimo (Stanford, 1996), p. 139. On "desertification" and the topos of the wasteland, see Harrison, *Forests.*

36. Vitello, quoting Nietzsche, "Desert, Ethos, Abandonment," p. 136. See the discussion of Nietzsche's notion of devastation in Martin Heidegger, *What Is Called Thinking?* trans. Fred D. Wieck and J. Glenn Gray (New York, 1968), pp. 29–30.

37. W. Robertson Smith, *The Religion of the Semites: The Fundamental Institutions* (1889; New York, 1972), p. 93.

38. See http://www.virtual.co.il/travel/neot/. The anonymously authored text "What Is Zionism and Should We Support It?" as well as the biblical quotations no longer appear as a part of Neot Kedumim's website.

39. Larry Abramson, correspondence with the author. See also Abramson, "Zionist Abstraction: The Art of Camouflage" (Hebrew), *Studyo,* no. 94 (June-July 1998); forthcoming in *The Jerusalem Review* in English.

40. As Walter Benjamin notes, the commandment against killing "exists not as a criterion of judgment, but as a guideline" (Walter Benjamin, "Critique of Violence," *Reflections: Essays, Aphorisms, Autobiographical Writings,* trans. Edmund Jephcott, ed. Peter Demetz [New York, 1978], p. 298).

41. Mark Levine of *Tikkun* magazine presented this remarkable image at the Birzeit conference. I am grateful for his illuminating discussion in much of what follows.

42. The "modernization" of Israel routinely appeals to a rhetoric of purification and public health. See Gilman, "Mark Twain and Hysteria in the Holy Land," pp. 93–114. See also Buber's account (*OZ,* pp. 150–51) of the logic of return as based in a mutual healing process, the "sick land" of Palestine to be cured by returning settlers (also sick) who will be cured by their reunion with the land.

43. This is not to deny the role of geopolitical strategy in the notion of Israel as a "buffer state" for the West in the heart of the Arab world. Since Napoleon's call to "Israelites" to return to Palestine in 1799, European powers have repeatedly taken a pragmatic interest in Zionism. See Howard M. Sachar, *A History of Israel from the Rise of Zionism to Our Time* (New York, 1976), p. 22.

44. Levinas, *Difficult Freedom: Essays on Judaism,* trans. Hand (Baltimore, 1990), p. 233; hereafter abbreviated *DF.*

T E N

JONATHAN BORDO

Picture and Witness at the Site of the Wilderness

> We will not attempt to decide the question whether the races, which we at present term savage, are all in a condition of original wildness, or whether, as the structure of their languages often allows of out conjecturing, many among them may not be tribes that have degenerated into a wild state, remaining the scattered fragments saved from the wreck of a civilization that was early lost. A more intimate acquaintance with these so-callled children of nature reveals no traces of that superiority of knowledge regarding terrestrial forces which a love of the marvellous has led men to ascribe to these nations. A vague and terror stricken feeling of the unity of natural forces is no doubt awakened in the breast of the savage, but such a feeling has nothing in common with the attempt to prove, by the power of thought, the connection that exists among all phenomena.
> —Alexander von Humboldt, *Cosmos*

> Giving grounds, however, justifying the evidence, comes to an end;—but the end is not certain propositions striking us immediately as true, i.e., it is not a kind of *seeing* [*eine Art* Sehen *unserseits*]; it is our *acting* [*unser* Handeln], which lies at the bottom of the language-game.
> —Ludwig Wittgenstein, *On Certainty*

I

Wilderness is a hallowed ground; it is at the origin speech, as in the phrase "the voice in the wilderness." It is the void and a voiding *(tohu-bohu);*

291

clearing, the clearing; a wasteland, a nest of wild beasts, the raging sea, the Teutonic night, the forest; "quelques arpents de neige vers le Canada";[1] *terre des sauvages* (from the seventeenth century), *Terre sauvage* (a painting by twentieth-century Canadian painter A. Y. Jackson); bereft of culture, the savage; the sacred precinct of summer camp. What condition is being addressed through the figural inscription of the subject in Wilderness? This is not only a question of the word *wilderness* behaving like a name tag attached to some one or group or tribe's intimate and parochial relationship to the real, to real estate. When it comes to wilderness, European tribal nations have come to be rather possessive of wilderness as its symbolics, a paradigmatic site for the symbolic staging of Benedict Anderson's imagined community of the nation-state: wilderness as the *utopos* of territory, the Republic in the Wilderness, the Great Trek into the Wilderness. Modern European linguistic dispensations of the word emphasize the root (Indo-Germanic *wilde*), but what about the suffix, the *-ness* that qualifies the wild, so to speak? (fig. 10.1).

To add a *-ness* to an adjective or past participle, such as *empty, sad, dark,* or *wild,* transforms qualities and properties into states or conditions: emptiness, darkness, sadness, wilderness, through which transformation *wild-* becomes almost magically a substantive and a subject—and darkness fell over the land, the trackless wilderness. The dictionary also notes one exceptional usage, having bearing on this inquiry, namely, *witness* betokening a condition of knowing, when nominalized, betokens the agent of the condition of bearing witness.[2] *Ness* transforms the wild from errant, arid, a void, to transgressive, exultant, a condition of pure presence or absence. Wilderness as a linguistic locator manifests or instantiates the condition of wilderness. *Ness* comes to hold the wild as in a nest or niche, as if the wild were contained or the core of something. At its core is the wild, the formless: *where the wild things are.* Is this the distinction that deep ecology seeks to draw between *wilderness* and *wildness* when it summons Thoreau's epigram that "in Wildness is the preservation of the world?"[3] Is it a transport from the ineffable envelope to its ineffable content? Thus we are right to insist on distinguishing between wilderness, a wilderness, and *the* wilderness.

The wilderness as the substance of that condition holds within itself the wild. It is not to chide Wittgenstein to say that grammar, not philosophy, has gone metaphysical on us when it comes to the ordinary word *wilderness* and its dispositions of use. *The* wilderness marks its (auto)promotion as a linguistic sign, a sign for dislocation and gaps, as a claim to an exception to culture within culture, pure willfulness (from Germanic *wil*), beyond the law. It offers signification by emptying and dissolving significance. It halos a very human enunciation by declaring human erasure. The wilder-

10.1 Maquette of gallery viewer, National Gallery of Canada, Ottawa. Courtesy Moshe Safdie Architectural Office.

ness posits itself as a sign to threaten the extinction of the very human sign. *The* wilderness is the name that I will retain from ordinary language for the linguistic sign, site and object, of my theorizing. Consider *the* wilderness as a proper name.

Despite the extraordinary, almost ubiquitous range of the word *wilderness*, four prognostically reoccurring clusterings of signification feed this problematization: (1) The wilderness as a tropic or symbolic orientation, tending northerly and westerly wherever it lands geographically; (2) the wilderness as a proper name used instead of inherited place names in colonial situations to justify the violent capture and dispossession of territory; (3) the wilderness as a transgressive way of acting that fabulates the "savage" way of life; (4) the wilderness as a temporality and an alleged past coincident with the emergence of the modern European idea of antiquity. These four clusterings taken together reveal the symbolics of the wilderness as a highly productive site for the very invention of modernity itself. This essay is concerned with the second theme, in conjunction with the necessary positing of a specular witness, constitutive of a kind of modern picturing. The specular witness performs a rather special and dual role. It exalts a picture that testifies to an unpicturable condition—the wilderness sublime—while simultaneously legitimating, as a landscape picture, terrain violently seized, dispossessed of its indigenous inhabitants, and reconstituted as territory.

Paintings, not written texts or physical expanses, have been my reflective starting point, paintings alleged to be of *the* wilderness with wilderness as their alleged referent. Why alleged? Because few of these pictures ever name themselves *the* wilderness but all of them are considered to be about *the* wilderness. These pictures might be taken as a paradigmatic ekphrastic assemblage at least in W. J. T. Mitchell's image-text analysis, with one qualification.[4] Because the word *wilderness* and its cognates are remotely, not contiguously, determinant, these pictures visualize a textual condition from Scripture when Scripture is seldom cited. The verbal referent is seldom empirically accessed when most ekphrastic analysis posits an assemblage, on, beside, or just below the inscriptional surface. Words and images might visibly cohabit a prolongated surface or be in a palimpsestic relation of alternation. In all these cases the composite object is empirically available. Classical landscape, for example, names its topos—Arcadia, the desert, and so on. However, the verbal referent of the paintings that I will shortly introduce appears remote and inaccessible. The landscape art that gave rise to this reflection on picturing has a place within the European tradition of northern symbolic art, closer in its nationalist yearning to the localist imprint of Worpswede than to the universalist aspirations of Ameri-

can landscape art of the nineteenth century, directed as it was, to justifying its project against a European standard.[5]

Indeed it was in the study of these somewhat austere and even parochial early twentieth-century Canadian landscape paintings that I first came to be troubled by their curious and oblique specularity, arising from the very idea of wilderness as positing and effacing a witness to an unwitnessable condition. Addressing this specularity in turn led to a more wide-ranging reflection on the apparatus of modern picturing and the subject that seems necessarily posited in the role of specular witness. This concern is an entrance for problematizing the relation between theory and picturing. "Pictures Theorize and Theory Pictures" is a slogan for saying that reflexivity is not the exclusive monopoly of language but spreads into pictures.[6] To the question, "What are the pictures that comprise the core of my examples doing?" the response is, they are witnessing, and the witness function underwrites their meaning. I am concerned with witnessing as a general and determinant *doing* of modern pictures, how it works and the cultural implications of pictures to perform such a role. What I have called the witness function is a strategic site for revealing this reflexivity. The picture's putative role to do this, to witness, is indicated, if not established, in part by the very apparatus of picturing itself—framing in an extended sense.[7] Thus this essay seeks to return a more general account of the witnessing operation of the picture to the problematics of wilderness.[8] *The* wilderness is a particularly fruitful site to reveal the tangle of modern picturing and the specular witness.

II

The reader might recall a short story by the Canadian author Margaret Atwood called "Death by Landscape," at the outset of which the narrator tells us about some early- to mid-twentieth-century Canadian landscape paintings by the Group of Seven, which hang on the wall of her protagonist's apartment in Toronto looking out on Lake Ontario.[9]

The pictures are signs of the wilderness; they represent solitary foregrounded trees and variously arranged northern landscapes, whose icon I have elaborated elsewhere as the figure of a solitary northern tree.[10] Pictures are the access and visual signs for the condition of the wilderness. As signs they evidence or testify to the condition of *the* wilderness, an ineffable condition (fig. 10.2).

The wilderness as enunciated from Tom Thomson's *The Jack Pine* is a condition that in principle denies access to the presence of a Subject. It both denies the speculation while inviting testimony to this situation or

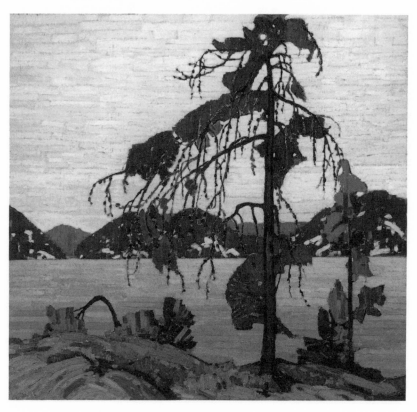

10.2 Tom Thomson, *The Jack Pine*, 1916–17. Acc. # 1519. By permission of the
National Gallery of Canada, Ottawa.

condition. The paradox of this situation describes the shifting of the bur-
den of picturing as a consequence away from the transitive of the picture
as proximal rendering over onto the intransitive of the picture as visual
sign; and yet the linguistic aspect of the visual sign, or the linguistic sign
preceding it, has to be called, as it were, from out of the wilderness of the
picture. Being in principle unrepresentable, the wilderness leaves a picture
as a testamental deposit for that which the picture was unable to picture.
These pictures of landscapes deny human presence by depicting landscapes
without figural witnesses. The very inscription of the subject as figural wit-
ness is an obstacle to the fulfilling of an apocalyptic intention, the utter
dissolution of human presence, which the witnessing itself arrests by its
being visually posited. The witness is a temporary stopping point in the
sign's apocalyptic journey to dissolution, a journey that will later find itself

interrupted by the intrusion of nonfigural visual inscriptions themselves, marks or signs testifying to that condition. So at least for Thomson and the Group of Seven, *the* wilderness as picturing seems marked by a sustained effort to fulfill pictorially a metaphysical intention to deny systematically human presence, the pictorial analogue to the fifth day of creation.

The paradox of the landscape without a figural witness comes to assume a particular visual significance when one recalls that the Western European landscape, at least as early as the fifteenth century, is enunciated as a witnessed landscape, a landscape marked by deliberate signs of human presence: if not human beings figuratively present, then evidences of living human presence (shelters, dwellings, paths, roads, signs marking enclosures such as walls and fences, smoke rising from a fire), if not material evidences of living human presence, then traces on the land of former human occupancies (cairns, tumuli, ruins, graves, architecture).

Indeed the witness figure as it appears in nineteenth- century Australian, American, and British North American landscape art in the "new world" transported these symbolic apparatuses of landscape along with other symbolic devices of capturing and laying claim (fig. 10.3). Such figures perform the role of witnesses, and I will refer to them as witness figures. Like the figure of the apostle, pointing to Christ on the Cross, there is an apostolic aspect to this testifying, but in this case the figure testifies to the condition of *the* wilderness, itself already prepared by Scripture.[11] The figure is a witness in the wilderness to the condition of *the* wilderness. The testimony is the rupturing event, inaugurating human presence itself. It is the moment when the clock started ticking: from this moment, history. While landscape is the stage for European memory, the wilderness is that state or condition that obliterates history by initiating history from that very moment enshrined as visual testament. *Before* is both the posit before memory as it points backward as memory. Thus *before* the European (human) advent is marked by the very present of sight, of testimony as that sighting, contaminated by that seeing. Because the wilderness alleges the zero degree of history, the indigens who are imputed to dwell in the wilderness are considered to be in a wild or savage state, even deemed to be fauna and flora, and/or deemed thus to be not there at all.

Even when American transcendentalist discourse raised ontological questions concerning human presence itself, the thought of no human place is seldom fulfilled by a visual step to void completely the figural inscription of the subject from the visual surface. Rather the ontological question of human presence itself becomes the assertion that it is *the* wilderness as a kind of human occupancy that marks America's cultural superiority over Europe.[12] But this assertion of human presence anticipates a threshold still to be crossed from wilderness as witnessed to wilderness as

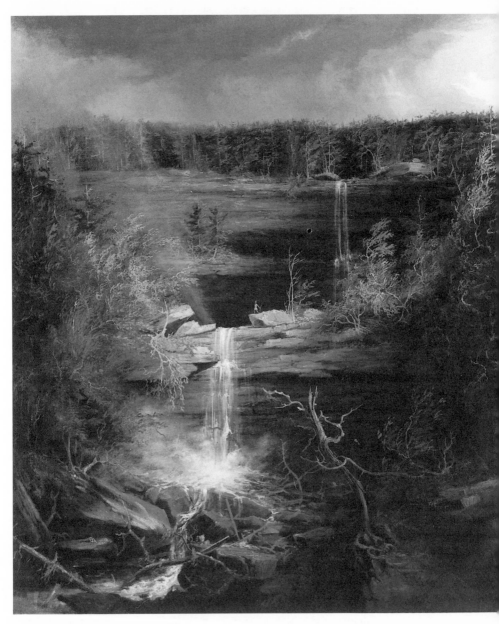

10.3 Thomas Cole, *The Falls of Kaaterskill*, 1826.

unwitnessed landscape art.[13] The crossing of the threshold from witnessed to unwitnessed is marked by the erasure of the figural traces of human presence from the contents of the representation and the substitution of that witness figure, for example, by the nonhuman figure of a solitary tree. The solitary tree is a stand-in for the specular witness.

III

I have designated these subjects, usually although not always human figures, as witnesses, assigning to them the role of signifying tokens in a chain of visual proofs or testimonies to a condition that is almost always unnamed and in principle unpicturable. I want to problematize the discourse of the subject more generally in terms of what I call the witness function and the way that the *dédoublement* of classical representation has the witness function as its necessary appurtenance.[14]

A picture is an ordered sedimentation of witnessings—of the *ergon*, in the *ergon*, around the *ergon*. In this regard the pictures of the wilderness are a region where testamentality takes on a special character. What, however, does it mean to witness? What is witnessed? The grammar of witnessing, as I have suggested, is scriptural and, most relevantly, with respect to visual art is part of the Gutenberg episode, "the era of the Book" in Jacques Derrida's encapsulation of early modernity.[15]

With modernity, the witness function becomes inseparable from the reflexivities of the subject, and the subject as witness comes to organize the space, frame, and contents of visual art in the very way that the word came to organize sight. The very well travelled example of Jan van Eyck's commemorative portrait of the Arnolfini bridal pair of 1434 is illustrative of this pictural testamentality with its saturation of authorizing inscriptions. The picture posits two specular witnesses, reflected in the mirror, as bearing witness to the marriage, making the picture an agent in the event of the marriage. Panofsky says of the picture that it is "both a double portrait and a marriage certificate."[16] A double portrait, it portrays two figures in the mirror, one alleged to be the artist van Eyck himself; it is alleged to be van Eyck because of the authority of the signature and date above the mirror, which declares "Johannes de Eyck fuit hic," with the not particularly exact date 1434. Thus the picture is both a portrait and a self-portrait. The painting, for Panofsky, doubles as "a marriage certificate" because the two figures in the mirror are the witnesses to the marriage; the picture, thus, is a proof of the marriage. In this role, the signature is the authorization of the witnessing, represented in the picture by the witness figures in the mirror. Panofsky emphasizes the juridico-legal status of the signature with these words: "the artist has set down his signature—

lettered in the flourished script normally used for legal documents—as a witness rather than as a painter."[17] For Panofsky, there is a picture *and* a witness in a somewhat loose conjunctive relationship. The picture is the record itself of the witnessing to the marriage by the witness Jan van Eyck who commemorates his witnessing with a double portrait of the bridal pair, Giovanni(?) Arnolfini and Giovanna Cenami(?).

More precisely, I want to say that the picture, not van Eyck the artist, is the witness. Even if such picturing could successfully authorize the facticity of the event, this would neither make the portrait a marriage certificate, as Panofsky claims, nor would it establish van Eyck to be a witness at the event of the marriage. However, the grammar of the picturing apparatus claims that it, the portrait, not van Eyck, the artist *or* the man, is the visual witness to the event. It, the portrait, is the putative visual witness, certifying the painting to be the visual witness by "notarizing" the painted mirror with the signature and the date.[18] The picture casts a double illusion that van Eyck is the witness for the event and that the picture is its certificate. These are significant pictorial allegations.[19] Panofsky is surely right to characterize the picture as casting a sacramental-legal aura, which his somewhat overelaborate iconographic analysis makes evident. But to cast that aura confers neither sacramentality nor legality on the painting. It does show the picture's self-ascribed assignation as performing (rhetorically speaking) a witnessing role to an event and thereby contributing to the marriage event's legitimation. The figures in the mirror testify, not to the event, but to the picture as a visual witness, just as the absent specular subject who is outside the picture, the alleged van Eyck, is a witness, not to the marriage but to the picture. Van Eyck is the first witness to his picture, inaugurating an iterative chain of witnessings from the event of the picture onward.[20] What seems to look out so transparently, looks at. A representation collapses into a sign.

The picture assumes its testamental force partially because it visually reproduces the iconography (however inexactly, casually, and profanely!) of the Book, most significantly the witness figures themselves testifying to the sacredness of the event. The testamental scenography invites the viewer to the party as vicarious specular witnesses. The picture assigns to itself the role of authorizing the event precisely by penetrating the event in order to give itself this role. Thus the figures in the mirror are to be taken as witness figures in view of the (extra)legal and commemorative role that the picture has assigned to itself. The autodeictic operations of witnessing around the internal mirror, the internal frame, flag the role that the picture assigns for itself as legitimating an event. The picture is an avowal—declaring that something took place to which it was the witness. For all these

claims to authorizing an event by visually capturing the real, are we any closer either to the empirical reality of the event or to its sacramental-legal status than before the picture's intervention?

Émile Benveniste presents two different words to distinguish the testimony of a witness *(testis)* from the testimony of the arbiter *(arbiter)*, the magistrate, the notary. His work confirms that the picture is invested to perform these two rather different and indeed binary witnessings. A witness *(testis)* has to be present to bear witness while an arbiter *(arbiter)* does not have to be present. The painting posits both present and absent witnesses, both *testis* and *arbiter*. On the one hand the picture carries a delegate or proxy witness to the event (the witness figure in the mirror). On the other hand the picture as witness substitutes itself for the witness. It is the picture that notarizes the event, is its arbiter, so to speak. It "arbitrates" because it sees without having to be present. The picture, performing both tasks, falls in between. It makes a claim to be both an absent and a present witness. Thus the van Eyck painting is a double witnessing.[21] We can invest in both witness functions but not simultaneously. What appears to be simple, straightforward, and unambiguous has become ambivalent and multistable. It is akin to Wittgenstein's duck-rabbit figure in the *Philosophical Investigations* because the picture casts both witness functions alternately but not simultaneously.

Leaving to one side the philosophical question as to what it means to impute to pictures the agency of witnessing, the Arnolfini double portrait as a model of modern picturing bathes its mimetic practice in an instrumental aura. Look at all the socially useful work it is performing—witnessing, notarizing, recording, officiating—the painter as magistrate, notary and priest all in one (a package deal)! This instrumental framing, gives to this picturing its legal and epistemological faces. The notary's practice of signature, date, and seal and the visual demonstration of verisimilitude in the mirror are two related instrumental postures. In this regard the notarization by signature and date around the mirror authorizes the verisimilitude of the picture as a "mirror to nature," recalling Richard Rorty.[22] The legal and epistemological charades leave the aesthetic as a remainder once they are cancelled. What we call the aesthetic is thus an excess that resides in and is concealed by the instrumental burden that the picture assigns to itself. The officially commissioned portrait that claims to sanction a marriage simultaneously casts an illusion that undermines that very instrumental framing. The aesthetic, so called, thus exceeds the frame that the picture has constituted instrumentally for itself.[23] That the painting has come, if not to justify itself, then at least to demonstrate its capacities, whether societally qualified or not to perform such tasks, suggests just how perva-

sive the language game of testimony is and just how much the specular witness is a dominant complication, and not an iconographic contingency, at the core of modern picturing.

IV

Analogous to the way that the Book prepares the Arnolfini portrait to arrogate to itself the testament to a marriage, the Book also prepares *the* wilderness for its being rendered as visual art. The very distinction between witnessing as absent and present, between presence and absence as marking and speculating, turns out to be decisive because there is a precariousness to the participation of witness figures pictorially, which the logic of wilderness, especially in "new world" spaces of colonization, accentuates to the point of aporia and paradox. Indeed the distinction completely reverses the relation between the aesthetic and the instrumental of the early modern picture because the aesthetic, not the instrumental, turns out to be the "public face" of the picturing practice. The modern discourse of the wilderness is compelled to display an unwitnessable condition. I will suggest that there is a change in the witness function of the picture when wilderness travels from Europe to the "new world" by discussing a few European topoi of wilderness: (1) Arcadia; (2) the "new world" itself; and (3) solitude.

Arcadia

The difference in the testamental orientation of the discourse of the wilderness between early modern European and nineteenth-century American and British colonial begins to be apparent when one recalls for example Poussin's *Et in Arcadia Ego*. The shepherds of Arcadia, ignorant of human ways, come upon a grave mound and puzzle about it. Human death, memory, and suffering are just below the surface of the idyll. Even a thought experiment cannot keep them out. The tomb's surface allows for graphic inscription. The shepherds are faced by indiscernible glyphs. They interrupt Arcadia. Writing penetrates the precinct of Arcadia, bringing history or, as was said about primitives without history, prehistory to Arcadia. The *seme* of the tomb blocks a regress to the other wild condition of Arcadia that the pastoral posits in Panofsky's reading of it.[24] Before Arcadia there was writing—the dark age of Arcadia. The "before" of the tomb *seme* makes history spatial. "Et in Arcadia" does not threaten the extinction of the subject. It foretells the death of the eternal present of a culture of speech. Neither Arcadia nor the prior condition, which the inscription on the tomb declares, is wilderness. The European utopics of landscape never seek to surrender the inescapable, unerasable traces of human continuance.

Landscape stages history. This is as true for Arcadia as it is for the desert of Poussin's *Gathering of the Manna*. The tomb *seme* of *Et in Arcadia Ego* is an outcropping of antiquity in the tropological space European modernity has opened for antiquity in depicting classical fables. The newly opened site for antiquity is situated just below the symbolic outcropping of Arcadia. By making time spatial, European landscape begins to posit antiquity as a deep history of itself, visually positing two layers.[25]

The Fable of the New World

There are more than a few officially commissioned portraits of René Descartes, the most famous being the one by Frans Hals. There is a portrait of Descartes by Weenix, dating to the epoch of the 1630s and belonging to Descartes's thwarted ambition to publish his complete scientific works in the repressive wake of the second trial of Galileo in June 1632 (fig. 10.4).[26] The trial prompted Descartes to withdraw its publication and disavow its contents. That this portrait belongs to that epoch is revealed by its very contents. The picture, purportedly of Descartes, is of a figure, holding up a book and pointing to the following sentence: "Mundus est fabula." This phrase is surely not the title of the open book that the figure is holding, but perhaps the phrase points to the title. Or is the book intended to be a trope for the world, as in these phrases, rather popular at that time, "the book of the world" and "the book of nature is written in mathematics"? What fable is this? Why is the world a fable? What world is a fable?

Indeed "the book of the world" comes up in the first *Discourse on Method*, coupled with the assertion that at least one of the worlds, frequented by Descartes is a fable; it appears in the initial chapters of Descartes's treatise on physics entitled *Le Monde*. "Mundus est fabula" is thoroughly discussed in at least two places. In a key text from the sixth chapter of *Le Monde*, Descartes writes that in order to spare the reader an account of the difference between the objects and processes of his physics and the commonsense view of the order of things, he will have recourse "to the invention of a fable" as a way of exposing his physics without giving offence. To understand his physics, Descartes requires the reader to shift conceptually "from this world in order to arrive at a completely new one fashioned in the imaginary spaces."[27] Elsewhere Descartes uses the word *feindre*—feigning, faking, pretending—for this abstraction: "feigning this new world." If the "new world of physics" is to be feigned, then, of course, it is a fiction, a fable—feign, faint, *virtus* not *actus*. Positing, supposing, hypothesizing, and conducting a thought experiment might all be taken as feigning. Indeed the term for all these negational conceptual operations is *theorizing*. That is why I didn't refer to Descartes's physics as physical

10.4 Weenix, *René Descartes,* 1630s?. Central Museum, Utrecht. Collection
Viollet.

theory; the space for modern theory was in the process of being enunciated
before it came to have the name theory, *avant la lettre,* so to speak. The
feigning arrives at the destination of an imaginary topos, the *nouvel monde*
of science, not, Descartes tells us, to be confused with the true world, *le
vrai monde,* created by God according to Scripture 6,000 years ago. This
nouvel monde is a fiction, devoid of reality. Suffice it to say that this "new
world" is rather empty—consisting of rather simple atomlike entities called
corpuscles, the results of their causal interactions, and the voids in be-

tween—compared to the true world, which is dense, teeming with life. This declaration of theory's alternate reality has important precedents, going back to Copernicus and Osiander's preface to *De revolutionibus*, where the word *hypothesis* is exactly analogous to Descartes's "fabula"; both characterize the nature of this new theory.[28] It arises in the space between existing cultural norms and an emerging epistemological practice. This kind of speculating marks its own activity as fiction generating. The declaring of the fiction of theory indicates a strategic site where an emerging science seeks to accommodate itself within the existing cultural formation, to effect what Fernand Hallyn has called a "cultural insertion."[29]

What does it mean to affirm something by disavowing its purchase on reality? *Le Monde* is not the only place in this compendium of writing where Descartes declares his thought to be a fable or a picture. It occurs significantly in the very preface to *The Discourse on Method*. The very first discourse contains a fictionalizing disavowal that is directed, not at the object of his speculation, but at the very narrative he is conducting, which is the story of his journey into science. He calls that account "a picture" ("d'y représenter ma vie comme en un tableau"). His physics is a fiction, and so is the account of its intellectual genesis. "Histoire," "tableau," and "fable" come to be used interchangeably: "But I offer this writing as a history, or if you prefer, a fable, in which a few exemplars might be found to be imitated, among many others that one wouldn't find reason to follow."[30]

Indeed we can say that the *discourse* is the word-concept Descartes deploys as the title of the preface to his compendium of science because it sets the stage for the report on his scientific results. One of the very first speech conditions for talking about science is that it be talked about as a negation. Thus Weenix's portrait of Descartes, a portrait that is literally a tableau or a picture, confirms in its literal pictureness the negation that Descartes enunciates in his discourse. The portrait is the discourse of the *Discourse on Method in figuris*. It says what it shows and shows what it says. It announces, "I, René Descartes, declare my physics a fable." The portrait is a visual speech act. While the van Eyck Arnolfini is a visual avowal to the reality of a marriage, the Weenix portrait of Descartes is a visual disavowal of the reality of physics.

The portrait of Descartes reveals a reiterative pattern of denial. Disavowal is an explicit and radical form of denial that seems here to have a legal cast to it: Descartes taking an oath. Disavowing *(verleugnen)* his physics by declaring it to be a picture, Descartes declares his whole scientific project to be a fiction. His disavowal is not a repudiation or a recantation. Through this denial, Descartes legitimates the speculative enterprise of theory.

This denial reiterates itself in the very vehicle(s) that Descartes deploys

for framing his disavowal whether as narrative or as figuration, whether in words or in images—fables and pictures. The very vehicle for framing his project of science as discourse is itself a denial. The picture itself, the (alleged) portrait of Descartes, is a denial. The vehicle for discourse marks itself as a picture.

A picture, unlike a photograph at least in Barthes's indispensable account, marks itself out as a sign, not to be confused for what it signifies.[31] It halos itself as standing in a particular relation, outside, above, and ontologically less than the stuff of the world. To picture is also a denial. To represent is thus a significant kind of negation. For something to stand for something else, the something else has to be put to one side, collected, dressed down, negated so that something can stand (in) for it, without being confused with it. The term *denegation* covers the broad range of these *nots,* a term that came into being as one of many efforts to translate the variety of meanings that Freud gave to the notion of negation and denial.[32] It moves from the *simpliste* of grammatical negation, to putting to one side, to cancelling, to an explicit disavowal.[33]

The Descartes portrait by Weenix is thus a picture in a picture, a disavowal in a denial—both *verleugnen* and *verneinen.* Descartes is testifying in a picture to a fable. The testimony, a disavowal, is a denegation of a negation whereas the van Eyck portrait, also a denegation is a testimony avowing to the reality of its referent authorized by the picture as real. Denegation is thus inseparable from the logic of picturing—whether in the way that Heidegger speaks in the broadest sense of a "world picture" or in the more nuanced cultural historicist articulations of contemporary theorists.

The strategies of denegation that I have considered indicate just how enmeshed theory and picturing are. The crux of the denegation of early modern theory constitutes a specular witness and a denial that its discourse is itself practice. The crux of the denegation is to deny that the speculation of physics is practice. Thus the picture posits a specular witness testifying to a content offered by the picture. The denegation of the picture opens up "free spaces" ("dans les espaces imaginaires") for speculation itself. The speculation denies its speculation to be complicit with and enmeshed in the world. For theory to picture and pictures to theorize require discourse to deny its effectivity by denying that its speech, by an act of speech, is an act. In short the constituting move of modern theory as framing itself as a picture is to declare itself as culturally exempt—*virtus* not *actus.*

Descartes's philosophical demonstration of the modern cogito is itself inseparable from picturing as denegation. Descartes produced a philosophical proof of the modern cogito by a demonstration of the specular witness as necessarily outside the picture and yet codependent with it. The pictures

are witnesses and the cogito is a specular witness. The self-reflexive performatives that we have encountered in pictures as specular witnesses come to be applied by Descartes to elicit the necessary accompaniment of a cogito outside the picture. The cogito proof works entirely in the language game of the denegation of picturing.

"Paisible solitude"

Denegation saturates Descartes's whole project. It positions the object in the fictive displacement of the "new world" to the wilderness of the incommunicado of writing that he calls "une paisible solitude"—the site for reducing to rubble shared culture.[34] "Une solitude paisible" is another seventeenth-century utopics, not the "new world" of geography or the "new world" of science but the site for the fable of monologue, a first-person writing that supplements itself as inward thought and professing—a public and a private witnessing. The writing itself is the testament. In the epoch of the Book, then, writing comes to posit about itself the picture—the cogito as a specular witness to its writing as a picture. The cogito is thus a philosophical demonstration of the already posited specular witness.

Solitude, the condition of secession of an inquiring subject is the typical seventeenth-century word for wilderness, a wilderness of the *eremos,* the subject in its solitude, separated socially from others. It neither postulates nor anticipates a condition extinguishing itself. Even Descartes's *deus malignus* does not threaten the subject's extinguishment. The cogito is savage in the way that it claims to strip from itself common culture and constitute itself out of itself, as if it carried its ground for speculation within itself. It aspires to the savage state, as Merleau-Ponty later came to recognize.[35] The move from one to zero is certainly as radical a move as the move from many to one. It is the completion of that which the first step inaugurates. Wilderness travelling from Europe to America attempts the passage from one to zero both in its relation to others and in its account of nature.

V

The modern cogito posits a specular witness facing the picture. The denegation that is the picture-sign, carrying its panoply of authorizing reflexivities, posits the subject as a specular witness looking at a picture as the privileged and indirect access to the real. The cogito of the new world wilderness is that very specular subject, a witness figure testifying to the condition of wilderness by marking itself as being there at the site of the wilderness. But the difference is that the very act of being seen and

the *factum* of the picture insult the condition to which the picture is the testimony. Whereas all the European topoi of the wilderness, however "empty," are stagings for Poussin's *istoria*—for Descartes's free zone of scientific speculation—the European wilderness transported to the geographical "new world" of exploration and colonization inextricably complicates the specular witness.

Atwood in "Death by Landscape" writes why her protagonist Lois has these paintings on the wall of her apartment; it is not from taste or *gemütlichkeit* but because it reminds her of a wordless dis-ease, of a trauma that took place in her summer camp youth in the trackless wilderness. The incident in question was the disappearance of an American friend in the Canadian bush and its unsolved mystery. Landscape pictures posit the specular witness because of this now very private and repressed incident (known to the narrator and not to the fictive subject). The pictures from the Group of Seven are proxies, stand-ins for this "unnameable" incident.

Wilderness for Atwood is the name for the site of the blow, and the pictures transfer, not the memory of the incident, but the blow that obliterates the event from memory; the vague memory of the blow substitutes for the memory of the event: trauma, in short. In this respect the two ends of the classical modern sublime, Burke and Kant, converge at the site of the wilderness. In Burkean terms, *the* wilderness is the name for the site of the incident, the blow that knocks out the witness as marking the difference between the picturesque (witnessed) and the sublime as unwitnessed. However, the wilderness is that very condition or state in terms of the very idea of wilderness that denies its being humanly witnessable. In this respect, it is curious, although not surprising, that Kant never problematized the wilderness as a sublime idea—the sublime of the solipsism of the subject itself. Trauma links the existentiality of Burkean threats to the conceptuality of the Kantian sublime. The event of the blow inevitably shifts to the effect of the blow that the subject is incapable of registering. Trauma colloquially understood as "an event without a witness" finds in *the* wilderness a symbolic scaffolding, which actualizes landscape as a mise-en-scène for obliteration and the memoryless in contrast with classical representation where landscape is the mise-en-scène for history and historical narratives.[36] Trauma makes the sublime forensic and historical. It introduces into the aesthetic the requirement of an incident as organizing visual meaning. An incident in the wilderness, projected onto these pictures, makes the pictures carriers of failing meaning. In Atwood's narrative, an incident that took place in the bush comes to be the traumatic punctum carried by these paintings.

Since the incident in the Atwood story has been repressed, it renders

the picture, an incident without a witness. This points to the special place landscape paintings have as the generic carriers of the incident. For the Group of Seven the figure of the solitary tree marks the site as it were of an incident, an X. The absence is the incident that is signed by the figure of the solitary tree. Atwood fills that X with a narrative. The figure of the solitary tree, a stand-in, is a phantom.[37]

VI

As the absolute limit of itself, *the* wilderness posits no traces, which is tantamount to positing a visual alibi that nothing took place there at all. Catastrophic and murderous incidents that took place, once reframed in the wilderness, lose their context as having meaningfully occurred.[38] *The* wilderness is a denial of the meaning of the event and as a topos locates the occurrence as falling below the threshold of its registration as an incident. *The* wilderness also comes to be a frame and topos of the aesthetic of the sublime, a reflexive specular looking, constituted through a cultivated or practiced relation to pictures, visually testifying to an unpicturable condition. With modernity, there is no wilderness without a picture, and the paintings that I have been considering are simultaneously of *terra nullius* and testimonies in the domain of the aesthetic sublime. From projects of collective emptying through the wilderness as the theological and aesthetic exaltation of pristine emptiness, *the* wilderness prolongs the European imaginary into a "new world" displacement that severs the land from its occupants. *The* wilderness obliterates history while advancing the abyssal and immemorial as the trace of the sign. *The* wilderness might thus be construed as a monument without a witness, a trace that denies its discernability as a sign. The argument that landscape art is a scenographic staging of oblivion in colonial projects of the "new world" and *Lebensraum* has been presented elsewhere. I have sketched the way that pictures, in this case pictures that purport to be of the wilderness, do their work across two registers, giving denial a double sense. In one register, let me call it the politico-legal, the wilderness is part of a declaratory apparatus for the constituting of territory. The symbolics of the picture is a screen that offers a visual alibi, a kind of wedge or spacing between an inherited culture saturated with place names and new projects of territorialization that insert themselves by declaring that this land is thinly populated or not populated at all—a juridico-political degree zero.

The British conquered North America without juridico-legal declarations of *terra nullius* to render inherited and dwelledupon land "crown land," but for Australia they did. The (Canadian) Royal Proclamation of 1763, which recognized the prior title over lands by indigenous people,

was confirmed in the Quebec Act of 1774.[39] These legal recognitions of prior aboriginal title are often understood as the *causis belli* of the American Revolution. It might be said that the history of Canada has always been a negotiation between the settler culture and its first inhabitants about title. Yet the dominant cultural project of Euro-North Americans came to articulate itself aesthetico-theologically in terms of the emptying of the wilderness initially by the Massachusetts Bay colonists, then by post-Constitution Americans, nineteenth-century transcendentalists, followed by Euro-Canadians during the first third of the twentieth century with Tom Thomson and the Group of Seven.[40] The emptying of deep ecology with the imaginary of the wilderness as its symbolic driver marks the close of the twentieth century. These North American and antipodean colonialist visions intimately configured the landscape imaginary by aestheticizing or "subliming" the *terra nullius*. The Australian imaginary came to articulate a hybrid space that contradicted the official operations of voiding. One might say the landscape imaginary overcame the declaration of *terra nullius* as preparation for the recent legal judgements on 3 June 1993 in the case of *Eddie Mabo* v. *Queensland*, 204 years after the declaration of 1788.

What is projective and instrumental about the wilderness picture in the register of *terra nullius* casts a retrospective and nostalgic aesthetic in the landscape art that forgets the trauma of history by depositing a picture as a monument. The sublime of the European wilderness thus sits on the register of *terra nullius*, which it retrospects. That it projects a totalization, as if it were completed, belies the fact of an ongoing resistance to that project. An indigenous absorption of this very picturing apparatus of specular testimony has been producing a countertestimony that displaces and rerecords incidences of European historical incursion in the indigenous picturing of landscape. The picture-as-witness, a mimesis, not a mimicry, comes to be the arbiter of a "double vision" in Homi Bhabha's influential construal.[41] A picturing practice converts a way of seeing into an unsupported way of acting, to revisit the epigraph of this essay.

Giving grounds, however, justifying the evidence, comes to an end;—but the end is not certain propositions striking us immediately as true, i.e. it is not a kind of *seeing* [*eine Art* Sehen *unsrerseits*]; it is our *acting* [*unser* Handeln], which lies at the bottom of the language-game.[42]

A series of recent paintings called *The Killing Times* by the late Australian aboriginal artist Rover Thomas are explicit pictures-as-witnesses. They record visually incidents of *terra nullius*, marked as stations on the public

facade of the aboriginal dreaming. By marking them, not on a ritual track, but on the imitation of a ritual track put to historical purposes, these paintings are forensic diagrams, leading the viewer backward to the scene of a crime. One painting in this series is called *Ruby Plains killing I,* which marks an X with a hollow log holding skulls; the hollow log itself recalls the hollow-log bone coffins of traditional Arnhem land burials as well as the Aboriginal Memorial.[43] The apparatus of picturing, not the land, carries the "two visions" that have been critically reversed and opened to further complications and recognitions. Thus picturing practices, emerging with modernity itself, come to assume a place as witnesses in an ongoing and contemporary cultural negotiation at an open, active, painful, and still unresolved site of memory.

Notes

I wish to thank Tom Mitchell, Jesper Svenbro, Paul Duro, Alberto Pérez-Gómez, Toby Foshay, and Yves Thomas. Over the period of my research leave in 1998–99, versions of this paper were read to the department of Art History at the Ohio State University, the graduate program in the History and Theory of Architecture at McGill University, the departments of English at the University of British Columbia and the University of Victoria (Canada), and the Fourth International Word and Image conference at Claremont College. I am also grateful to the editorial board of *Critical Inquiry* for engaging my core claim about modern painting.

1. *Le Petit Robert,* s.v. "arpent."

2. *New Oxford Shorter Dictionary,* s.v. "-ness."

3. Henry David Thoreau, in *Essays: English and American,* ed. Charles W. Eliot, 50 vols. (New York, 1910), 28:421.

4. See W. J. T. Mitchell, *Picture Theory: Essays on Verbal and Visual Representation* (Chicago, 1994), esp. pp. 3–8; for the image-text relationship, see also pp. 411–18.

5. See especially Robert Rosenblum, *Modern Painting and the Northern Romantic Tradition: Friedrich to Rothko* (New York, 1975); Roald Nasgaard, *The Mystic North: Symbolist Landscape Painting in Northern Europe and North America, 1890–1940* (Toronto, 1984); Charles C. Hill, *The Group of Seven: Art for a Nation* (Toronto, 1995); Barbara Novak, *Nature and Culture* (New York, 1980); and Angela Miller, *The Empire of the Eye: Landscape Representation and American Cultural Politics, 1825–1875* (Ithaca, N.Y., 1993).

6. See Mitchell, *Picture Theory,* esp. chap. 3.

7. See Paul Duro's introduction to *The Rhetoric of the Frame: Essays on the Boundaries of the Artwork,* ed. Duro (Cambridge, 1996) where he effectively diagnoses the uncontrollable slippages between the meaning of the wide and the narrow and the material and the conceptual senses of *frame.*

8. For a more general account, see Jonathan Bordo, "The Witness in the Errings of Contemporary Art," in *The Rhetoric of the Frame*, pp. 178–202. On the wilderness as the painting site whence the witness figure arose, see Bordo, "The *Terra Nullius* of Wilderness–Colonialist Landscape Art (Canada and Australia) and the so-called Claim to American Exception," *International Journal of Canadian Studies* 15 (Spring 1997): 13–36 and "Jack Pine—Wilderness Sublime or the Erasure of the Aboriginal Presence from the Landscape," *Journal of Canadian Studies* 27 (Winter 1992–93): 98–128.

9. See Margaret Atwood, "Death by Landscape," *Wilderness Tips* (New York, 1991), pp. 97–118. For a more detailed elaboration of this narrative, see Bordo, "The *Terra Nullius* of Wilderness," p. 14.

10. See Bordo, "Jack Pine," esp. pp. 112–15.

11. See Bordo, "The Witness in the Errings of Contemporary Art," for a sketch of its diexis and its relation to eucharistic representation.

12. See Bordo, "The *Terra Nullius* of Wilderness," esp. 22–30; see also Bordo, "Cultural Symbology," review of *The Rites of Assent: Transformations in the Symbolic Construction of America*, by Sacvan Berkovitch, *Semiotic Review of Books* 5 (Mar. 1994): 4–8.

13. See Perry Miller, *Errand into the Wilderness* (Cambridge, Mass., 1956); Roderick Nash, *Wilderness and the American Mind* (New Haven, Conn., 1967); and Max Oelschlager, *The Idea of Wilderness: From Prehistory to the Age of Ecology* (New Haven, Conn., 1991). I particularly recommend Miller, *The Empire of the Eye*, esp. chap. 3, and a companion volume *American Iconology: New Approaches to Nineteenth-Century Art and Literature*, ed. David C. Miller (New Haven, Conn., 1993). See most recently Mitchell, *The Last Dinosaur Book: The Life and Times of a Cultural Icon* (Chicago, 1998), esp. chaps. 16–19, which drops the American wilderness sublime from just before the landing at Plymouth, Massachusetts, into the Jurassic.

14. On the dédoublement of classical representation, see especially Louis Marin, *La Critique du discours: Sur la "Logique de Port-Royal" et les "Pensées" de Pascal* (Paris, 1975), esp. pp. 58–67. I have argued elsewhere that what is called the gaze as secured to an opticality is itself an appurtenance of the witness function and not the other way around. See Bordo, "The Witness in the Errings of Contemporary Art," p. 197.

15. See Derrida, *De la grammatologie* (Paris, 1976), esp. chap. 1. See also Hans Blumenberg, *Die Lesebarkeit der Welt* (Frankfurt am Main, 1975), and Lucien Febvre and Henri-Jean Martin, *The Coming of the Book: The Impact of Printing, 1450–1800*, trans. David Gerard (London, 1976).

16. Erwin Panofsky, *Early Netherlandish Painting: Its Origins and Character*, 2 vols. (Cambridge, Mass., 1964), p. 203.

17. Ibid. Damisch gives the following gloss:

Like the painter of the *Arnolfini Wedding*, an image of which, returned by the mirror situated in the very spot on the picture plane toward which the orthogonals converge, bears the famous inscription *Johannes van Eyck fuit hic* and the date 1434. . . . *Hic* means *here*, in the spot from which I see it, as reflected, and

not *there*, where I see it to be by means of the mirror, in the position of the witness facing this man and woman whose portrait was executed by van Eyck, if we are to accept Panofsky's classic reading, as a kind of marriage certificate.

Here Damisch rides on Panofsky's coattail, accepting his marriage certificate allegation and using it to link the technical device of perspective to an imaginary as providing a specular topic (Hubert Damisch, *The Origin of Perspective*, trans. John Goodman [Cambridge, Mass., 1995], pp. 130–31).

18. Compare Linda Seidel's tendency to invest in the expertise of van Eyck's notary practice when she writes, "Jan asserts, through the use of notarial 'style', that he has set down what we see on the panel without actually claiming that he saw it happen. He both stakes out a claim for his authority *and* pretends to no greater truth than that which this genre of scribal practice allows" (Linda Seidel, *Jan van Eyck's Arnolfini Portrait* [Cambridge, 1993], pp. 138–39) to Hall's reducing of that notarial practice to a rhetoric tout court: "moreover there is no indication of a notary officiating at the ceremony to verify the couple's consent. Van Eyck himself could not have fulfilled this role: his florid signature alone would not have made up for his lack of credentials as a trained and publicly authorized legal professional, nor could it have constituted the painting itself a legal document, since the date under the signature gives only the year of the ceremony" (Hall, *The Arnolfini Betrothal* [Berkeley, 1994], p. 64). See more generally Hans Belting, *Likeness and Presence: A History of the Image before the Era of Art*, trans. Edmund Jephcott (Chicago, 1994), esp. chap. 19.

19. Hall, *The Arnolfini Betrothal* shows them to be just that—allegations, unsupported by the historical facts.

20. This is what I understand Seidel to mean when she writes, "Thus, it is not the painter who bears witness to the marriage. . . . His role is finished as he tells us in his inscribed text. Instead, it is the painting, like the ones made for Joos Vijd and Chancellor Rolin but further abetted here by magical authenticating glass, that fulfills that role on into the future. We and our successors are constituted as witnesses to the event we see; to each successive generation, Jan's painting provides first hand testimony" (Seidel, *Jan van Eyck's Arnolfini Portrait*, p. 162).

21. See Émile Benveniste, *Le Vocabulaire des institutions indo-européennes*, 2 vols. (Paris, 1969), 2:110–22. "Ces passages indiquent clairement la différence entre *arbiter* et *testis:* le *testis* est là au vu et au su des parties; l'*arbiter* voit et entend sans être vu. . . . On n'invoque jamais en justice le témoignage d'un *arbiter* pour remplir une fonction testimoniale; car c'est toujours l'idée de voir sans être vu que ce terme implique" (2:120).

22. See Richard Rorty, *Philosophy and the Mirror of Nature* (Princeton, N.J., 1979).

23. Damisch's technicist approach to locating the autonomy of painting is belied by this account. Perspective is part of the illusion apparatus of witnessing.

24. See Panofsky, "*Et in Arcadia Ego:* Poussin and the Elegiac Tradition," *Meaning in the Visual Arts* (Chicago, 1955), pp. 295–320.

25. For the ancient Greek practice of reading tomb monuments that are enunciated in the first-person singular, see Jesper Svenbro's remarkable *Phrasikleia:*

An Anthology of Reading in Ancient Greece, trans. Janet Lloyd (Ithaca, N.Y., 1992), esp. chaps. 1–2. Svenbro demonstrates that in a significant class of stelai or gravestones dating between the seventh and the fifth century B.C. the epigraphy inscribed in the first-person singular calls on the passerby to read out loud the inscription as an act of commemoration. In studying the epigraphies of daughters, whose role is to proclaim the fame of their fathers, Svenbro shows decisively (and against a whole tradition of interpretation) that and why the epigraphies are written in the first-person singular. The first person refers, rather than to its cogito, to the *Hierheit* of the tombstone, which will be there when the writer and the previous readers are gone.

26. For an interpretation of the trial of Galileo and its impact on Descartes, see my "The Appeal to Reason: The Legitimation of Science and Cartesian Genealogy of Knowledge" (Ph.D. diss., Yale University, 1980), esp. pt. 2, sect. 2.

27. "De ce Monde pour en venir voir un autre tout nouveau que je ferai naître en sa présence dans les espaces imaginaires" (René Descartes, *Le Monde, ou traité de la lumière*, in *Oeuvres Philosophiques*, ed. Ferdinand Alquié, 3 vols. [Paris, 1963–73], 1:343).

28. See Blumenberg, *The Genesis of the Copernican World* (Cambridge, Mass., 1987), esp. pt. 3., chaps. 1–2.

29. Fernand Hallyn, *The Poetic Structure of the World: Copernicus and Kepler* (New York, 1993), p. 24.

30. Descartes, *Discours de la méthode*, ed. Étienne Gilson (Paris, 1964), p. 48. "Mais, en proposant cet écrit que comme une histoire, ou, si vous l'aimiez mieux, que comme une fable, en laquelle, parmi quelques exemples qu'on peut imiter, on en trouvera peut-être aussi plusieurs autres qu'on aura raison de ne pas suivre" (ibid.).

31. See Roland Barthes, *La Chambre clair: Note sur la photographie* (Paris, 1980), p. 18: "Mais pour qu'il y ait signe, il faut qu'il y ait marque; privées d'un principe de marquage, les photos sont des signes qui ne prennent pas bien, qui *tournent*, comme du lait."

32. See Sigmund Freud, "Negation," *The Standard Edition of the Complete Psychological Works of Sigmund Freud*, trans. and ed. James Strachey, 24 vols. (London, 1953–74), 19:235–39. See also, most recently, André Green, *Le Travail du negatif* (Paris, 1993).

33. Marin in his decisive study of French classical painting, transported the notions of denegation and negation from psychoanalysis into the study of early modern culture in a particularly appropriate and effective way by showing how denegation is essential to understanding the very apparatus of modern representation. See Marin, *To Destroy Painting*, trans. Mette Hjort (Chicago, 1995), pp. 45–64.

34. Descartes, *Méditations métaphysiques* (Paris, 1976), p. 6.

35. My thanks to Alberto Pérez-Gómez for recalling me to the savage cogito of Merleau-Ponty in *Le Visible et l'invisible* (Paris, 1964), and his distinction between Descartes's *cogito tacite* and his *cogito langagère* to use Merleau-Ponty's own distinction. Each project for the radicalizing of the cogito in the pursuit of common seam between nature and culture leads to disburdenment of the cultural posit that it seeks to ground. So a Deleuzean nomad never escapes its Cartesian

inheritance, even despite its ventriloquism. The pursuit of a radical alterity results in the reinvestment of the same. The "nomad" and the "savage" are out-croppings of the European predator. They are its hunting masks.

36. In the genealogy of the "preclinical" notions of trauma, antecedents from the classical sublime will appear later in Kierkegaard and Nietzsche. For an earlier effort to formulate the linkage between trauma and the sublime, see Bordo, "Ecological Peril, Modern Technology, and the Postmodern Slime," in *Shadow of spirit: Postmodernism and Religion*, ed. Philippa Berry and Andrew Wernick (New York, 1992), pp. 165–81.

37. Stimulated by the recent reading of an essay by Nicolas Abraham and Maria Torok entitled "Notes on the Phantom": "In no way can the subject relate to the phantom as his or her own repressed experience, not even as an experience by incorporation. The phantom which returns to haunt bears wit-ness to the existence of the dead buried within the other" (Nicolas Abraham and Maria Torok, *The Shell and the Kernel: Renewals of Psychoanalysis*, trans. and ed. Nicholas T. Rand, 2 vols. [Chicago, 1994], 1:175).

38. Here I am referring to the title of Jeremy Gilbert-Rolf, "Blankness as a Signifier," *Critical Inquiry* 24 (Autumn 1997): 159–75. The wilderness as a semiotic operator blankets whatever it encounters with blankness.

39. Special thanks to the Commonwealth historians Bruce Hodgins, J. S. Milloy, and Henry Reynolds who have been the best tutors over the past ten years in conversation and in writing on the history of the constitutional path-ways to the up-to-the-minute settlements of aboriginal land claims in Canada, Australia, and New Zealand.

40. See Bordo, "The *Terra Nullius* of Wilderness," esp. 28–32 and "Cul-tural Symbology." See also Donald H. Akenson, *God's Peoples: Covenant and Land in South Africa, Israel, and Ulster* (Ithaca, N.Y., 1992).

41. See Homi K. Bhabha, "Of Mimicry and Man: The Ambivalence of Co-lonial Discourse," *October*, no. 28 (Spring 1984): 125; rpt. in Bhabha, *The Location of Culture* (New York, 1994), p. 88. Mimesis, not mimicry, because the entering into a practice in this case of picturing, whatever the predisposition or agenda, requires the mastery of a technique and in view of the availability of European painting practices, not closed by initiation, the ulterior motive for having the practice counts as much as it counts to speak about the ulterior motives of play. Even if the Australian aboriginal initiation in European pictur-ing practices is relatively recent, what is remarkable at least for this author is how fully and completely it has come to explicate and dispose for its political and cultural purposes of an "evangelical" version of the specular witness. The picture as counterwitness as constituting a site of memory occupies the latter part of the monograph I am presently completing entitled *The Landscape with-out a Witness: An Essay in Modern Painting*.

42. Ludwig Wittgenstein, *On Certainty*, trans. Denis Paul and G. E. M. Anscombe, ed. Anscombe and G. H. von Wright (New York, 1969), 204.

43. See Rover Thomas, *Roads Cross: The Paintings of Rover Thomas* (exhi-bition catalog, National Gallery of Australia, Canberra, 18 Feb.–5 June 1994), pp. 40–45.

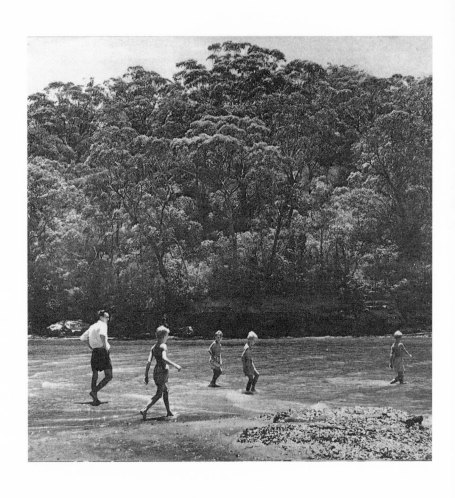

MICHAEL TAUSSIG

The Beach (A Fantasy)

> Thus live waves—thus live we who will—more I shall not say.
> —Nietzsche, *The Gay Science*

Prologue

The ultimate fantasy would be to write about a fantasy because as soon as you realize it's fantasy, it changes. But where does it go? What happens to it? Freud suggested fantasy was a montage of sight and sound drawn from prior experience so as to disguise that experience and repress memory of it. But if the fantasy increased in intensity beyond a certain point, it too would be repressed, and a physical symptom would take its place.[1] Might writing be just such a symptom, particularly in the form of the cut-up that meets Freud's montage head-on? "Cut-ups? but of course. I have been a cut-up for years. . . . I think of words as being alive like animals. They don't like to be kept in pages. Cut the pages and let the words out."[2]

The History of the World

The history of the world, says the American poet Charles Olson in his little book on Moby-Dick, *Call Me Ishmael*, published in 1947, could be summed up by three oceans; the Mediterranean, the Atlantic, and now the Pacific. (Homer, Dante, and now Melville.)[3]

The Disappearance of the Sea & Its Fantasmatic Recovery

Yet how unthinkable Olson's proposition has become. Not because of the ordering but because of its substance. For now so few of us have any direct experience of ships or the sea. Today we relate to the ocean and its histories

317

through the commodities brought in the hulls of ships. Joseph Conrad's writing is not a reflection of the sea and a worldwide experience of it so much as an anxious premonition of its disappearance as a key element of nature from human experience. Conrad retired from the sea shortly after receiving his master's certificate, just when sail gave way to steam, which is when radical experiments in modernism were born. This displacement of everyday experience by commodities caught Karl Marx's eye, too, in his notion of fetishism. The point of this concept was not, as many writers on this concept seem to think, that a more significant reality (for example, the process of material production) is occluded and people (other than intellectuals and party leaders) become blinded to reality. Rather, that reality is displaced and thereby, as with the labor of the negative underlying fantasy, propels strange flights of imagination and even stranger ways of juxtaposing time and place.

Today the old ports have gone. Concrete container terminals have replaced them, and the wharves have moved to industrial sites far from the people who go as tourists to the gentrified old ports where sailing ships are resurrected as museums. Yet as never before, so we are told, is the whole world unified into the One Big Market, which must mean immense amount of shipping and human dependence on sea-borne freight: the iron ore from Australia and Canada, the apples we eat from Tasmania, the cheap steel from China, sun-ripened tomatoes from Israel, transistor radios and teevees from Taiwan, cars and computers from the U.S. and Japan, the blue jeans from Medellin, oil from Venezuela and Kuwait, and so on. The conduct of life today is completely and utterly dependent on the sea and the ships it bears, yet nothing is more invisible.[4] How different it must have been until well into the twentieth century when ships and sailors filled the horizon of Western experience from Ulysses onward! Is this what Joyce sensed would happen when he backtracked on Melville and demythologized Ulysses, forgot the great white male and instead had his Ulysses be a fumbling everyman, a Dublin Jew named Bloom, barely making it through life, masturbating on the beach? " 'She is our great sweet mother,' " declares "stately, plump Buck Mulligan," " 'the snotgreen sea. The scrotumtightening sea.' " And he turns abruptly to Stephen Dedulus. " 'The aunt thinks you killed your mother.' " " 'Someone killed her,' Stephen said gloomily."[5]

Sea provides the medium of travel for Homer in his starkly out-of-body travelogue, while for Joyce it establishes the setting for inner travel as inner speech. The first section of Joyce's *Ulysses* is a seascape of mind flowing in and out of Western history in which the movement of the sea onto the

shore, immense, restless, and mesmerizing, is the movement of the uncon-
scious mind sifting images, just as the author sifts styles in the mad inheri-
tance we call a language, a language on the edge of empire. We overhear
young Stephen Dedalus talking to himself as he walks the beach. It could
just as well be language talking to itself, "shellcocoacolored." Forgive my
playing with his playing with its playing as we are all swept up for the
"flood is following me. . . . These heavy sands are language tide and wind
have silted here. And there, the stoneheaps of dead builders. . . . A school
of turlehide whales stranded in hot noon, spouting, hobbling in the shal-
lows. Then from the starving cagework city a horde of jerkined dwarfs,
my people, with flayer's knives, running, scaling, hacking in green blubbery
whalemeat. . . . Do you see the tide flowing quickly in on all sides, sheeting
the lows of sands quickly, shellcocoacoloured?" (*U*, pp. 55, 56, 57).

Young Dedalus's eye wanders to a dog playing at the water's edge.
(Such a site for play, this edge.) Now we see the dog. Through Stephen.
We no longer listen to Stephen talking to himself via the sea, but to the
dog via Stephen. The animal's consciousness has displaced the historical
consciousness, just as the historical was displaced by the primeval, which
is to say by a dying sea and a mother's green bile torn from a rotting liver.
The dog is "looking for something lost in a past life" (*U*, p. 57). Sniffing
at the sand. "His snout lifted barked at the wavenoise, herds of seamorse.
They serpented towards his feet, curling, unfurling many crests, every
ninth breaking, plashing, from far, from farther out, waves and waves" (*U*,
p. 58). This is language moving into the sea as our very bodies might,
ending up newly buoyant and happy somewhere between its watery mov-
ing energy and the human facility with mimesis. "Listen: a fourworded
wavespeech: seesoo, hrss, rsseeis, ooos. . . . In cups of rocks it slops:
flop, slop, slap: bounded in barrels" (*U*, p. 62). Beyond representation.
Bounded in barrels. And at the very end of this first section of Joyce's
Ulysses, the end before we meet Bloom bustling in his kitchen frying kid-
neys for his ladylove upstairs, young Dedalus sees Joseph Conrad's ship
disappearing into the slipstream of time behind our very backs. "He turned
his face over a shoulder, rere regardant. Moving through the air high spars
of a threemaster, her sails brailed up on the crosstrees, homing, upstream,
silently moving, a silent ship" (*U*, p. 64). Joyce has suddenly changed tack
here at the end "rere regardant" with this fulsomely self-conscious lyrical
moment coming out of nowhere, going home, this all too silent ship.

As the ships sailed home into oblivion across the "snotgreen sea" sometime
after World War Two, so the beach became increasingly popular in the
affluent West, and the sea underwent a phantasmatic recovery by virtue of

a new structure of feeling: Billy Butlin's camps by the sea; topless Swedes and Germans basking by the water's edge, leaving the Spaniards on the *costa del sol* aghast, tightening their kerchiefs; Greek peasants in the Peloponnese selling off their coastal plots to the floods of Germans as the peasants never built on the exposed seaside of the slopes on account of pirates. But all this has changed. That sort of piracy belongs to the past, and the beach is where just about everyone wants to be.

In Sydney, where I was born in 1940 and grew up, the coastal beaches and harbor waterfront were with few exceptions where the working class lived or to where they would go on Sundays to surf or, in the case of the harbor, drink Toohey's lager and gamble on the sixteen- and eighteen-footers—beamy racing dinghies with huge amounts of sail and crew. The ferries hired to follow the race would heel over almost as much as the racing dinghies as the inebriated followers would anxiously cram the rail. There were corrugated iron shacks in the deep bays like Mosman and Castlecrag in which poor people lived close to the oysters clinging to the orange-faced sandstone that like a curtain hung at the water's edge. Soft she-oaks whispered sad tunes to the receding tide, and their delicate needles felt soft underfoot. Today they are not called she-oaks but casuarinas. The name change says it all, a certain critical distancing has occurred, a more precise, even scientific nomenclature contains the nature we love, and such suburbs, like the previously working-class, waterside area of Balmain, for example, are among the wealthiest in Australia. Famous city beaches such as Bondi and Coogee, with their hideous brick homes and squat apartment buildings, which were solidly working-class areas, are now battlegrounds for people with money fighting for their place in the sun. They will do anything just short of murder to get their "harbor view" or be by the beach. Twenty years ago they wouldn't have given a shit.

Today it's the strangest thing to watch the ferries from the city disgorge their well-heeled passengers off the wharf at Long Nose Point at Balmain, for instance, as they come home from a tiring day in the law firm or stockbroker's office. Each passenger forms a quiet monument to the self, set into a noble tranquility by the gentle harbor crossing, God's newfound gift to the mentally spent. As they spring invigorated onto the shore of their new, if not quite yet natural, habitat, a waterside working-class suburb converted into luxury housing, there is a curious anachronism, a slight shuffling of the cards of world history as impoverished Vietnamese families, taking advantage of the public space offered by the wharf, pull in their fishing lines to make way for the ferry. Nobody speaks. The Vietnamese seem not to be aware they really shouldn't be there even though it's perfectly legal. Indeed they seem far more naturally part of the scene than the tired white professionals stepping ashore. The Vietnamese are an unknown

entity. They come in the early evening from remote slums in battered cars for which it is difficult to find parking space around here. Now and again it is reported in the media they eat dogs. They are quintessentially foreign and out of place. Yet they blend intimately with it and fish just about all night long, it seems, with their flashlights and thermoses, and they fish with the same mix of pleasure and boredom as did the white Australian watersiders before them who have, it seems, around this harbor at least, become quite extinct, other than in their reincarnation in these refugees from Southeast Asia.

To me the oddest thing is the stillness of the encounter between those coming off the ferry and these fishermen and women. It is as if the latter didn't really exist, that they are invisible and are seen straight through. Yet they're the ones actually using the water as something other than real estate or what Marx called exchange-value. Perhaps with time they will pass into the spectacle as part of the flora and fauna, the flora having been carefully selected and planted as Australian Wild.

Benjamin cites Adorno's letter to him, 5 August 1935, ruminating on the mysteries of the "dialectical image" that was so dear to Benjamin's practice as a writer in search of a form by which words and things could be juxtaposed in terms appropriate to the reality of capitalist modernity. At one point Adorno speculates that as the world becomes increasingly subject to commodification and "things lose their use value, they are hollowed out in their alienation and, as ciphers, draw meanings in."[6] Benjamin agrees that such "'hollowed out' things" are increasing at a rate previously unknown in world history and that in their very hollowed-outness, torn between death and meaning, they naturalize subjective intention, one's hopes and one's anxieties ("N," p. 12). In this regard I wonder if these strange silhouettes of "hollowed out" businessmen and women stepping off the ferry, no less than the quiet people fishing on the wharf, more nature than culture, have absorbed into themselves the dead past of these waterfront suburbs, their dead boat-building industriousness and once busy social life? In which case, that moment when the boat hits the wharf to unload its passengers, that moment in the dusk after work, that is the dialectical image. You feel the shudder radiating along the creaking wooden wharf. It goes way down the piles into the ocean floor. Softly.

With his love of children's literature, Benjamin would surely be among the first to acknowledge the role of the adult's imagination of the child's imagination in the constitution of the dialectical image and its claims on prehistory. And it is with the confidence born of this self-nourishing circuit that I can claim that the renaturalization of the harbor as archaic second

nature was foreseen by a book I read as a child aged about ten in 1950. It was called *Mates of the Kurlalong*, in which a group of animals escape from the Sydney zoo, located on a steep, rocky, hillside plunging into the harbor, and take over a ferry, the giraffe, of all things, becoming the engineer and having to find room for its neck somehow down in the engine room.

The adult's imagination of the child's imagination is markedly accentuated, I believe, by rights to remembrance granted expatriates, such as myself, for whom the childhood past across the seas lies petrified as a dead object preserved under glass awaiting a hand to shake it into life. Adorno puts it like this, summing up what for him was important in Benjamin's method: "He is driven not merely to awaken congealed life in petrified objects—as in allegory—but also to scrutinize living things so that they present themselves as being ancient, 'ur-historical' and abruptly release their significance."[7]

Down in the bay from where I lived as a kid, there was a wharf with slips and a large boatshed. Its owner, who lived on this beautiful site at the head of the bay (Sailor's Bay was its name), repaired boats and before that had been a champion cyclist, in those pre-yuppie days a very working-class sport. Fishing off the wharf for leatherjackets, my eye would idle over the yachts at anchor. There were about ten. That's all. But today you can hardly see the water there are so many. What's more, when I was a kid many of those yachts had been built by their owners. Years it would take. Hard to imagine today. Later, aged fourteen or so, I joined a sailing club on the other side of the bay at Seaforth, racing eleven-foot-long boats called Moths with one enormous sail and a nineteen-foot mast. The club consisted of men, all of whom who worked at a trade, like carpentering or plumbing.

It was an unusual place where I grew up, a peninsula jutting into the Middle Harbour. I am told that in the 1920s or 1930s the easiest way to get there was to row from the Spit, a narrow tract of land to where trams ran from the inner city. Mainly oddballs lived there, communists, refugees like my parents, from central Europe, and artists. By and large, respectable people shied away even though it was in a sense middle class and professional, culturally, if not economically. It was covered with she-oaks and soaring white-skinned eucalyptus trees, and in summer the cicadas would sing. All around was water, salt water from the Pacific. But very few people had boats or were in any sense, I think, oriented to the sea. The only person that comes to mind was Ern Claridge who had worked his way up in a small company selling hot water systems. He was a kind, overweight

man with a great laugh, who lived with his wife and daughter in a stone house fifteen-minutes' walk from the water's edge that had been built for an actor with a star-shaped living room that could serve as a theater, and just about every afternoon, I think, he would go down to the harbor and out in a clinker-built rowing boat and fish until nightfall. He smoked huge Havana cigars and loved white wine, both of these habits being distinctly unusual for a real Australian, but his credentials were assured by his sitting in the bath for hours of a morning and going carefully through the racing guide, then calling his bookie, before departing for work. I seem to remember he caught a lot of fish. What is my point? Of all the people I knew in my "middle-class" peninsula suburb laid out in the beautiful bay of the beautiful harbor, he was one of the very few adults I can remember who made use of the sea, only minutes by foot from our homes. I find this remarkable.

Down the steep hillside from where I lived, squeezed in a narrow space between the water's edge and large rocks, almost a mile from the roadway, were four or five houses built of wood and corrugated iron, illegal building materials, dating from another era, probably the Great Depression. Who lived there? I never knew. Whoever they were, they were like a foreign element. They must have come and gone in boats or surreptitiously up and down the zig-zag paths only they and we children knew about. I do remember however that the doctor who looked after me, as I was often sick, told me he once had to run all the way down there to attend to what was called a New Australian, a Yugoslav, I think, who being "new" had failed to heed warnings about sharks and was in the habit of swimming back and forth across the bay of a morning. An unthinkable event and totally shocking. He had been bitten in half, so it was said, by a shark, no doubt inspired by the same attitudes towards migrants as held by Old Australians, and when my dear doctor, who was once a football star, and still pretty fleet of foot, got there it was too late. Now yuppies and latter-day hippies have pushed the previous dwellers out and elbowed their way into that hidden colony on the water's edge by the mangroves, the sharks, and the ghosts of their victims. And doctors no longer sprint down craggy hillsides or consider house calls as part of their job.

Perhaps nothing more dramatically captures the world change in the orientation to the water than the fate of the shark. When I was a kid you couldn't put your toe in the water for fear of sharks. When the tiny sailing boats three of us had (we were among the vanguard of the new dispensation) heeled under the impact of a squall, you were exquisitely careful to retract your feet, and you never ever waded or heaven forbid! went swimming outside of a shark-proofed area, of which there were pitifully few. Apart from the New Australian bit in two, there was the woman school-

teacher we all heard about who, merely wading, had been yanked into the water and lost her leg. When we were older and started surfing at the ocean, we sometimes saw a trawler inching its way between the beaches, hauling in nets. It was Nick Gorshenin, as I remember the name and spelling, attending to the shark nets laid in front of all Sydney beaches. I never actually saw a shark, but I could easily imagine their torpedo-long bodies writhing in his cruel nets as they were joyfully hoisted aboard and given the treatment they deserved. You can imagine my surprise, therefore, when upon my return in 1995 I found kids gleefully jumping into the harbor (did they do it to spite me?) and people swimming outside the net at Nielsen Park where as teenagers we used to carouse, drink beer, sing, make love till the early hours and transgress in many ways but never, ever, swim outside the net. Yet now it's as if the shark no longer exists. A new era has dawned. The sea has come to mean something else, and its demons have been laid to rest. Or instead the demonic has been displaced onto the panic of skin cancer and pollution in the water caused by raw sewage and lead.

Across the bay from where I grew up, there was of all things a liver-red brick working-class suburban bungalow. Absolutely, stereotypically, typical. But, also, totally incongruous because it was so isolated in the bush. Nothing else for miles around. It belonged, as I remember, to one H. C. Press, and from its heights elaborate wooden steps and bush paths zig-zagged down to a jetty and a fenced in shark-proof swimming pool where, as a twelve-year-old child, I used to sneak in with friends on hot weekday afternoons, rowing across the bay, and skinny dip. Press had been an eighteen-foot dinghy sailing champion and on retirement from his real job had built this little park by the harbor to rent out for weekend excursions from the city. Hence the butchers', the bakers', and the candlestick makers' unions would hire ferries and spend the day picnicking, while the middle class and the wealthy were nowhere to be seen. They chose to live and raise children on the leafy "north shore," which, despite its name, was inland with no trace of the ocean. As I said before, they didn't give a shit.

A mile or so through the bush along from H. C. Press was an extraordinary thing, a castle, exacerbating the wonderful working-class fantasy that the Press picnic grounds brought to life. A castle! In Australia! We kids called it Dr. Willis's castle, for some reason, but I myself suspected it really belonged to one John Mystery, who wrote rather unpopular scary books and whose face I seem to remember seeing as a tiny drawing the size of a postage stamp in the frontispiece of one of those books, where details of the publisher are printed, together with the outline of that same little castle. Once or twice we nerved ourselves to row across the bay, haul the boat up under the overhanging trees, and creep up a wide, smooth, path

in the forest to peer at the beautiful garden. We never dared get closer, and we never once saw a person. That entire stretch of headland was deserted, except for these two idiosyncratic phenomena, H. C. Press's liverbrick working-class bungalow, at one end, and John Mystery's stone castle, at the other. The bay lay still and empty, shimmering in the beauty of its translucent green water irradiated by shafts of blue and gold sunlight. I can still touch them as I write. Today the land has been developed by one L. J. Hooker and is covered by huge and ugly houses, while on weekends the bay is littered with yachts and motorboats, often tied one to the other so as to make more of a party or perhaps squeeze as many vessels into what has become, in reality, not a natural waterway but a parking lot.

This reconfiguration of money and the sea began and has been completed in my lifetime, this total reversal of value and forced exodus of the economically weaker from the seaside. It is by no means as dramatic or as consequential as the appropriation of the land from the Aboriginals that was begun in the late eighteenth century, the land having been legally defined by the British government as without owners, much the same as was done to the Palestinians by the Israelis this century, but was achieved freely by the anonymous force of the market instead, the market of fantasy.

The Archaic

I think of this revaluation of the sea as testimony to the force of the archaic in modernity, a coming into fullness of a "second nature" in which objects and landscapes, along with indigenous people, acquire radically intensified meaning as the physical melts into virtual reality.

"The beginning of man was salt sea, and the perpetual reverberation of that great ancient fact, constantly renewed in the unfolding of life in every human individual, is the important single fact about Melville. Pelagic." This is Olson toward the end of *Call Me Ishmael.*[8] And what does "pelagic" mean? "Of or pertaining to the open or high sea."[9]

But the current turn to the sea I am describing would seem to be quite different, not something to be *inhabited* but something to be *contemplated* as an expensive backdrop or as a yachting playground for Republican millionaires like William F. Buckley, Jr., testing their manhood against the elements on weekends and in continuous radio and radar contact with the coast guard. Down market there is the one-week getaway to the Caribbean with black waiters in tuxedos standing in the blue sea with martinis on a tray, or the two-week cruise on a tarted-up ocean liner that once plowed the seven seas on a regular passenger route. It is hard to imagine the sailors Melville describes in the mid-nineteenth century, for example, or Conrad's, at the end of the century, having the advantage of the "second na-

ture" that such alienation from the sea and physical nature provides. For it is by virtue of the separation and loss that the sea acquires a new magnificence, as when Benjamin, sensing the demise of storytelling in European cultures, notes that at that point it is "possible to see a new beauty in what is vanishing."[10]

This rupture into modernity of the archaic as "second nature" gives quite a different sense of historical progression to that of Olson's chronological sequence through the three oceans: Mediterranean, Atlantic, and Pacific. For with the surfacing of the archaic, we become aware that different orders of time may coexist with a past precisely because that past is both real and fictional, nature and "second nature," reminiscent of Freud's depiction of fantasy as a play with memories involving montage and overlays. As a site of such fantasy production, the beach's job is not to conceal but reveal and revel in revealing just such play, announcing itself as playground and transgressive space par excellence, displacing by far all previous rituals of reversal and pleasure. The beach, then, is the ultimate fantasy space where nature and carnival blend as prehistory in the dialectical image of modernity.

Dialectical Image

As a presence surfacing (in montages and overlays) in modernity, the archaic provides both the power and the texture for what Benjamin called the dialectical image. The vital nerve here lay with what was seen as the dynamic architecture of the commodity, a surreal object of such cultural influence and such self-transformative, shape-changing, magnificence that, far from demanding oppositional practice, it invoked mimetic strategies to take advantage of its futuristic powers. It may be that Lukács's essay on reification was the decisive transfer point here, with its Hegelian notion of "second nature" (what today is often referred to as social construction). To this one should add the related notion of commodity fetishism, creating out of capitalist culture a "phantom objectivity."[11] Hence Benjamin can be seen as retooling his notion of allegory, worked out in his early 1920s study of the baroque, so as to assimilate it to Lukács's formulation of the commodity. If allegory made much of the complexity between the graphic form of words and their meaning, image and text, it also made much of history as tragedy passing into the depiction of a petrified nature. What is so novel with the retooled version of allegory, namely, the dialectical image, is its being an invitation to rework "second nature" into history as prehistory in the modern era of commodity fetishism—as in this note Benjamin wrote to himself: "In the dialectical image, the past of a particular epoch is also 'the past from time immemorial' " ("N," p. 10). Such an

image contains time within itself, the cinema compressed into a still, and this is the messianic moment of stillness in the flow of time, arresting thought and allowing reality to collide and roll over it in search of another and until then unacknowledged history in what often seems to be a political fight over the past and its meanings. The sea must be a paramount instance in the West of "'the past from time immemorial,'" and I can think of no better example of a dialectical image than the postcard that serves as frontispiece, here reproduced, to the English edition of Klaus Theweleit's book, *Male Fantasies*. He found this card in his mother's photo album, as she lay "unconscious from a stroke and on a journey that is no journey. When people die," he adds, "we look at their photo albums and hear the voices that belonged to the images" (fig. 11.2).[12]

Pacific

It is this I yearn for and fantasize, the "southern sea," as it was first called by Europeans, writing here in a dark room in New York. It is winter, perfect time and situation for fantasies about the beach. But my history reverses Olson's history of the three oceans. I trace the movement of my life in reverse order to world history, back through history, as is the way

11.2 From Klaus Theweleit, *Male Fantasies*, trans. Stephen Conway, Erica Carter, and Chris Turner, 2 vols. (Minneapolis, 1987), 1:xviii.

of fantasy, back through oceans of time from the Pacific to England, then across the Atlantic to Colombia, and now I live on a coast, the East Coast as they call it, of the Atlantic, a coast I find ugly and cannot, will not, understand because every time I approach it I am reminded of something infinitely more splendid, bobbing in a line beyond the breaking waves waiting for the big one. We sung to strange gods like Huey, to send us one of these Big Ones, and he would oblige. Above the sound of the waves I could hear cicadas in the eucalyptus trees in the midday heat on the headland. It was magical escape, beyond words, the fate well known to the surfer trying to convey the sensation of waves. This bears a direct relation to the fragile freedom, always already lost, of what Hakim Bey calls the "temporary autonomous zone," such as pirate utopias.[13] Truly nothing remains but green twilight and green lightning in this sea of sadness at the unrecuperable loss that memory registers. All or nothing, I say. The real beach or the urban sublime with its rat poison and iron rails rusting into oblivion, home to the homeless. "I have blown a hole in time with a firecracker," says William Burroughs, the Survivor, at the end of *Cities of the Red Night*, a book dedicated to pirate utopias in the Caribbean and Madagascar. "A few may get through the gate in time. Like Spain, I am bound to the past."[14] However, "this does not imply," wrote Benjamin in reference to history as a state of seige, "that for the Jews the future turned into homogeneous, empty time. For every second of time was the strait gate through which the Messiah might enter."[15]

Atlantic

Living in the antipodes on the edge of the great southern sea did little to prepare me for what the south, let alone the beach, meant, once I went to live on the rainy island of England on the edge of the Atlantic at the age of twenty-seven. Never had I seen such desolate, ugly, uninspiring beaches as there. More than a cruel joke, a betrayal.

Years later I read of the same despair with that depressing English coast by Sylvia Plath in her exquisite memoir, "Ocean-1212W," written for the BBC in 1962 towards the end of her life, which a sailor from Baltimore, named Alicia Rabins, also a poet, brought me. The title refers to the telephone number of Plath's Austrian grandparents whom, living on the seaside, she would as a little girl call via the operator from her own house, on the bayside of a Boston headland of the Massachusetts coast, until the age of nine when her father died and her mother took the children to live away from the sea. It was gone. Utterly and forever. Along with the loss of childhood and the loss of the father.[16]

Much has been made of the death of the father, not least by her late

poet-laureate husband, Ted Hughes, who seems at times anxious to find her death in that death, killing herself at the age of thirty-one in 1963, a few months after their marriage broke up.

> As if you descended in each night's sleep
> Into your father's grave
> You seemed afraid to look, or to remember next morning
> What you had seen. When you did remember
> Your dreams were of a sea clogged with corpses,
> Death-camp atrocities, mass amputations.[17]

Ted had in mind poems like "Daddy," the most infamous of her *Ariel* poems written at fever pitch, sometimes two to three a day, in the months before she took her own life. The second and third stanzas:

> Daddy, I have had to kill you.
> You died before I had time—
> Marble-heavy, a bag full of God,
> Ghastly statue with one grey toe
> Big as a Frisco seal
>
> And a head in the freakish Atlantic
> Where it pours bean green over blue
> In the waters off beautiful Nauset.
> I used to pray to recover you.
> Ach, du.[18]

"Ach, du" ties the sea to language as tied to paternal power and memory, the next stanza implanting the German tongue in Polish towns scraped flat by incessant war. His is a phantom presence ("I could never tell where you/Put your foot, your root") such that she could never talk to him ("the tongue stuck in my jaw"):

> It stuck in a barb in a wire snare.
> Ich, ich, ich, ich,
> I could hardly speak.
> I thought every German was you.
> And the language obscene
>
> An engine, an engine
> Chuffing me off like a Jew.
> A Jew to Dachau, Auschwitz, Belsen.
> I began to talk like a Jew.
> I think I may well be a Jew.[19]

"In the waters off beautiful Nauset." A place for a prayer. "A head in the freakish Atlantic." His head? A headland? The same thing? "I began to talk like a Jew." Off to Auschwitz. "Where it pours bean green over blue." In any case, language going, going, gone, this Atlantic that, in Peter Linebaugh's recovery of William Blake's recovery of mythical Atlantis, in an article entitled "'All the Atlantic Mountains Shook,'" is seen in its African, European, and New World immensity as a crisscrossed multicultured history of the present.[20] More than a passageway to the New World, so the argument runs, this busy busy ocean provoked a New Way of thinking about the World, most especially about idiosyncracy replacing the norm, what Paul Gilroy, following Linebaugh's extraordinarily suggestive essay, called "the black Atlantic," anarchic mix of sailors and slaves and riff-raff plying the waves, planting the plantations, loading the ships both sides, all sides, of that ocean, humming with creolized languages and music and preindustrial visions of the Rights of Man that were, given the ways of ships and the sea, by no means rigidly bound to the categories of the nation-state. It was a new deal, a volatile and heterogeneous mass drawn from wherever the Atlantic washed ashore.[21] More a subaqueous influence and a utopic vision, a piratical antiauthoritarian potential *something*, waiting to be to sprung, this reemergent Atlantis cannot displace the dystopia of African slavery or the fact that the life of the sailor was nasty, brutish, and short. Instead the two realities, slavery *and* the Rights of Man, have to be recognized as two sides of the one coin, and this is why the Atlantic mountains shook. It could have been different. It still could!

Mediterranean

> Now, at last, I have seen the sea with my own eyes and walked upon the beautiful threshing floor of the sand which it leaves behind when it ebbs. How I wished the children could have been with me! They would so have loved the shells. Like a child, I picked up a good many because I have a special use for them.
> —Goethe, *Italian Journey, 1786–1788*

A "black" Atlantic directs us to the unwritten history that would alter the terms of historical reckoning as presently constituted, beginning with the search for an alternative to the father's signifying authority bound to the power of loss, which I see as Plath's endeavor, too. The transformation of language into play and the body may well have its liberatory side, notes Jacqueline Rose, but for her it also demonstrates "the high price, at the level of fantasy, that such a psychic process entails."[22] The most conspicu-

ous and contentious historical referent in this poem is the holocaust perpetrated by the Nazis and the vivid fantasies that that terror has created in its wake, a Holocaust that now, forty years after Plath's poem, has been extended to the trade in Africans as slaves to the New World. The "price" to which Rose refers us—and the term speaks for itself as testimony to the foreclosures enacted by Freud's restricted economy—demands I think more, not less fantasy, understanding thereby Atlantis and the Rights of Man as gifts we have been granted by the very horror of slavery, the Holocaust, and yes! by the enormity of Plath's death no less than by her poetic gifts. And by gift I mean something that can both recognize and cancel the debt in such a way as to extricate itself from that sad economy where the deck is always stacked.

As I understand it, Atlantis asks us here to examine how a freakish Atlantic exists retrospectively as montage and overlays on a long-sustained European—especially German—love affair with its exotic, even "black" or "African," south and with the antiquity it came to represent around the Mediterranean. However we might respond to this love affair, to the claims made for the body, beauty and sensuousness, light and sun, I feel we must include the image of truth, an image of layering into surface and depth, as well as secrecy and revelation. For is not the south, which is to say "the beach," the radical Other to truth as northern virtue? And is this dichotomy not built into the world's dominant languages and habits of perception?

Freud's thoughts, for instance, constantly turn south, as with his extended essay "Delusions and Dreams in Jensen's *Gravida*" (1907), analyzing a Danish author's tale of love and repression in the north, mimetically encased in the hardened lava of Pompeii as a result of the eruption of Vesuvius in 79 A.D. Finding this one of Freud's most charming writings, and noting Freud's enthusiasm for antiquities from the ancient Middle East, Greece, and Rome, Ernest Jones sees the essay as equating "the ancient time of two thousand years ago when the pair [of lovers] were supposed to have known each other . . . with the forgotten period of their actual childhood. The repression that blotted this out corresponds with the interment of Pompeii under ashes, but in neither case is there destruction, only burial."[23] The south is thus prehistory whose ruins, hardened in stone, are hidden stories for the analyst to excavate. To top it off, current childhood is antiquity—down "south," that is. Freud "had in him the dichotomy, not rare," relates Jones, "between the call of the North and that of the South. The high ideals of duty spoke for the North. There was Berlin, for instance, with its restless activity and unceasing impulse for achievement. But for pleasure, happiness, and pure interest the South was

preeminent." He showed Freud some poems from Browning expressing his love for Italy, at which, Jones recalls, Freud smiled, saying, "'I have no need for that; we have our own enthusiasts.'"

> O Woman country
> Woo'd, not won,
> Loved all the more by earth's male lands
> Laid to their hearts instead.[24]

Recall also Nietzsche's attachment, memorably expressed in his use of Italian *(La gaya scienza)* for the title of his most suggestive work, *The Gay Science* (1882), and a century before that, Goethe's *Italian Journey, 1786–1788*, and far from being something peculiar to past centuries, the South remains still an unselfconsciously sexualized site, as we witness in the work of W. H. Auden and Elizabeth Mayer, translators of Goethe's *Italian Journey*, and who, in 1962, assert Italy to be Goethe's sexual awakening and do so based on the evidence of portraits painted of him before and after his return. The latter show a "masculine, self-assured face," they claim, "that of man who has known sexual satisfaction."[25] Surely such endearingly brazen use of physiognomy says more about attitudes to Italy and habits of reading faces than it does about Goethe's sexual experience? But that is not the real point. As a pervasive instrument for navigating social space, the art of reading the secrets of the soul from the exteriority of the face bears an intimate relationship to the face of the South, overly expressive, overly endowed with the mimetic faculty.

In his justly famous section on "primitive accumulation" of modern capitalism, Marx evokes this issue of secrecy and "decadence" in the South, where he writes that the "villainies of the Venetian thieving system formed one of the secret bases of the capital-wealth of Holland to whom Venice in her decadence lent large sums of money."[26] This early modern history of capital's dependence on the (secret of the) South is, moreover, a relation among trading ports, the Venetian empire, in decline, and the burgeoning port city of Amsterdam, the former representing the history of the Mediterranean, the second the history of the Atlantic and the Dutch East Indies. Not only are these maritime cities but both are built on canals along whose turbid waters came the spices and silks from the East. Indeed the canals not only *are* the city but remind us that these cities are in essence continuously operating salvage operations squatting on swamps and mud precariously rescued from the ravages of the sea. The huge defenses of Venice were described by Goethe in 1786 as built of "uncemented stone blocks" pro-

tecting the city from storms and high tides, a city built on protuberances poking out of the muddy swamp that had been formed by "the interaction of tides and earth" as the "primeval ocean" gradually fell.[27] These prehistoric places of entry and exit where the coast breaks into neither one thing nor the other, anastomoses of islets, lagoons, and peninsulas—natural canals, we could say—seem to have been selected out by a historically informed nature as the generically fertile zones for generating money and trade, just as the prehistoric space-substance that is neither water nor land is where life began, and to which it will return. It took a seafaring nation operating out of an island with the largest navy in the world, namely England, to complete this process by adding, from the late-eighteenth century on (when the Venetian sea-borne empire finally died), the factory system to the African American plantation system.

What specific secret Marx had in mind in this financial relationship between Amsterdam and Venice, I cannot say. Certainly Venice had long been associated with sexual license. Its reputation for "decadence" brings to mind Richard Sennet's observation that "sensuality was a crucial element in the image of Venice in Europe, and in the Venetians' sense of themselves." Around the sixteenth century, this included high- and low-class prostitution, "a flourishing homosexual subculture devoted to cross-dressing, young men lounging in gondolas on the canals wearing nothing but women's jewels," and, also, the sensuous body of the ghettoized Jew, as the incarnation of attraction and repulsion.[28] The first ghetto in history was in Venice. Both Jews (from 1397) and prostitutes (from 1416) were forced by the city to wear yellow as their distinguishing color, the prostitute displaying a yellow scarf, the Jew a yellow star of David (or a hat). The public executioner was always a Jew. Always likely to be thought of by Christians as the quintessential depository of leprosy, syphilis (at first said not to be brought by Columbus but by Jews), other venereal diseases, and mysterious powers of pollution, these same Jews were the moneylenders, without whom the long-distance trade in spices underlying Venetian naval power would be brought to a halt. Hence *The Merchant of Venice* and, of course, his pound of flesh.[29]

Thus when Marx collapses "the villainies" and "decadence" of the Venetian "thieving system" into one of the secrets of capital, and specifically does so in relation to moneylending from south to north, it is hard to escape the feeling that this secret is grotesquely overdetermined by many centuries of intricate cultural practice fusing money, sex, magical pollution, ethnic division, and transgression. Not so much a secret as a public secret, it cannot but be a formidable player in the games of truth to which both Nietzsche and Freud spent their life's work alerting us. As with Marx's idea of the fetish of commodities, their idea was not that the secret conceals

truth like a blanket. Rather, the secret enters into the truth it conceals, making it impossible to separate the two, at least in the human, the social, world. Yet, at the same time, it seems impossible for human beings to accept such a gray-on-gray view of truth. Or, if they can accept such a view, they carve it up into distinct regions of truth, as for instance along the north-south axis—as when Julian Pitt-Rivers observes, in his skillful ethnography of secrecy in a small town in Andalusia around 1950, that by virtue of their skill at lying Andalusians put a higher value on truth than the naive and honest English.[30] This wonderful paradox not only makes the point that deception and truth can be conveniently plotted geopolitically, but that in fact they lie hand in glove and that knowing what not to know is what it takes to be a social being. Along with Nietzsche continually calling our attention to the positive social need for active forgetting and endorsement of illusion, thus raising the stakes of truth and writing truth to infinite heights, I think of such active not-knowing as a well-guarded public secret. In my opinion this type of knowledge is the most ubiquitous, the most powerful, and the most complex type of social knowledge there is. Ideology, discourse, and habitus pale into insignificance compared with this social art of knowing what not to know—and knowing when and how to reveal it, what Brecht called showing showing ("Showing Has to Be Shown"), the crucial component of his work as playwright, director, and poet.[31]

By linking such a public secret with the genesis of modern capitalism—its "*primitive* accumulation," no less—Marx can be read as picking at a theme in his general economic theory that I see as worth our while to think about. This theme, at least as I choose to identify it, concerns the argument that control over the trick of truth lies as much at the heart of business as it does over the way by which "labor," meaning human beings at work, is flip-flopped between its market-value and its use-value so as to create profit. This idea is reinforced when we read Marx's chapter in *Capital* on labor power in which, as in a stage play, we follow Moneybags going to market to hire a laborer but, at the point where he and his newly hired man pass into the factory, we are stopped from following them. "No admittance except on business," says Mr. Marx primly, drawing the line between the openness of the market, on the one hand, and the alchemy of the labor process, on the other. But then he relents, as we knew he would, the whole point about secrets being the love we share in revealing them. "Here we shall see," writes the great exposer, taking us into the dark depths of the factory, "not only how capital produces, but how capital is produced. We shall at last force the secret of profit making."[32] What he intends to reveal is how labor is the unique use-value that can produce more market-value than it itself was bought for. This is given in labor itself,

we might say, but only if we stack up the vast philosophical edifice writ into the reifying function of the market and the Hegelian concern with the logic of matter versus the matter of logic, which is to say use-value versus exchange-value, two sorts of value that, thanks to the market and the function of abstract equivalence provided by money, can be constantly articulated, disarticulated, and rearticulated once again.

If the Enlightenment was ruthless in exposing secrets as its claim to power, as in the heroic trope of demystification, other engagements with power, such as Nietzsche's notion of *la gaya scienza*, do recognize the truth game as tougher than this and have settled on the strategy of the ruse in the never-ending struggle with the Nervous System of social reality.[33] And although Marx most certainly can be cast in the heroic mold of the demystifier, stealer of Promethean fire, and so on, the secret of profit making to which he points us demands a completely different aesthetic of revelation—not so much exposure of the secret, as Benjamin once put it, but a revelation that does justice to it.[34]

For if it wasn't for this spiral-like transformation back and forth between its use- and exchange-value, between the logic of matter and the matter of logic, there could be no expansion in value and no capitalism. Everything hinges on what Marx early on refers to as the articulation of the *substance* with the *magnitude* of value, the concrete particular with the abstract universal, the flesh-and-blood sensuous mimetic with the system of relationships of difference that is the semiotic—which is how Benjamin would have us understand the exploitation of the archive of nonsensuous correspondences by the labor involved in writing and reading, too.[35] This suggests we might look for an understanding of the secret of profit in just that flashlike recognition which Benjamin repeatedly singles out in essays spanning his life's work on language, history, and the image.

"The mimetic element in language, can, like a flame, manifest itself only through a kind of bearer," he wrote in 1933 in his astonishing essay on the mimetic faculty. "This bearer is the semiotic element." The "secret" in this labor for Benjamin is manifested, not revealed, by his curious figure of the momentary "flash" of recognition with which the mimetic connection is ignited between signifier and its signified. "Thus the coherence of words or sentences," he explains, "is the bearer through which, like a flash, similarity appears."[36] In an earlier version of this essay, "Doctrine of the Similar," this "flash" is presented as follows: "The perception of similarity is in every case bound to an instantaneous flash. It slips past, can possibly be regained, but really cannot be held fast, unlike other perceptions. It offers itself to the eye as fleetingly and transitorily as a constellation of stars."[37]

This mysterious flash of recognition, emerging then disappearing, is the

same exquisite moment he postulates for the role of memory in his famous commentary on Marxist historiography, "Theses on the Philosophy of History," the fifth thesis of which begins like this: "The true picture of the past flits by. The past can be seized only as an image which *flashes up at an instant* when it can be recognized and is never seen again." In the following thesis we encounter the well-known dramatic lines, "To articulate the past historically . . . means to seize hold of a memory as it *flashes up at a moment of* danger."[38] And it is this same emergence and equally sudden disappearance of recognition that he recruits for the *dialectical image,* which he once referred to as "the primal phenomenon of history." "It is like lightning," he jotted down in the "*Konvolut* N," together with the other notes he carefully kept for his never-finished Paris arcades project. "The past must be held like an image flashing in the moment of recognition. A rescue thus—and only thus—achieved, can only be effected on that which, in the next moment, is already irretrievably lost" ("N," p. 21). To which he added that "what matters for the dialectician is having the wind of world history in his sails. Thinking for him means: to set sail. It is the way they are set that matters. Words are his sails. The way they are set turns them into concepts" ("N," p. 21).

Given this abrupt motion of recognition as disappearance, we may well ask, Is not this dialectical ship of Benjamin's the same three-master Joyce showed us so suddenly coming out of nowhere behind Stephen Dedalus's back, "rere regardant"? One thing is for sure, and that is the function here of the beach on which young Dedalus stands, then, and all the more so, now. If, as I have stated, the beach is the ultimate fantasy space where nature and carnival blend as prehistory in the dialectical image of modernity, the beach in the Western tradition has achieved this status on account of its propensity for play and childhood (witness Goethe and his shells). The point is, however, that this is precisely the setting for the boosting of the mimetic faculty, binding in a flash of disappearing recognition nature to artifice, a speaker to a language, and sensuousness to sense. "Rere regardant."

There are many themes that course through this "flash" articulating the logic of matter with the matter of logic, such as Benjamin's abiding passion for montage as epistemology as well as style, thus appropriating Freud's notion of fantasy as montage and overlays and converting it into a veritable technique, not so much of psychoanalysis as of cultural analysis. A crucial difference with Freud, of course, lies with the surrealist flair in Benjamin's method, the montage being the essential component of analytic expression and not something to be translated into the logic of narrative. This, after

all, paralleled Benjamin's efforts to outshock the shock effects wrought by modernity on memory and hence on the capacity for experiencing reality. But there is little doubt in my mind that the most significant theme in this mysterious flash of recognition is the eruption of a prehistoricity into the present and the impact this carries as waking from a dream to see, in that instant of awakening, the surrealist face of things.

"The *correspondances*," wrote Benjamin, in reference to Baudelaire's forest of symbols, "are the data of remembrance—not historical data, but data of prehistory." And he cites Baudelaire's sonnet "La Vie antérieure" with "its images of caves and vegetation, of clouds and waves" arising from the "warm vapor of tears, tears of homesickness." "There did I live."[39] This is another home or *heim*, both homely and secret, and for Benjamin it is also Kafka's uncanny *heim* where in time and through time the nineteenth- and twentieth-century European city installs a Venetian swamp world of prelinguistic, gesturally vivid animals, spirits, and curious intermediary persons in transformative flux as collected in "Amerika" by the Nature Theater of Oklahoma.[40] "'The Hunter has been turned into a butterfly. Do not laugh,'" demands the hunter Gracchus, the centuries-long dead hunter brought into port by an author living in one of the most landlocked regions of the world, hence stimulating the title of a recent and strikingly original study of Czech history by Derek Sayer, *The Coasts of Bohemia*.[41] "'I am always in motion,'" insists the hunter Gracchus, who envisions a shining gate before him in his supreme exertions, while all the time lying on a wooden pallet wearing a filthy winding sheet, his hair and beard, black tinged with gray, grown together, his limbs covered with a great flower-patterned woman's shawl with long fringes. "'A sacramental candle stands at my head and lights me,'" he says. "'On the wall opposite me is a little picture, evidently of a bushman who is aiming his spear at me and taking cover as best he can behind a beautifully painted shield.'" It is a dead man speaking, adrift on the high seas winding around him like hair, time flowing as images come and go. For the moment he has come into our landlocked port. Through a hole in the side of the boat the warm air of the southern night enters, and he hears the slapping of the water on the old hull.[42] Back to Joyce. Back to the beginning. This is language moving into the sea as our very bodies might, buoyed up by its watery, moving energy and the human facility with mimesis. "Listen: a fourworded wavespeech: seesoo, hrss, rsseeis, ooos. . . . In cups of rocks it slops: flop, slop, slap: bounded in barrels."

The secret of capital's capacity for self-expansion thus begins to look even more intriguing than what Marx himself elaborated as the interplay of use- with exchange-value within that unique commodity, the commodity of labor. And it certainly looks a lot more fascinating than the arithmeti-

cal forms to which capital's self-reflection translates and reduces the mystery of value as price, the outcome of "supply" and "demand" beholden to the logic of profit maximization by individuals in rational pursuit of self-interest. For what I am arguing is that the secret of the expansion in value is a consequence of an artistically contrived revelation around the axis of prehistory. The trick, for the modern capitalist magic to function, is to deface the commodity of labor, allowing its mimetic or use-value component to surge forth, flashlike, only to disappear once again as an expanded semiotic or exchange-value. Hence fetishism is not a consequence but the magical precondition for the commodity, and hence for mature capitalism, to function. We should not be overly surprised, therefore, at the spectacular "return" of the archaic within modernity.

I am arguing that the prehistoric, as "second nature," tied to the history of the world as the economic history of three oceans, is subject by the conditions of modernity to a specific aesthetic of revelation, expanding value. I have also argued that this revelation is not of a secret so much as of a public secret, of knowing what not to know, the very basis of being social, and that the manipulation of this labor of negation, as involved by its revelation, implies a specific mix of repression and of expression, what Georges Bataille called nonprofitable "expenditure."[43] The chronicle of this mix and its extraordinary tensions is displayed in yet another tale of Venice and its all too southern secrets, namely, the history of the plague in relation to the love that dare not speak its name in Thomas Mann's 1912 novella, "Death in Venice."[44]

Here the secret of cholera, seeping from the south into the soft underbelly of Europe, is spliced to the private fantasy of Gustav von Aschenbach, an uptight, middle-aged, mentally spent German writer on holidays, smitten by a beautiful boy aged fourteen, also holidaying by the beach in Venice. State authorities stoutly deny the existence of cholera, while busily spraying the canals with carbolic, and the local serving class, waiters and barbers for instance, take pleasure in emitting obscure signals as to death in Venice. It is a city ruled by a secret, a public secret, a secret about secrecy. Its inhabitants know what not to know. It is the intimation of this that haunts von Aschenbach. Finally it is a tweed-clad Englishman who tells him the truth. He is a clerk in a British travel agency, "still young," writes Mann, "with his hair parted in the middle, his eyes close set, and having that sober, honest demeanor which makes so unusual and striking an impression amid the glib knaveries of the south" ("DV," p. 252).

For the secret is overdeterminedly southern. But, at the risk of enormous and enormously forgotten banality, note there can be no south with-

out a north. The secret then is "Asiatic cholera," and its lair is the innermost recess of the Third World—originating in the "sultry morasses of the Ganges delta, rising with the mephitic exhalations of that wilderness of rank useless luxuriance, that primitive island jungle shunned by man, where tigers crouch in the bamboo thickets"("DV," pp. 252–53).

The secret is not only southern but of the sun—of the sun that Bataille, in the opening pages of *The Accursed Share,* wrote of as emblematic of the principle of exuberant expenditure, which unlike other gifts with their demand to be paid back, *it gives without receiving.*[45] This is the same principle expressed in Mann's "sultry morass of the Ganges delta" and is even more explicit in the figure of the secret as rising with the exhalations of "that wilderness of rank useless luxuriance." Indeed the dizzying interaction of sun and plantlife is central to Bataille's picture, too; as prelude to his exposition of *general economy* he wrote, "The living organism ordinarily receives more energy than is necessary for maintaining life; the excess energy (wealth) can be used for the growth of a system (e.g., an organism); if the system can no longer grow, or if the excess cannot be completely absorbed in its growth, it must necessarily be lost without profit; it must be spent, willingly or not, gloriously or catastrophically."[46]

Compare with von Aschenbach at the beginning of *Death in Venice* when, caught off balance by the sight of a strange person in the portico of a mortuary chapel in Munich, he is spun into the following fantasy in the form of an hallucinatory seizure.

His imagination, still not at rest from the morning's hours of work, shaped for itself . . . a tropical swampland under a cloud-swollen sky, moist and lush and monstrous, a kind of primeval wilderness of islands, morasses and muddy alluvial channels; far and wide around him he saw hairy palm-trunks thrusting upward from rank jungles of fern, from among thick fleshy plants in exuberant flower; saw strangely misshapen trees with roots that arched through the air before sinking into the ground or into stagnant shadowy-green glassy waters where milk-white blossoms floated as big as plates, and among them exotic birds with grotesque beaks stood hunched in the shallows, their heads tilted motionlessly sideways; saw between the knotted stems of the bamboo thicket the glinting eyes of a crouching tiger; and his heart throbbed with terror and mysterious longing. ["DV," p. 197]

In other words, Bataille's "principle of expenditure," of the universal necessity of humankind to spend without profit, "gloriously or catastrophically," guides this fantasy of fusing the wilderness of rank luxuriance with the compressed figure of concealment of the tiger, wild and magnificent and of course glinty-eyed, crouching in the bamboo thickets. We can almost see one of the *douanier* Henri Rousseau's tigers, vintage 1910, wink-

ing at us, its sad wandering eye the most human thing in this swampland of waves and stripes like a prisoner's, blending with the bamboo stalks pressed tight under a silver moon. This is also Elias Canetti's zoomorphic figure of the secret as a wild animal, epitome of a violence made all the more horrible on account of its infinite patience, stalking its prey.[47]

And why the Ganges and the "tropical swampland" with its "primeval wilderness of islands, morasses and muddy alluvial channels"? Conrad has his heart of darkness begin as a mysterious serpentine river emerging from central Africa on a map he saw as a boy in Poland, and Mann in Germany not too many years later has his river, too, in India, as if these waterways are predestined to flow into the northern imagination. After all, it has been largely by virtue of their mighty rivers that Africa, Asia, and the Americas were laid open to the European, who in many places, conducted business right there on the ship's deck and not a step further.

Indeed it is flow and the liquid force of a metamorphosing animality, preestablished by the mysterious force of the Ganges with its sun and wild luxuriance, that comes to inflame von Aschenbach's dreaming that fateful night, when he decides against telling the boy's family of the plague in the hope that in their ignorance they will stay a few more days by the beach. In making the momentous decision not to tell the secret of the plague, so as to conserve his secret fantasy of a troubled love, his nocturnal mind wanders feverishly through a Dionysian fantasy of lust and transformation at the primordial beginning of time itself. When day breaks, the sky clears, and there stands not the tropical swampland with the glinting eye of the tiger, but the beach.

The south would not be what it has to be in this scheme of things concerning secrecies and transgression were it not for its glorious sun and, better still, its beach, where children play building sandcastles and adults play at becoming children, where bright awnings flap in the sultry breeze, bodies are partially stripped of their clothes, and colors leap in the reflections of the sun playing on the water's moving surface. Here the margin between land and sea is where the repression sustaining civilization takes a transgressive dive and where, moreover, it is to be seen doing so. And beyond the beach, the sea, to what in this tale is the empty eternal, the great nothingness into which von Aschenbach's gaze escapes from the rigor his life as a writer demands.

Von Aschenbach's own body, if only he knew it, is to serve as Mann's beachhead, a playground of passion let loose, like line from an angler's reel, only to be jerked into place by dying forces of artistic creativity dependent upon repression. This is the ultimate and terrible cruelty, this image

of creativity as the sublimated product of repression. Here on this body as beachhead, Bataille sets a course diametrically opposed to the restricted economy of Freud for whom the north travels south to the beach to stoke the primitive fires of the flesh and then returns to the north to advance the spirit. An age-old pattern, it seems. An eternal return. A geography of the human soul. But what if we one day got stuck and didn't come back? Death in Venice. That's what.

"'You see,'" said a friend in Munich, "'Aschenbach has always only lived like *this*,'" and he closed his fist tightly. "'Never like *this*'—and he let his open hand hang" ("DV," p. 201).

As he sinks into the transgressive realm, von Aschenbach tries to make his face younger with lipstick, facial creams, and a cute haircut. At least his face shall grant some physical reality to the fantasy consuming him. This is where his life will now for the first time meet and transcend his art, where life and art will change places, and it must needs be that this fatal encounter will occur on the beach and on the artwork that is the surface of his awakening body, notably on his fake face, window and mask to the soul. Now he is on the beach, where life forms began, but from which people now flee on account of death. He is watching the boy playing his last game in the sand before leaving Venice. A playmate wrestles the boy to the ground, buries his face in the sand, suffocating him with the cruel force of his knee. "His attempts to shake off the weight of his tormentor were convulsive; they stopped altogether for moments on end and became a mere repeated twitching" ("DV," p. 262). When finally released the boy walked away, ignoring the calls of his playmate, laughing at first, then anxious, who was brushed aside. This boy is locked in Aschenbach's gaze. He is walking now into the water, wading to the sand bar. He is slowly pacing back and forth on this narrow strip of unsubmerged land divided from the shore by a width of water, an apparition walking as if on water with his floating hair "out there in the sea, in the wind, in front of a nebulous vastness" ("DV," p. 263). On impulse he turns towards Aschenbach, his eyes seeming to call and beckon to the horizon. He is still. The beach is still. Just them. Everything is frozen. And as Aschenbach struggles to clamber out of his deck chair and project his body into the flight path of his eyes, Mann kills him—and thus contains his writerly fantasy of forbidden love wrought from the water's edge.

"Will and Wave"

"Will and Wave" is the title Nietzsche gives to a passage in *The Gay Science*, surging with the rhythm and disorder inherent to what I call the Nervous System, always one step ahead of one's grasp. This of course is writing,

dissembling itself in anticipation of its exposure, so as to all the more effectively come to grips with the chameleon we call truth.

So? You mistrust me? You are angry with me, you beautiful monsters? Are you afraid that I might give away your whole secret? Well, be angry with me, arch your dangerous green bodies as high as you can, raise a wall between me and the sun—as you are doing now! Truly, even now nothing remains of the world but green twilight and green lightning. Carry on as you like, roaring with overweening pleasure and malice—or dive again, pouring your emeralds down into the deepest depths, and throw you infinite white mane of foam and spray over them.[48]

The Dionysian impulse for Nietzsche involved mimicry as a form of immersion into the substance of the Other, the notion of mimicry later adopted by Benjamin and Adorno with regards to the aesthetic force and media of representation released by modern life. The sea as it breaks on the shore provides an apt figure for such a mimesis, the profound transformation no less than the chaos of an eternal becoming. By talking to nature, the writer indulges a necessary fantasy in which the waves, both broken and about to break, have become humanlike, yet distinct from him, so that, within the fusion of self with Other, the writer and the waves maintain the distance of discourse. This involves the fantasy of a secret compact with nature about secrecy, precisely what is necessary to reconfigure the way capitalism has recruited the mimetic faculty as the nature culture uses to create second nature, home of the archaic. "How could I think of betraying you? For—mark my word!—I know you and your secret, I know your kind! You and I—are we not of one kind? You and I—do we not have *one secret?*"[49]

And while the sun is of great importance in his scheme, as it was for Bataille and his pineal eye, the sea is what I remember, my home, my secret *(Heim und Geheimnis)*, as much for what it is as for the fluency with which Nietzsche draws upon it for poetic and philosophic inspiration concerning explanation and Being as liquid force. A chance, a chance to make a difference. Walter Kaufmann sees "Will and Wave" as a deliberately purposeless piece of writing, a Dionysian moment in which childish play is allowed a space, as on the beach, just prior to Nietzsche's first formulation of the eternal return as the sign of meaninglessness and lack of purpose in the apparent design that is world history.[50] Yet surely the point of such Dionysian "moments" is that they transgress time as well as custom, so as to seem anything but "moments" fixed to a cordoned-off site licensing disconformity? For the beach is precisely the scene where prehistory became human history, as when Nietzsche, citing the enormity of the break with what went before the invention of guilt and instinctual repression, "turn-

ing man against himself," compares it with the fate of sea animals forced to become land animals or perish. "I do not think there has ever been such a feeling of misery on earth, such a leaden discomfort." Here there is certainly no "lack of design" in human history, and the Dionysian play of will and wave acquires premeditated political force. For the whole point of Nietzsche's work was to try for "the reverse experiment," undoing the repression that turned man against himself. It should be possible, "*in principle*—but who has sufficient strength?"[51] No accident, then, that the reverse experiment has to be down there at the water's edge, edge of history, edge of repression, "turning man against himself," the most fateful mimetic act of all. Prehistory, as Benjamin kept emphasizing for his cherished "dialectical image," returns in the form of "second nature," ensuring that as fantasy overextends itself, turning memories into bodily symptoms and corporeal signs, so a newly buoyant language moves us into the sea as our very bodies might. Returning to Winthrop on the Massachusetts coast in the winter of 1958, Sylvia Plath found it "shrunk, dulled, wrinkled its dense hide: all those rainbow extensions of dreams lost luster, shells out of water, color blanching out."[52] Goethe rediscovered the imagination of the child when, at Venice, for the first time in his life he saw the sea and strode along the beach at low tide and found shells. The surf was breaking on the beach in high waves. He loved what he called "the beautiful threshing floor of the sand" left when the waves went out to sea again. "Like a child, I picked up a good many," these same shells that make Plath despair and ask whether "our minds colored the streets and children then and do so no longer." She could have been echoing Nietzsche as to the fate of sea animals forced to become land animals or perish. "I do not think there has ever been such a feeling of misery on earth, such a leaden discomfort." "We must fight," she went on in her journal; "we must fight to return to that early mind. . . . We must recreate it, even while we measure baking powder for a hurry-up cake and calculate next month's expenses. A god inbreathes himself in everything. Practice. *Be* a chair, a toothbrush, a jar of coffee from the inside out: *know* by feeling in."[53] Like the poems, the journal highlights fantasy and montage. Burroughs: "I think of words as being alive like animals. . . . Cut the pages and let the words out." The beach. Something we enjoy, an eternal childhood we continuously lose to green twilight and green lightning, afterimage of waves arching themselves between myself and my sun. Practice.

Notes

This essay was written for the conference "Fantasy Spaces: The Power of Images in a Globalizing World," organized by the Research Center for Religion and Society of the University of Amsterdam, Amsterdam, 27 August 1998.

1. See Sigmund Freud, letter to Wilhelm Fliess, 2 May 1897, in *The Complete Letters of Sigmund Freud to Wilhelm Fliess,* trans. and ed. Jeffrey Moussaieff Masson (Cambridge, Mass., 1985), p. 239.

2. William Burroughs, "The Literary Techniques of Lady Sutton-Smith," *Times Literary Supplement,* 6 Aug. 1964, p. 682.

3. See Charles Olson, *Call Me Ishmael* (San Francisco, 1947).

4. This theme is evoked and explored with originality and great insight by Allan Sekula in his *Fish Story,* a catalogue of 204 pages of text and photographs to accompany a travelling exhibit (Dusseldorf, 1995). Reminiscent of John Berger's work with photographs by Jean Mohr, Sekula writes a terse, telegraphic, echoing prose alongside his photographs that, through a wide-ranging Marxist sensibility, knits together political with art historical interests concerning the awesome mix of business and romance that is the sea and the ships that cross it. (Thanks to Tom Mitchell and Antony Gormley for reminding me of this work, and Michael Watts for giving me a copy of it as the deluge descended over San Francisco.)

5. James Joyce, *Ulysses: Annotated Student's Edition,* ed. Declan Kiberd (Harmondsworth, 1992), pp. 3, 1, 4; hereafter abbreviated *U.*

6. Quoted in Walter Benjamin, "N [Theoretics of Knowledge; Theory of Progress]," *The Philosophical Forum* 15 (Fall–Winter 1983–84): 12; hereafter abbreviated "N."

7. Theodor W. Adorno, "A Portrait of Walter Benjamin," *Prisms,* trans. Samuel and Shierry Weber (Cambridge, Mass., 1981), p. 233.

8. Olson, *Call Me Ishmael,* p. 13.

9. *Oxford English Dictionary,* 2d ed., s.v. "pelagic."

10. Benjamin, "The Storyteller: Reflections on the Work of Nikolai Leskov," *Illuminations,* trans. Harry Zohn, ed. Hannah Arendt (New York, 1969), p. 87.

11. Georg Lukács, "Reification and the Consciousness of the Proletariat," *History and Class Consciousness: Studies in Marxist Dialectics,* trans. Rodney Livingstone (London, 1971), p. 83.

12. Klaus Theweleit, *Male Fantasies,* trans. Stephen Conway, Erica Carter and Chris Turner, 2 vols. (Minneapolis, 1987), 1:xviii–xix.

13. See Hakim Bey, *T. A. Z.: The Temporary Autonomous Zone, Ontological Anarchy, Poetic Terrorism* (New York, 1985). See also Peter Lamborn Wilson, *Pirate Utopias: Moorish Corsairs and European Renegadoes* (New York, 1995).

14. Burroughs, *Cities of the Red Night* (New York, 1981), p. 332.

15. Benjamin, "These on the Philosophy of History," *Illuminations,* p. 264.

16. Her father was German, born in Grabow, in the Polish Corridor, and a professor of entomology. See Anne Stevenson, *Bitter Frame: A Life of Sylvia Plath* (Boston, 1989), pp. 4–5.

17. Ted Hughes, "Dream Life," *Birthday Letters* (New York, 1998), p. 141.

18. Sylvia Plath, "Daddy," *Ariel* (New York, 1966), p. 49.

19. Ibid., pp. 49–50.

20. See Peter Linebaugh, "'All the Atlantic Mountains Shook,'" *Journal of Canadian Labour Studies* 10 (Autumn 1982): 87–121.

21. "I have settled on the image of ships in motion across the spaces between Europe, America, Africa, and the Caribbean as a central organizing symbol for this enterprise and as my starting point" (Paul Gilroy, *The Black Atlantic: Modernity and Double Consciousness* [Cambridge, Mass., 1993], p. 4). This helps him get away from nationalistic and ethnically rooted analyses, in favor of "rhizomorphic, fractal structure of the transcultural, international formation I call the black Atlantic" (ibid.).

22. Jacqueline Rose, *The Haunting of Sylvia Plath* (Cambridge, Mass., 1991), p. 227. Rose has suggested that the poem "Daddy" outlines "the conditions under which that celebrated loss of the symbolic function takes place." She goes on to point out that if identity and language thus lose themselves in the place of the father (and the Lacanian reference is resonant here), his absence nevertheless gives him unlimited powers. In fact she regards this poem as addressing the "production of fantasy as such," "a poem about its own conditions of linguistic and phantasmic production" (ibid., pp. 227, 230). See also pp. 235–38.

23. Ernest Jones, *Years of Maturity: 1901–1919*, vol. 2 of *The Life and Work of Sigmund Freud* (New York, 1955), p. 341. See Freud, "Delusions and Dreams in Jensen's *Gravida*," *The Standard Edition of the Complete Psychological Works of Sigmund Freud*, trans. and ed. James Strachey, 24 vols. (London, 1953–74), 9:7–93.

24. Jones, *The Formative Years and the Great Discoveries, 1856–1900*, vol. 1 of *The Life and Work of Sigmund Freud* (New York, 1953), p. 331. Freud's letter to Fliess are a gold mine for such Italian references.

25. W. H. Auden and Elizabeth Mayer, introduction to J. W. Goethe, *Italian Journey, 1786–1788*, trans. Auden and Mayer (San Francisco, 1962), p. xvii.

26. Karl Marx, "The So-Called Primitive Accumulation," *Capital: A Critique of Political Economy*, trans. Samuel Moore and Edward Aveling, ed. Frederick Engels, 3 vols. (New York, 1967), 1:755–56.

27. Goethe, *Italian Journey, 1786–1788*, p. 82.

28. Richard Sennet, *Flesh and Stone: The Body and the City in Western Civilization* (New York, 1994), p. 223.

29. See ibid., and Jan Morris, *The Venetian Empire: A Sea Voyage* (New York, 1980), p. 148.

30. See Julian A. Pitt-Rivers, *The People of the Sierra*, 2d ed. (Chicago, 1971), pp. xvi–xvii.

31. See Bertolt Brecht, "Five Theatre Poems," *Bertolt Brecht Poems: 1913–1956*, ed. John Willett, Ralph Manheim, and Erich Fried (London, 1976), pp. 340–43.

32. Marx, *Capital*, 1:176.

33. See Michael Taussig, *The Nervous System* (New York, 1992), esp. the introduction.

34. See Benjamin, *The Origin of German Tragic Drama,* trans. John Osborne (London, 1977), p. 31.

35. See Benjamin, "On The Mimetic Faculty," *Reflections: Essays, Aphorisms, Autobiographical Writings,* trans. Edmund Jephcott, ed. Peter Demetz (New York, 1978), p. 335.

36. Ibid.

37. Benjamin, "Doctrine of the Similar," trans. Knut Tarnowski, *New German Critique* 17 (Spring 1979): 66.

38. Benjamin, "Theses on the Philosophy of History," *Illuminations,* p. 255; emphasis added.

39. Benjamin, "On Some Motifs in Baudelaire," *Illuminations,* p. 182.

40. See Benjamin, "Franz Kafka: On the Tenth Anniversary of His Death," in *Illuminations,* pp. 111–41.

41. Franz Kafka, "The Hunter Gracchus," *Franz Kafka: The Complete Stories,* ed. Nahum N. Glatzer (New York, 1971), p. 228. See Derek Sayer, *The Coasts of Bohemia: A Czech History* (Princeton, N.J., 1998).

42. Kafka, "The Hunter Gracchus," p. 229.

43. See Georges Bataille, "The Notion of Expenditure," *Visions of Excess: Selected Writings, 1927–1939,* trans. Allan Stoekl, Carl R. Lovitt, and Donald M. Leslie, Jr., ed. Stoekl (Minneapolis, 1985), pp. 116–29.

44. See Mann, "Death in Venice" (1912), *"Death in Venice" and Other Stories,* trans. David Luke (New York, 1988); hereafter abbreviated "DV."

45. See Bataille, *The Accursed Share: An Essay on General Economy,* trans. Robert Hurley, 3 vols. in 2 (New York, 1988), 1:28.

46. Ibid., 2:5.

47. See Elias Canetti, "Secrecy," *Crowds and Power,* trans. Carol Stewart (London, 1962), pp. 290–96.

48. Friedrich Nietzsche, *The Gay Science,* trans. Walter Kaufmann (New York, 1974), pp. 247–48.

49. Ibid., p. 248.

50. Kaufmann, footnote 38, *The Gay Science,* p. 248.

51. Nietzsche, *On the Genealogy of Morals,* trans. Carol Diethe, ed. Keith Ansell-Pearson (Cambridge: 1994), pp. 61, 70.

52. Plath, *The Journals of Sylvia Plath,* ed. Ted Hughes and Frances McCullough (New York, 1982), p. 182.

53. Ibid.

Hic Jacet

In an interview with the German magazine *Der Spiegel* in 1966, Martin Heidegger declared that "only a god can save us," but I live in a part of the country where new houses and buildings are cropping up everywhere—expensive ones at that—and hardly a day goes by that I don't think to myself, "only an architect can save us."[1] As a layperson I get the impression that a discrete catastrophe is taking place in America these days, the loss of the basic art of building. It seems that we can no longer design a simple, inoffensive home that does not somehow appear false, or erect a public edifice in which "truth of feature [is] related to truth of being," as Frank Lloyd Wright once expressed his wish for American architecture.[2] The fracture between truth of feature and truth of being grows ever wider, for reasons that we can speculate about endlessly and probably not very fruitfully. Manfredo Tafuri believed that any substantial reforms in architecture would have to wait until after the existing social and economic structures of society have been overturned. Heidegger believed that only a new epochal revelation of the sacred could alter the way we dwell and, hence, the way we build. Must we change our way of existing before we can change our way of building? Or would changing the way we build change the way we exist? Frankly it's undecidable. Yet if human being is a "being in the world," as Heidegger maintained, then nothing is more essential to our being than our building practices, given that the world into which we are thrown is always a *built* world. We take our measure of being from what surrounds us, and what surrounds us is always, to some extent, of our own making. Building, which starts from the ground up, is where the fundamental ontology of our mundane lives both begins and ends.

349

The following essay engages one of the basic questions around which such an ontology inevitably revolves, that of place. What is a place? How does it get established? How does building define or articulate its where-withal? In what does its placehood consist? Much has been written about place of late, both by philosophers and historians of architecture, and while the literature is extremely good, some of it suffers from a lack of anthropological insight when it comes to identifying the ground on which places have traditionally been founded.[3] I intend the term *ground* both literally and nonliterally. It is because places come into being through acts of human grounding that the term possesses its literal and nonliteral senses. The wherewithal of place does not preexist the act of building but is created by humanity's mark—its edified sign or signature—on the landscape. It is the substance of such marking that interests me here, for I believe it is impossible to understand the nature of place without taking into account the origin and founding power of that marking.

Let me begin with an unproblematic proposition: A place is defined by its boundaries, its intrinsic limits, its distinctly local "here" that remains fixed in space even as it perdures in time. I follow with a slightly more controversial claim: Places do not occur naturally but are created by human beings through some mark or sign of human presence. A wilderness in itself is placeless, for it has no human center or point of convergence around which nature can gather and become bounded. Wallace Stevens's poem "Anecdote of the Jar" describes the minimal conditions of this sort of place-making:

> I placed a jar in Tennessee,
> And round it was, upon a hill.
> It made the slovenly wilderness
> Surround that hill.
>
> The wilderness rose up to it,
> And sprawled around, no longer wild.
> The jar was round upon the ground
> And tall and of a port in air.
>
> It took dominion everywhere.
> The jar was gray and bare.
> It did not give of bird or bush,
> Like nothing else in Tennessee.[4]

I would draw attention first of all to the way in which "a hill" in the second verse becomes "that hill" in the fourth, suggesting that the placement of the jar has established a horizon of reference for the demonstrative pro-

noun's deictic gesture. The jar is not a piece of architecture, properly speaking, yet it brings about the *domestication of space* that we associate with architecture's place-creating functions. Tamed by the object's presence, the "slovenly wilderness" now "rises up to" and "surrounds" this center of orientation. The jar provides the surrounding nature with a measure of containment, of *human* containment, I would insist, by virtue of the fact that the object is man-made and has been placed there by a human being. It lies there as a kind of urn in the midst of the wilderness. The entire transfiguration of the scene of nature—its topical convergence in one place—is due to the introduction of this sign of human worldhood.

That worldhood is defined above all by time. In *The Ethical Function of Architecture* Karsten Harries writes that "any view that understands architecture as the art of establishing place by the construction of boundaries in space is inevitably one-sided. While dwelling requires the establishment of place, place must also be understood temporally."[5] I would go even further and say that a place is where time, in its human modes, takes place. A place cannot come into being without human time's intervention in nature's eternally self-renewing cycles—the cycles of "bird and bush," as it were. What intervenes in natural time is human finitude, which is unlike other finite things in that death claims our awareness before it claims our lives. We dwell in space, to be sure, but we dwell first and foremost within the limits of our mortality. When we build something in nature, be it a dwelling, a monument, or even a fire, we leave a sign there of our being mortal sojourners on the earth.

The aboriginal sign of this mortality, of which Stevens's jar is a kind of everyday correlate, is the grave marker. It is not for nothing that the Greek word for sign, *sema*, is also the word for grave. For the Greeks the grave marker was not just one sign among others. It was a sign that signified the source of signification itself, since it stood for what it stood in—the ground of burial as such. In its pointing to itself, or to its own mark in the ground, the *sema* effectively opened up the place of the "here," giving it that human foundation without which there would be no places in nature.

In his book *Statues: Le Second Livre des fondations,* Michel Serres reminds us that the archaic statue came into being as an anthropomorphic stele or the lapidary representative of the person who lay buried at the site of its erection. Indeed, in its earliest instantiations there was no such "representation" involved, since the first statue, according to Serres, was the mummified corpse itself. If "the cadaver and the mummy lie where their statue is raised," and if the latter bodies forth the figure of the former, then the statue is indeed a *sema* in the full, multivalent Greek sense.[6] Earlier I suggested that Stevens's jar lies in the Tennessee landscape like

a kind of urn, to which I would now add that it stands there like a kind of primitive statue, not because it represents a deceased person or marks a grave in any explicit sense, but because in its createdness and deliberate placement on the hill it embodies the mortality of whoever forged it, placed it there, or recognizes it as the object it is, either in itself or in the poem that names it.[7]

I agree with Harries, David Kolb, Edward Casey, and others who have meditated in depth on this topic and concluded that no one has thought more radically and originally about the nature of place than Heidegger, yet I believe that Heidegger's ontology is in need of some anthropology. This is especially true when it comes to his thinking about the conditions under which places come into being. For example, Heidegger speaks abstractly about the disclosure of the world in and through the *Da* of *Dasein*, but surely the *Da* is first opened, and subsequently kept open, by the institutional order, about which Heidegger has next to nothing to say.[8] And surely Giambattista Vico (a true anthropological philosopher or philosophical anthropologist) was right to consider burial of the dead one of the three "universal institutions" of humanity, along with religion and matrimony.[9] What does burial have to do with *Dasein*'s place? In what way does the enclosure of the tomb open its *Da*? Serres remarks that the term *être-là* could be said to transcribe in another idiom the phrase *ci-gît*, or "here lies," which one finds on old French tombstones.[10] The Italian for "here lies"—*qui giace*—is even closer to the Latin matrix of this tombstone deixis: *hic jacet*. If one wanted to speak Heideggerese, one could say that the *hic* of *hic jacet* is the aboriginal *Da* that grounds *Dasein*'s situatedness and historicizes its being in the world, especially since *jacet* alludes to the finite temporality that *Dasein* makes its own in its so-called being-unto-death. In any case the *hic* of *hic jacet* is no ordinary locative adverb. It is an indicator that appropriates the ground of indication, drawing a boundary of belonging around it. It is a shifter that refuses to shift. In its always pointing to the same place, it marks that persistent finitude that underlies the placehood of place and pervades the *Da* of *Dasein*. No human words need be inscribed on the tombstone. A crude gravepost is sufficient to indicate this mortal *hic* or "here."

In his 1939 essay on the meaning of *physis* in Aristotle's *Physics*, Heidegger talks about the deeper commonality that underlies the difference between the two terms by which the Greeks thought and named the beingness of being: *hypokeimenon* and *hypostasis*. The former means literally that which lies under. Its Latin equivalent is *subjectum*, literally that which is thrown under. The latter term—*hypostasis*—means that which stands on its own. Its Latin equivalent is *substantia*. Heidegger claims that while to lie and to stand are quite opposite, "only what stands can fall and thus lie;

and only what lies can be put upright and thus stand."[11] I would insist that there is at least one case in which this dialectic fails, namely, in the case of the dead. The dead cannot "be put upright and thus stand," except vicariously, as when their statues, for example, are erected on the ground under which they lie. Be that as it may, if Heidegger can get away with saying that "both [hypokeimenon and hypostasis] have equal weight, for in both cases the Greeks have one and the same thing in view: being-present of and by itself, presencing," then perhaps I can get away with saying that this "equal weight" derives from the "subjective" commonality that links the living to the dead in the modes of memory, genealogy, tradition, history, and so on.[12] It is as if we the living can stand (culturally, institutionally, economically, in other words humanly) only because the dead underlie the ground on which we take our stance. To speak once again in Heideggerese, *Dasein* can inhabit its *Da* only because the *Da* is preinhabited by those who came before. The essence of human "subjectivity" may well consist in such preinhabitation. And perhaps even human "understanding," in its analytic and synthetic modes, derives from the same underlying source.

It is, I believe, impossible to understand the institution of places on the earth independently of the institution of burial. For what is a place if not its memory of itself—a place where time reflects back upon itself? The grave marks a site in the landscape where time cannot merely pass through, or pass over. Time must now gather around the *sema* and mortalize itself. It is this mortalization of time that gives place its articulated boundaries, distinguishing it from the infinity of homogeneous space. As the sign of human mortality, the grave domesticates the inhuman transcendence of space and marks human time off from the timelessness of the gods and the eternal returns of nature. That is why gods are not the original founders of place. Mortals are. An immortal god may bless a place that has already been founded, but such a god cannot introduce the mark of finite time necessary to ground it. Let us listen to what the historian Walter Burkert has to say about the difference between the cult of heroes and the cult of gods in ancient Greece:

An important difference between the hero cult and the cult of the gods is that a hero is always confined to a specific locality: he acts in the vicinity of his grave for his family, group or city. The bond with a hero is dissolved by distance. . . . In the newly established colonial cities, the founder generally becomes the *Hero Ktistes* who is often buried in the market place. In this way the new land is immediately given a centre which, even if not from a greater past, nevertheless symbolizes the good fortune and obligations that flow from the new beginning.[13]

The hero's burial here performs the function of Stevens's jar in that it provides the newly inhabited land with a center, makes of it a proper place. A god cannot do this. The city of Athens had in Athena its protective goddess, but even Athens needed the presence of Oedipus's grave in its vicinity to assure its founding and good fortune into the future. The cult of heroes to which Burkert refers in this passage is more ancient in origin than the cult of the gods. It goes back to the very earliest worship of the Indo-Europeans, to a time when people venerated their own ancestors and when the only gods who existed were domestic, mortal gods.[14]

Let me put forward another proposition here, to the effect that places are not only founded but are also appropriated by burial of the dead. The Sicilian Baron in one of Luigi Pirandello's stories is no doubt a savvy realist when he stubbornly refuses to allow his peasants to bury their dead on his land, fearing they would promptly come to believe that the land belonged to them by natural right.[15] The surest way to take possession of a place and secure it as one's own is to bury one's dead in it. Consider in this regard the controversy that erupted in Israel a few years ago between religious leaders and Jewish archaeologists who were disinterring ancient Hebrew graves. Jewish religious law holds the profanation of graves a sacrilege; hence the rabbis were demanding an end to the excavations. The archaeologists, in turn, argued that the more evidence they could uncover confirming that Jews had been buried there in ancient times, the more it would legitimate Israel's claim to its territories. The rabbis responded with a devastating logic: by attempting to legitimate the claim, the diggers were violating its basis.

The establishment of belonging through burial has origins that go back into the night of time. Vico—the Neapolitan to whom my work is most indebted—speaks of *homo humandi* and holds that our early ancestors first humanized themselves through burial of their dead. In his *New Science* he declares that these primitive "giants" would point to the wooden grave-posts of their forefathers to indicate their ground of belonging, hence their ownership of the land: "Thus by the graves of their buried dead the giants showed dominion over their lands, and Roman law called for burial of the dead in a proper place to make it religious. With truth they could pronounce these heroic phrases: we are sons of this earth, we are born from these oaks."[16] The pronouns—"this earth," "these oaks"—demonstrate possession of the *hic* in and through their gesture of pointing. Such was the giants' natural language. Vico calls them giants in the sense that they were "sons of this earth" who descended from buried ancestors whose place in the ground they could point to as their own.

Vico is probing the earliest origins of the ancient house, which was not merely a place of residence but an institution that linked the living to the dead, the dead to the unborn, and the family to its native ground. And

since I have mentioned Vico let me invoke another author who is dear to me and who was considerably influenced by Vico—Numa-Denis Fustel de Coulanges, the nineteenth-century French author of *The Ancient City*. The crux of this masterpiece of classical philology is the claim (abundantly substantiated) that the ancient city was built on the foundations of the ancient house, and that the ancient house was built in turn upon the ancestor's grave. Fustel de Coulanges, who boasted of having read every word in Greek and Latin that had come down to his age from antiquity, claimed that every Greek and Roman house featured an altar on which burned a sacred fire that was to remain perpetually lit and that the occupants identified with their domestic gods, that is to say, their buried forebears. Indeed, there is even evidence suggesting that the dead were sometimes placed *inside* these altars, hence that the house was literally and figuratively erected upon their tombs, forming a sort of mausoleum around them. We will never know to what extent Fustel de Coulanges's specific claims are historically exact, yet there is little doubt that the ancient house, and in its turn the ancient city, were founded upon such sepulchers.[17]

Unless we understand the binding terms of this genealogical contract between the living and the dead, we will never understand the heavy burden of Aeneas, leader of the Trojan refugees and mythical founder of Rome. After the destruction of Troy, Aeneas was entrusted with the responsibility of transporting the House of Troy from one land to another so as to save the house itself. More exactly, he was charged with carrying the ancestral gods of his family to a new home. In a dramatic passage of *The Aeneid*, the ghost of the dead Hector appears to Aeneas in a vision to give him instruction:

'Ah, goddess-born, take flight [cries Hector] and snatch
yourself out of these flames. The enemy
has gained the walls; Troy falls from her high peak.
Our home, our Priam—these have had their due:
could Pergamus be saved by any prowess,
then my hand would have served. But Troy entrusts
her holy things and household gods to you;
take them away as comrades of your fortunes,
seek out for them the great walls that at last,
once you have crossed the sea, you will establish.'
So Hector speaks; then from the inner altars
he carries out the garlands and great Vesta
and, in his hands, the fire that never dies.[18]

The household gods, or *Penates*, live on in that fire that never dies, except once a year, when it is ceremoniously extinguished and rekindled.

To save the House of Troy and preserve its continuity in time, Aeneas must not only relocate the *Penates* to a new land, he must also domesticate the *terra nova* by interring his people there. *The Aeneid* is punctuated by such ritual burials. Aeneas buries his father Anchises in Sicily; Palinurus he buries at the bottom of the mainland; Misenus he buries near Cumae; his nursemaid Gaeta he buries at Gaeta, a hundred miles south of the future imperial city. Each one of those sites becomes in its turn a place in Rome's future history. In this retrospective epic of Rome's founding—all the more revealing insofar as its mythic burials *are* retrospective—Virgil makes of Aeneas a tamer of the Italian peninsula, a hero who founds places in its wilderness by giving them the names of those whom he buries there. It is as if, by planting his dead at various sites as he makes his way up the coast, he lays the ground for Rome's future claims on those territories.

It is not only places, then, but also nations and empires, that repose on such human—call them humic—foundations. And lest we think that this claim relies on ancient myth and outdated French philology, we have only to look at the founding of a modern, "enlightened" nation like the United States of America. The American republic, we're told, is founded upon its Constitution. But how does or how must the Constitution ground itself upon that continent where its otherwise abstract, universalizing laws are supposed to apply? For it is one thing to frame a Constitution. It is quite another to give it a grounding that will secure the place of its authority. At a critical moment in American history, when the nation was divided over the issue of slavery, Abraham Lincoln realized that the Constitution needed to be rescued by those who, in coming to the rescue, would decide the fate of its authority. He realized, in other words, that the nation's founding scripture was in need of a refounding that the scripture itself could not provide:

Four score and seven years ago our fathers brought forth on this continent, a new nation, conceived in Liberty and dedicated to the proposition that all men are created equal.

Now we are engaged in a great civil war, testing whether that nation, or any nation so conceived and so dedicated, can long endure. We are met on a great battle-field of that war. We have come to dedicate a portion of that field, as a final resting place for those who here gave their lives that that nation might live. It is altogether fitting and proper that we should do this.

But, in a larger sense, we can not dedicate—we can not consecrate—we can not hallow—this ground. The brave men, living and dead, who struggled here, have consecrated it, far above our poor power to add or detract. The world will little note, nor long remember what we say here, but it can never forget what they did here. It is for us the living, rather, to be dedicated here to the unfinished work which they who fought here have thus far nobly advanced. It

is rather for us to be here dedicated to the great task remaining before us—
that from these honored dead we take increased devotion to that cause for
which they gave their last full measure of devotion—that we here highly resolve
that these dead shall not have died in vain—that this nation, under God, shall
have a new birth of freedom—and that government of the people, by the peo-
ple, for the people, shall not perish from the earth.

 Emerson's "Experience" opens with a question to his countrymen:
"Where do we find ourselves?"[19] To this haunting, deeply American query,
Lincoln at Gettysburg replies: *hic*. The word "here" occurs a full eight
times in his brief address. In each case it points to the ground—"this
ground"—to which the martyrs and victims of the nation's contradiction,
its civil war, have been consigned. A discrete grammatical breakthrough—
from "that nation" at the beginning of the address to "this nation" at the
end—indicates that the securement of the nation's *hic* has taken place,
precisely through the sepulchering act of the address itself.

 The Latin word *sepulcrum* comes from *sepelire*, which means to bury
but which has an Indo-European root that means "to render honor." The
historical irony of Lincoln's speech is that, had it not been for its honoring
gesture, the world would not much have noted what happened at Gettys-
burg. In other words, it does not suffice to bury the dead. As I stressed
earlier, it is also necessary to mark that burial. In this case Lincoln's address
is the *sema*, or grave marker. Its speech act makes of that ground a place
or *the* place where the nation finds itself, on which it must found, or re-
found, its republic. Not only in their sacrificial deaths, but above all in
their ritual sepulture, the remembered dead enable the nation to make its
own the continent on which it first came forth. The "here" in Lincoln's
speech is where nation and continent come together on that plot of
"earth" from which "government of the people, by the people, for the
people, shall not perish." Henceforth the continent becomes a veritable
place, a place where the idea of America can take root geographically.

 Yet the most important place secured in Lincoln's address is perhaps
that of the nation's time. Its *hic* does not only mark a geographical "here"
but also a historical "now": "Four score and seven years ago. . . . Now
we are engaged in a great civil war. . . ." The speech locates the nation's
place in time, in an ongoing, critical history, at a moment of decision about
whether such a nation can temporally perdure. America, in short, needs a
place to take place historically. That place is not only upon the earth of
"this continent" but also in the hearts of those who would assure, through
their rededication to the cause for which the dead here have died, that the
idea of America shall endure, that this *hic* shall henceforth be the place
where history, geography, and the Constitution intersect.[20]

To these reflections I would add the following reminder: such foundational acts are never completely primordial. Latium was not an inhuman wilderness when Aeneas arrived there. Far from it. The second half of *The Aeneid* tells of the Trojans' wars with and against the indigenous inhabitants of the new land. Likewise with the American continent. Stevens's poem about the jar may seem like an allegory of place-founding in the midst of a wilderness—I even read it as such—but we can't overlook the fact that the speaker "placed a jar in Tennessee," that there was already a place there in which to place the jar. The place name itself, Tennessee, speaks of this indigenous prehabitation. As Thoreau wanders through the so-called wilds of New England, he finds arrowheads everywhere in the soil. We are all latecomers, even those of us who believe we are firstcomers. The ground in which we lay the dead to rest has always already received the bones of others—"others" in the most radical sense of the term, including those of other species, many of whom who have died on our behalf and at our hand.

So far my claims about the foundation of place have drawn mostly on the archives of our cultural past. I now turn my attention to the present and then, by way of conclusion, consider how all this might relate to the concerns and vocation of architecture.

If cultural memory has a future, which at present seems doubtful, the twentieth century will one day be remembered as the fitful and prolonged continuation of a process that began in earnest a century earlier: the end of the neolithic era. Throughout this era, which got underway with the domestication of animals and discovery of agriculture, the great majority of human beings lived and toiled on the land where their ancestors were interred, where they and their children and their children's children would also be interred. This is no longer the case in Western societies. For the first time in millennia, most of us don't know where we will be buried, assuming we will be buried at all. The likelihood that it will be alongside any of our progenitors becomes increasingly remote. From a historical or sociological point of view, this is astounding. Uncertainty as to one's posthumous abode would have been unthinkable to the vast majority of people a few generations ago. Nothing speaks quite so eloquently of the loss of place in the postneolithic era as this uncertainty.

It goes hand in hand with another indeterminacy that until recently would have been equally unthinkable for the majority. Most of us have no idea where the food we eat comes from. We are oblivious of the fields that yield our grain, the gardens our vegetables sprout in, the orchards where our fruits are gathered. We are not familiar with the individual ani-

mals we eat: we do not tend to them, we do not watch them grow, we don't know what flock they came from or on which pastures they grazed, and above all we have no hand in their sacrifice. The daily holocausts that supply the world markets' demands for meat, fish, and poultry take place in another world than the one most of us inhabit. And yet we live off such holocausts, inevitably.

The fact that so many of today's children have never seen a cow is not necessarily a problem for the cows, but some of us would say it's a problem nonetheless. Milk remains more or less the same substance whether we know where it comes from or not, but when a staggering proportion of first-world children respond to the question, "Where does milk come from?" with answers to the effect that "It comes from the carton," or, in the case of meat, "It comes from the supermarket," there is reason to believe that more is at stake here than urban distantiation from the conditions of food production. Origins are in some ultimate sense unknowable, yet there is a difference between not knowing where life in its original impulse comes from and not knowing where milk comes from. When the "from" of the things we consume becomes not only remote but essentially unreal, the world we live in draws a veil over the earth we live on—a veil that obscures not only the source of our foodstuffs but also of our relation to the earth, namely our death, insofar as the earth is both our *unde,* or "from," as well as our *quo,* or "whereto."

Uncertainty about the provenance of one's food and the destination of one's corpse relate to one another not accidentally but essentially. Both are the consequence of a singleminded effort undertaken by the West in the last few centuries to emancipate ourselves, by whatever means necessary, from our millennial bondage to the land and our servitude to the dead. Who can blame us for striving for this emancipation? The sweat and tears of untold generations—an ocean of them—have gone into our labors. We have worked the earth to death and borne the curse of our earthbound race in every way imaginable. We have suffered endless hardships and indignities in the name of our obligations to the dead and the land. Haven't we paid our dues several times over? Don't we have the right to settle, once and for all, our debts with the dead, with the earth, even with God, if it comes to that?

This remains to be seen. A genuine modernity or postneolithic freedom would consist in a genuine settlement of this sort, but we are not genuinely modern, and for the most part we have presumed to settle our debts merely by disowning them. Certainly no amount of emancipation, be it through mechanized food production, technological innovation, or genetic engineering, can absolve us from the "substance" of our humanity, regardless of whether biomedical science succeeds in finding ways to prolong human

life indefinitely. Endless prolongation of life does not amount to absolution. Mortality is absolved only by the lucid reappropriation of its condition. The destruction of place that is occuring almost everywhere at present, and that has been occuring for some time now, is linked, at least in part, to an anxious and even frenzied flight from death. We are running away from ourselves, not so much in the sense that we are forsaking or destroying our traditional homelands but in the sense that we are forsaking or destroying the places where our dying is at home.

In his interview with *Der Spiegel*, during which he asserted that "only a god can save us" from the nihilism that is uprooting us from the earth, Heidegger declared: "We do not need atomic bombs at all [to uproot us]—the uprooting of man is already here. All our relationships have become merely technical ones. It is no longer upon an earth that man lives today" ("O," p. 56). These are the kind of solemn pronouncements that render Heidegger so irksome to many people. Certainly he managed to annoy his urbanite interviewers over the course of their long interview. Well-prepared and in no way intimidated by the philosopher's lofty stature, they responded to Heidegger's lament with the following challenge:

Spiegel: Well, we have to say that indeed we prefer to be here [on the earth], and in our age we surely will not have to leave for elsewhere. But who knows if man is determined to be upon this earth? It is thinkable that man has absolutely no determination at all. After all, one might see it to be one of man's possibilities that he reach out from this earth toward other planets. We have by no means come that far, of course—but where is it written that he has his place here? ["O," p. 57]

This is the most crucial "philosophical" question posed by the interviewers during the entire interview, for it goes to the heart of Heidegger's faith in the ontological relationality between "man" and the earth, indeed, his faith that Being, in the final analysis, is nothing other than this relationality. Heidegger answered awkwardly enough: "As far as my own orientation goes, in any case, I know that, according to our human experience and history, everything essential and of great magnitude has arisen only out of the fact that man had a home and was rooted in a tradition" ("O," p. 57). There is something feeble about the response, not only because the talk of "home" and "tradition" smacks of Swabian provincialism, but also because Heidegger, who had nothing but contempt for all forms of empiricism throughout his career, invokes his personal "orientation" and appeals, very uncharacteristically, to the authority of "experience and history," as if avowing that the faith that underlies his philosophy cannot be justified on philosophical grounds. If it is indeed the case that no such justification is

possible, then the statement that effectively culminates the interview—
"only a god can save us"—appears, if not inevitable, then at least coherent.
Such a god would presumably save our connection to the earth and thus
save "man" from the homelessness, or indetermination of nature, posited
by the interviewers' question.

I would have answered the interviewers somewhat differently, or in any
case more anthropologically. To begin with, I would have pointed out
that it is in the earth itself that it is "written" that we have our "place
here." Dig up its fossils, unearth its graves, excavate its cities, and read the
scripts for yourselves. They all say the same thing: *hic jacet*. To this I would
have added that it may well be the case that *man,* in his species being, is
not determined to be upon the earth, but that the same cannot be said
for *humanity*. Humanity is not a species. As Vico reminds us, and as the
word's etymon itself indicates, it is a connection with the humus. The
Neanderthals belonged to a different species than us, yet the fact that they
buried their dead is evidence enough that their mode of being was human.
If one day we colonize other worlds then we might be able to say, empiri-
cally and definitively, that man was not determined to be upon this earth
after all. But such a man, when and if he comes to exist, will no longer
be human, at least not in the sense in which Vico talked of *homo humandi,*
or in which his giants pointed to "this earth" and "these oaks" as their
place of belonging.

If Heidegger is right that "philosophy will be unable to effect any imme-
diate change in the current state of the world" or offset in any way the
"world movement . . . that is bringing about an absolutely technical
state"—a state divorced but not free from the earth—the same cannot or
need not be said for architecture, which determines the concrete configu-
ration of our life worlds ("O," p. 57). When I declared at the outset that
only an architect can save us, I was being only half-facetious, for architec-
ture has it within its power to house our mortality, and, in so doing, to
re-place the jar in our postneolithic habitat. Architecture not only reflects
but pragmatically shapes our modes of being in the world. We build who
we are. We edify ourselves. I would hope that we need not wait for a
global revolution or the advent of a god before we can rehumanize the
fundamental ontology of our building practices. I would like to believe
that our dying is accessible to us at any moment and that we can build or
rebuild upon that basis here and now. For as long as we think of our
houses, cities, and nations as merely places to live, and not as places to
die, those houses, cities, and nations can never become homes or reside
within the containing limits of mortality from which all shelter and place-
hood ultimately derive.

I see no reason why architecture, for all its past deliquencies, could not

lead the way to a fully modern redemption of our debt to the earth and hence to a new economy of habitation. Such an architecture would take its measure from our humic natures rather than from the empty expanse of a false transcendence—false in the sense in which earlier I spoke of our false modernity. We do not need an architecture of the milk carton that poses as the origin of its contents but an architecture of the cow, as it were, which brings to bear in its lineaments and materials the *unde* and the *quo* of life itself. Its buildings must not only rise from but also rede-scend into the ground of their edification. They must not only stand there but also lie there. In short, we need an architecture not so much of the humanistic (in the grand modernist sense) as of the humic.

I would expect a humic architecture of this sort to be palpably haunted by the earth in which the existential and historical past ultimately come to rest. By that I do not mean that it should be funereal, commemorative, or self-consciously pious toward the has-been, but that its buildings should sink into and emerge out of the recesses of mortal time, especially the underworld of the dead, in which the spirit of place ultimately resides. If a house, a building, or a city is not in some sense haunted in its architectural features—if the earth's placed historicity and containment of the dead do not visibly pervade its articulated forms and constitutive matter—then that house, building, or city is dead to the world. Dead to the world means cut off from the earth and closed off from the dead. For that is one of the ironies of our life worlds: they receive their animation from the ones that underlie them.

Notes

This essay originated as a talk delivered at the University of Virginia in Octo-ber 1999. It is dedicated to Karen Van Lengen, dean of the school of architec-ture. Unless otherwise indicated, all translations are my own.

1. Martin Heidegger, interview with *Der Spiegel*, "Only a God Can Save Us: The *Spiegel* interview (1966)," trans. William J. Richardson, in *Heidegger: The Man and the Thinker*, ed. Thomas Sheehan (Chicago, 1981), p. 57; here-after abbreviated "O."

2. "When *unfolding* architecture as distinguished from *enfolding* architec-ture comes to America there will be truth of feature related to truth of being" (Frank Lloyd Wright, *An American Architecture*, ed. Edgar Kaufmann [New York, 1955], p. 256).

3. The following titles represent only a small portion of the literature on place, but they are the ones that I have reviewed most thoroughly: Karsten Harries, *The Ethical Function of Architecture* (Cambridge, Mass., 1998); Ed-ward S. Casey, *The Fate of Place: A Philosophical History* (Berkeley, 1997); Da-vid Kolb, *Postmodern Sophistications: Philosophy, Architecture, and Tradition*

(Chicago, 1990); Kenneth Frampton, "Towards a Critical Regionalism: Six Points for an Architecture of Resistance," in *The Anti-Aesthetic: Essays on Postmodern Culture*, ed. Hal Foster (Port Townsend, Wash., 1983), pp. 16–30; Massimo Cacciari, *Architecture and Nihilism: On the Philosophy of Modern Architecture*, trans. Stephen Sartarelli (New Haven, Conn., 1993); and Manfredo Tafuri, *The Sphere and the Labyrinth: Avant-Gardes and Architecture from Piranesi to the 1970s*, trans. Pellegrino d'Acierno and Robert Connolly (Cambridge, Mass., 1987).

4. Wallace Stevens, "Anecdote of the Jar," *The Collected Poems of Wallace Stevens* (New York, 1983), p. 76.

5. Harries, *The Ethical Function of Architecture*, p. 223.

6. Michel Serres, *Statues: Le Second Livre des fondations* (Paris, 1987), p. 281.

7. I use the word *embodies* by way of allusion to Heidegger's short essay "Art and Space," *Man and World* 6 (1973): 3–8, in which he claims that sculpture, even more primordially than architecture, "embodies" *(verkörpern)* places by localizing space and figuring the site of human habitation.

8. See Heidegger, *Being and Time*, trans. John Macquarrie and Edward Robinson (New York, 1962), pp. 182–87.

9. See Giambattista Vico, *The New Science*, trans. Thomas Goddard Bergin and Maz Harold Fisch (Ithaca, N.Y., 1958), pp. 97–99.

10. Serres, *Statues*, p. 63.

11. Heidegger, "On the Essence and Concept of *Physis* in Aristotle's *Physics* B, I," trans. Thomas Sheehan, in *Pathmarks*, ed. William McNeill (Cambridge, 1998), p. 200.

12. Ibid.

13. Walter Burkert, *Greek Religion*, trans. John Raffan (Cambridge, 1988), pp. 206–7.

14. For an extensive archaeology of the early domestic religions of the Indo-Europeans, see Numa-Denis Fustel de Coulanges, *The Ancient City*, trans. pub. (Baltimore, 1980).

15. See Luigi Pirandello's novella "'Requiem aeternam dona eis, Domine!'" *Novelle per un anno*, vol. 1 of *Opere di Luigi Pirandello* (Milan, 1956), pp. 559–66.

16. Vico, *The New Science*, p. 185.

17. I deal more fully with this topic in my essay "What Is a House?" *Terra Nova* 1 (Spring 1996): 17–26.

18. Virgil, *The Aeneid*, trans. Allen Mandelbaum (New York, 1972), 2.285–95, p. 39.

19. Ralph Waldo Emerson, "Experience," *Essays: Second Series*, vol. 3 of *The Complete Works of Ralph Waldo Emerson*, ed. Edward Waldo Emerson (Boston, 1903), p. 45.

20. For a directly relevant discussion of how the intersections of geography, ideology, and history give rise to what he calls "holy landscapes," see W. J. T. Mitchell, "Holy Landscape: Israel, Palestine, and the American Wilderness," herein. At the end of his essay Mitchell refers to "the fantasies of the destiny

of Judaism as the possession of a physical place, rather than as an ideal of universal human value. This fantasy has now been realized in an idolatry of place, a territorial mysticism enforced by bullets and bulldozers. The challenge is to sound out this idolatry, to unbind its fascination" (p. 223). From the point of view of my essay, the challenge is to avoid the idolatry of place while holding on to the placehood of place.

Contributors

Ann Jensen Adams is assistant professor in the Department of the History of Art and Architecture at the University of California, Santa Barbara. She is the author of *Seventeenth-Century Dutch and Flemish Paintings from New York Private Collections* (1988).

Ann Bermingham is professor of art history at the University of California, Santa Barbara. She is the author of *Landscape and Ideology: The English Rustic Tradition, 1740–1860* (1986).

Jonathan Bordo is associate professor of cultural studies at Trent University. His current project is a monograph entitled *The Landscape without a Witness: An Essay in Modern Painting*.

David Bunn is associate professor at the University of the Western Cape. He is the coeditor of *From South Africa: New Writing, Photographs, and Art* (1988).

Charles Harrison is Reader in history of art at the Open University, England. He is the author of *English Art and Modernism 1900–1939* (1981) and *Essays on Art & Language* (1991) and coeditor of *Modernism, Criticism, Realism* (1984) and *Art in Theory 1900–1990* (1992).

Robert Pogue Harrison is the Rosina Pierotti Professor of Italian Literature at Stanford University. His most recent book is *Rome, la pluie: A quoi bon la littérature?* He is currently working on the topic of the relations the living maintain with the dead in modern Western culture.

Elizabeth Helsinger is professor in the Department of English Language and Literature at the University of Chicago. She is the author of *Ruskin*

and the Art of the Beholder (1982) and coauthor of *The Woman Question: Society and Literature in Britain and America 1837–1883* (1983).

W. J. T. Mitchell is the Gaylord Donnelley Distinguished Service Professor in the Departments of English Language and Literature and Art at the University of Chicago. His books include *Iconology* (1986), *Picture Theory* (1994), and *The Last Dinosaur Book* (1998). He is the editor of the journal *Critical Inquiry*.

Edward W. Said is University Professor of English and comparative literature at Columbia University. He is author of *Out of Place: A Memoir* (1999).

Joel Snyder is professor in the Department of Art at the University of Chicago. He is the author of *American Frontiers: The Photographs of Timothy H. O'Sullivan, 1867–1874* (1981). He is a coeditor of *Critical Inquiry*.

Michael Taussig is professor of anthropology at Columbia University. He is the author of *The Devil and Commodity Fetishism in South America* (1990), *Mimesis and Alterity* (1993), and *Defacement* (1999).

Index

Abramson, Larry, 283
Abstract painting, 13
Accursed Share, The (Bataille), 339
Adams, Ann, 3
Adams, Ansel, 183, 192
Addison, Joseph, 84, 85
Adorno, Theodor, 263, 322, 342
Aeneid, The (Virgil), 355–56, 358
Africa, 20, 244. *See also* South Africa
After the Last Sky: Palestinian Lives
 (Mohr), 28, 254
Albright, W. F., 252
"Aleph, The" (Borges), ix
Alkaline Lake, Nevada (O'Sullivan),
 275
All That Remains (Khalidi), 255
"All the Atlantic Mountains Shook"
 (Linebaugh), 330
American landscape art, 297
American West, xi, 268–70
"Amerika" (Nature Theater of Okla-
 homa), 337
*Analytical Inquiry into the Principles of
 Taste* (Knight), 79
Ancient City, The (Fustel de Cou-
 langes), 355
Anderson, Benedict, 13, 292
"Anecdote of the Jar" (Stevens), 350–
 51
Appleton, Jay, 16, 157
Arabs in Israel, The (Jiryis), 255
architecture, 349–51, 361–62

Aristotle, 14
Assassins of Memory (Vidal-Naquet),
 241–42
Atwood, Margaret, 295, 308–9
Auden, W. H., 332
Augustine, Saint, 11
Austen, Jane, 77, 248
Australia, 19, 24, 156, 320–25
Australian landscape art, 297, 310–11

Bachelard, Gaston, viii
Bardenstein, Carol, 257
Barrell, John, 6, 8, 211
Barthes, Roland, 275, 306
Bataille, Georges, 338–39, 341–42
Baudelaire, Charles, 181, 337
Beagle, 18
Beautiful Girl I Saw in a Dream
 (E. Schiele), 221, 223
Before Their Diaspora (Khalidi), 255
Bellow, Saul, 253
Benjamin, Walter, 322, 326, 328,
 335–37, 342–43
Benveniste, Émile, 301
Bermingham, Ann, 3, 6, 8, 128, 131
Bernard of Clairvaux, 246
Bey, Hakim, 328
Bhabha, Homi, 310
Bierstadt, Albert, 185
*Black Canyon, Looking Below Near
 Camp 8, Colorado River, Arizona*
 (O'Sullivan), 196